Objects an

CW01083572

Material Mediations: People and Things in a World of Movement

Edited by **Birgit Meyer** (Department of Religious Studies and Theology, Utrecht University) and **Maruška Svašek** (School of History and Anthropology, Queens University, Belfast)

During the last few years, a lively, interdisciplinary debate has taken place between anthropologists, art historians and scholars of material culture, religion, visual culture and media studies about the dynamics of material production and cultural mediation in an era of intensifying globalization and transnational connectivity. Understanding 'mediation' as a fundamentally material process, this series provides a stimulating platform for ethnographically grounded theoretical debates about the many aspects that constitute relationships between people and things, including political, economic, technological, aesthetic, sensorial and emotional processes.

Objects and Imagination

Perspectives on Materialization and Meaning

Edited by
Øivind Fuglerud and Leon Wainwright

berghahn
NEW YORK · OXFORD
www.berghahnbooks.com

Published by
Berghahn Books
www.berghahnbooks.com

Library of Congress Cataloging-in-Publication Data

Objects and imagination : perspectives on materialization and meaning /
edited by Øivind Fuglerud and Leon Wainwright.
 pages cm. — (Material mediations: People and things in a world of
 movement ; . 3)
 Includes bibliographical references and index.
 ISBN 978-1-78238-566-0 (hardback : alk. paper) —
 ISBN 978-1-78238-568-4 (paperback. : alk. paper) —
 ISBN 978-1-78238-567-7 (ebook)
 1. Material culture—Social aspects. I. Fuglerud, Øivind. II. Wainwright,
Leon.
 GN406.O27 2015
 306—dc23

 2014029070

British Library Cataloguing in Publication Data

A catalogue record for this book is available from the British Library

Printed on acid-free paper.

ISBN 978-1-78238-566-0 hardback
ISBN 978-1-78238-568-4 paperback
ISBN 978-1-78238-567-7 ebook

CONTENTS

ILLUSTRATIONS

ACKNOWLEDGEMENTS

———◆◆◆———

The work on this book would not have been possible without the support given for a series of international meetings and exchanges that began with the project 'Creativity and Innovation in a World of Movement' (CIM; 2010 to 2013) and the conference 'Materiality, Movement, Museum' at the Museum of Cultural History, University of Oslo, held in September 2011. CIM was financially supported by the HERA Joint Research Programme 'Humanities as a Source of Creativity and Innovation', co-funded by AHRC, AKA, DASTI, ETF, FNR, FWF, HAZU, IRCHSS, MHEST, NWO, RANNIS, RCN, VR and the European Union's Seventh Framework Programme for research, technological development and demonstration. Leon Wainwright expresses his personal thanks for the Philip Leverhulme Prize in the History of Art, given by The Leverhulme Trust, which supported him during the completion of this publication, and for the endowment funding associated with his chair at Colgate, New York.

INTRODUCTION

Øivind Fuglerud and Leon Wainwright

This volume brings together new empirical studies on a variety of topics ranging from ritual and art to advertising and museums. It shows that, regardless of their differences, these topics hold something in common, and complement and speak to one another. While the chapters are grouped into three thematic parts, these themes are overlapping and the contributions are commented upon in this Introduction without regard to these divisions. Working to address their importance in diverse parts of the world, our contributing authors share an interest in the way that the material world comes into being, how its objects are seen and used, and how they acquire and change value and meaning. Above all, we have granted a special place to objects, which are brought to the fore in order to treat them as the locus for understanding the intersections between materiality and the imagination. Consequently, this book contributes to what is now often called the 'material turn' in the social sciences (Knapp and Pence 2003) by offering a range of cases for appreciating how objects precipitate diverse imaginaries and make 'presence' possible.

One aspect of this has to do with what Maruška Svašek, represented in this volume, has elsewhere (2007, 2012) termed 'transit' and 'transition'. This describes the movement of people, objects and images across space and time, which allows individuals and groups to overcome space–time distances through material extensions of themselves or to re-create familiar environments in new surroundings while sometimes changing the meaning and emotional value of objects and images in the process. In chapter 4, Anders Emil Rasmussen discusses presence through the medium of money in Papua New Guinea, documenting an instance of the first kind of dynamic. Chapter 5, by Stine Bruland, offers an example of the second, presenting the material

repertoire involved in rituals that are performed by diasporic supporters of the Liberation Tigers of Tamil Eelam.

While we seek to emphasize the importance of such dynamics, in our opinion there is every reason to show that much more is involved in the relation of objects to space and time: that they are as capable of inertia as of movement, and of continuity as much as change. As noted by Morgan (2008: 228), the appeal of the turn to material culture lies in the opportunity to understand in what concrete ways the construction of everyday life, addressed more generally, actually happens. There are several strands of anthropological theory which are important to the historical development of this focus of interest. Not least, on the one hand, are the early studies of 'embodiment' as the existential ground of culture and self (e.g. Csordas 1990, 1994); on the other are the varieties of 'practice theory' that have broadened an understanding of human motivation and agency from being self-interested, rational and pragmatic to embedded in modes of perception and cultivated dispositions (e.g. Bourdieu 1977). Out of this has grown an interest in 'messy meaning'; the suggestion that sense is produced and re-produced in non-intellectual and often unrecognized ways through people's interactions with their material surroundings.

Within anthropology, the general interest in materialization has been accompanied by growing attention to museum anthropology and the anthropology of art. Several of our chapters focus on these fields. Chapters 2 and 3, by Peter Bjerregaard and Saphinaz-Amal Naguib respectively, deal with museum-related questions, while chapter 1 by Sylvia Kasprycki, chapter 9 by Fiona Magowan, chapter 10 by Amit Desai and Maruška Svašek and, chapter 11 by Tereza Kuldova, all deal with art. It should be noted that this contribution to mainstream anthropology by analysts of art and museums amounts to a reunion old companions. Historically speaking, anthropology is no stranger to either museums or to aesthetics. To say that the origin of anthropology can be found in the knowledge needed to judge, categorize and exhibit curiosities that came to Europe from far-flung corners of the world is only a slight exaggeration. The institutionalization of anthropology developed in close proximity to such collections, and was often led by geographers, historians and natural scientists with an interest in the exotic. For example, Adolf Bastian in Germany, Edward Tylor in Britain and Franz Boas in the United States all worked, for at least brief periods, out of museums. During that time, the study of aesthetics and 'primitive art' became part of standard anthropology (Boas 1927). This link was broken, however, when Anglo-American anthropology from the 1940s onwards lost interest in material objects, thereby relegating museum anthropology to a dusty corner of their discipline and focusing instead on social structures and contexts of interaction.

In part this turning away from 'the material' can be understood as an effort by the discipline to free itself from the burden of history; from its association with the adventurers, missionaries and colonizers whose actions epitomized the unequal relationships of power and the modern age of acquisitiveness in which anthropology was born. At the time, this was an attempted break from the evolutionist paradigm, with the items in collections being intended to document Man's climb from nature to civilization. By a twist of history, the same need may now be invoked to explain anthropology's renewed interest in art. The globalizing processes in which European nations were the chief benefactors have undergone a long phase of decolonization, and the migration of peoples from the 'global South' has helped to bring the political economy of ethnographic work – in museums and anthropology – under uncomfortable scrutiny. On this shifting ground, as indicated by the debate on 'writing culture' among anthropologists during the 1980s and 1990s (Clifford and Marcus 1986), the project of representing others, whether through exhibitions or writing, has become inherently problematic. As noted by Clifford, 'Gone are the days when cultural anthropologists could, without contradiction, present "the Native point of view"' (Clifford 2004: 5–6). A probable reason why it cannot be done any longer is that the conventional object of anthropological study – the strange and exotic – has become, by virtue of migration and the flow of images, part of the anthropologists' own societies. The 'neutral space' where anthropologists used to withdraw to in order to work out their 'translation' from one culture to the other is no longer available, if it was ever there at all. Yet it is not only that the supposed gap to be 'translated' – figured by geographical distance and lack of communications – has closed up. The very notion of a disinterested space of reflection for purely intellectual work has been systematically, and rightfully, contradicted.

Matter and Meaning

The relationship between anthropology, art and museums can also be approached from a different angle, namely in terms of what objects are and how they become significant – in those circumstances where meaning adheres at all. A suitable starting point for this is Gell's seminal book *Art and Agency* (Gell 1998). Undoubtedly one of the most important works in the field of material anthropology in recent times, its impact has been felt far beyond his own discipline. Gell's exposition is complex and the outline of his argument well known, and we will not attempt here to do justice to the work as such.[1] Suffice it to say that Gell sets out to establish an anthropological theory of art based not on art history or the categorization of objects

in terms of aesthetic qualities (and not even as such values are locally con-
strued), but on the way objects operate as 'agents' in advancing the social
relationships that are constructed through them. Art, as he conceptualizes it,
constitutes 'a system of action, intended to change the world' (ibid.: 6). Seen
in this way, anthropological analyses should concentrate on the production,
circulation and reception of objects functioning in particular ways, not on
their qualities as such (cf. Layton 2003: 449). This functional approach
does, of course, serve well for a volume like ours which deals both with
art and non-art objects as normally conceptualized in the Western world.
Even so, set against that background we are seeking to raise a number of
questions.

From the position of new materialism (see below), Gell's notion of agency
has been critiqued for retaining a conception of the human mind as the
source of creativity, thereby not overcoming the mind–matter divide of
Western science (Leach 2007). We will here pick up on another issue, his
refutation of art as a carrier of semantic meaning and communication (Lay-
ton 2003; Morphy 2009). According to Gell, art objects are neither part
of language nor do they constitute an alternative language (Gell 1998: 6),
since that would imply that their meaning and significance rest on socially
established conventions. This point is reiterated repeatedly in his work. He
writes, for instance, that he is 'anxious to avoid the slightest imputation that
(visual) art is "language-like" and that the relevant forms of semiosis are
language-like' (ibid.: 14). Instead, art objects attain their agency as indexes
of their producers or users, the term 'index' being Gell's preferred term to
identify the meaning of a 'natural sign' by which the observer can make a
causal inference (Gell 1998: 13; Layton 2003: 452).

The main issue here, of general importance to the field in which this book
places itself, is to what extent the impact, and therefore the significance, of
objects rests on social convention or on something much more material –
that is, the extent to which its impact makes itself felt through an object's
own 'thing-ness'. That the latter is sometimes the case, for example when a
person is run over by a bus, must be conceded, but is this also applicable to
the circumstances normally studied by anthropologists and art experts? The
question has recently come to the fore through the much acclaimed volume
by Henare, Holbraad and Wastell, *Thinking Through Things*, suggesting
that 'meanings are not "carried" by things but just *are identical to them*'
(2007: 3–4; italics in original). While, frankly, we suspect that the precise
meaning of this statement is not clear even to the editors themselves, it seems
natural to assume, by implication, that to the extent that things are signifi-
cant to humans at all, such significance must lie in some kind of causal im-
pact. In actual fact, this discussion is older than both that volume and Gell's
book. In an earlier discussion of the question, taking the form of a critique

of earlier formal readings of Oceanic art, Thomas (1995) argues that the 'meaning' (or significance) of decorations found on Asmat war shields lies not in what they convey about the society or worldview of their users, but in their effect. This effect, basically, is to make their opponents 'shit scared, paralyzed with fright, and prone to submit meekly to capture'. These are effects 'which are indexed in a viewer's body, which precede and supersede deliberate reading' (ibid.: 101).

While Thomas's point may be valid and important, his discussion shows the difficulties involved in moving beyond a notion of meaning as based on convention when talking about objects. Clearly, the fear experienced by enemies of the Asmat when seeing their shields may not be shared by, for instance, a Western audience observing the same shield in an ethnographic museum. Somehow this fear takes us past natural signs; somewhere and in some sense convention has to enter the picture. The same point is made by Morphy with reference to Gell, observing that Gell is inconsistent in his application of the concept of index (Morphy 2009: 10). He argues that Gell's refutation of socially established – in other words, conventional – meaning actually excludes the factors making it possible for social actors to use objects as agents of their individual agency, thus becoming an obstacle to what Gell himself wishes to demonstrate. Semantic meaning includes the purposes for which people come together in action and the content of the relationships established; in that sense, conventional meaning makes action of the kind that interests Gell possible (ibid.: 14). We regard this as a valid and important insight with implications for the study of material culture. We share Morphy's view that the knowledge, interpretations and experiences that people bring to bear on objects cannot be reduced to individual agency, nor can they be thought of as contained in the objects themselves. As he has stated, 'People act in relation to objects as a part of a history of relating to objects, a history that is supra-individual yet reproduced through individual action' (ibid.: 20).

Another way of framing this would be in terms of institutionalization, something we return to below. This institutionalization can involve actual institutions as perceived in the West and decisions made by people who work there (such as professionals in museums), or it can involve authoritative traditions guarded by elders or ritual experts. In this volume, Arne Aleksej Perminow (chapter 6) shows how specific categories of culturally valued things/objects are used among Tongans to mark and stage events of social significance. Against the backdrop of ancient traditions his aim is to look for contrasts in the staging of ritual spaces of sociality among homeland and overseas-based Tongans. The central point is that processes where the meaning of objects is given shape and form should be regarded as aspects of social and political life in the societies where they unfold. Such

meaning is often the outcome of contention, conflict or social drama. In the article by Thomas (1995) already cited, he points out that Polynesian canoes were not made simply to be seen, nor to transport people, but to be forcefully presented in certain contexts in which chants, ritual and the scent of oiled bodies compounded the effects of the decorations and material objects – with the consequence of animating people with the drama and strength of their own collectivity before they went on to overpower others. For this reason the 'art forms and the overall experience must … be seen to work both in some negative sense for others confronted by them and in an affirmative way for those who can identify with the canoe or canoe fleet' (ibid.: 106). Something similar, we argue, often goes on in museums that set out to portray 'the Other'. Visual representations of otherness may be taken to be more direct and perhaps also more prone to essentialism and stereotyping than written representations. In modern nation-states, exilic, migratory and diasporic populations have been especially subject to institutionalized forms of representation that show up this inequality. There is a pact of sorts, or at least an apparent complementarity, between vision and truth, which lends visual representation the semblance of 'givenness' or 'facticity', especially in fields of production where there is a tacit acceptance of the 'realism' of visual media, and a premium placed on 'making present' through the display of objects and collections. It would follow, then, that wielding the means of visual representation is a considerable power in itself.

The notion of institutionalization does not, of course, mean that traditions and institutions, and the authority they command, do not change. As Perminow shows with his example from Tonga and the overseas Tongans, they do. In chapter 10, Desai and Svašek provide a concrete example of the way the supra-individual and the individual, pointed to by Morphy above, may be interrelated; how one influential artist defines himself and his own innovation as growing out of age-old tradition, and as a result may renew and alter this very tradition. When it comes to museums, such organizations have often felt the need to reorient themselves to presenting a harmonious view of what Gilroy (2004a, 2004b) has dubbed the 'carnival of hetero-culture' of the contemporary metropolis. They have responded to the needs of the marketplace, the wide embrace of 'multiculturalism' in public policy, corporate and bureaucratic discourse, and an intensified identity politics issuing from minority groups whose own experience of insecurity is intertwined with the disruptive processes of multinational capitalism and its global cultural modernity (Žižek 1997). The results corroborate the sense of a slow shift from 'pedagogic' to 'performative' models of democracy that were noted by Dipesh Chakrabarty, drawing from literary studies by Homi Bhabha (Chakrabarty 2000). Museums have at the same time come to contend with the proliferation of other spaces of representation in which

the historical 'Other' may speak: the increasing visibility of a plural and globalized world, shaped by the spreading availability of internet and 'new technologies', and the peculiarly distributed and resistive uses of digital and social media. When these pressures have made it seem as though museums might be left behind by external social change, they have intensified their efforts and demonstrated an 'institutional self-consciousness', in tune with the general modernizing of organizations throughout contemporary society (Prior 2003; cf. Dewdney, Dibosa and Walsh 2012).

Such challenges have been especially patent and deeply felt in ethnographic museums. Burdened with their colonial legacy, a common strategy is to adopt an approach to museum spaces in which aesthetic qualities are emphasized and objects are largely left to 'speak for themselves' in exhibition displays. In an article first published in 1991, Clifford observes that 'treatment of artifacts as fine art is currently one of the most effective ways to communicate cross-culturally a sense of quality, meaning, and importance' (Clifford 1997: 121). Indeed, the twenty years since the publication of Clifford's paper have seen a growing emphasis on aesthetics in ethnographic exhibitions. In museum after museum, dioramas and reconstructed environments have been taken down and replaced by individually exhibited objects of 'beauty'. The display of objects as art has come to manifest a break from 'the ethnographic', and holds the purpose of relegating ethnography to an outdated path of thinking and exhibiting – a means for museums to readdress their epistemological claims by way of aesthetic ones. Such patterns of display also issue from assumptions that surround the aesthetic 'autonomy' of objects and images, so that materials that were until recently treated as artefacts have undergone another sort of profound 'translation'. The blurring of the divide between artefact and art – through the entanglement of all forms of material production in a penumbra of 'aesthetics' – has gone further than Clifford's post-processual account. His invocation of Greimas's semiotic square in order to specify a diagrammatic 'art-culture system' now seems inadequate for describing how objects that are granted the value of 'cultural evidence' in a historical or ethnographic museum may at the same time acquire the status of 'art'. If museums have repositioned themselves in the present moment of heightened 'institutional self-consciousness', they have done so by directly investing in an abstracted and expanding field of aesthetics. In chapter 1, Sylvia Kasprycki raises this broad range of issues underlying the reception, classification and representation of art produced outside the Western mainstream, including the dispute over the appropriate disciplinary competence to evaluate these visual expressions. She points out that despite a growing body of literature, symposia and exhibitions that have in recent years aimed at throwing some light on the conceptual and representational problems involved, it seems that artists, curators, scholars

and the art-consuming public alike are still grappling with conflicting para-
digms and (more often than not) preconceived notions of 'non-Western art'
and its place on a global scale.

The reframing of the holdings of museums has served to downplay
some older, once strident critiques. They were issued when demands for
representation within the museological order were at their height, with the
inception of the identitarian, feminist and deconstructionist approaches
that framed the 'new museology'. Certainly, these complexities stem from
changes taking place in democratic states where the museum has come to
be recognized as a crucial institution among several others responsible for
governance, social 'inclusion' and the production of citizenship. In seem-
ing to shrug off some of that burden of responsibility, the orchestration of
aesthetic encounters has gone along with a virtually libertarian argument
that museums are far from the totalizing 'discursive formations' that many
academics (such as Preziosi 1995) had shown them to be. The exponents
of aestheticization insist that the best sort of contemporary museum is one
where visitors are left to make up their own minds about what to look at,
how to look, and what to conclude from their visit (Cuno 2011).

Evidently this is a disavowal of the authority of the museum by its tech-
nologists, which devolves any decision about the 'quality, meaning, and
importance' (as Clifford had noted) of objects to a public which is allegedly
free to inscribe its own significance and to find its own 'visual pleasure'. But
quite apart from the neo-liberal purpose for museums that is at the core of
such arguments, the objection may be raised that such an ideology is suc-
cessfully masked by an unquestioned belief that aesthetics may have the sta-
tus of a universal category, or else occupy the 'neutral' ground for 'effective',
if not 'authentic', cross-cultural relations. The entire process of reification
is underscored by a lately sharpened rhetoric that exploits the idea of the
Enlightenment museum: a supposedly buried set of encyclopedic principles
whose rediscovery promises to return objects themselves to their rightfully
central place in museological experience.

It is easy to understand the countless reasons why ethnographers should
see these changes as detrimental to their vocation. We take the view, how-
ever, that in order to understand what is at stake in such a turn towards aes-
theticization in museums, the need has never been greater for ethnographic
work, together with anthropology and a distinctive 'post-museology'. Ma-
gowan's discussion, in chapter 9, of suburban-based Aboriginal artists is an
important reminder of this. She shows how these exhibiting artists redefine
and reclaim their rights in the present, as well as in the migratory pasts of
their relatives, challenging hegemonic cultural readings of Aboriginal art.

We propose that such an approach should also draw freely from art his-
tory. The discipline has been long accustomed to unmasking the normative

claims that are made for objects and images within and beyond institutional, commercial and ideological settings in the past, to which we must now add 'global contemporary art' as a network of sites that intersect erstwhile ethnographic objects and the operation of 'art worlds'. What we have witnessed in the turn to aesthetics is the suspension of ethnography, suggesting to us that a set of approaches which involves ethnography is imperative in order to reflect meaningfully on this process. As we show, such a manoeuvre is at its most dynamic when coupled with disciplines and approaches with a history of accomplishment in the project of defamiliarizing aesthetics. On that basis, we are more capable of showing in critical terms the diverse, unstable and historical interconnections between objects and the imagination.

The New Materialism

In order to gather the resources for such an intervention, it is worth tracing out the historical emergence of the intellectual landscape of the social sciences today. As already mentioned, in the first part of the twentieth century, art and material culture were split off from mainstream developments and treated as subjects of specialist interest. Since then we have seen, among other developments, the tremendous impact across social science disciplines of linguistic perspectives and their articulations in different forms of structuralism, semiology and social constructivism. This prompts a brief mapping of the new topography that the present volume traverses. We should make it clear, however, that we do not seek to resolve or to establish a settled and shared view on the many difficult issues involved. Assembled in this volume is a group of contributors who have entered into productive disagreements on some areas as much as they have also found room for carefully reached consensus. Several of them have reservations as to the position taken in this Introduction, but even so they have worked on problems that share a common territory. What we will do here is to indicate this common ground, while maintaining a central assumption that a sharpening of focus on the imagination will contribute crucially to studies in material anthropology.

If what we are now seeing in the social sciences is a new interest in material perspectives, this can be linked to the slow waning of the linguistic turn that began in the 1970s. Led by pioneers like Latour and Ingold, many have felt in recent years that this paradigm is about to utterly outplay its role; that the description of a linguistically mediated reality misses out on something fundamental about the material foundation of people's everyday lives. The liberating potential of its deconstructive project is ebbing: as Latour has put it, that 'critique has run out of steam' (Latour 2004). The new materialism is not a coherent movement; it has found diverse expressions in

science studies, ANT (Actor-Network Theory), studies of consumption, and ecologically oriented studies on human–nature entanglements (Rose and Tolia-Kelly 2012). This new focus has brought fresh conceptualizations of the material world. Researchers like Donna Haraway (1991) and Anne-marie Mol (2002) have shown that the material can no longer be taken as a priori, as a given and passive opposite to the cultural, but must be seen as an active and 'unstable' result of specific practices; as something to be, in a sense, 'performed'. In chapter 7, Katherine Swancutt takes on the challenges of this unstable materiality through a case study of ritualistic warfare among the Nuosu of South West China – a Tibeto-Burman highlands group also known by the Chinese ethnonym of Yi – where effigies, sacrificial meat or chicken decoys may undergo some degree of ontological slippage from being mere representations to becoming material vessels of unwanted ghostly agency. In response, throughout this book we refer to materiality in the form of a verb, as 'materialization'.

A more precise characterization of what has sheltered under the umbrella of new materialism is made difficult by the fact that several of the leading figures in the social sciences prefer not to see their own contributions in terms of theory with universalizing ambitions. Instead, they argue with questionable modesty that what they bring to the table is only a method to be applied concretely (e.g. Latour 2006: 20; Henare, Holbraad and Wastell 2007: 7). At the same time there is no doubt that many of the studies in this genre rest on assumptions and aim to document claims that are new to the Cartesian science that took hold in the West. Latour succinctly sums up this new perspective by noting that:

> Subjectivity, corporeality, is no more a property of humans, of individuals, of intentional subjects, than being an outside reality is a property of nature ... Subjectivity seems ... to be a circulating capacity, something that is partially gained or lost by hooking up to certain bodies of practice. (Latour 2006: 23)

Setting out from a different starting point, yet essentially in agreement on many points, Ingold has charged the social sciences working under the Cartesian paradigm with following a logic of 'inversion' where a person's involvement in the world 'is converted into an interior schema of which its manifest appearance and behavior are but outward expressions' (Ingold 2006: 11; also 1993a, 1993b). Through this inversion 'beings originally open to the world are closed in upon themselves, sealed by an outer boundary or shell that protects their inner constitution from the traffic of interactions with their surroundings' (2006: 11).

This entire wave of material-ecological perspectives has brought inspiration and energy to the social sciences, gasping for air in the wake of the 'writing culture' debate and the 'posts' of the 1980s and 1990s (post-struc-

turalism, post-modernism, post-colonialism, and so on). Still, we cannot help but feel that something is missing in this new materialism. Somehow, the perspectives tend to remain too close to the ground. Both Latour and Ingold seem to imply that human attention is structured by the 'flow-through' of our immediate material environment. They demonstrate their conclusions by a preference to look at how the immediate physical context, the encounter or exchange with materials and substances outside their own bodies, serves to focus human brain activity on this exchange itself.

Latour, in a brief but important text (Latour 1996: 238) conjures up the image of the post office, with its counter and speaking grille, in order to explain how physical structures have a hold or exert an agency which impacts on customers. While most of the ensuing research analysing science and technology is more elaborate and larger in scale, it derives from a similar approach. Ingold's long-held arguments are comparable. With attention to a notion of *skill,* here the dynamic exchange between human and material gives shape to stone axes and dwellings. While all this is persuasively deployed across a corpus of such studies, we are left asking whether this sort of immediacy in human experience has been given analytical prominence at the cost of a more widely reaching account. It seems to us that the growing complexity of the world calls for an analysis that diverges from currently available perspectives.

A dimension of this complexity has to do with the fact that humans have a developed awareness of what goes on outside their immediate material environments, such that the material world is not the boundary of all thought and feeling. So even while we chop wood and build canoes, we may be just as involved in a vast scope of other activities: students study for their coming exams, military officers construct potential war scenarios, migrants worry about family members they left behind, families plan vacations in faraway countries, old people reminisce about days gone by. Even a cursory survey of human experience has to respect its inestimable diversity, in which there is apparently no limit to what people do. Looked at in this way, beyond what can be gathered at a glance, there is the dimension of those activities that sit between dreams and fantasy – a nexus of projected futures and remembrance which enfolds humans with the material world. In capturing some of this, ours is a move towards a notion of the imagination and a field of imaginaries.

The Nature of Imagination

In a recent paper it was pointed out that 'imagination' in anthropology is currently changing status from a 'fairly exotic topic' to 'enjoying an emerg-

ing vogue' (Robbins 2010: 306). If this is so, one should not be surprised to find that debates on the concept, and on the phenomenon as such, will implicate many of the fundamental questions of social theory: the nature of the social, the consequences of historical change, the role of human agency, the workings of power, and so on. This is precisely the ground on which we move in this book, and by way of introduction we will briefly offer comments on some of these questions.

Concerning its role in the constitution of society, one line of thought on imagination can be generally traced back, as with much social theory, to Durkheim and to Hegel (Stretski 2006, Chapter 2; Knapp 1985). In the history of thought, Hegel's concept of *Geist* is the forerunner and probable inspiration for Durkheimian notions like collective conscience, collective representations, society as a *sui generis* reality, and the transition from mechanical to organic solidarity. For Durkheim, systems of social representations – imaginaries – exist independently of individuals, anchored in social institutions like religion and family structures, reproduced and circulated in myths, rituals and art.

In contemporary debates on social imagination, this heritage of collective representations is lifted by the towering figures of Benedict Anderson, Charles Taylor and Arjun Appadurai. According to Strauss it is no coincidence that references to imaginaries are becoming more frequent just as culture is losing out in academic parlance: 'to a certain extent *the imaginary* is just *culture* or *cultural knowledge* in new clothes' (Strauss 2006: 322; italics in original). Both Taylor (2002) and Appadurai (1996) acknowledge their debt to Anderson, in particular his path-breaking book, *Imagined Communities* (Anderson 1983), on the development and spread of the concept of the nation from the late eighteenth century onwards, which he demonstrates as ensuing from practices related to new technologies, the print media and vernacular print-languages in particular. These practices made it possible for language users to picture themselves as being part of communities sharing the same conceptual space, the same concerns and destiny, in contrast to other communities sharing other languages and other concerns. Taylor's influence in anthropology, made from an external position in the field of political philosophy, has rested largely on his conception of a modern social imaginary, or 'the way we imagine our society'. Seen by Taylor as evolving from its origin in theories that were argued and debated among elites, subsequently becoming a widely shared conception held by ordinary people, this imaginary implies a sense of both how things usually go and how they *ought* to go. The social imaginary is 'not a set of ideas; rather it is what enables, through making sense of, the practices of a society' (Taylor 2002: 91).

The empirical focus of Anderson's book and Taylor's essay is the historical transformation giving rise to the new moral order of Western modernity.

By contrast, Appadurai's book, *Modernity at Large* (1996), draws attention to the next, and ongoing, major historical transition: what follows after modernity in its classical form, namely the postnational, the postcolonial, the diasporic, the deterritorialized. While he is not clear on the precise dating of this historical process – according to Appadurai 'the globe has begun to spin in new ways' (1996: 58) – there has been a technological rupture causing the imagination to enter 'the logic of ordinary life from which it had largely been successfully sequestered' (1996: 5). In Appadurai's historical understanding, imagination was until recently confined to the special expressive spaces of art, myth and ritual. They were domains controlled by specialists or under the domination of especially gifted individuals. Today, as a result of the proliferation of media and migration, and made possible by new forms of transport and transmission, 'ordinary people have begun to deploy their imaginations in the practice of their everyday lives' (1996: 5). The work of the imagination has consequently become 'a constitutive feature of modern subjectivity' (1996: 3).

Our aim here is not so much to debate the historical specificity of these authors' arguments, but more to inquire into how they look upon the role of imagination and social imaginary, as well as how their positions are seen by others. It should be noted that all three thinkers link the role played by imagination to a process of historical change and to modernity in some version.

Interestingly, the understanding of a historical rupture is shared by Ingold, who in other respects is far removed from the perspectives of Anderson and Appadurai. In his discussion of human evolution, Ingold (1993a, 1993b) seems to imply that imagination plays a larger role in modern than in premodern societies. In hunting and gathering societies survival depended on skill. Skill, according to Ingold, is not the application of knowledge previously gained and transmitted, since through interacting with materials – whether or not mediated by tools – technical knowledge is gained and applied (1993a: 434). However, as mechanically determined systems have gained dominance, a division has been created between knowledge and practice, and we come 'to confront the spectre of a meaningless environment', the objective world 'out there' (1993b: 465). Technical evolution describes a process of objectification of productive forces (1993a: 439). We can only try to recover the meaning lost through disengagement from practical engagement with nature symbolically, by attaching cultural significance to it. It is in this process that, for Ingold, imagination finds its place. It is seen as an intellectualist and, in a sense, artificial effort to re-establish a lost enchantment.

To us this kind of historical understanding is unsatisfactory. As pointed out by Handler (2002: 71), it is one thing to argue that new economic for-

mations and communication technologies facilitate new imaginings – this is
business-as-usual in human culture. It is quite another matter to suggest, like
Appadurai and Ingold do, that such imaginings, or technological develop-
ments underlying them, amount to a qualitative rupture in human history.
This comes close to postulating a stereotype of differences between 'the tra-
ditional' and 'the modern'. With respect to Appadurai's argument we agree
with Handler that in arguing that 'the imagination' has in the past been
confined to a ritual–religious domain and excluded from the ordinary lives
of ordinary people, Appadurai seems to take as a starting point a contempo-
rary Western understanding of the religious as confined to a specific corner
of society. For our purposes here this is an important question, as we do
suggest that objects and practices are indeed able to bring about processual
imaginative effects in ordinary people's lives outside the realm of modern
technology. In the same way that we believe that objects – material forms
– were and are able to precipitate imaginaries without modern technology,
we also believe that people in modern societies have, surprisingly often, non-
intellectual, emotional relationships to objects and artefacts – many of them
industrial products – of the kind Ingold seems to reserve for pre-industrial
society. We can only agree with Miller (2007: 25–26), who in a comment on
a critique by Ingold (Ingold 2007) on contemporary studies of materiality,
characterizes Ingold's position as 'primitivism'.

Claudia Strauss, a well-known proponent of cognitive anthropology, in a
broad discussion paper is ready to accept the existence of social imaginaries,
provided observers are able to answer the question: 'Whose imaginaries
are these?' (Strauss 2006: 339). Her attitude towards Anderson and Taylor
is sympathetic, but she makes the general point that since the imaginaries
they are interested in must be located in the minds of actual people, they are
really what cognitive theorists have since the 1980s called 'cultural models'.
This is a way of saying that the cognitivists got there first. In an introduction
to a special issue of *Ethnos* on 'technologies of the imagination', Sneath,
Holbraad and Pedersen (2009) are less accepting. Their position is that
recent writings on imagination have tended only to 'enlarge' on concepts
of culture, to 'upgrade' them in newer versions (ibid.: 7–8). In their view
'imagination is best understood in non-holistic and non-instrumental terms'
(ibid.: 6). They criticise the fact that social imaginaries are often 'teleologi-
cally defined in accordance to a hypostatized socio-psychological function,
such as "making sense of the world"' (ibid.: 8), and go to great lengths to
try to refute the belief that the imagination is something *purposeful*. The
'making-sense-of' they seek to replace with a perspective on 'imagination
as an outcome rather than a condition' (ibid.: 19). Intriguingly, however,
while being posited as an effect of processes of some kind, these effects are
said to be 'undetermined' by the same processes. The only answer to how

this can be is that 'the imagination is *defined* by its essential indeterminacy' (ibid.: 24; italics in original). It is a proposition that we will consider in the following section in a slightly broader perspective.

The Power of Aesthetics

One important question raised by an understanding of imagination as undetermined is the question of power, which again is linked to the questions of human intention and of holism in social life. Not wishing to prolong the discussion unnecessarily, as editors of the present volume we should state that we regard the capacity to act with purpose as a fundamental human capacity, separating people from stones, trees, houses and furniture. This does not mean that humans always achieve what they try to accomplish. Nor does it suggest that their actions are not influenced or modified, or even at times made impossible, by their environment, whether human or non-human. Neither does it mean that social life is preconceived, planned at the drawing board and then implemented, as in Ingold's caricature of social sciences – *far from it*. Life, social life included, is becoming, emergent, always unfinished, and so are thought and imagination.

To the intentionality of human existence, imagination is vital. It plays out both in coming to terms with our own life and with our role in the world. Due to life's emergent character neither self nor society has any inherent essence. As noted by Taylor in another context: 'What I am has to be understood as what I have become' (Taylor 1985: 47). To maintain and come to terms with this self-understanding is for many a constant struggle, dependent on the ability – and possibility – of stabilizing illusion. For most, giving meaning to their own lives will involve seeing themselves as part of a larger story than their own, involving other people, other stories, in a plot transcending them (Hastrup 2007: 197; also 2004). This, however, is not only a glimpse in the rear-view mirror; it is a way of incorporating the future. Action is not reaction. Human agency is linked to anticipation, to a vision of a plot, or a line of possible future development (Hastrup 2007: 199). This is how society happens. As noted by Hastrup:

> All social fields, ranging in scale from the global community to villages and families, depend on illusion (as suspense of form) to be real ... The point is that by investing their own interests and actions in filling out the form, social agents make the community happen. (Hastrup 2007: 198)

This is where objects, or rather aesthetics, enter the picture. The objects referred to in the title of this volume are not of interest primarily as artefacts, as 'accessories', but because, as meaningful objects, they help to give form

to the world(s) that people inhabit. Aesthetics involves more than contem-
plation of beauty in the Kantian sense. Rather, we need to go back to the
Aristotelian notion of *aisthesis,* the way we perceive the world through *all*
our senses (Verrips 2006). The importance of the material stems not from
the fact that humans are without will, purpose or agency, but by virtue of
the world in which we operate being always mediated to us through form.
This material element is not the objective, stable form of old-school natural
science so much as a result of the exteriorizing force characteristic of human
imagination.

A leading thinker in this area is Birgit Meyer, whose contribution is dis-
tinctive for applying such an understanding largely through studies of reli-
gious practices and film. She has coined the term 'sensational form' as a way
of expressing the importance of mediation for making religious experience a
reality. This notion includes all media that act as intermediaries in religious
mediation practices. According to Meyer:

> Sensational forms can best be understood as a condensation of practices, atti-
> tudes, and ideas that structure religious experiences and hence 'ask' to be appro-
> priated in a particular manner. Religious sensational forms work in the context
> of particular traditions of usage, which invoke sensations by inducing particular
> dispositions and practices toward these forms. (Meyer 2009: 13)

Sensational forms, therefore, involve mediation but are not limited to objects
– they include practices and ideas constituting the material, in a particular
shape and form, as real. In chapter 8, Birgit Meyer presents her thoughts in
a broad sweep on mediation, rejecting the assumption of an originally un-
mediated state into which media enter with their alienating logic, insisting
instead on mediation as generating communication, thereby making a world
possible. In this perspective the world created is not merely a construction,
in the sense of being artificial. Mediation refers to the process through which
a world – 'culture' if you wish – is made and vested with reality.

In a sense every action is holistic, not because people are cultural robots,
but because the single act incorporates in itself an imaginative whole; 'the
wholeness of the plot is present in the individual action' (Hastrup 2007:
198). What people do when they do something is to invest themselves in a
whole which they either confirm or seek to change (Hastrup 2004). Human
imagination, which is a form of action precipitating other forms, is governed
by a logic of closure, seeking to interpret what it engages with in a particu-
lar way. This point is important because it allows us to see that individual
imagination is not a pure mental act unaffected by social processes, but
always plays out in a world already constituted through social categories.
Operating in a world of meaning, the imagination is closely linked to what
the philosopher Jaques Rancière (2004, 2009) has termed 'distribution of

the sensible', world-making understood as a political project grounded in the perception of material cultural forms.

What About Art?

A note on art may be relevant here. The current anthropological interest in art is mainly motivated by an interest in the importance of aesthetics and in questions pertaining to the creation of value. In chapter 11, Kuldova presents a particularly interesting case relevant to this field: the 'artification' of the Indian fashion industry – a junction between design, the alcohol industry and art, or rather the 'aura of art'; a world where media and advertising play a crucial role in making certain objects and certain people more valuable than others. In contemporary, everyday speech 'art' is often seen as a particular form of activity, resulting in works expressing something essential about the human condition and gaining their value by being located at the periphery of short-term economic interests. For example, as formulated by Georg Simmel in his *Philosophy of Money* from the year 1900, art is the one area where the fragmentation and alienation involved in capitalist production can be overcome. According to Simmel, 'the autonomy of the work of art signifies that it expresses a subjective, spiritual unity. The work of art requires only one single person, but it requires him [*sic*] totally, right down to his innermost core' (Lloyd 1991: 96).

This, the way we see it, is a rationalization that can be done away with quickly. In general terms we agree with Rancière (2009: 29) that the existence of art depends on socially established criteria for identifying art, that is 'a specific relationship between the practices, forms of visibility and modes of intelligibility that enables us to identify the products of these latter as belonging to art or to *an* art'. A statue of a goddess – Rancière's own example – may or may not be art, or may be art differently, depending on the regime in which it is apprehended. But there are other questions here. In a recent and much acclaimed introduction to a volume on creativity and cultural improvisation, Hallam and Ingold (2007) have criticized the linking of the concept of creativity to notions of innovation, arguing instead for the central role of improvisation. According to them, to read creativity as innovation is to read it backwards, in terms of its results, instead of forwards, in terms of the movements that gave rise to them (ibid.: 3). It is, indeed, very easy to agree with Hallam and Ingold when they argue that since social and cultural life is not scripted, life itself is dependent on improvisation, and that since improvisation is generative 'it is not conditional upon judgments of the novelty or otherwise of the forms it yields' (ibid.). Nevertheless, out of two paintings in your living room, one may be worth a fortune and the

other next to nothing. The same is the case with other forms of action. In other words, the continuous improvisation taking place throughout society plays out within institutional frameworks and regimes of value contested or validated by emergent action. Reading forwards or backwards, this constant process of institutionalization is also part of social life.

There are various other contemporary perspectives on art that have tried to enlarge on this picture, while striving to go beyond the treatment of artworks as if they are indeed 'readable' forms of social life, and somewhat regardless of whether they are found in a state of process or product. The anthropology of art and aesthetics, and the forays from art history into anthropology, each offer a background to this book, and it is worth bringing into the open how such movements among disciplines have brought us to a study of objects and the imagination. The art historian Hal Foster's essay 'The Artist as Ethnographer?' broaches a discussion of those artists who appear to take on the mantle of the ethnographer, a creative practitioner who is 'a paragon of formal reflexivity, sensitive to difference and open to chance, a self-aware reader of culture understood as text' (Foster 1994: 14). Evidently this falls into the 'culturalist' tendency that we outlined earlier. Somewhat more gravely, however, it is complicit with what Barbara Stafford has seen to be the 'ruling metaphor of reading', or 'the intellectual imperialism of collapsing diverse phenomenological performances, whether drawings, gestures, sounds or sense into interpretable texts without sensory diversity' (Stafford 1995: 8). The same tendency has served as the focus for much approbation among critics of 'semiological reductionism' throughout the humanities and social sciences, sharing the historian of philosophy Martin Dillon's view that 'One way not to see the world is to read it as text' (Dillon 1995: 104). The preferred alternative, when manifest in art historical research specifically, has a rather familiar ring. The art theorist Jean Fisher, for instance, has written passionately against the prevailing tendency to suggest that 'art is more a cultural *product* than a dynamic *process* or complex set of immanent and sensuous relations' (Fisher 1994: 33; emphasis added). Art history's criticism of the popularity of models of signification, textuality and representation for understanding works of art is much like Hallam and Ingold's contribution *avant la lettre*.

Indeed, very few thinkers are capable of moving theorization beyond such a polarized analytical focus, whether those poles are 'process and product', or the reified difference between significance and form. Likewise, there is rather too much 'reductionism' at work in existing studies of how artworks stand in relation to those features that acclaimed mid-twentieth-century authorities on artistic Modernism such as Clement Greenberg had argued were 'external' to art: its makers, audiences, patrons, institutions, other works of art, and so on, typically generalized in an abstract (and thereby potent) con-

cept of art's 'context'. Finally, we would like to make clear for the purposes of this book that these shortcomings are rather more difficult to make up for than those the available formulas of inter- or transdisciplinarity have promised to resolve. Art history not only needs more awareness of how the social sciences have come to approach the ideas and operations of artworks, and for such interest to be mutual, but to accept that the specific terms of this interaction now need scrutiny. We hold little store however by Bruno Latour's description of the criss-crossings that take place between and beyond such disciplinary territory, such as his observation that 'To shuttle back and forth, we rely on the notion of translation, or network. More supple than the notion of system, more historical than the notion of structure, more empirical than the notion of complexity, the idea of network is the Ariadne's thread of these interwoven stories' (Latour 1993: 3). As art comes to be of increasing concern across multiple academic sites, it enters such spaces at the considerable risk of transforming beyond recognition. Latour's suggestion that we ought to rely on the notion of 'translation, or network' would subject artworks once more both to the linguistic paradigm, and to the situation we outlined above where the 'immediacy' of a relation to materials in any given environment will hold analytical primacy.

Hovering around this discussion is an approach to the imagination which may yet return us to measures of individual involvement in art-making, in a way that recognizes the 'ecology' among diverse aspects of art's worlds. Marsha Meskimmon (2010, 2013) has developed the idea of imagination specifically in relation to contemporary art and cosmopolitanism, and in more recent work by Nikos Papastergiadis (2012) surfaces the notion of a cosmopolitan 'imaginary'. For each author, the potential of the imagination – addressed in its 'cosmopolitan' dimensions – is to 'open the fabric of the ordinary and change it forever', and to formulate an ethical subjectivity which fixes on the politics of imagination. This is to take up what Edward Casey (2000) called the 'possibilising' force of imagining, or the potential of the imagination to serve as a standpoint for exploring new horizons of thought. As Meskimmon writes:

> Art-making as world-making in the stronger sense of materialising these precarious ecologies does not image the cosmopolitan, but enables imagination to play a critical part in its articulation. Art is thus not a mirror of the world (a representation of *the world*), but a constituent component in its perpetual remaking, a component whose materiality and affective agency are paramount. (Meskimmon 2013: 22; emphasis in original)

Such declarations of art's potential – its 'possibilising' – brings us to the uneasy relationship between individual imagination and processes of institutionalization which is the main subject of Cornelius Castoriadis's (1987)

social theory. A comprehensive discussion of his complex work is beyond the scope of this Introduction; suffice it to say that he contributes to the topic under discussion by offering a critique of structuralism's inherent functionalism – seeing meaning as a systemic result – and bringing an alternative perspective on language, language use and the production of meaning in general as an interplay of individual intentionality and social institutionalization. Social reality for Castoriadis is seen as 'the union *and* the tension of instituting society and of instituted society, of history made and of history in the making' (ibid.: 108; emphasis added).

Seen in this way, a notion of institutionalization is necessary to comprehend how objects attain and change meaning and value. With respect to the present volume, we would like to suggest a very simple model of the contexts or dimensions that we need to take into account in order to get a grasp of the object, to understand what the object *is* in any meaningful sense of the word – contexts which today more often than not coexist not in harmony but in friction (Tsing 2005). 'Friction', in Tsing's use of the term, includes 'the awkward, unequal, unstable, and creative qualities of interconnection across difference' (ibid.: 4). Deploying friction as an analytical concept implies taking seriously the evidence that social phenomena, whether objects or ways of life, are rarely the result of localized, self-generating processes, but of trajectories of interaction and dialogue between partners who are unequal or different in terms of power, scale and outlook. Our proposed model in response would look something like figure 0.1.

We suggest that the model has equal relevance to cash-notes in Melanesia as to advertising in India. The basic idea would be that an object may – if today only occasionally – be understood in terms of the way it is produced locally or in terms of the intention of its creator. It may also be 'appropriated' and ascribed new meaning by institutional actors, without the producer having much say in the matter. However, these encounters between creator/actor and object take place and attain form within a shared space – a socially imagined space if you like – which is constituted and upheld by the encounters themselves. When the Chinese Nuoso make a ritual effigy to fight their demonic adversaries (chapter 7), this effigy is not a (passive) result of pre-programmed Shamanism, it is culture in the making; a giving of form to the convictions people hold in common. When textiles produced by economically marginal women in Lucknow are reframed by New Delhi business interests through their mixing with art and alcohol (chapter 11), this branding gives particular shape to Indian capitalism, and structures relationships in the value-chain. In each of these settings and beyond, what is at stake in this volume is the specificity of the social imagination as it produces human relationships and comes to have a distinctive impact on them.

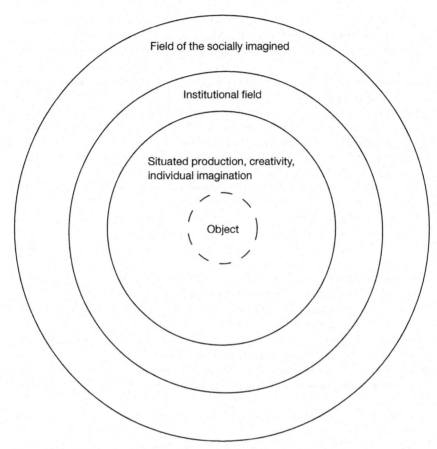

Figure 0.1. Objects and imagination.

Notes

1. Some of the more absorbing reviews of Gell's volume include: Pinney and Thomas 2001; Layton 2003; Rampley 2005; Leach 2007; Morphy 2009.

References

Anderson, B. 1983. *Imagined Communities: Reflections on the Origin and Spread of Nationalism*. London: Verso.
Appadurai, A. 1996. *Modernity at Large: Cultural Dimensions of Globalization*. Minneapolis: University of Minnesota Press.

Bhabha, H.K. 1994. *The Location of Culture*. London and New York: Routledge.
Boas, F. 1927. *Primitive Art*. Cambridge, MA: Harvard University Press.
Bourdieu, P. 1977. *Outline of a Theory of Practice*. Cambridge: Cambridge University Press.
Casey, E. 2000. *Imagining: A Phenomenological Study*, 2nd edn. Bloomington: Indiana University Press.
Castoriadis, C. 1987. *The Imaginary Institution of Society*. Cambridge: Polity Press.
Chakrabarty, D. 2000. *Provincialising Europe: Postcolonial Thought and Historical Difference*. Princeton, NJ: Princeton University Press.
Clifford, J. 1997. *Routes: Travel and Translation in the Late Twentieth Century*. Cambridge, MA: Harvard University Press.
———. 2004. 'Looking Several Ways: Anthropology and Native Heritage in Alaska', *Current Anthropology* 45(1): 5–30.
Clifford, J., and G.E. Marcus (eds). 1986. *Writing Culture: The Poetics and Politics of Ethnography*. Berkeley: University of California Press.
Csordas, T.J. 1990. 'Embodiment as a Paradigm for Anthropology', *Ethos* 18(1): 5–47.
——— (ed.). 1994. *Embodiment and Experience: The Existential Ground of Culture and Self*. Cambridge: Cambridge University Press.
Cuno, J. 2011. *Museums Matter: In Praise of the Encylopedic Museum*. Chicago and London: University of Chicago Press.
Dewdney, A., D. Dibosa and V. Walsh. 2012. *Post Critical Museology: Theory and Practice in the Art Museum*. London: Routledge.
Dillon, M.C. 1995. *Semiological Reductionism: A Critique of the Deconstructionist Movement in Postmodern Thought*. New York: State University of New York Press.
Fisher, J. 1994. *Global Visions: Towards a New Internationalism in the Visual Arts*. London: Kala Press.
Foster, H. 1994. 'The Artist as Ethnographer?', in J. Fisher (ed.), *Global Visions: Towards a New Internationalism in the Visual Arts*. London: Kala Press.
Gell, A. 1998. *Art and Agency: An Anthropological Theory*. Oxford: Clarendon Press.
Gilroy, P. 2004a. 'Foreword: Migrancy, Culture, and a New Map of Europe', in H. Raphael-Hernandez (ed.), *Blackening Europe: The African American Presence*. London: Routledge, pp. xi–xxii.
———. 2004b. *After Empire: Melancholia or Convivial Culture?* London: Routledge.
Hallam, E., and T. Ingold. 2007. 'Creativity and Cultural Improvisation: An Introduction', in E. Hallam and T. Ingold (eds), *Creativity and Cultural Improvisation*. ASA Monographs 44. Oxford: Berg, pp. 1–24.
Handler, R. 2002. 'What is New about Culture in the Postnational World?', *National Identities* 4(1): 69–75.
Haraway, D.J. 1991. *Simians, Cyborgs, and Women: The Reinvention of Nature*. New York: Routledge.
Hastrup, K. 2004. 'The Imaginative Texture of Social Spaces', *Space and Culture* 7(2): 223–36.

———. 2007. 'Performing the World: Agency, Anticipation and Creativity', in E. Hallam and T. Ingold (eds), *Creativity and Cultural Improvisation*. ASA Monographs 44. Oxford: Berg, pp. 193–206.

Henare, A., M. Holbraad and S. Wastell (eds). 2007. *Thinking Through Things: Theorising Artefacts Ethnographically*. London: Routledge.

Ingold, T. 1993a. 'Tool-Use, Sociality and Intelligence', in K. Gibson and T. Ingold (eds), *Tools, Language and Cognition in Human Evolution*. Cambridge: Cambridge University Press.

———. 1993b. 'Epilogue: Technology, Language, Intelligence: A Reconsideration of Basic Concepts', in K. Gibson and T. Ingold (eds), *Tools, Language and Cognition in Human Evolution*. Cambridge: Cambridge University Press.

———. 2006. 'Rethinking the Animate, Re-animating Thought', *Ethnos* 71(1): 9–20.

———. 2007. 'Materials against Materiality', *Archaeological Dialogues* 14: 1–16.

Knapp, P. 1985. 'The Question of Hegelian Influence upon Durkheim's Sociology', *Sociological Inquiry* 55: 1–15.

Knapp, J.A., and J. Pence. 'Between Thing and Theory', *Poetics Today* 4: 641–71.

Latour, B. 1993. *We Have Never Been Modern*. Cambridge, MA: Harvard University Press.

———. 1996. 'On Interobjectivity', *Mind, Culture, and Activity* 3(4): 228–45.

———. 2004. 'Why Has Critique Run Out of Steam? From Matters of Fact to Matters of Concern', *Critical Inquiry* 30: 225–48.

———. 2006. 'On Recalling ANT', in J. Law and J. Hassard (eds), *Actor Network Theory and After*. Oxford: Blackwell Publishing.

Layton, R. 2003. 'Art and Agency: A Reassessment', *Journal of the Royal Anthropological Institute* 9: 447–64.

Leach, J. 2007. 'Differentiation and Encompassment: A Critique of Alfred Gell's Theory of the Abduction of Creativity', in A. Henare, M. Holbraad and S. Wastell (eds), *Thinking through Things: Theorising Artefacts Ethnographically*. London: Routledge, pp. 167–88.

Lloyd, J. 1991. 'Emil Nolde's "Ethnographic" Still Lifes: Primitivism, Tradition, and Modernity', in S. Hiller (ed.), *The Myth of Primitivism: Perspectives on Art*. London: Routledge, pp. 90–112.

Meskimmon, M. 2010. *Contemporary Art and the Cosmopolitan Imagination*. London and New York: Routledge.

———. 2013. 'The Precarious Ecologies of Cosmopolitanism', *The Open Arts Journal* 1: 15–25. Retrieved 1 December 2014 from http://openartsjournal.files .wordpress.com/2013/07/oaj_issue1_meskimmon.pdf.

Meyer, B. 2009. 'Introduction: From Imagined Communities to Aesthetic Formations: Religious Mediations, Sensational Forms, and Styles of Binding', in Birgit Meyer (ed.), *Aesthetic Formations: Media, Religion, and the Senses*. New York: Macmillan, pp. 1–30.

Miller, D. 2007. 'Stone Age or Plastic Age?', *Archaeological Dialogues* 14: 23–27.

Mol, A. 2002. *The Body Multiple: Ontology in Medical Practice*. Durham, NC: Duke University Press.

Morgan, D. 2008. 'The Materiality of Cultural Construction', *Material Religion* 4(2): 228–29.

Morphy, H. 2009. 'Art as a Mode of Action: Some Problems with Gell's Art and Agency', *Journal of Material Culture* 14(1): 5–27.

Papastergiadis, N. 2012. *Cosmopolitanism and Culture.* Oxford: Polity.

Pinney, C., and N. Thomas. 2001. *Beyond Aesthetics: Art and the Technologies of Enchantment.* Oxford: Berg.

Preziosi, D. 1995. 'Museology and Museography', *Art Bulletin* 77(1): 13–15.

Prior, N. 2003. 'Having One's Tate and Eating It: Transformations of the Museum in a Hypermodern Era', in A. McClellan (ed.), *Art and its Publics: Museums Studies at the Millenium.* Oxford: Blackwell, pp. 51–74.

Rampley, M. 2005. 'Art History and Cultural Difference: Alfred Gell's Anthropology of Art', *Art History* 28(4) (September): 524–51.

Rancière, J. 2004. *The Politics of Aesthetics,* trans. G. Rockhill. London: Continuum.

———. 2009. *Aesthetics and its Discontents,* trans. S. Corcoran. Cambridge: Polity.

Robbins, J. 2010. 'On Imagination and Creation: An Afterword', *Anthropological Forum* 20(3): 305–13.

Rose, G., and D.P. Tolia-Kelly (eds). 2012. *Visuality/Materiality: Images, Objects and Practices.* Farnham and New York: Ashgate.

Sneath, D., M. Holbraad and M.A. Pedersen. 2009. 'Technologies of the Imagination: An Introduction', *Ethnos* 74(1): 5–30.

Stafford, B. 1995. *Good Looking: Essays on the Virtues of Images.* Cambridge, MA: MIT Press.

Strauss, C. 2006. 'The Imaginary', *Anthropological Theory* 6(3): 322–44.

Stretski, I. 2006. *The New Durkheim.* New Brunswick, NJ: Rutgers University Press.

Svašek, M. 2007. *Anthropology, Art and Cultural Production.* London: Pluto.

———. 2012. 'Introduction Affective Moves: Transit, Transition and Transformation', in M. Svašek (ed.), *Moving Subjects, Moving Objects: Transnationalism, Cultural Production and Emotions.* Oxford: Berghahn Books.

Taylor, C. 1985. *Sources of the Self: The Making of Modern Identity.* Cambridge: Cambridge University Press.

———. 2002. 'Modern Social Imaginaries', *Public Culture* 14(1): 91–124.

Thomas, N. 1995. 'Kiss the Baby Goodbye: Kowhaiwhai and the Aesthetic in Aotearoa New Zealand', *Critical Inquiry* 22: 90–121.

Tsing, A.L. 2005. *Friction: An Ethnography of Global Connection.* Princeton, NJ: Princeton University Press.

Verrips, J. 2006. 'Aisthesis and An-aesthesia', in O. Löfgren and R. Wilk (eds), *Off the Edge: Experiments in Cultural Analysis.* Copenhagen: Museum Tusculanum Press.

Žižek, S. 1997. 'Multiculturalism, or, the Cultural Logic of Multinational Capitalism', *New Left Review* 225: 28–51.

Part I

MUSEUMS

1

Contemporary Iroquois Art between Ethnographic Museum, Art Gallery and Global Market Place

Reflections on the Politics of Identity and Representation

———◆◈◆———

Sylvia S. Kasprycki

The opening of a comprehensive show of modern and contemporary Native American art at the Ethnological Museum Berlin in March 2012, entitled 'Native American Modernism – Art from North America' (Bolz and König 2012), once again gave rise to a debate on the inevitable question: 'Should non-Western art be displayed in a museum of ethnography?' Reference was made by one reviewer to the 'war of opinion' between proponents of the cultural contextualization of art on the one hand and critics of the 'ghettoization' of non-Western artists on the other. With assessments ranging from 'antiquated and folkloristic in our pop- and concept-art flooded eyes' to 'so surreal that it becomes quite cool again', the particular charm and appeal of this art was credited to its consistent engagement with 'tradition and identity'. While qualifying that 'not all of the works would stand their ground in the "art context"', the art museum was suggested as the better place for these artists to gain the recognition they deserve, and elsewhere the optimistic prognosis was expressed that this desirable change in policy was imminent.[1] The tenor of these sentiments echoes the reactions already

elicited a decade earlier by an exhibition of contemporary Iroquois art at the Museum of World Cultures in Frankfurt (Kasprycki and Stambrau 2003). Reviewers then regretted that Iroquois art was to be encountered in the 'context of cultural anthropology' rather than having been acknowledged at the Documenta 11 of the previous year. At the same time, occasional hints at the 'uneven quality' of the works on display or their too obvious indebtedness to European modernity seemed to selectively limit their potential to compete in the global art market.[2]

Small and arbitrary as this selection of quotes may be, they reflect a broad range of issues underlying the reception, classification and representation of art produced outside the Western mainstream, including the dispute over the appropriate disciplinary competence to evaluate these visual expressions. Despite a growing body of literature, symposia and exhibitions that have in recent years aimed at throwing some light on the conceptual and representational problems involved,[3] it seems that artists, curators, scholars and the art-consuming public alike are still grappling with conflicting paradigms and (more often than not) preconceived notions of 'non-Western art' and its place on a global scale. This is perhaps not surprising given the entanglement of these questions in historical contingencies, which not only touch upon the very foundations of the disciplines of art history and ethnology but are grounded in the history of colonial encounters and the postcolonial condition of contemporary non-Western artists and thus take on additional political and emotional charge.

This chapter is an attempt to sort out some of these conceptual complexities, drawing examples from my more intimate knowledge of contemporary Iroquois art and its practitioners.[4] The crucial questions relating to the politics of identity and representation raised in this context, however, may well have a bearing on the study of other contemporary Native American or non-Western art practices.

'Contemporary Iroquois Art', 'Art by Iroquois Artists' or Just 'Art'?

To speak of 'contemporary Iroquois art' – here used as a convenient short form to denote an admittedly wide range of aesthetic expressions at present produced by members of the Six Nations (Mohawk, Onondaga, Oneida, Cayuga, Seneca and Tuscarora) – already encapsulates some of the historically based problems of defining and categorizing these visual forms. The designation in itself indicates a separation of these artistic practices as something other than the mainstream art we are used to dealing with, qualifying them as 'ethnic', with all attendant possible biases, and moreover suggests that the practices constitute a discrete field of study.

What exactly characterizes 'Indian' art, whether it is defined by subject matter or the cultural identity of the artist – if it is indeed a valid, identifiable category at all – has been a matter of debate for decades (Blomberg 2008). Quite a few contemporary Native American artists have over time outspokenly contested the 'ethnic qualifier' as relegating their creative achievements to second rank as compared to Western art: 'People don't call a work by Picasso a Spanish painting, they call it a Picasso', Kiowa artist T.C. Cannon stated as early as 1975 (quoted in Blomberg 2008: 15). This claim to individual artistic recognition has also been brought forward by several Iroquois artists – for example, Mohawk photographer and filmmaker Shelley Niro, who was recently quoted as saying that 'it would be great if we were just considered artists' (Lippard 2008: 139). At the same time, Iroquois (like other Native American) visual arts are deeply rooted in culturally specific traditions, philosophies and imagery – or, in the words of Mohawk artist and curator Ryan Rice (2007: 64), proudly 'nourishing an aesthetic and ethos that are "oh so Iroquois"'. Not least for this reason, 'location' and 'culture' have remained key reference points when outsider views address this corpus of work. The complex blend of personal artistic ambition (aiming at acknowledgment by the global art world), cultural indebtedness and political agenda, all presently observable in contemporary Iroquois art, may on the face of it seem contradictory and confusing, and is often interpreted within an explanatory framework that foregrounds a dichotomy between 'tradition' and 'modernity'. Before entering into a more detailed discussion of how contemporary Iroquois art practices may be situated within a global context today, we need to briefly recapitulate the outcome of historical processes.

Arguably one of the most powerful indigenous polities in eastern North America, the Haudenosaunee Confederacy,[5] played a prominent role in the arena of colonial encounters in the seventeenth and eighteenth centuries, yet the Iroquois did not escape the eventual fate suffered by other indigenous populations of the continent: dispossession of their lands and cultural assimilation through missionary, educational and economic programmes enforced by colonial and nation-state policies. Presently living on remnants of their original territories in upstate New York, Quebec and Ontario, and on land bases established in Wisconsin and Oklahoma during the course of nineteenth-century removal policies (as well as, of course, in metropolitan centres throughout North America), the Iroquois are not only forcefully reasserting their cultural and political sovereignty; they have also been influential in pan-Indian political movements and activism in the twentieth and twenty-first centuries.

Their rich and distinctive cultural heritage includes a wide range of visual forms of expression, which since prehistoric times have been characterized by the innovative incorporation of new materials and styles into existing

canons of forms, based on far-reaching intertribal contact and exchange. European trade goods, which started flowing into Iroquois country in the sixteenth century, were initially heavily reworked to conform to pre-existing Native forms, and even when they gradually replaced local products and techniques, they triggered a florescence of decorative arts that were thoroughly 'indigenized'. The use of Venetian and later Czech glass beads for distinctly Iroquoian embroidery on items of clothing and other accessories, subsequently collected by European visitors and eventually giving rise to an industry of tourist art in the nineteenth century, may be seen as an example of globalization long before the term was invented. In this sense the experimentation with Western forms of visual representation in the early nineteenth century did not in itself constitute a decisive break, but rather continued a long-standing receptiveness to creative innovation and adaptation. However, while indigenous visual expressions were always judged according to aesthetic criteria, and while their makers were esteemed for their special skills, the value of form was never separated from function. It was the introduction of the Western notions of the 'autonomous' artist and of art as a discrete and 'universal' category that eventually revolutionized prior conceptions of visual production. More importantly, the attendant phenomena of the Western 'art system' not only predetermined the European reception of traditional visual productions but also dictated the terms of the development of modern art forms, and their repercussions still underlie many of the incongruities, contradictions and constraints plaguing contemporary Iroquois art practices today.

As Feest (e.g. 1996, 1997) has repeatedly argued, an analysis of the history of European engagement with indigenous visual arts and the emergence of Native modernisms has to take into account what Alsop (1982) has called the 'by-products' of art. The Western concept of art (as it has come to dominate the global scene, even though it was shared by very few other historic cultures) owes its origin to the practice of systematic collecting, motivated by the assignment of an 'inherent' value to form because of its rarity or limited availability, 'which in turn can be defined on the basis of individual excellence or genius, antiquity, or foreign origin (or distance in space, time, and kind)' (Feest 1997: 66). The artificial preservation of visual forms (as in museums) resulting from this practice of collecting not only effected a disjunction of form and function, but also gave rise to a special class of producers of such esteemed visual expressions, the emergence of markets (i.e. the transformation of ideal value into monetary value), as well as the possibility to re-evaluate visual forms based on a corpus of works assembled over time (i.e. an art history). None of these phenomena were present in Native North America prior to intensive contact with Europeans,[6] and indigenous modern art did not develop organically from a Native-based

system of aesthetic evaluation, but through adoption of foreign concepts, subsequently reinforced through Western (art) education. European styles and media were taught in schools, such as the Santa Fe Indian School and the University of Oklahoma art department, where students were at the same time particularly encouraged to express the cultural traditions of their ancestors in Western genres of art, thus contributing to the development of regional art markets, in which the ethnic origin of the artists was considered essential. The collection, classification and display of Native visual forms remained determined by Western ideas of a separation of 'artefact' and 'art,' the study of which was assigned to different disciplines.

In the second half of the nineteenth century the Western idea of a separate domain of 'art' had also led to attempts to integrate both prehistoric European visual forms of expressions and aesthetic manifestations of non-Western cultures into a universal history of art. The creation of an anthropological concept of 'primitive art' by Franz Boas in 1904 (Feest 2004) coincided with the discovery of 'primitive art' by Western modernist artists (Rubin 1984) and helped to achieve the transformation of visual forms not originally produced as 'art' into artworks worthy of places in museums and valuable in the market place. These two approaches developed side by side for several decades without obviously influencing one another. In the public perception the art historical discourse on this subject clearly became the dominant one.

Whereas anthropologists since at least the 1960s increasingly distanced themselves from the term 'primitive' in connection with art, art historians continued to assert its usefulness and positive connotations. It was only with the rise of the 'new art history' in the 1970s that the unitary, Eurocentric history of the Western tradition came into question, the impact of gender, colonialism and commoditization acknowledged, and the heretofore marginalized groups (including indigenous artists) included on the basis of equality (Berlo and Phillips 1998: 6–7). Even here, however, a distinction is maintained between 'traditional' productions created outside the Western paradigm of art and contemporary indigenous art, where 'the use of Western categories is less problematic' (ibid.: 7–8).

Contemporary Iroquois artists deploy the same wide range of genres that can be encountered in art making on a worldwide scale – drawing, painting, graphic arts, photography and film, sculpture, assemblage, installation, performance – but in addition they creatively manipulate and turn 'traditional' media like beadwork, weaving or pottery into contemporary statements, thus purposefully undermining the divisive Western classifications of 'fine art' and 'crafts'. Replete with allusions to fundamental philosophies – oral traditions and cultural principles still embraced by the Iroquois today – a substantial segment of this diverse body of work likewise critically (and,

quite often, ironically) addresses the ramifications of Native historical ex-
perience on postmodern existence. In this respect, contemporary Iroquois
art does not shy away from exposing the hybrid quality of present-day life,
attempting to reconcile traditional values (or even the loss thereof) with the
challenges of the present. A majority of contemporary Iroquois artists are
still community based and participate in the broad array of cultural activi-
ties encountered on the reservations, which helps to affirm and strengthen
identity. For those living in the urban diaspora, on the other hand, recollec-
tions of Iroquoian traditions are more often also combined with influences
from pan-Indian perspectives, even though this liminal zone or 'Reservation
X' (McMaster 1998) may still prove energizing and creative.

It is the heritage of the colonial experience that has led to the continued
need for indigenous minorities in nation-states to assert their identity vis-
à-vis the dominant society. Similarly, while the dominant Western art dis-
course leaves the cultural constitution of Western art unmarked (by claiming
universal validity), there is a need for indigenous artists to identify their
works as originating from a distinctive tradition. Native artists continue to
insist on being Indian, in spite of the fact that 'to present as both Indian and
modern, they disrupt systems of reception as well as compete for scarce re-
sources' in the mainstream art market (Mithlo 2008: 114–15).[7] Rather than
privileging Native viewers (Tremblay 2009: 14), marking the identity of
contemporary indigenous art (like tourist art of the past; cf. Phillips 1998)
would therefore seem to be especially directed at non-indigenous audiences,
asserting the continued importance of indigenous worldviews. However, the
fact that the non-indigenous audiences to whom this message is directed
generally lack the cultural literacy to understand these references may be
one of the crucial problems underlying the continued marginality of con-
temporary Native art. What may not be 'authentic' enough in the regional
niches of the Indian art market for those consumers and collectors in search
of the 'tribal' is most often considered 'too Indian' to be acceptable in the
metropolitan art centres. Despite its claim to multiculturalism, the main-
stream art establishment has largely remained informed by a Western-based
understanding of art – an insight recently expressed by art historian Markus
Brüderlin (2004: 124) in his criticism of the Documenta 11, which he found
to be the result of a 'flattened, uniform program of a One-World under the
guidance of a universal, secularized Western art concept'.

Representation: Is Context a Lie Indeed?

Intrinsically related to the 'art museum versus ethnography museum' po-
larization is the debate over the cultural contextualization of art, which is

a direct outcome of the histories of these institutions and their respective epistemological foundations. If for the longest time ethnographic museums felt responsible for (and entitled to) explaining the embeddedness of visual forms in their social, economic, political and symbolic contexts, albeit focused on the productions of 'Others', art museums, on the other hand, privileged aesthetic value divested of function within hierarchies of form established by European art history. In many respects this trend has been inverted in recent decades. While ethnography museums have responded to postmodern/postcolonial critiques by increasingly hosting exhibitions that display visual expressions of indigenous cultures as 'art' (thereby implicitly acknowledging the neighbouring discipline's regimes of value), art museums have come to focus increasingly on contextualization. Interestingly enough, the latter development was not only propelled by the challenge of an ever more visible presence of contemporary non-Western art (not forgetting progressive pluralism in Western societies), but also by the realization that in our accelerated world even Europe's own art heritage is increasingly removed from immediate understanding and in need of 'translation'. Temporal remoteness equals spatial distance here, and in this sense, to borrow Lowenthal's (1985) congenial phrase, 'the past is a foreign country' as well. This parallel was also drawn by one reviewer of the above-mentioned Berlin show, who stated that modern Native American art was difficult to understand without knowledge of its context, but that herein it did not differ much from late medieval paintings (cf. Dörre 2012).

This confluence of representational concepts, while well intentioned in terms of giving non-Western visual productions (whether traditional or contemporary) their 'rightful recognition', in some ways rather serves to obscure the underlying precepts than clarify the issues at hand. The critique of ethnographic museums' authority was sparked by the 'writing culture' debate of the 1980s and the following 'reflexive turn' in cultural anthropology (Clifford and Marcus 1986), which also triggered a re-evaluation of ethnographic exhibition practices as situated in specific historical and cultural discourses (e.g. Karp and Lavine 1991; Hall 1997). Given the contingencies of collecting, the curator's choice of exhibits, the dependence of an exhibition's narrative on the 'state-of-the-art' knowledge at a given point in time, not to mention the modes of presentation inspired by current fashions, a naive claim to portrayal of 'real-life' contexts in ethnographic museums has to be critically questioned indeed. Karl-Heinz Kohl recently went so far as to call such attempts at contextualization 'a lie'; his succinct analysis of what has come to be called the 'crisis' of ethnographic museums arrives at the conclusion that indigenous visual expressions should be disassociated from these 'supposedly genuine contexts', which are in fact only extensions of the norms and values of the museum visitors' culture, and should rather

be assigned their proper place in the art museum. The decontextualization
of aesthetic value has long been achieved with regard to European art, Kohl
argues, and no Kirchner, Nolde or Macke would be exhibited in the History
Museum within the clutter of an early twentieth-century living room; what
is true for the masterworks of European art should only be fair for those of
non-Western art (Kohl 2008: 220; cf. also Kohl 2010).

This view, which more or less explicitly underlies many of the recent
'masterpieces shows' in museums of ethnography, seems to be totally oblivi-
ous to the very similar discursive constraints and appropriations reigning in
the art museum context. By tacitly positing established notions of art as the
unquestioned norm, it documents how deeply entrenched the 'global hyper
value' of art is in the Western understanding of modern society (Volkenandt
2004: 18).[8] It also mirrors a disciplinary hegemony at work, which is clearly
reflected in the respective social prestige, budgets and public visibility of art
versus ethnographic museums. Why else would ethnographic museums, af-
ter two decades of wading through self-reflective critique and reorientation
in an effort to acknowledge and shed their colonial burden, simply accept
without question the claim to the universality of 'art' and 'aesthetic value'
developed in the West in order to 'elevate' non-Western visual expressions
to a higher level of recognition? This kind of 'auto-critique', while aimed at
countering criticism of ethnography's hegemonial authority over other cul-
tures, may well fall into the trap of perpetuating existing circuits of power
under a different name (cf. Mosquera 2004: 220).

The opening of the Pavillon des Sessions at the Louvre in 2000, where 160
'classic artworks' from Africa, Oceania, Asia and the Americas are shown
'on a par' with the Western masters, was hailed as a pioneering enterprise
and remains one of the most frequently quoted examples of the ultimate
and long-overdue recognition of the aesthetic contributions of indigenous
peoples to world heritage. Why the puristic and context-free display of
these diverse visual expressions (which starkly contrasts with the extended
contextualizing labels provided, for example, for medieval altar paintings
in that same institution) should be regarded a major step towards a true
understanding of these objects remained puzzling to a number of critics.
Not only does this kind of display perpetuate notions of the 'timelessness' of
non-Western peoples that seemed long overcome, it also serves to disguise
the *implicit* context – hidden away, so to speak – in the collectors' names
on the respective labels: as documents of selective European collecting ac-
tivities and of European artists' inspiration by 'primitive art', these objects
stand testimony to imperialist claims and Western appropriations no less
than in any ethnographic museum. Moreover, the underlying judgements on
quality – that is, authority over inclusion or exclusion – are unquestionably
anchored in Western assumptions.

One may interject at this point that there is a major difference between museum representation of 'traditional arts' and the creations of contemporary non-Western artists, who explicitly aspire to recognition by the Western art establishment rather than be 'relegated' to museums of ethnography. In a way, it could be argued that this distinction signifies acceptance of and accommodation to the institutional hierarchies in the West, which award greater value (symbolic and material) to the rarity of form. However, I would venture to state that indigenous artists' claims to global acceptance today far surpass the mere incorporation into Western categories of artistic worth, and that while striving to overcome continued marginality, they resist simply being subsumed into the global art mainstream. This effort has a very concrete bearing on the question of contextualization as well. If contemporary non-Western art is to be understood on its own terms, rather than refracted through a Western aesthetic lens – however open it is to multicultural polyphony – the mediation of cosmological, spiritual, social, political, economic or other culturally and historically constituted values and conditions nourishing this creative practice will be of decisive importance in educating the distant viewer. This is not to deny that works of art (like any objectified utterance) once 'out there' can and will take on new meanings and trigger imaginations beyond the producers' intention and control. What is at issue here is recognition of the fact that consumption of art in Western societies is expanding on prior and implicit knowledge of some sort, which is not a given with regard to the artistic creations produced outside these confines.

Cree art historian Alfred Young Man's recent assessment of the exhibition practices at the National Gallery of Canada in Ottawa may serve as a telling example. While the establishment of a separate gallery of contemporary First Nations art in this institution in 1989 apparently raised stinging Native criticism about the continued 'segregation' of indigenous art, the museum's subsequent move of exhibiting works by Aboriginal Canadian artists amidst mainstream Canadian art without further explanation likewise missed the point, at least in Young Man's opinion, who dismisses the attempt as an 'exercise in futility' that only further 'emasculated, marginalized, and made invisible' the achievements of contemporary Native art. Young Man bases this critique on the lack of contextual information, which is taken for granted with respect to global icons like, for example, an Andy Warhol (given the host of publications and media presence putting his work in cultural and historical perspective), whereas scholarship (or, for that matter, an art history) relating to contemporary First Nations art is lacking. Visitors may or may not find their prior knowledge of Warhol confirmed, but will at any rate leave without having learned anything about the cultural context informing works of Northwest Coast artist Lawrence Paul, for example (Young Man 2008).

The point here is that the claims made by the Western art establishment at large in reference to the universal value of art or specific artistic productions are in fact grounded in culturally specific understandings that are still more or less taken for granted. Moreover, these tenets are reinforced by their seemingly worldwide acceptance, which is in turn owing to the global expansion and dominance of Western culture, however entangled it is in webs of local significance. Innovative inter- and transdisciplinary scholarship may have advanced in exposing the normative claims that underlay established notions of what art is or should be, but the prevailing practice of museums and galleries typically indicates a backlog in the institutional implementation of cutting-edge research, and both art market dynamics and the general public's perception of non-Western art remain informed to a considerable extent by familiar and socially accepted assumptions grounded in Western education. As the various quotes at the beginning of this chapter attest, even sympathetic approaches clearly fall back on established categories when attempting to 'locate' contemporary Native American art. The increasing participation of indigenous artists in the larger Western art circuits may signal a broadening of the conceptual confines of 'world art' or 'global art', but it does not necessarily invalidate the argument. What is still at stake here, from the point of view of many Native artists and intellectuals, is that the terms of acceptance are still being defined by a largely Western discourse.

Recent years have witnessed intensified international activity on the part of Native American artists and curators, who have, for example, been represented at the Venice Biennale for more than a decade.[9] A conference panel organized by Iroquois artist, visual historian and curator Jolene Rickard during a recent meeting of the Native American Arts Studies Association addressed some of the factors complicating the reception within a global context of artwork that 'transcends cultural location while simultaneously insisting upon knowledge of deep Indigenous philosophical and historic traditions' (Rickard 2011), and the assessments voiced by several participants in these international endeavours during the ensuing discussions seemed to reflect a certain amount of disenchantment with their eventual impact. In her writings Rickard has repeatedly posited the equation of indigenous art with indigenous *knowledge* and the consequential necessity of understanding the underpinnings of these creative expressions in any evaluative attempt (e.g. Rickard 2007: 197). 'Visual literacy is tied to cultural competence', as Native art historian Nancy Mithlo (2008: 121) emphasized.

It would seem to me (and I am acutely aware that this view will meet with scepticism if not outright rejection not only by some Native theorists but also by those who consider the educational role of museums an outdated model) that some of the smaller and less publicized ethnological exhibitions of contemporary Native American art have in many respects made larger strides towards breaking down established categorizations of 'art', at least

at a grassroots level. By placing these visual expressions within a storyline informed by their social, political and historical backgrounds as well as individual artists' explicit intentions (aesthetic and otherwise), these exhibitions have attempted to mediate culturally situated art practices and to give pronounced voice to indigenous perspectives. Based on my own experience, the average museum visitor's response to this kind of 'translation' is overwhelmingly positive, in many cases attesting to the 'eye-opening' quality of contextual information, without precluding the affective impact any artwork may have beyond its immediate intention and meaning. Even though it can safely be said that these efforts have hardly been successful in significantly permeating the boundaries between established institutional discourses, it may be worth noting that reception of non-Western art is indeed capable of expanding (cf. Mosquera 2004: 223).

New Native Art Criticism

Whatever tools ethnography at its best may use in mediating the creative practice of contemporary indigenous artists for a non-Native audience, this kind of intervention is at the current moment definitely not what indigenous practitioners are envisioning, who would rather like to shake the 'proverbial anthropological dog off the leg of the Indian artist' (Young Man 2008: 89). Regardless of any self-reflective theoretical advances ethnological scholarship may have made in the last decades, the prevailing Native imagination still views it as mired in the context of colonialism and exhibition practices that place Native cultures in close proximity to natural history. Indigenous agency today is directed against both anthropological and art historical appropriations in an effort to reclaim authority over traditional cultural heritage as well as over ongoing negotiations of colonial and postcolonial identities.

In a word, the major issue is perhaps not so much *what* is being said but *who* is speaking for *whom*. In this sense, the debate has turned from being a discussion of aesthetic concepts negotiating the elasticity of the category of 'art' to a political issue challenging the very foundations of the West's relations with indigenous societies (cf. Volkenandt 2004: 14). In the United States and Canada since at least the 1990s, the demand for Native American/ First Nations representational autonomy with respect to the interpretation and exhibition of contemporary arts has fostered the consistent development of Native curatorial practice and research, which is also beginning to take root on a broader organizational and institutional level. The Aboriginal Curatorial Collective (ACC), for example, which was officially incorporated as a non-profit organization in 2006, is dedicated to supporting, promoting and advocating First Nations art, artists and curators in Canada, and internationally not only by collecting, interpreting and exhibiting art, but also

by sponsoring conferences and publications in an effort to increase public understanding of the issues at hand. In the United States, the Museum of Contemporary Native Arts (MoCNA) in Santa Fe, which evolved out of the art collection of the Institute of American Indian Arts and only recently moved to a new and larger facility, prides itself on being the 'the country's leading museum for exhibiting, collecting and interpreting the most progressive work of contemporary Native artists'. It sees its mission as challenging 'audiences to rethink previous representations' and allowing Native arts 'to gain entry into the mainstream'.[10]

According to Mohawk artist and MoCNA chief curator Ryan Rice, who is also a co-founder of the Aboriginal Artists Collective, 'the presence of a "first perspective" challenges institutional paradigms and monotheism created by conventional ethnographic and anthropological approaches to Aboriginal art' and has 'shifted the dominant authority of space into sites of intervention within museums, galleries, and/or public venues by means of interrupting the mandated/outdated master narrative' (Rice 2011). An exhibition of contemporary Iroquois art curated by Rice for the Ottawa Art Gallery, 'Oh So Iroquois' (2008), additionally underlines the assertion of sovereignty by having the accompanying catalogue published in a trilingual version, supplementing the Canadian nation-state's mandate of bilingual publication in English and French with Mohawk as one of the Iroquoian languages. The political statement made here possibly eclipses the publication's practical use, given the comparatively small number of fluent Mohawk speakers, in spite of the fact that it is the best preserved of the original Iroquoian languages.[11] But this circumstance only serves to bring to the forefront one of the central problems Native Americans are contending with today: loss of their languages due to colonial policies of assimilation and the need for concerted efforts to revive this part of their heritage.

Contemporary Native art, as a site of resistance and critical cultural production, is speaking both to inherited worldviews and to the alienation from these worldviews in the course of colonial and postcolonial histories; it wrestles with questions of identity in acknowledgement of cross-cultural transfers and participation in global discourses; and as practice it is influenced and constrained by the institutional infrastructures and market conditions which gave rise to its existence in the first place. Native artists, curators and scholars argue for a critical consideration of these broader contexts, which are deemed essential to a true understanding and appreciation of the beauty and significance of contemporary art. A recent volume produced by the MoCNA, entitled *Manifestations: New Native Art Criticism* (Mithlo 2011), which brings together the works of sixty Native American artists discussed by exclusively indigenous writers, attempts to provide a template for this kind of discussion. By offering 'initial assessments of indigenous standards at play', the authors aim to fill a void that has long characterized and plagued the

reception of contemporary Native art, namely the lack of criteria for an appraisal of quality: 'If there is no bad art, can there be good one?' (ibid.: 23).

The question of art criticism is perhaps one of the most sensitive and complex issues to tackle in this respect. Emotionally charged and dependent on the quite often accidental interplay of mentorship, current trends, market dynamics and a multiplicity of other factors influencing aesthetic evaluation at any given point in time (and indeed revealing art making as a collective social enterprise even in the strictly Western context; cf. Becker 1982; Zolberg 1990), critical assessments of contemporary indigenous art carry the additional burden of colonial legacies, cross-cultural misunderstandings and competition over disciplinary 'authority'. Presumably the majority of practising artists in the West do not make it to the Documenta, for one reason or another, but exclusion of indigenous artists inevitably takes on the additional implication of suspected discrimination. Even if Native American artists may at times have been 'too quick to label honest critiques as racist insults', as Comanche author Paul Chaat Smith (2006: 69–70) recently pointed out, the fact remains that the global art world's criteria of quality continue to be defined by a largely Western understanding and indigenous artists still feel subject to unequal relations of power with regard to their access to the metropolitan canon. Ethnology's interest, on the other hand, has always been directed towards understanding the functioning of art in its social, political and economic contexts, giving precedence to *meaning* within given cultural environments, and has thereby been able to elicit insights into the criteria for technical excellence, rules of form and symbolic significance of visual expressions within specific 'traditional' settings. While this approach has doubtlessly also helped in mediating the cultural underpinnings of contemporary non-Western art practice, it has so far failed to deal adequately with the aspect of its aesthetic evaluation. This neglect is due to two interrelated circumstances. For one, contemporary indigenous artists' work transcends cultural specificity in so far as it engages with and aspires to be recognized within a global art world discourse. Second, the 'aesthetic regime' of Western society has hardly ever been seriously subject to scrutiny as cultural practice from an ethnological point of view.

What is noteworthy in the current strife for Native American representational sovereignty is that it foregrounds an 'indigenous aesthetic' – one that is deeply rooted in culturally specific concepts but at the same time sustained by the broader experiential horizon of common indigeneity and shared histories vis-à-vis the dominant culture. That legitimacy to speak about and on behalf of Native art is seen as anchored in an intimate understanding of these histories, more than first-hand knowledge of cultural specificity, underlines the political momentum at work. The exploration of shared concerns and visual approaches in contemporary indigenous arts is currently being extended on a global scale, paralleling similar developments on other

levels of political activism. 'Sakahán: 1st International Quinquennial of New Indigenous Art', co-organized by Mohawk curator Greg Hill and featuring works by more than seventy renowned and emerging artists from around the world, was staged at the National Gallery of Canada in 2013. Derived from an Algonquian expression, the title of the show means 'to light a fire' and seems to imply the hope for a new impetus in the critical discussion of contemporary non-Western art. It may be worth mentioning that the previous working title of this project, 'Indigenopolis', more explicitly addressed the closing of ranks, so to speak, of 'the rest against the West'. This 'horizontal communication', as opposed to 'vertical' engagement with dominant Western art discourse, can be regarded as a realization of the mandate already voiced two decades ago in Mosquera's seminal article (2004: 223–24).

In seeking new forms of influence and autonomy, rather than assimilation, the goals put forth by the 'new Native art criticism' can be compared to similar claims in other fields of cultural production. The call for an alternative approach to Native American literature by subverting the dominant culture's academic discourse, summarized by Creek/Cherokee scholar Craig S. Womack at the end of his seminal study *Red on Red,* may very well be applied to the study of Native American art as well:

> Rather than revising dominant-culture literary and critical aesthetics and 'fitting' Native texts and cultures to such criteria, the criteria themselves will be questioned as to their applicability, and more radical approaches will be posited as possibilities. Integration, acceptance, and assimilation to literary norms will no longer be our highest goal. Native critics will turn toward more disruptive tactics ... (Womack 1999: 303)

Future Perspectives

What can be concluded at this point with regard to the entangled field of contemporary indigenous art is that new avenues of investigation are called for. Indigenous advocacy of Native-defined interpretive contexts as a prior condition for equal participation in a global art discourse may help to upturn established assumptions; their eventual impact remains to be seen. In the meantime, Western disciplines may take up the challenge and develop their own 'disruptive tactics' in an effort to work towards breaking up the dichotomy of 'art as context-bound' versus 'art as universal'. A promising field for ethnological analysis may lie in the study of the consumption of art, or, in ethnographic parlance, a 'thick description' of the diffuse contact zone where the cultural conditionings and claims of producers and consumers meet in the sensual presence of both work and viewer, acknowledging the polysemantic ambiguity of art (cf. Volkenandt 2004: 24–25; Mosquera 2004: 224). This may in turn shed light on the production and consump-

tion of Western art as culturally and historically constituted practice. It is the pluralistic revision of Western culture, rather than simply expanding its categories in order to include the non-West, that will make possible a global dialogue among cultures. If it means exhibiting a Picasso amidst period furniture and the clutter of a living room – or, in these days perhaps more aptly, amidst the designer furniture of a billionaire collector's domicile – it is perhaps time to do just that.

Notes

1. With about 160 paintings, sculptures and examples of graphic art consistently collected since 1975, the Ethnological Museum Berlin today houses one of the largest collections of modern and contemporary Native American art in Europe. For reviews of 'Native American Modernism,' which presented more than half the collection, see, for example, Preuss 2012; Dörre 2012.
2. 'Lifeworlds – Artscapes. Contemporary Iroquois Art' was first opened at the Galerie 37, a showroom of the Museum of World Cultures in Frankfurt am Main exclusively devoted to the presentation of non-Western art (and unfortunately discontinued in 2010); the show subsequently travelled to the Nordamerika Native Museum in Zurich and the (Native-run) Woodlands Cultural Centre in Brantford, Ontario. For a selection of reviews, see Huther 2003; Streb 2003; Görisch 2003; and Waldmann 2004.
3. Significantly, these issues have predominantly been approached by art historians; cf., e.g., Volkenandt 2004; Elkins 2007; Weibel and Buddensieg 2007; and Belting and Buddensieg 2009.
4. My research on contemporary Iroquois art was conducted between 1997 and 2003 in conjunction with two exhibition projects co-curated with Doris I. Stambrau (Kasprycki, Stambrau and Roth 1998; Kasprycki and Stambrau 2003; cf. Stambrau 2004, 2007) and was resumed in 2011 in preparation of a more comprehensive exhibition of Iroquois history and culture (Kasprycki 2013).'
5. The self-designation 'Haudenosaunee' (People of the Longhouse) metaphorically refers to the Confederacy, which was symbolically envisioned as a longhouse (the traditional multi-family dwellings of the Iroquois). Today the ethnonym 'Onkwehonwe' (Original/real People) is sometimes preferred.
6. While there is limited evidence of the accumulation of artefacts and materials based on their meaning, as, e.g., on the Northwest Coast, these forms of 'collecting' never engendered the side effects constitutive of the Western art traditions based on the preservation of objects valued for the rarity of their form (Feest 1997: 66–67).
7. This is not to deny the occasional cases where artists of Native ancestry have left behind issues of identity. Mohawk artist Robert Markle (1936–1990), for example, remained committed to painting nudes throughout his career, merging into mainstream art to the extent that his Iroquois ancestry is not even well known.
8. In other words, the hierarchical art/artefact divide inherent in these assumptions remains unexamined as a thoroughly Western construct. The ways in which representational practices make objects into art according to the perspectives,

imaginations and needs of Western culture were strikingly visualized in a series of pioneering exhibitions curated by Susan Vogel at the Center for African Art, most notably 'ART/artifact' (Vogel 1988; cf. also 1991).

9. Several Iroquois artists have exhibited at the Venice Biennale since 1999. Shelley Niro's film *The Shirt* was, for example, featured at the Fiftieth Biennale in Venice in 2003 (cf. Mithlo 2004).

10. http://www.iaia.edu/museum/about/missionmandatevision/. Retrieved 10 September 2013.

11. There are approximately 3,500 fluent Mohawk speakers today, representing roughly 10 per cent of the overall Mohawk population; this percentage far exceeds estimates for the respective numbers of native Oneida, Onondaga, Cayuga and Seneca speakers, which in some cases do not amount to more than a few dozen.

References

Alsop, J. 1982. *The Rare Art Traditions: The History of Art Collecting and Its Linked Phenomena Wherever these Have Appeared*. Princeton: Princeton University Press/Bollingen and Harper and Row

Becker, H.S. 1982. *Art Worlds*. Berkeley: University of California Press.

Belting, H., and A. Buddensieg (eds). 2009. *The Global Art World: Audiences, Markets, Museums*. Ostfildern: Hatje Cantz.

Berlo, J.C., and R.B. Phillips. 1998. *Native North American Art*. Oxford: Oxford University Press.

Blomberg, N. (ed.). 2008. *(Re)Inventing the Wheel: Advancing the Dialogue on Contemporary American Indian Art*. Denver, CO: Denver Art Museum.

Bolz, P., and V. König. 2012. *Native American Modernism – Art from North America. The Collection of the Ethnologisches Museum Berlin*. Petersberg: Staatliche Museen zu Berlin – Stiftung Preußischer Kulturbesitz and Michael Imhof Verlag.

Brüderlin, M. 2004. 'Westkunst – Weltkunst. Wie lässt sich der Dialog der Kulturen im Ausstellungskontext inszenieren?', in C. Volkenandt (ed.), *Kunstgeschichte und Weltgegenwartskunst. Konzepte – Methoden – Perspektiven*. Berlin: Reimer, pp. 121–43.

Clifford, J., and G.E. Marcus (eds). 1986. *Writing Culture: The Poetics and Politics of Ethnography*. Berkeley: University of California Press.

Dörre, S. 2012. '"Indianische Moderne. Kunst aus Nordamerika" im Ethnologischen Museum' [Exhibition review]. *tip Berlin*, 1 March. Retrieved 22 August 2012 from http://www.tip-berlin.de/kultur-und-freizeit-kunst-und-museen/indianische-moderne-kunst-aus-nordamerika-im-ethnologischen-mus.

Elkins, J. (ed.). 2007. *Is Art History Global?* New York and London: Routledge.

Feest, C.F. 1996. 'Iskusstvo korennykh amerikantsev: "redkoie" i "ovydennoie"', in V.A. Tishkov (ed.), *Amerikanskiie indieitsy: Novye fakty i interpretatsii. Problemy indjeanistiki*. Moscow: Nauka, pp. 242–51.

———. 1997. 'On Some Uses of the Past in Native American Art', in M. Mauzé (ed.), *Present is Past: Some Uses of Tradition in Native Societies*. Lanham, MD: University Press of America, pp. 65–79.

————. 2004. 'Franz Boas, *Primitive Art*, and the Anthropology of Art', *European Review of Native American Studies* 18(1): 5–8.

Görisch, S. 2003. 'Illusion eines bösen Traums' [Exhibition review]. *Darmstädter Echo*, 13 May.

Hall, S. (ed.). 1997. *Representation: Cultural Representations and Signifying Practices*. London: Sage.

Huther, C. 2003. 'Mit Foto und Video-High Tech auf der Suche nach der guten alten Mitter Erde' [Exhibition review]. *Frankfurter Neue Presse*, 9 May.

Karp, I., and S.D. Lavine (eds). 1991. *Exhibiting Cultures: The Poetics and Politics of Museum Display*. Washington, DC: Smithsonian Institution Press.

Kasprycki, S.S. (ed.). 2013. *On the Trails of the Iroquois*. Berlin: Nicolai.

Kasprycki, S.S., and D.I. Stambrau (eds). 2003. *Lifeworlds – Artscapes. Contemporary Iroquois Art*. Frankfurt: Museum der Weltkulturen

Kasprycki, S.S., D.I. Stambrau and A.V. Roth (eds). 1998. *Iroquois Art: Visual Expressions of Contemporary Native American Artists*. ERNAS Monographs 1, Altenstadt: ZKF Publishers.

Kohl, K. 2008. 'Kontext ist Lüge', *Paideuma. Mitteilungen zur Kulturkunde* 54: 217–21.

————. 2010. 'Zwischen Kunst und Kontext. Zur Renaissance des Völkerkundemuseums', *Sitzungsberichte der wissenschaftlichen Gesellschaft an der Johann Wolfgang Goethe-Universität Frankfurt am Main* 48(2): 101–23.

Lippard, L.R. 2008. 'All Six Legs', in N. Blomberg (ed.), *(Re)Inventing the Wheel: Advancing the Dialogue on Contemporary American Indian Art*. Denver, CO: Denver Art Museum, pp. 127–44.

Lowenthal, D. 1985. *The Past Is Foreign Country*. Cambridge, UK: Cambridge University Press.

McMaster, G. (ed.). 1998. *Reservation X: The Power of Place in Aboriginal Contemporary Art*. Seattle: University of Washington Press.

Mithlo, N. 2004. 'Reappropriating Redskins: Pellerossasogna (Red Skin Dream): Shelley Niro at the 50th La Biennale die Venezia', *Visual Anthropology Review* 20(2): 22–35.

————. 2008. 'A Realist View of Image Politics: Reclamation of the "Everyday Indian"', in N. Blomberg (ed.), *(Re)Inventing the Wheel: Advancing the Dialogue on Contemporary American Indian Art*. Denver, CO: Denver Art Museum, pp. 127–44.

———— (ed.). 2011. *Manifestations: New Native Art Criticism*. Santa Fe, NM: Museum of Contemporary Native Arts.

Mosquera, G. (1992) 2004. 'The Marco Polo Syndrome: Some Problems around Art and Eurocentrism', in Z. Kocur and S. Leung (eds), *Theory in Contemporary Art since 1985*. Oxford: Blackwell, pp. 218–25.

Phillips, R.B. 1998. *Trading Identities: The Souvenir in Native North American Art from the Northeast, 1700–1900*. Seattle: University of Washington Press.

Preuss, S. 2012. 'Raus aus dem Reservat' [Exhibition review]. *Berliner Zeitung*, 2 March. Retrieved 22 August 2012 from http://www.berliner-zeitung.de/kultur/indianische-moderne-raus-aus-dem-reservat,10809150,11754122.html.

Rice, R. (ed.). 2008. *Kwah Í:ken Tsi Iroquois/Oh So Iroquois/Tellement Iroquois*. Ottawa: The Ottawa Art Gallery and The Aboriginal Curatorial Collective.

————. 2011. 'Stand By Me: Activism and Aboriginal Curatorial Practice'. Panel proposal for the 18th Biennial Conference of the Native American Arts Studies Association. Ottawa, 26–29 October.

Rickard, J. 2007. 'Haudenosaunee Art: "In the Shadow of the Eagle"', in J.C.H. King and C.F. Feest (eds), *Three Centuries of Woodlands Indian Art: A Collection of Essays.* ERNAS Monographs 3. Altenstadt: ZKF Publishers, pp. 196–200.

————. 2011. 'Globalizing Native Art'. Panel proposal for the 18th Biennial Conference of the Native American Arts Studies Association. Ottawa, 26–29 October.

Rubin, W. (ed.). 1984. *Primitivism in 20th Century Art.* New York: Museum of Modern Art.

Smith, P.C. 2006. 'Americans Without Tears', in R. Klein (ed.), *No Reservations: Native American History and Culture in Contemporary Art.* Ridgefield, CT: The Aldrich Contemporary Art Museum, pp. 67–72.

Stambrau, D.I. 2004. 'The Iroquois as Mirrored in Contemporary Art / The Art Reflects the People'. Ph.D. dissertation. Frankfurt: University of Frankfurt.

————. 2007. '"The Art Reflects the People": Perspectives on Works by Contemporary Iroquois Artists', in J.C.H. King and C.F. Feest (eds), *Three Centuries of Woodlands Indian Art: A Collection of Essays.* ERNAS Monographs 3, Altenstadt: ZKF Publishers, pp. 184–95.

Streb, A. 2003. 'Remember You Are on Indian Land' [Exhibition review]. *Liga 6000,* 12 May. Retrieved 22 August 2012 from http://www.liga6000.de/content_core .php?topic_id=5&article_id=216&date=1052731853.

Tremblay, G. 2009. 'Issues in Contemporary American Indian Art: An Iroquois Example'. *Enduring Legacies Native Case Studies.* Retrieved 20 October 2012 from http://nativecases.evergreen.edu/docs/TremblayIssuesincontAmIndian%20 Art.pdf.

Vogel, S. (ed.). 1988. *ART/artifact: African Art in Anthropology Collections.* New York: The Center for African Art.

————. 1991. 'Always True to the Object, in Our Fashion', in I. Karp and S.D. Lavine (eds), *Exhibiting Cultures: The Poetics and Politics of Museum Display.* Washington, DC: Smithsonian Institution Press, pp. 191–204.

Volkenandt, C. 2004. 'Kunst weltweit? Versuch einer Einleitung', in C. Volkenandt (ed.), *Kunstgeschichte und Weltgegenwartskunst. Konzepte – Methoden – Perspektiven.* Berlin: Reimer, pp. 11–30.

Waldmann, T. 2004. 'Eine feine Art von Rückeroberung. Irokesische Gegenwartskunst im Nordamerika Native Museum in Zürich' [Exhibition review]. *Basler Zeitung,* 25 June.

Weibel, P., and A. Buddensieg (eds). 2007. *Contemporary Art and the Museum: A Global Perspective.* Ostfildern: Hatje Cantz.

Womack, C.S. 1999. *Red on Red: Native American Literary Separatism.* Minneapolis: University of Minnesota Press.

Young Man, A. 2008. 'Segregation of Native Art by Ethnicity: Is It Self-imposed or Superimposed?', in N.J. Blomberg (ed.), *(Re)Inventing the Wheel: Advancing the Dialogue on Contemporary American Indian Art.* Denver, CO: Denver Art Museum, pp. 79-104.

Zolberg, V.L. 1990. *Constructing a Sociology of the Arts.* Cambridge, UK: Cambridge University Press.

2

DISCONNECTING RELATIONS
EXHIBITIONS AND OBJECTS AS RESISTANCE

———————◆•◆•◆———————

Peter Bjerregaard

The proliferation of research on material culture in its recent guise of *materiality* has brought about a new interest in museums. Not only have museums become increasingly interesting as objects of research (Henare 2005; Bouquet 2001a), they have also become sites for exploring the effects of the material turn in practice (Latour and Weibel 2005; Herle, Elliott and Empson 2009; Dudley 2010).

A critical aspect of exhibition design discussed in the literature seems to be the capability of materiality to overcome the distance created by the institutionalized authority and styles of display of the museum of the past. In a recent volume on *Museum Materialities,* Sandra H. Dudley argues that

> [C]reative, materialist thinking about embodied and emotional engagements with objects can provide more powerful alternatives or additions to textual interpretation in enabling visitors to *understand and empathize with the stories objects may represent.* (Dudley 2010: 4; emphasis added)

Thus, if the political museology of the 1990s provided source communities access to the secluded treasures of the museum, the capability of touch allows the individual museum visitor an enhanced relation to the worlds from where these objects originate.

Basically, I am in agreement with the idea that engaging senses is an imperative aspect of museum visiting but framed as a matter of 'empathizing'

and 'understanding' the renewed attention to touch can in fact be seen as a continuation of an age-old questioning of how the museum may best mediate between the present and the past or the distant. This is the project I want to consider in this chapter. My concern is with the entire idea of museums and collections being capable of mediating between the present and the past or the distant; that objects, so to say, should be able to move us in historical time and geographical space.

Drawing on two recent exhibitions in Switzerland and Denmark, I will argue that what the exhibition does is not, in fact, to bring the past into the present but to create a 'present' as such – a space where our senses become present to us and we attend to the world, not through an understanding of an organized history, but through an engaged bodily presence.

Villa Sovietica: Protecting by Disconnecting

In order to explicate the problem I want to deal with in this article, I will start out with a case. In 2008 Alexandra Schüssler began her work on what was to become 'Villa Sovietica', an exhibition at the Musée d'ethnographie de Genève (MEG). At that time Schüssler was new at the museum and had, in fact, never seen the collections on which the exhibition should be based. In the exhibition catalogue she records her first meeting with the Soviet objects thus:

> If someone had asked me where this forlorn material culture did belong I could not have said. Should these remnants be sold for a dime on a flea market? Should they be returned to the people who had discarded them for nicer looking items appropriate to the winds of change? Or thrown on the garbage heap? Or kept for eternity in the depot of some ethnographic museum? I had no answer for these questions, but I was convinced that the pots and pans, toys and clothes, stools and sofas should not be exposed to a Western gaze. I did not want these objects to be displayed in front of an audience who would compare them with familiar items from another epoch of their own cultural horizon. (Schüssler 2009: 5)

Schüssler's response to the character of the collection was to reject any attempt to 'explain' the objects on display. Had she displayed these objects as if they re-established the reality of a Soviet home, what they would have done was, according to the curator, only to allow a Swiss audience 'to carry off the exhibits as trophies of an alleged victory over a hated and feared political and economic regime' (Schüssler 2009: 5). Rather, Schüssler decided to work through the 'obstinate otherness' (ibid.: 6, quoting van de Port 1999) of the other by engaging in a close collaboration with artists from Russia, Slovakia, Ukraine and Romania. The space given for the exhibition

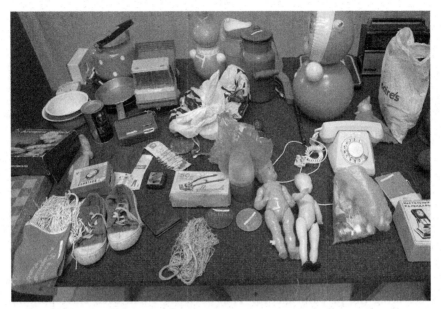

Figure 2.1. Soviet objects in the museum storage at Musée d'ethnographie de Genève, May 2008. Photo courtesy of Willem Mes.

was a bourgeois villa, which had been equipped with black box exhibiting facilities, but Schüssler decided to tear down the black box and use the physical structure of the building as an organizing frame for the entire design.

In the basement – the *humus* – objects from different MEG collections as well as objects obtained from local flea markets were placed in large numbers, some of them on the floor, others in corners and corridors, as an overwhelming material presence. The ground floor divided this massive materiality into ordered collections. In contrast to traditional museum collections, however, the collections presented here consisted of everyday objects such as various versions of the Soviet mascot 'Cheburashka' (best known outside of the Soviet Union from the 1980 Olympic Games), Lenin badges, and a private collection of Communist Party propaganda films and photographs.

On the first floor, different ways of displaying objects were explored. For instance the pieces of furniture, with which a Soviet living room could have been re-established, were randomly placed on top of each other, encircled by a linen drape and lit from inside of the drape, so that what was visible to the audience were only the shadows of this random construction. In this sense the display rejected the practice of putting the objects 'in context', stressing how perception demands action from the spectator; the furniture itself could only be seen when stepping onto the ladders on either side of the installation, enabling one to look down on the objects behind the drape.

Finally, the atelier on the second floor functioned as a working unit, where invited artists and audiences could engage in producing new objects related to the exhibition.

Thus, the exhibition building as a totality offered the opportunity for organizing the display partly according to Bachelard's *Poetics of Space*, and partly according to central considerations on museum practice as such: the experience of materials, organization of materials into collections, the display of objects, and, finally, the museum as a site for new production.[1]

Camouflaging

What the Villa Sovietica exhibition did was, I believe, to challenge our conventional ways of thinking about museums, as connecting points. It did not try to explain or reconstruct 'Soviet life', nor did it aim to make visitors understand or empathize with a particular way of life. Rather, there was a disconnect both from the alleged world of origin as well as from the curator conveying a specific meaning.

During the preparations for Villa Sovietica I had been corresponding regularly with Schüssler. At one point I had asked her what kind of effect she wanted from the exhibition. The answer came promptly: 'I have no clue! Well, something about subject–object relations. Could there be subjects that have a very different relation to the world around them, and could we apply this to Western consumption? Is there not a beyond?' (Bjerregaard 2009b: 221).

If we see Villa Sovietica in this light, we may see that it was an effort to transgress the ordinary subject-relations through which we approach exhibition making, that of the visitor as an interested student appropriating information or, indeed, the visitor as a consumer, the needs of whom the museum should seek to comply with. In Schüssler's own words:

> In the display, I intended not only to resist the collective memory of the Cold War, but also to interrogate an institutional memory in the sense of a reflection on museum canons. Visiting a museum, the audience usually expects to see what there is to see. My goal was to make clear that there is nothing to see except what the museum 'produces'. (Schüssler 2009: 5)

To some, the notion that 'there is nothing to see except what the museum "produces"' may seem to point to a postmodern deconstructionism. I will suggest, however, that this idea gives a particular role to the museum that exceeds a mere mirroring of the world.

This observation points to the fact that we cannot look at an object in isolation from the museum framing in which it appears. So, while in a semiotic conceptualization of exhibitions the task would be to create a framing

through which the worldviews carried by objects could somehow be manifested through the three-dimensional space of the exhibition hall, what Schüssler suggests is that, in fact, the task of the exhibition is to break such frames in order to let the concepts through which we perceive the world come into experience.

The Space of Things: From '*Realität*' to '*Wirklichkeit*'

Museum display in ethnographic museums has passed through a number of changing paradigms throughout history (Ames 1992; Bouquet 2001b). What I am particularly interested in here is how objects have been conceived of as 'holding worlds', and how it has been conceived as the museum's role to unravel these worlds. How have objects been thought of as representations or expressions of the places from which they originate?

As long as culture could still be comprehended as holistic units (see Otto and Bubandt 2010 for a thorough discussion of the use of holism in anthropology) the museum object was somehow representative of such cultural wholes. An ongoing discussion in terms of ethnographic displays has pivoted around the question of whether ethnographic objects should be displayed as 'art', as the creative endeavours of human civilization, or as artefacts invoking the meaningful contexts in which objects are embedded (see, for instance, Naguib in this volume; Faris 1988; Gell 1992; and Plankensteiner 2003 for discussions on the relation between art and artefact). Both cases imply, however, an understanding of the cultural or social world as being expressed *through* the object.

While an 'artwork' may be displayed in its singularity condensing complex systems of thought into one image (as, for instance, Benin plaques or Aboriginal bark painting), everyday material culture has been collected and displayed as systems, where each object becomes meaningful through its relation to other objects and narratives (Bjerregaard 2013). In this sense, everyday material culture could be organized as a meaningful image of the social structure of particular cultures. With this perspective follows the implication that these underlying systems of ideas or social structure may be conveyed to the museum audience through the design of an exhibition.

It is, however, this tendency to see worlds as semiotically built into objects, or groups of objects, which Alfred Gell opposed with his work on art through the 1990s (Gell 1992, 1996, 1998). Art is, according to Gell, not a semiotic system. It is not communicative in a sense which is meaningful and comparable to language. Rather, art is a way of acting, a way of imposing will and intentionality on the social world. Therefore, the aim of the artwork is not to convey meaning, but to confront the spectator with a kind of

intellectual resistance that allows the artwork to infiltrate the spectator into the intentional sphere of the artist (Gell 1992: 24–25; 1998: 36–38).

Gell's theory of art has been widely criticized – on the one hand for its rejection of semiotics (Layton 2003; Morphy 2012), and on the other, for maintaining the mind as the creative impetus to art (Miller 2005; Leach 2007). Still, in museums, Gell's work together with actor-network theory and a generally renewed interest in art has opened up new avenues for how to display objects.[2]

What these approaches to exhibiting attest to is the way in which putting things on display may draw out aspects of objects that may not necessarily refer to their origin or the logic through which they have been collected. In other words, the display may in itself create what Schüssler referred to as a 'beyond' that works in the present while not necessarily connecting to 'reality' understood as the world as we know it. In many ways, the current attention to touch and the sheer material qualities of objects, 'stuff' (Dudley 2012: 5), takes such approaches to a logical consequence in arguing that objects in their material presence may have a power to affect us as audiences without inter-pretational exegesis or scientific documentation – indeed such close encounters with objects may be more powerful than explanatory styles of display.

But how may we conceive of this 'reality', which museum displays may purposefully disconnect from? In his work on atmosphere, the German philosopher Gernot Böhme suggests a difference between two words which would both be translated into English as 'reality', namely '*Realität*' and '*Wirklichkeit*'. While *Realität* refers to 'the factual fact', the kind of information that would be noted in the museum files (what may be seen objectively, in terms of size, colour, origin or age – what we may know of an object), *Wirklichkeit* refers to the 'actual fact' – the effect of an object in a particular presence (Böhme 2001: 57).

Atmosphere, as Böhme defines it, as 'the common reality of the perceiver and the perceived', is a kind of reality which is different from the *Realität* we would confer on object and subject as isolates. Atmosphere thus refers to the in-betweenness of object and subject (Böhme 1993: 122). It is worth dwelling on Böhme's idea of the object as part of atmosphere. Böhme argues that, in terms of *Realität,* we conceive of objects as containers that carry certain information and certain qualities. When it comes to *Wirklichkeit,* we may still talk about objective qualities in the sense that the physical presence of the object radiates into space – colour, density and shape fill the space as the ecstacies of the object (ibid.: 120–22). In the same vein we may talk about a subject, but not as one decoding or carrying certain inclinations, but rather a subject in terms of being present in a certain bodily state (ibid.). Thus, the subject of atmospheres is characterized by perception rather than interpretation.

In the following I will take a look at an exhibition I took part in myself at Moesgård Museum outside of Aarhus, Denmark in 2007. I will use this case to consider what kind of subject we may think of in terms of museum exhibitions.

'One World – A Thousand Stories'

In the autumn of 2006 the director of Moesgård Museum, Jan Skamby Madsen, addressed the head of the ethnographic collections, Sibba Einarsdottìr, asking her to arrange an exhibition on the museum's ethnographic collections. For his entire directorship (that is since 1996) Skamby had been working on establishing a brand new museum building to take over from the old barns and stables of the manor of Moesgård, which had comprised the exhibition facilities of the museum since it moved out from the centre of town in 1970.

In the autumn of 2005, after a design contest for the new museum building had been finalized and an impressive project with a total budget of approximately €45 million had been selected, intensive work started on raising the money needed. The idea of organizing a new exhibition on the ethnographic collections should therefore be seen in the light of this process taking place at Moesgård. As a central part of the argument for establishing a new exhibition building had been the need for permanent displays of the ethnographic collections, the director wanted a broad presentation of them to showcase their range and quality. The response to this request was an exhibition entitled 'One World – A Thousand Stories'.

The Ethnographic Collections

Moesgård Museum is best known for its archaeological materials – particularly the bogman from Grauballe and the war sacrifices from Illerup Ådal. But it also hosts an ethnographic collection of approximately fifty thousand objects. Established in 1948 as a new collection, it was based on very few objects that had come into the museum around the 1870s.[3] Initially, the theoretical framing of the Ethnographic Collections was within German *Kulturgeschichte* and the study of economic culture.[4] Thus, ethnographic material was thought of as a supplement to the archaeological material, in the sense that it could provide collections of the main forms of economic culture that were only sketchily represented in the collections on prehistoric Denmark.

Around 1970 the head of the Ethnographic Collections, Klaus Ferdinand, formulated a new collecting strategy as one of collecting 'snapshots' – that

is, collections of what could actually be found at a certain place at a given moment in time (Ferdinand 1974). Faced with the effects of industrialization, the aim of the museum could no longer be documentation of the pure forms of economic culture; it could, instead, create historical snapshots that could be located in time and space. This collection strategy was very democratic in the sense that no object category would have a higher status than others. Therefore, what was sought was not the unique or spectacular, but rather the mundane and everyday – aluminium and plastic kitchen utensils, adzes, ploughs, everyday clothes.

This collecting strategy worked well in relation with the naturalistic displays developed at the museum up until and through the 1970s. In contrast to the former showcase-based displays, these new displays reconstructed sites such as the Afghan bazaar, the school and the local festival ground, as snapshots of social situations for which the very simple, everyday objects collected fitted in well. For different reasons (see Bjerregaard 2009a) this regime of collecting and display remained an almost unquestioned practice during the following decades, which Skamby had questioned as the framework for the future ethnographic exhibition at Moesgård. When he asked the staff at the Ethnographic Collections to make a new exhibition that presented the collections and their importance to the future museum, this task implied not only the making of an exhibition, but more than that, a reconsideration of the role of objects in ethnographic collections and exhibitions. Working with the ploughs, adzes, plastic containers, pots and pans, we needed to make a break in our set way of making exhibitions that had worked so well in former types of displays.

As a Ph.D. student at the collections and as one of two ethnographic curators, I was expected to contribute with ideas based on my ongoing research on ethnographic exhibitions in Europe and North America.

Setting the Scene

In January 2007 a selected group of fifteen people met for a brainstorming session, stretching over one full day and the next morning, to develop a concept for the prospected exhibition. As the discussions developed it became clear that the exhibition should not only present the world out there, but also deal with the way in which the collections portrayed local, Danish perspectives through collection practices of different types of collectors (such as explorers, missionaries and Marxist ethnographers). This idea was pretty much agreed upon, and it was decided that the introduction to the exhibition should conjure up a chaotic experience, conveying the idea that the material world is basically an unordered chaos, which the museum imposes order on through collecting and display. Still, we struggled to find a way of

turning this into an attractive exhibition concept that might present a new take on exhibition design. At some point we discussed whether it would be possible to organize the whole exhibition as a chaos through which it would be possible for visitors to find trails leading to particular collector types. But

Figure 2.2. First sketch of 'One World – A Thousand Stories'. Sketch courtesy of Lars Foged Thomsen.

by the end of the evening, despite visiting both the exhibition space and the museum storage, no clear idea had materialized.

The next morning, as most of us had become somewhat disillusioned by not yet having been able to come up with a workable idea, one of the participants made a sketch on the blackboard, which comprised several of the paths we had been discussing, as well as considerations of the room we were to exhibit in, which we had visited the previous day.

This plan helped to organize many of the ideas we had been talking about according to the physical setting of the exhibition space. On entering the exhibition the visitors would be met by a chaotic accumulation of objects, after which they would be presented with three different ordering principles: 'locality', 'red/colour' and 'highlights/value'.

Through this point of departure we wanted to convey that each display is based upon a particular perspective that depends as much on the people who have collected and displayed the objects as on the people who produced them. This would be made apparent in three rooms that followed, which focused on 'a locality', 'the colour red' and 'highlights', respectively. In other words the physical space of the exhibition hall afforded a way of breaking the multiple ideas raised during the brainstorm into a conceptual idea.

Thus, it seemed as if we had a plan – we had a working group settled, and we had a sketch and a synopsis, which everybody had accepted. From here, we only needed to develop the content that would materialize the idea. In practice, though, things got quite a bit more complicated. I will now focus on two of the rooms, the 'chaos' and the 'locality' rooms, to explain how the process did not go straight from idea to product.

Conceptualizing 'Chaos'

A few days after the brainstorm the designer presented us with the first sketch of the exhibition. This sketch caused the first heated debates concerning the 'chaos room'. Many people felt that the design was too rigid and cold – particularly because the racks suggested were steel racks, similar to the ones in the museum storage. Most of the staff had expected wooden cabinets with glass doors, which would provide, it was argued, a warmer atmosphere. The designer maintained that steel racks would, for many reasons, be the right solution – they were cheaper, more flexible, and they suited the kinds of objects we had better than the 'curiosity' approach suggested by the wooden cabinets.

Finally, as the discussion on racks went on, the designer provided a sketch of what a stuffed rack might look like. While this did not stop the debate completely, it became clear after this meeting that we would eventually stick to steel.

Figure 2.3. Sketch envisioning how a steel rack stuffed with objects might look. Sketch courtesy of Lars Foged Thomsen.

For each meeting the designer would provide new sketches with the latest alterations included, and we would sit and discuss the sketch, draw on it and develop it further. In other words, while a lot of issues were discussed among us, these sketches were imperative to establishing a common idea of what the exhibition was going to look like, both as points of conflict and as points of collaboration.

A few other instances from this room are worth mentioning. While we had agreed on 'chaos' as the overarching concept for this first room, we had to face the difficulties of how to install chaos. Quite early on we came to the conclusion that an entirely random placement of objects would not work, so we went through a number of plans for how to organize and select objects: according to types with regional chaos, according to region with typological chaos, and so on.

In the end, rather than following a major plan, and somehow unintentionally, as a result of time pressure, we started to make up categories on the spot as we faced the thousands of objects taken out of the storage and brought into the exhibition hall. Sibba organized a rack with containers. The designer and some students started installing music instruments and suddenly found that they could let the instruments wind their way up the racks. And as some of the students started to find a number of highly

stylized religious figurines from very different regions we placed these just above a shelf with highly realistic statuettes of Indian casts. Thus in practice, rather than executing a prepared plan, what happened was that we all improvised in the space made up by the framing of architecture and racks and the objects already installed (Hallam and Ingold 2007).

Only two principles guided this improvisation. In texts we presented five different collector types (the 'collector' as a general human phenomenon, the expeditions, missionaries, ethnographers and 'adventurers' – five of the main types of collectors that have contributed to the development of the Ethnographic Collections). Therefore we wanted objects collected by these types of collectors to be placed close to the relevant text. Furthermore, some of the objects had to be covered by glass; therefore almost half of the racks ended up being glass covered, and the objects that demanded particular care were placed there.

Thus, in the end, the objects and the space available for them in the racks, as well as the demands of museum legislation, determined what the installation came to look like, as we discarded our initial plans. Interestingly, despite all this improvisation, the room ended up looking quite a lot like the drawing made by the designer early on in the process.

Locality

In the next room, on 'locality', things turned out quite differently. We ended up deciding on the Guaraní of lowland Bolivia as the theme for this section, for three reasons. Firstly, Skamby had asked us to include a contemporary theme in the exhibit and we thought that the Guaraní claim for intellectual rights to traditional knowledge on medicinal plants would be an apt illustration of how 'locality' today is made up by global interests. Secondly, the Guaraní were the object for the annual 'Operation Dagsværk', where Danish high school students would take one day off from school in order to work and earn money to support the Guaraní. Hence, we expected that the Guaraní would be present in the mind of our visitors, and that high school classes in particular would be interested in visiting the exhibition. Finally, a group of Guaraní people had made a collection in collaboration with the museum, which could be included as a commentary on contemporary museum practice.

But a lot of things did not work out as expected. First of all, the objects were very hard to present in an exciting way. Even though we knew that the Guaraní objects were not exquisite treasures it turned out to be amazingly difficult to make anything interesting out of them. Lars, the designer, raised these problems in an early email correspondence:

The objects are generally boring, some of them bad craftsmanship and others broken. If we do not want to show large quantities, what we do show has to be 'supreme'. Are these objects really representative, would the Guaraní be proud of the selection of objects here at Moesgård? (Email, 6 April 2007, my translation)

So, neither did we have large quantities of objects to create a space with, nor were the objects we had really appealing. We did have a couple of boxes of (allegedly) jaguar grease and an instrument used to make the sound of a jaguar in heat, but these objects did not look very spectacular and thus needed quite some explanation in order to be staged properly.

Secondly, we found it very difficult to break with the context of the collection. The collection had been made by a group of Guaraní in collaboration with a Danish anthropologist. While this provided us with a well-documented collection reflecting the Guaraní struggle for cultural recognition and intellectual rights, it was very difficult – morally and intellectually – to break with this story, which we feared would resemble the social realism of the 1980s too much to really appeal to contemporary visitors. Furthermore, we had a feeling that many of the objects were actually 'constructed' as Guaraní objects, inspired by Andean highland crafts, in order to strategically place the Guaraní as 'a culture' that might qualify for support from, for instance, NGOs and development programmes. But we did not have the in-house expertise to evaluate whether this was actually the case, and also, such a conceptualization would go counter to the collaboration we had established with the Guaraní, who had made the collection.

In the end, the Guaraní room was less successful than we had hoped for. It looked too much like the naturalistic exhibitions we had been making for years, and it basically just told the story laid down in the original collection. This was made very clear to me during a special day arranged at the museum on Bolivia and indigenous peoples' rights. On this occasion the Bolivian ambassador to Denmark highlighted the recent attention to indigenous people in Bolivia in the wake of Evo Morales' presidency; after that, Justo, one of the Guaraní who had taken part in making the collection, guided the visitors into the exhibition, where he continuously referred to it as 'our exhibition' – that is, the Guaraní's exhibition.

At first I got somewhat irritated by this. By all accounts, it was not Justo, but *us* who had been working day and night for weeks to make this exhibition materialize. But after a while, Justo's appropriation of the exhibition gave me some consolation – at least we had found a group of people who appreciated our work (which had otherwise been quite heavily criticized, both within and outside of the museum).

I think Justo's presentation revealed a very central problem in this part of the exhibition. While the first room emerged as an idea and an expression

of itself, we never succeeded in creating an expression out of the Guaraní room. After the opening, a few of us considered whether, rather than narrating the information that had been given to us through the collections, we should, in fact, have constructed and installed a more-than-life-size feta cheese, Lego Bionicles, music CDs and herbal medicine, stressing the fact that this room was actually about intellectual property. This would have framed our approach to how we may think of 'locality' in the contemporary world.

Mind and Making

In order to analyse our lack of success with this room, I will initially return to Gell. Gell's idea of objects as 'secondary agents' or 'indexes' of action (Gell 1998: 16–21) seems to maintain a notion of a system where the artwork is the result of a strategizing intentionality. At least, Gell bases his theory on the idea that art is about willing and intentionality. This part of Gell's theory has led Tim Ingold to a critique of Gell's notion of art. It seems, Ingold argues, that we just have to spread some 'magical mind dust' on objects, and suddenly they become powerful art objects (Ingold 2007: 11). Indeed, Ingold is perhaps even more explicit than Gell in his critique of an alleged individual or cultural mind preceding the fabrication of artefacts.[5] Over a number of articles, Ingold has criticized the conventional understanding of 'creativity' as something pertaining to a particular ingenious mind (Hallam and Ingold 2007; Ingold 2007). For instance, in describing the weaving of a basket, Ingold argues that we cannot simply say that the basket is a result of the making of the basket maker. Instead, by being engaged in the practice of basket making the basket maker is engaged in a 'field of power', where he constantly has to adjust to the flexibility of the raw material, the force of gravity and the qualities afforded by the materials used. Thus, rather than 'making' a product from a mental design, the basket maker 'weaves' a thing in a constant engagement with and exploration of the qualities of the materials applied.

This orientation from 'making' to 'weaving' takes us from seeing the material world as one of representations, inbuilt worldviews that need to be interpreted to come out into the open, to one of action and exploration that take place in the open. I will argue that exhibition making is exactly about establishing such a field of forces, but not in the straightforward political sense, as a relation between represents and represented or exhibition makers and visitors. Rather, Ingold's observations take us back to the discussion on framing and atmosphere.

Cutting Out Frames

If we look at what took place in making 'One World...', as we can even trace it through the sketches made during the process, it seems evident that the two rooms described are all about framing. In the chaos room a physical frame emerged very quickly in terms of the metal racks selected for display. These racks made it possible for the different staff members engaged in the installation to improvise, creating their own selection and combination of objects, while still producing an installation that conformed to the early sketch laid out by Lars.

I will argue that in this sense the chaos room succeeded in creating a physical form that was able to cut (Strathern 1996) the networks that the objects on display were part of, in order to create a new totality out of them in the exhibition hall. Thus, these objects were assembled in a way that created a new particular totality, a new perspective that did not refer to any idea of reality outside of the museum. Instead, a particular spatial relation to objects was created. For instance, many visitors would comment on how, when entering the room, they had the impression of this being a second-hand store, compressed with objects, but as they approached the racks they would realize that these were really fine and interesting objects served to them. Thus, the organization of the space opened up new ways of engaging with and discovering the objects. In this sense, this part succeeded in achieving the creation of a 'world' (Henare, Holbraad and Wastell 2007) in itself that did not refer to an external reality but established its own, spatial points of reference.

The Guaraní room never succeeded in creating such a totality. The objects on display here were still hinging upon their particular history without creating a convincing presence in the exhibition. We never succeeded in creating a space where these objects became effective as part of the design without having to be explained through text. Thus, many visitors would complain about having to read four or five posters before getting an idea about what this room was all about.

In hindsight, I find it striking that the design of this room continuously changed in the sketches produced. In this way, a proper frame was never developed for this room within which we could actually explore how the Guaraní objects might stand out as more than mere illustrations.

These observations lead me to conclude that rather than approaching exhibitions as a way of framing the strange in order to understand it or empathize with it, the task of exhibition making is a matter of cutting out the proper frame that may disconnect objects from their contextual binding, and let them become effective in a spatial presence.

Conclusion: Exhibition, Framing and Imagination

In his essay, 'The Question Concerning Technology', Heidegger has a passage on 'the danger zone' (Heidegger 1977). Heidegger describes modern technology as an 'unconcealment' that brings forth what is concealed within the object, and stores this as 'standing reserve'. Thus while the windmill of the past immediately brings forth the power hidden in the air, it does not store this power – it is not kept as something that may be useful later. With modern technology, Heidegger argues, the world around us is changed from one of direct engagement to one of 'standing reserves' – that is, we search for the usefulness of the objects of the world.

This way of seeing ourselves and the world around us as 'standing reserve' constitutes a danger zone. So, while technology as such is a way of bringing forth potentials that are concealed in the immediate experience of the world, the danger zone arises when we see technology as purely instrumental; when we see it as something that is only there in order to create storable energy, rather than observing what happens when we bring forth new potentials from objects. The danger zone is thus a world where mankind only reproduces itself. A kind of large mirror-world, where all we see in the objects we produce is ourselves, because we never break the frames through which we produce 'the world' and let this framing in itself appear before us.

The argument running through this chapter has suggested that the museum has a potential to become a technology of imagination (Sneath, Holbraad and Pedersen 2009) if we refrain from thinking of framing as a way of communicating the complexities of *Realität*. Through attending, instead, to the *Wirklichkeit* of the concrete space we are working with, museums may draw out unforeseen potentials of the object world. This implies, however, a disconnection from 'reality', from the way in which we conventionally frame objects and subjects, parts and wholes.

While the concern with representation in museums may largely be considered as a way of 'flipping the coin' of the power structures of political reality, an orientation towards disconnection may be considered a deep political act, in the way it suggests imaginations that transcend the given. Thus, the museum may take a position of generating rather than representing imaginaries.

Notes

This chapter is based partly on my Ph.D. thesis (Bjerregaard 2009a), partly on the 'Objects on the Move'-seminar organized in September 2011 in Oslo by the editors

of this volume. My Ph.D. research was supported by the Industrial Ph.D. Programme under the Danish Agency for Science, Technology and Innovation, and hosted by the University of Aarhus and Moesgård Museum. My supervisors, Ton Otto and Inger Sjørslev, offered indispensable guidance throughout this process. I also want to thank the group behind the Hera-project, in particular Øivind Fuglerud, for inviting me to the 'Objects on the Move' seminar.

1. For instance, for one of the Sunday activities related to the exhibition, audiences were invited to help to plant tulips in the garden just outside the museum building. After the work was done the audience were invited up to the atelier to have a look at their work from the window – and they saw that what they had planted was in fact a portrait of Lenin made of flowers.

2. Noteworthy examples to mention may be 'Making Things Public' (presented at ZKM in Karlsruhe, co-curated by Bruno Latour and Peter Weibel), 'Assembling Bodies' (presented at the Museum of Archaeology and Anthropology, University of Cambridge, curated by Anita Herle, Mark Elliott and Rebecca Empson), the art interventions at the Pitt Rivers Museum (Kim 2007), as well as 'Medusa en Afrique' (curated by Boris Wastiau), which presented African masks through a heavily Gell-inspired logic.

3. The Ethnological Study Collection at Aarhus University was established in 1948 when Henning Haslund-Christensen approached the city of Aarhus for support for his Third Danish Central Asian Expedition. The city council granted the money for this, given that the expedition would bring home objects that could serve to develop a proper ethnographic collection.

4. The framework that connected archaeological and ethnographic research was really the idea of the seven main forms of economic culture, ranging from hunters and gatherers to agriculturalists with ploughs. Within this framework the use of the pickaxe in Danish prehistory could, for instance, be compared with contemporary use of the same device among the Mumuye; similarly, economic forms that could not be accounted for through the prehistorical material could be accessed through ethnographic cases (Bjerregaard 2009a: 61–63, 68–72; Høiris 1986).

5. Ingold does not operate with a concept of art like Gell's. Ingold is interested in craftsmanship as human practice, attached to adaptation and evolution – i.e. the human being in the environment. In this universal, biological perspective, 'art' as a concept related to aesthetics is merely a local (Western) phenomenon. In the larger scheme, Ingold sees art as a material exploration of the world (Hallam and Ingold 2007).

References

Ames, M. 1992. *Cannibal Tours and Glass Boxes: The Anthropology of Museums*. Vancouver: University of British Columbia Press.

Bachelard, G. 1994[1964]. *The Poetics of Space*. Boston: Beacon Press.

Bjerregaard, P. 2009a. 'Inside the Museum Machine: Mind and Agency in Contemporary Ethnographic Exhibitions', Ph.D. thesis. Aarhus: University of Aarhus.

————. 2009b. 'The Other Side of Objectivity: Art and Correspondence in Ethnographic Exhibitions', in A. Schüssler (ed.), *Villa Sovietica. Soviet Objects: Import-Export*. Exhibition catalogue. Gollion: Infolio éditions / Genève: Musée d'ethnographie de Genève, pp. 215–224.

————. 2013. 'Assembling Potentials, Mounting Effects: Exhibitions Beyond Correspondence', in C. Suhr and R. Willerslev (eds), *Transcultural Montage*. London and New York: Berghahn Books, pp. 243–61.

Böhme, G. 1993. 'Athmosphere as the Fundamental Concept of a New Aesthetics', *Thesis Eleven* 36: 113–26.

————. 2001. 'Athmosphären', in G. Böhme (ed.), *Aisthetik: Vorlesungen über Ästhetik als allgemeine Wahrnehmungslehre*. Munich: Hans Fink Verlag, pp. 45–58.

Bouquet, M. 2001a. 'Streetwise in Museumland', *Folk, Journal of the Danish Ethnographic Society* 43: 77–102.

————. 2001b. 'Introduction: Academic Anthropology and the Museum. Back to the Future', in M. Bouquet (ed.) *Academic Anthropology and the Museum: Back to the Future*. New York and Oxford: Berghahn Books, pp. 1–16.

Dudley, S. (ed.). 2010. *Museum Materialities: Objects, Engagements, Interpretations*. New York and London: Routledge.

————. 2012. 'Encountering a Chinese Horse: Engaging with the Thingness of Things', in S. H. Dudley (ed.) *Museum Objects: Experiencing the Properties of Things*. London and New York: Routledge, pp. 1–15.

Faris, J. 1988. 'Art/Artifact', *Current Anthropology* 29: 775–79.

Ferdinand, K. 1974. 'The Ethnographical Collection of Moesgård Museum, Aarhus University', *Folk, Journal of the Danish Ethnographic Society* 16–17: 475–487.

Gell, A. 1992. 'The Technology of Enchantment and the Enchantment of Technology', in J. Coote and A. Shelton (eds), *Anthropology, Art and Aesthetics*. Oxford: Clarendon Press, pp. 40–67.

————. 1996. 'Vogel's Net: Traps as Artworks and Artworks as Traps', *Journal of Material Culture* 1(1): 15–38.

————. 1998. *Art and Agency: An Anthropological Theory*. Oxford: Clarendon Press.

Hallam, E., and T. Ingold. 2007. 'Creativity and Cultural Improvisation: An Introduction', in E. Hallam and T. Ingold (eds), *Creativity and Cultural Improvisation*. Oxford: Berg, pp. 1–24.

Heidegger, M. 1977. 'The Question Concerning Technology', in *The Question Concerning Technology and Other Essays*. New York: Harper & Row.

Henare, A. 2005. *Museums, Anthropology and Imperial Exchange*. New York: Cambridge University Press.

Henare, A., M. Holbraad and S. Wastell. 2007. 'Introduction: Thinking through Things', in A. Henare, M. Holbraad and S. Wastell (eds), *Thinking through Things: Theorising Artefacts Ethnographically*. London and New York: Routledge, pp. 1–31.

Herle, A., M. Elliott and R. Empson. 2009. 'Assembling Bodies Art, Science & Imagination'. Exhibition catalogue, Museum of Archaeology and Anthropology, University of Cambridge.

Høiris, O. 1986. *Antropologien i Danmark: Museal etnografi og etnologi 1860–1960*. Copenhagen: Nationalmuseet.

Ingold, T. 2007. 'Materials Against Materiality', *Archaeological Dialogues* 14(1): 1–16.

Kim, S.E. 2007. 'Ethnographic Collections in the Hands of Contemporary Artists: The Joachim Schmid Collection and Mrs Cook's Kete in the Pitt Rivers Museum', *The World Under One Roof: Past, Present, and Future Approaches to Universality in Ethnographic Museums* conference, Vienna, 19-24 August 2007. Retrieved 1 November 2012 from http://icme.icom.museum/fi leadmin/user_up load/pdf/2007/EunKimProof.pdf.

Latour, B. and P. Weibel (eds). 2005. *Making Things Public: Atmospheres of Democracy*. Cambridge, MA: MIT Press; Karlsruhe: ZKM/Center for Art and Media.

Layton, R. 2003. '*Art and Agency*: A Reassessment', *Journal of the Royal Anthropological Institute* 9(3): 447–64.

Leach, J. 2007. 'Differentiation and Encompassment: A Critique of Alfred Gell's Theory of the Abduction of Creativity', in A. Henare, M. Holbraad and S. Wastell (eds), *Thinking Through Things: Theorising Artefacts Ethnographically*. London and New York: Routledge, pp. 167–88.

Miller, D. 2005. 'Materiality: An Introduction', in D. Miller (ed.), *Materiality*. Durham, NC: Duke University Press, pp. 1–50.

Morphy, H. 2012. 'Art as a Mode of Action: Some Problems with Gell's *Art and Agency*', *Journal of Material Culture* 14(1): 5–27.

Otto, T., and N. Bubandt (eds). 2010. *Experiments in Holism: Theory and Practice in Contemporary Anthropology*. Oxford: Wiley-Blackwell.

Plankensteiner, B. 2003. '"Völlige Fühllosigkeit dem Künstlerischen gegenüber…": Der Streit um den "asiatischen Kunstsaal" anlässlich der Neueröffnung des Museums für Völkerkunde in Wien im Jahre 1928', *Archiv für Völkerkunde* 53:1–23.

Schüssler, A. 2009. 'Yurij said…Alexandra skazala', in A. Schüssler (ed.) *Villa Sovietica. Soviet Objects: Import-Export*. Gollion: Infolio, pp. 4–9.

Sneath, D., M. Holbraad and M.A. Pedersen. 2009. 'Technologies of the Imagination: An Introduction', *Ethnos* 74(1): 5–30.

Strathern, M. 1996. 'Cutting the Network', *Journal of the Royal Anthropological Institute* (N.S.) 2: 517–35.

3

MATERIALIZING ISLAM AND THE IMAGINARY OF SACRED SPACE

Saphinaz-Amal Naguib

Sharon Macdonald posits that museums are, in a way, sacralized places and may be compared to religious sites. They are said to be temples of culture, cathedrals of knowledge, mausoleums of past civilizations and keepers of the world's heritage and memories. Museums and religious sites also 'share an aesthetic: hushed tones, dimmed lighting, a sense of reverence – of being in communion with the sacred; they may emanate an aura of age, the past, anachronism' (Macdonald 2005: 209). This scenography affects both the displays and the public.

Since the 1970s, museums have shifted their priorities from the presentation of authentic artefacts and established taxonomies to the production of experiences, where design, the originality of the display and performance are central to exhibitions (Hein 2000: 65f.; Poulot 2005). This in turn has also influenced the relationship between museums and their public and brought about new forms of participation. These include collaborative projects and the active involvement of individuals and communities in planning and setting up exhibitions, as well as the implementation of new technologies.

Nowadays, exhibitions are more idea-oriented and focused on the public and on reception. In a number of Western countries, museums of cultural history pursue a politics of positioning and endeavour to establish themselves as 'authorities of recognition' (Feuchtwang 2003: 78). As such they acknowledge the sense of a certain loss among various minority groups, and as a token of redemption aim at strengthening a feeling of belonging and

citizenship and at promoting respect and social cohesion in plural societies. With the establishment of various diasporas in different parts of the world citizenship has become multiple, global, regional and local concurrently. Several scholars have recently noted that the semantic dimension of the term 'diaspora' has expanded during the last three decades or so to include various types of migrant communities and displaced populations so as to address different intellectual, cultural and political programmes (Brubaker 2005: 1). To James Clifford (1994, 1997: 255f.) diaspora cultures and discourses rest on transnational belonging and networks while trying to reconcile 'separation and entanglement'. Drawing upon her own life experience, Ien Ang (2001) is more critical of diasporas and the constraints of enduring territorial and ethnic roots and identities. She considers diaspora as a concept of 'sameness-in-dispersal, not of togetherness-in-difference' (ibid.: 13) that stands in opposition to cosmopolitanism. In my view, diasporas exemplify the polysemy and hybridity of 'imagined communities' while retaining, in the majority of cases, three core aspects which are more or less emphasized according to the circumstances. These are their dispersion in space; their orientation to a conceptual 'homeland'; and the maintenance of boundaries between them and 'others'. Diasporas are not homogeneous. They are often mixed, that is transethnic, transcultural and transnational, which, in my opinion, adds the notion of what I would label 'sameness-in-diversity' to Ang's 'sameness-in-dispersal'. They may, for example, be set up as racial groups like Black, European or Asian diasporas, or as linguistic groups such as the francophone, anglophone, arabophone or lusophone diasporas. They may also constitute global religious communities like the Buddhists, the Catholics, the Sikhs or the Muslims. Thus, instead of restricting the study of diasporas to their boundedness and in-betweeness it would be more fruitful, as Brubaker and Wagner, propose to explore diasporic identities, practices, attitudes, projects and contentions (Brubaker 2005: 13; Wagner 2012). I would also include diasporic spaces and environments where these practices and projects unfold. These spaces and environments may be open landscapes, countries or cities. They may also be more restricted to buildings and institutions. Museums have, during the last two decades, been urged to create 'third spaces' where individuals are given the opportunity of crossing the barriers of belonging (Bodo 2012: 184). By following that path, museums are developing into places where diasporic identities and practices are mediated.

Discussing some of the challenges that face museums in representing religions, Chris Arthur pointedly asks:

> [H]ow do you picture the unpicturable; how do you mount a display about what, at root, is resistant to all forms of expression; how do you convey to visitors that what religions themselves see as of primary importance is something which lies

beyond all the carefully assembled material which museums present for their scrutiny? (Arthur 2000: 2)

These queries pertain to the imaginaries of religion. By imaginary I mean a dialogic process encompassing the interaction between the manner in which a religious group perceives and expresses the spiritual dimension of its own worldview and the ways museums articulate and visualize it in exhibitions. I shall try to answer some of these questions in this chapter. I am concerned with the ways a religion – here Islam – is materialized in a diasporic context, and I investigate the relationship between matter and religion, as well as how faith is articulated through material culture and how it is displayed in a museum of cultural history.[1] One of the salient aspects of the museological turn of the last decades is, in my opinion, the blurring of boundaries between art and non-art. Taking an installation combining art and artefact at the St Mungo Museum of Religious Art and Life in Glasgow (hereafter 'St Mungo') as a point of departure, I examine how fundamental concepts in Islam are given concrete shapes to communicate the imaginary of an Islamic sacred space.

Conceptions of Sacred Space

Sacred spaces are implicitly tied to notions of purity and to a sense of property rights and belonging. Accordingly, they are contested spaces which are regulated by policies and strategies of inclusion and exclusion. We may envision sacred spaces as combining physical and conceptual qualities. They are the bearers of religious meaning and cover a great variety of sites, from nature and landscapes to specific areas in buildings. Sacred spaces are not only considered holy because they fulfil certain functions as places of communication with a divinity and where religious rituals are performed, but also because they are religiously and emotionally laden sites that trigger the believer's affective response. Moreover, sacred spaces are defined spaces that are oriented towards a symbolically significant focal point. Whether this locality is imaginary, like heaven and paradise, or real, like Jerusalem and Mecca, is not important. In the belief of the community it exists. Thus, by mapping out a sacred geography, sacralized places provide direction to a religious group. I shall come back to this point later on. Further, sacred spaces are also tied to memory. They are *lieux de mémoire* (sites of memory), to use the expression coined by the French historian, Pierre Nora (1984–1992), and as such evoke a religion's most significant narratives. Thus, the Wall of Lamentation in Jerusalem reminds us of the destruction of the Temple and of the plight of the Jews through the centuries; a cross in a church

tells the life of Jesus; the Ka'ba brings forth the stories of Abraham, Ismail and Hagar, and of Mohammed; Karbala recounts the martyrdom of Hussein; and Lourdes discloses the miraculous visions of Bernadette Soubirous. However, to be able to recognize the narratives, to listen to the stories which the different sites unfold, and to comprehend their symbolic meaning, one has to have some knowledge of the cultural and religious environments in which they were elaborated. Finally, sacred spaces are also related to time or, more exactly, to sacred time – that is, a time out of time: the time of a beginning. The actual moment of this beginning may be lost in the memories of the believers, as for example the time of creation, or be tied to a given historical event and have a precise date which marks the religious calendar of the community.

There are two main lines of approach to the study of the sacred, including sacred spaces. The first is the substantial, phenomenological viewpoint which was endorsed by scholars such as Rudolph Otto, Gerardus van der Leew and Mircea Eliade, for whom the sacred spaces have inherent supernatural qualities that emanate a sense of mystery and power (Otto [1923] 1950; Eliade 1958, 1961: 20f.; van der Leeuw [1938] 1986: 52f.). Eliade went on to set up archetypes without, however, taking into account changes in religious symbolism and practices or the religious significance different cultural and religious groups have attributed to their sacred spaces. Basing himself on a celestial prototype and the concept of hierophany, he distinguished three aspects of sacred spaces. One is tied to cosmogonic repetition, the second points to the symbolism of a centre, or *axis mundi,* and the third to the assimilation of the temple with the axis mundi as the point of junction between heaven, earth and the netherworld (Eliade 1958: 368). The other main perspective to the study of sacred space is the situational, processual one which grew out of the works of Emile Durkheim and maintains that the sacred is contingent to rituals and social relations. Nothing is inherently holy, but rather, sacredness is bestowed upon a site in compliance with its historical and contemporary setting. Accordingly, space is sacralized through ritual (Smith 1987: 103f.). In order to communicate perceptions of sacred space, museums tend to blend elements from these two approaches and visualize them according to the regime(s) of representation and the frame(s) they choose to deploy.

Representation and its Frames

Museum exhibitions are organized according to certain contemporary regimes of representation that prevail among museum practitioners internationally at a given time (Varutti 2011: 14–16; Feuchtwang 2011). The term 'regime' refers to political governance and choices that comprise sets of

rules, appropriate conditions and suitable patterns for their implementation and visibility. 'Representation' is here understood as a process to create meaning through taxonomy and display (McLean 1998: 247f.). It is related to metonymy, where the part stands for the whole, and to metaphors – or rather to visual metaphors. Visual metaphors are conventional schemes rooted in a given tradition where artists and craftsmen use specific artefacts, materials, motifs and colours to evoke given themes (Herméren 1969). In the long run, and after repeated usage, some of these objects and motifs may turn into clichés and be used as framing tools that reproduce stereotyped mental images of a culture and a religion. Accordingly, an object refers to something else beyond itself. It is the concrete thing and at the same time the materialization of some intangible element that is bestowed upon it. In the context of museums, representation requires classification and presentation. The latter entails a focus on the object and how it engages with the beholder (Moxey 2008: 133). Today, aesthetics is a favoured regime of representation in museums of cultural history. It is often combined with other regimes of representation as a way of producing meaning and imparting knowledge. It is based on the idea that art leads visitors to resort to their accumulated knowledge, both learned and tacit, to understand a culture's social structures and practices, ways of life, beliefs and rituals. Drawing upon Aristotle's *aisthesis* and its emphasis on sensorial experiences, Birgit Meyer (2009: 6f.) introduces the notion of 'aesthetic formations' that refers to both a community and processes of shaping it through shared imaginations that are given aesthetic forms. I posit that in plural societies and diasporic settings the various aesthetic formations that share a common space would influence each other, contest each other and negotiate with one another. Aesthetic formations may, in my understanding, also be established in institutions like museums and heritage sites. As Mieke Bal (2008) rightly points out, in museums aesthetics and politics operate together. Aesthetics reflects the opinions, policies and priorities of institutions and funding organizations. With the new forms of participation and collaborative projects nowadays the resulting exhibitions reflect what I would describe as a state of consensus between the aesthetic formations of the communities represented and their imaginaries and those of the museum displaying them (Bodo 2012; Reeve 2012: 127f.).

In exhibitions, regimes of representations are articulated and visualized through framing. Framing denotes a perspective, a specific angle of interpretation of objects and texts. It implies the act, process and manner of producing and shaping meaning. In the context of museums, framing gives coherence to exhibitions by applying certain ways of arranging the different elements of an exhibition so that together they convey a specific worldview, an atmosphere or an idea (Naguib 2011: 112–14; Varutti 2011: 14f.). This involves methods of representation where every choice has consequences –

for *what* kind of meanings are produced, for *how* they are produced and also for how they are understood by individuals and communities (Hooper-Greenhill 2007 Hall 1997: 8; Watson 2007: 3f.). From the institutional side, curators and designers decide on the content, form and objectives of an exhibition. But, the message sent is received in the manner of the receiver, as visitors do bring along their own experiences, perceptions and individual backgrounds, plus their baggage of memories and preconceived ideas, to any exhibition. Their interpretations and reactions may therefore be quite different from the intentions of the organizers.

Framing may consist of many – often overlapping – themes and perspectives. At St Mungo the main frame is religion as it is lived and practised. It is visualized by relying on what Olivier Remaud describes as translation and familiarization approaches (Remaud 2012). Translation denotes a shift from one form to another, whether it is a language, a style or a medium: oral to written text, written text to still picture, artefact or film, or idea and belief into material culture. In museums, 'translation' means to use artefacts, texts and pictures to represent cultures and worldviews; 'familiarization' means to make something known and to acknowledge it. It considers cultures or religions in terms of their own understandings and concepts. Nowadays, the translation and the familiarization approaches are normally used together in a dialogic relationship in exhibitions. Translation involves what Peter Bjerregaard describes in his chapter in this volume as 'dis-connecting' objects from their original context in order to confer upon them a presence and agency suited to the chosen theme and allotted space of the exhibition. It entails the selection and arrangement of objects to put on display, the compilation of the explanatory texts and deciding on the kind of mixed media devices to set up. The familiarization approach tends to rely on experience, the senses, emotions and narratives. In the process, some objects may be transformed into something else and acquire layers of meaning and symbolic values they did not have before being put on display in a museum. This is particularly true in the case of artefacts that normally are used during religious rituals, and of objects of devotion when they end up in a museum collection and lose their primary function and purpose. It is my contention, however, that in the majority of cases the objects displayed in exhibitions on religion, especially living religions, continue to connect. I will now go over to the example from St Mungo and to the materialization of fundamental concepts in Islam.

Materializing of Islam

The St Mungo Museum of Religious Art and Life in Glasgow was inaugurated in April 1993. It is situated alongside the medieval Glasgow Cathedral

and across the road from Provand's Lordship, which is the oldest house in
the city. The building was designed by the architect Ian Begg in 1989 in a
style complying with that of neighbouring buildings. The museum was con-
ceived as an engaged and engaging institution (O'Neill 1995).[2] The purpose
of the museum as stated on its webpages is 'to promote mutual understand-
ing and respect between people of different faiths and people of none'.[3]
Mark O'Neill explicates that:

> St Mungo is not an 'objective' museum. It exists explicitly to promote a set of
> values: respect for the diversity of human beliefs. It aims to do this by showing
> how important religion has been in humanity's struggle to find a meaning for
> life. It ranges over five continents and over 3,000 years, from Neolithic times to
> the present ... The museum is not the result of systematic collection of religious
> objects, but draws upon Glasgow Museum's reserve collections of anthropology,
> fine and decorative art, and local history. It goes beyond these disciplines, by try-
> ing to display objects in such a way that they retain some of their spiritual power,
> blurring the boundaries between the disciplines and between secular and sacred.
> (O'Neill 1995: 50)

Moreover, the museum follows different forms of participation by involv-
ing representatives of local communities and individuals in the elaboration
of their exhibition programmes and in providing a shared space to present
alternative knowledge and personal narratives. In addition, the museum
organizes activities directed towards schools and the younger population, as
well as other groups in society.

The exhibition space at St Mungo is divided into three parts. The first is
an open gallery with a high ceiling where singular artefacts and art objects
represent one of the main world religions from antiquity to modern times.
From there one has access to an adjacent room devoted to 'Religious Life:
From Birth to Death and Beyond'. The approach is comparative and treats
the different religious rituals and practices marking the various stages of
life, and other themes such as war and peace, persecution and spreading
the Word. At the entrance of this room a declaration signed by representa-
tives of the different religious groups in the city and by the Lord Provost of
Glasgow underlines the importance of interfaith dialogue in such a complex
society as the Glaswegian. The third room is the Scottish gallery which is
also arranged thematically.

The installation representing Islam in the main gallery combines art and
artefact. It consists of a seventeenth-century prayer rug from Turkey placed
in front of a painting entitled *The Attributes of Divine Perfection* by the
artist Ahmed Moustafa.[4]

The prayer rug is in blue, red and ochre hues and is adorned with the
usual central niche symbolizing the *mihrab* with a lamp hanging from the
top. A mihrab is the central architectural feature in mosques and serves to

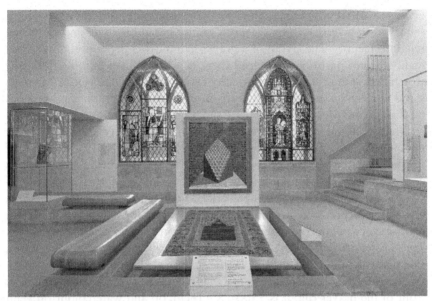

Figure 3.1. Representing Islam at St Mungo Museum of Religious Art and Life, Glasgow. Turkish prayer rug and painting, 'The Attributes of Divine Perfection', Ahmed Moustafa, 1987. Courtesy of Ahmed Moustafa and St Mungo Museum of Religious Life and Art, Glasgow. Photograph by Saphinaz-Amal Naguib.

mark the *qibla,* that is, the direction of the Ka'ba in Mecca. It is usually formed as an arched doorway with a column on each side and an empty space in between. The latter denotes that, according to Islamic thought, God is omnipresent and not fixed in a given spot. In popular Islam the mihrab is invested with transcendental significance, and many consider it to be a symbolic gate to paradise (Naguib 2001: 55f.). Among the most important features of Islamic ornament is the transposition of the same design from one medium to another. Thus, three-dimensional patterns can be flattened and, conversely, two-dimensional motives can be taken over in architectural projects and rendered three-dimensionally. Another characteristic of Islamic ornament is its ability to radically change the purpose, function and use of its carrier (Grabar 1992: 41; Naguib 2001: 70). It is the design on a carpet that transfigures it from being a mere commodity into becoming a religious artefact and acquiring the status of prayer rug. Prayer five times a day is one of the five pillars of Islam.[5] In addition to expressing piety, prayer involves the obligation (at least for men) to participate in the Friday prayer at the congregational mosque. By this Muslims testify their allegiance to the *'ummah,* namely, the community of believers. In a non-Muslim context as the one in Glasgow, the commitment to an 'ummah which is multi-ethnic, consisting of various national origins and composed of people ad-

hering to different branches and schools of Islam, bestows on its members sameness-in-diversity and a diasporic stance based on an all-encompassing religious identity. The layout of a prayer hall mirrors the notion of the 'ummah. It is not partitioned; instead there is a lateral disposition so that the worshipers stand shoulder to shoulder facing the Ka'ba in Mecca. Muslims stand in rows on an egalitarian basis in order to perform their prayers behind an imam. Men and women are separated. In practice, such a gendered egalitarian layout is more an ideal conception of society and the 'ummah than a reflection of the experienced reality (Naguib 2001: 59). The floor of the prayer hall is normally covered with either small individual prayer rugs or woven mats, or long multi-niched carpets or mats adorned with lines of symbolic mihrabs. The various prescribed movements of prayer – standing, kneeling and prostration – mean that each worshipper needs a minimum private space of approximately 1m x 2m. Prayer rugs are handled with care. The smaller prayer rugs are usually rolled up or folded, and kept in a clean, safe place after usage. The same is true for private prayer rugs.

The painting, *The Attributes of Divine Perfection,* is placed standing in front of the prayer rug. It is 130cm x 116cm, oil and watercolour on velin arches. The painting is in shades of blue, white, grey and black. It shows a cubic shape transversally cut open and resting on a white ground that is inscribed in blue-green Arabic calligraphy. The background of the painting is dark blue and covered with Arabic script in a lighter tone of blue. The sides of the central form are brown with specks of gold. The texts consist of two quotations from the Qur'an. The one used for the background reiterates verse 255 in surah 2 (*al-Baqarah* God! There is no God but Him, the Ever Living, the Self Subsistent, Formest of all beings...'). The text at the base consists of the repetition of verse 110 in surah 17 (*al-'Isra'* 'Invoke God or invoke the Most Merciful by whichever name you invoke Him, He is always the One for His are all the attributes of perfection...'). The interior of the cube is subdivided into what I have somewhere else described as the principle of 'ornamental fractals', namely, smaller identical units recalling the *muqarnas* (Naguib 2001: 72). These are the honeycomb-like elements in Islamic architecture that are used to fill vaults and niches. The muqarnas at the Alhambra in Granada are among the most famous examples. In his creation, the artist Ahmed Moustafa has inscribed each smaller unit within the central cube with one of the ninety-nine names, or rather attributes, of God.

Style is, according to Birgit Meyer, at the heart of religious aesthetics (Meyer 2009: 10). The hallmarks of Islamic visual art are its use of ornamentation to transfigure space, and the place of Arabic script and calligraphy. As the language of the Revelation, Arabic has acquired a special status of sacredness in the Muslim world. Even in countries where other alphabets and scripts have replaced Arabic, it has remained a fundamental part of the Muslim religious heritage and retained a privileged position. Today, Arabic

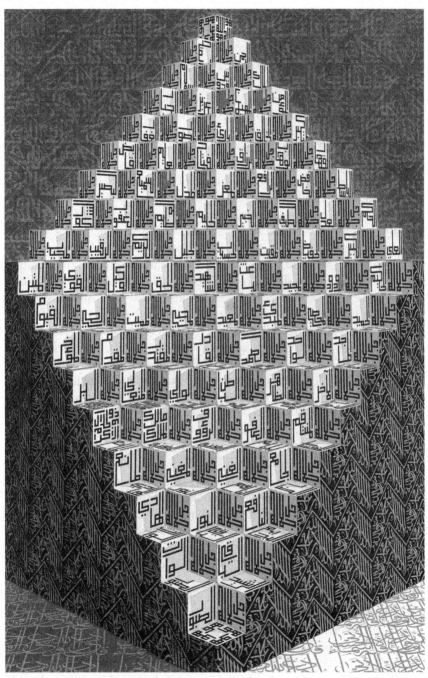

Figure 3.2. Detail from *The Attributes of Divine Perfection*, Ahmed Moustafa, 1987. Courtesy of Ahmed Moustafa. Collection of St Mungo Museum of Religious Life and Art, Glasgow.

calligraphy is a recurrent form of expression resorted to by contemporary artists from the Middle East and North Africa in their quest for identity and their endeavour to emphasize the unbroken spiritual and cultural line between the past and the present. Monia Abdallah (2010) observes that several museums in Western countries do actually acquire the creations of Muslim contemporary artists to their exhibitions about the Islamic world, its civilization and religion. These works are often then displayed in what I would call a neo-orientalistic mode so as to enhance this sense of continuity and intransience. The objects of art are thereby transfigured into objects of civilization, with religion as one of its main components. The atmosphere in such exhibitions is imbued with a feeling of nostalgia for what is perceived by both the artists and the museums as a glorious, almost mythical, past.

Seeing is an active process which implies interpretation and the recognition of conventional designs and themes. In my understanding, the installation at St Mungo materializes the fundamental precepts of Islam and hence serves to bind and bond the community of believers, that is, the 'ummah. The main cube recalls the Ka'ba in Mecca which physically consists of a hollow cube covered with a black tent embroidered with quotations from the Qur'an in gold thread.[6] It is diagonally oriented and its corners face the four cardinal points. According to the Islamic worldview, the Ka'ba symbolizes the axis mundi of Islamic cosmology (in Arabic, *qutb*). Hence, the installation at St Mungo refers to the three fundamental concepts of Islam. The first one, which is the most important, is *tawhid* (unity) that is expressed in the attestation of faith or *shahada*. Tawhid means literally 'making one' or 'asserting oneness', and refers to the belief in the indivisible oneness of God. The shahada represents the dogma of Islam as well as testifying to the finality of Muhammad's prophethood. The second major concept is the *qibla* or orientation towards Mecca and its focal point, the Ka'ba, which represents the axis mundi in the Islamic worldview. This is the direction Muslims face when they pray. The third concept is the 'ummah, the community of believers, and it designates the social and political dimension of Islam (Naguib 2001: 94f.).

The Enchantment of Materiality

Paradoxically, in organizing and setting up exhibitions about religion, in our case Islam, museums of cultural history seem, in my opinion, to de-sacralize the objects. When displayed in museums – even in exhibitions treating religious faiths and practices, as at St Mungo – the artefacts that are decontextualized, that is 'dis-connected' and no more used in rituals or devotional practices, appear to lose their religious aura. But in the process they do acquire another quality: they become objects of knowledge and what James

Wertsch calls 'cultural tools' (Wertsch 2002: 52f.). As such they are tools of translation and familiarization that mediate information and impart learning, understanding and respect about a 'foreign' religion, its fundaments and its articulation in time and space. The artefacts exhibited whether they are unique pieces, commodities or what I have elsewhere called 'religious kitsch' (Naguib 2001: 84f.) serve, in my view, to materialize religious thought and belief. Thus, the installation at St Mungo plays on the convergence of the spatial qualities of the qibla pointing to Mecca and the Ka'ba, the quantitative, social and political significance of the 'ummah, and the qualitative and imaginary attributes that refer back to the concept of tawhid and the oneness of God. Even as de-sacralized objects of knowledge, artefacts on display and installations like the one at St Mungo Museum combining a prayer rug and a painting by a renowned artist of Middle Eastern origin do retain their resonance. That is their affective presence and power of evocation, of reaching the beholder's feelings (Armstrong 1972; Greenblatt 1991). At the same time, they unravel their own individual message and biographies. As I perceive it, the installation at St Mungo links the aesthetic formations of the Muslim diasporic environment of Glasgow with those of the museum. It may, hence, act as a site of religious memory for Muslim visitors and as such may trigger emotions and bring forth various forms of remembrance, both individual and collective.

Notes

1. The generic denomination includes universal survey museums, museums of history and archaeology, museums of ethnography and ethnology, and art museums (cf. Elaine Barroso and Emilia Vaillant (eds). 1993. *Musées et société: actes du colloque,* Mulhouse Ungersheim, June 1991; Répertoire analytique des musées: bilans et projets: 1980–1993, Direction générale des Musées de France Paris. For recent studies on materiality and materialization processes, see the studies in Naguib and Rogan (eds) 2011.
2. I thank Dr Anthony Lewis, curator of Scottish History at the St Mungo, for taking the time to discuss the goals and visions of St Mungo with me.
3. http://www.glasgowlife.org.uk/museums/our-museums/st-mungo-museum/Pages/home.aspx (accessed 3 January 2012).
4. About the artist and his works, see http://www.fenoon.com/artist/artist.html (accessed 3 January 2012). The spiritual dimension of the painting and the concept of 'cosmic homogeneity' introduced by the artist Ahmed Mostafa are discussed in a forthcoming article by Stefan Sperl entitled 'Islamic Spirituality and the Visual Arts', *The Wiley-Blackwell Companion to Islamic Spirituality.*
5. The other ones are: the attestation of faith (*shahada*), fasting (*sawm*) during the month of Ramadan (9th month of the Islamic calendar), almsgiving (*zakat*)

and pilgrimage (*hajj*) to Mecca once in a lifetime during the month of *dhul-hajj* (12th month of the Islamic calendar). This last pillar is contingent on one's health and economical means.

6. One of the meanings of the root of the word *ka'b* is cube.

References

Abdallah, M. 2010. 'Polysynthèse d'une characterisation entre "objet d'art" et "objet de civilisation"', in T. Dufrêne and A.-C. Taylor (eds). *Cannibalismes disciplinaires. Quand l'histoire de l'art et l'anthropologie se rencontrent*. Paris: Musée du Quai Branly-INHA, pp. 245–53.

Ang, I. 2001. *On Not Speaking Chinese: Living between Asia and the West*. London: Routledge.

Armstrong, R.P. 1972. *The Affecting Presence: An Essay in Humanistic Anthropology*. Urbana and Chicago: University of Illinois Press.

Arthur, C. 2000. 'Exhibiting the Sacred', in C. Paine (ed.), *Godly Things: Museums, Objects and Religion*. Leicester: Leicester University Press, pp. 1–27.

Bal, M. 2008. 'Exhibition as Film', in R. Ostow (ed.), *(Re)Visualizing National History: Museums and National Identities in Europe in the New Millenium*. Toronto: University of Toronto Press, pp. 15–43.

Barroso, E., and E. Vaillant (eds). 1993. *Musées et Sociétés: actes du colloque, Mulhouse Ungersheim, juin 1991. Répertoire analytique des musées: bilans et projets: 1980–1993*. Paris: Direction générale des Musées de France.

Bodo, S. 2012. 'Museums as Intercultural Spaces', in R. Sandell and E. Nightingale (eds), *Museums, Equality and Social Justice*. Museum Meanings Series. London: Routledge, pp. 181–91.

Brubaker, R. 2005. 'The "diaspora" diaspora', *Ethnic and Racial Studies* 28: 1–19.

Clifford, J. 1994. 'Diasporas', *Cultural Anthropology* 9(3): 302–38.

———. 1997. *Routes: Travel and Translation in the Late Twentieth Century*. Cambridge, MA: Harvard University Press.

Eliade, M. 1958. *Patterns in Comparative Religion*. London: Sheed and Ward.

———. 1961[1959]. *The Sacred and the Profane: The Nature of Religion*. New York: Harcourt.

Feuchtwang, S. 2003. 'Loss, Transmissions, Recognitions, Authorisations', in S. Radstone and K. Hodgins (eds), *Regimes of Memory*. London: Routledge, pp. 76–89.

———. 2011. 'Exhibition and Awe: Regimes of Visibility in the Presentation of an Emperor', *Journal of Material Culture* 16(1): 64–79.

Grabar, O. 1992. *The Mediation of Ornament*. Bollingen Series 35. Princeton: Princeton University Press.

Greenblatt, S. 1991. 'Resonance and Wonder', in S. Lavine and I. Karp (eds), *Exhibiting Cultures: The Poetics and Politics of Museum Display*. Washington, DC: Smithsonian Institution Press, pp. 42–56.

Hall, S. (ed.). 1997. *Representation: Cultural Representations and Signifying Practices*. London: Sage.

Hein, H. 2000. *Museum in Transition: A Philosophical Perspective*. Washington, DC: Smithsonian Institution Press.

Herméren, G. 1969. *Representation and Meaning in the Visual Arts: A Study in the Methodology of Iconography and Iconology*. Lund: Læromedalsforlaget.

Hooper-Greenhill, E. 2007. 'Interpretive Communities, Strategies and Repertoires', in S. Watson (ed.), *Museums and their Communities*. Leicester Readers in Museum Studies. London: Routledge, pp. 76–94.

Leeuw, G. van der. 1986[1938]. *Religion in Essence and Manifestation*. Princeton: Princeton University Press.

Macdonald, S. 2005. 'Enchantment and its Dilemmas: The Museum as a Ritual Site', in M. Bouquet and N. Porto (eds), *Science, Magic and Religion: The Ritual Processes of Museum Magic*. New York: Berghahn Books, pp. 209–27.

McLean, F. 1998. 'Museums and the Construction of National Identity: A Review', *International Journal of Heritage Studies* 3(4): 244–52.

Meyer, B. 2009. 'Introduction. From Imagined Communities to Aesthetic Formations: Religious Mediations, Sensational Forms, and Styles of Binding', in B. Meyer (ed.), *Aesthetic Formations: Media, Religion, and the Senses*. New York: Palgrave Macmillan, pp. 1–28.

Moxey, K. 2008. 'Visual Studies and the Iconic Turn', *Journal of Visual Culture* 7(2): 131–46.

Naguib, S.-A. 2001. *Mosques in Norway: The Creation and Iconography of Sacred Space*. The Institute of Comparative Research in Human Culture. Serie B: Skrifter CVII. Oslo: Novus forlag.

———. 2011. 'Engaging with Gender and Diversity in Museums of Cultural History', *ARV. Nordic Yearbook of Folklore* 67: 111–28.

Naguib, S.-A., and B. Rogan (eds). 2011. *Materiell kultur og kulturens materialitet*. Oslo: Novus forlag.

Nora, P. 1984–1992. *Les Lieux de mémoire*. 3 Vols. Paris: Gallimard.

O'Neill, M. 1995. 'Exploring the Meaning of Life: The St Mungo Museum of Religious Life and Art', *Museum International* 47(1): 50–53.

Otto, R. 1950[1923]. *The Idea of the Holy*. Oxford: Oxford University Press.

Poulot, D. 2005. *Musée et muséologie*. Paris: La Découverte

Reeve, J. 2012. 'A Question of Faith: The Museum as a Spiritual or Secular Space', in R. Sandell and E. Nightingale (eds), *Museums, Equality and Social Justice*. Museum Meanings Series. London: Routledge, pp. 124–41.

Remaud, O. 2012. 'On Vernacular Cosmopolitanisms, Multiple Modernities and the Task of Comparative Thought', in M. Freeden and A. Vincent (eds), *Comparative Conceptions of the Political*. London and New York: Routledge, pp. 155–71.

Smith, J.Z. 1987. *To Take Place: Toward Theory in Ritual*. Chicago studies in the history of Judaism. Chicago: University of Chicago Press.

Sperl, S. (forthcoming). *Islamic Spirituality and the Visual Arts*, in B. Lawrence and V. Cornell (eds), *The Wiley-Blackwell Companion to Islamic Spirituality*. London: Wiley.

Varutti, M. 2011. 'Gradients of Alterity: Museums and the Negotiation of Cultural Difference in Contemporary Norway', *Arv. Nordic Yearbook of Folklore* 67: 13–36.

Wagner, L. 2012. 'Feeling Diasporic', *Tilburg Papers in Culture Studies,* paper 21. *Understanding Society.* Tilburg University. Retrieved 30 July 2012 from http://www.tilburguniversity.edu/research/institutes-and-research-groups/baby lon/tpcs/paper21.pdf.

Watson, S. (ed.). 2007. *Museums and their Communities.* Leicester Readers in Museum Studies. London: Routledge.

Wertsch, J. 2002. *Voices of Collective Remembering.* Cambridge: Cambridge University Press.

Part II

PRESENCE

4

Visible While Away
Migration, Personhood and the Movement of Money amongst the Mbuke of Papua New Guinea

———◆◆◆———

Anders Emil Rasmussen

I begin this chapter with a peculiar situation I found myself in while making kinship diagrams on Mbuke Islands (Manus Province, Papua New Guinea). I was asking a young man how many brothers he had. He told me he had two, both of whom were away as work migrants. It so happened that I had also interviewed his parents who had informed me that they had four sons, three of whom were work migrants. 'Only two?', I asked the young man, while presumably looking suspicious or confused. He said: 'Well, there is another one, but I don't know about him, he doesn't know about me, he never sees me; maybe he's dead or has become a criminal or something'.

I argue in this chapter that it was no coincidence that the young man used the word 'see' when criticizing his third brother, and that in fact there is a problem of invisibility between them, explaining why he did not mention him initially. Requests and remittances in response to them are ways of valuing a relationship, even determining the qualitative existence of the relationship and the aspect of the involved parties' personhood that constitutes the relationship. But the question is not simply one of existence of the relationship – it involves the value of the relationship and of the people involved.

My informants frequently expressed the notion that in knowing what another person knows and feels and what relationships a person recognizes,

words are questionable; rather, these should show in visual form. In that sense, and in such contexts, words cannot fully be trusted to reveal the invisible, but can only refer to that which has become manifest in visible form. Rendering invisible things, such as intentions, relationships and the interior aspects of one's personhood, visible in actions of giving and as things given are ways of making others see what is in one's own mind, and help to transilluminate what has been termed 'the opacity of other minds' (Robbins and Rumsey 2008). I argue that this is what remittances are in this case; they are people and their relationships appearing in perceptible forms, even if those involved are far away from where they assume appearance in social relations. Remittances are familial love, relations of kin and, ultimately, personhood, in perceptible form; they are one among many ways for an absent person's personhood and the nature of their relationships to be transformed into temporary material or visual forms.

Fifty Years of Elite Migration

Mbuke is a small group of islands in the southern part of Manus Province, Papua New Guinea (PNG). Mbuke people belong to the biggest ethnic group in the province, a group that currently identify themselves as the Titan, but who previously were known simply as Manus or Manus-true, and gave the name to the province. This is the group that especially Margaret Mead (2001) made known for the speed at which they adapted to the changed situation during late colonial times. The Second World War, particularly, had profound effects in Manus Province, because the American army constructed a large military base there, exposing Manusians to the technologies and apparent wealth of 'white people'. In response to this, Mead concluded, Manus people (and Titans in particular) managed to change their way of life incredibly quickly. They were now 'asking for a place in the modern world' (ibid.: xxxiii). During the indigenous social movement known as the Paliau Movement, the standard of living of 'white people' was indeed one of the stated goals (Mead 2001; Schwartz 1962; Otto 1992). Even if the changes described by Mead have not turned out to be as radical as they seemed to her at the time (cf. Schwartz 1975), some of the effects of the Paliau Movement that continue to this day are the high levels of education and work migration in comparison to other provinces of PNG. There is a general tendency among work migrants from Manus Province to be disproportionately highly educated and to occupy equivalently high-level jobs. Carrier and Carrier, who did work on migration and remittance in the 1980s on Ponam Island, and also in Manus, stated that many migrants were 'elite migrants' (Carrier and Carrier 1989: 167); likewise, in 1975, Schwartz wrote that

'young men and women from Manus are disproportionately represented in the educated work force all over Papua New Guinea' (Schwartz 1975: 316). The same is still the case today, both for Manusians in general (Dalsgaard 2010: 231) and for Mbuke people in particular (Rasmussen 2011: 27).

Mbuke people are not just those who are actually living on those small islands. Nearly half of the people who identify themselves as Mbuke live in urban centres around PNG; in a group of approximately 1,500 people, 400 live in Port Moresby alone (Rasmussen 2011: 27, 61). Extensive work migration, and the remittances and need for education which have come with it, has been a part of the lives of people of Manus Province for nearly fifty years (see Carrier and Carrier 1989 and Rasmussen 2011 for overviews of this history). Being a relatively small group, their disproportionate representation in high-level public and private sector jobs is extraordinary – there are, for example, two senior public prosecutors, the Governor of the National Capital District, and a female senior manger of Coca Cola in PNG, to mention a few. Generally, work migrants from Mbuke occupy well-paid white-collar jobs, and have correspondingly high levels of education, many of them being college or university graduates. This, along with decreasing access to resources on the village level (due to population growth, among other things), has led to remittances being an important, if not essential, part of household finances for those who are not migrants.

Robbins and Akin (1999: 2) have asserted that Melanesia provides a unique opportunity to study the effects of the introduction of general-purpose state monies in its early stage, but obviously, as time goes by, this becomes less and less true. Manus and Mbuke are not in a situation where money is completely new and has some kind of 'impact' as described in classical anthropological accounts of the effects of the introduction of money (e.g. Bohannan 1959). The situation on Mbuke Islands is rather a question of how unequal access to significant resources (money in particular) has already affected social relations for decades, opened new possibilities for transactions and provided alternative ways in which forms of value may be created. There are even certain widespread practices, such as sending one's first pay check to one's parents for further distribution in the village, that are now referred to as 'kastom' (custom/tradition), a term that otherwise connoted practices associated with ceremonies and exchanges that also existed in the precolonial period (Otto 1992), before general purpose state money was introduced. As we shall see, money can be kinship and sociality, not its opposition or the acid of its dissolution, and there are many different potential uses of money that have different and occasionally conflicting effects on social relations and the constitution of personhood. In the context of remittances, I argue here, banknotes, changed numbers on account statements, and envelopes carried home by visitors are indeed things on the

move, but they are also people and their minds on the move, in the visible form of things. They provide a temporary body, to use Gell's terminology (1998: 7), for those who are away. Appearing in such perceptible forms is especially necessary when, as is the case among Mbuke people, nearly half of the population are away as temporary work migrants.

To show how remitting and otherwise sharing money has become an important way for relationships and personhood to be made to appear in visible form, I start with a case in which relationships are disputed by those involved in them.

Appearing as a Relative

Adoption is widespread among Mbuke people, and therefore parent–child relations are not always completely clear or indisputable. Paying school fees is one way of 'appearing as' a parent and a way of placing the student in a situation of reciprocal obligation when later getting access to money by becoming a work migrant. The following example illustrates this and the conflicts of visibility involved therein.

George, now a highly placed civil servant living in Port Moresby, and Margaret, a woman who has lived her whole life in the village, had a daughter, Karen, when they were still very young. But since George lived in Port Moresby, and was enrolled in university at the time, the child remained with Margaret, and when later she married a man in the village, called Jeff, Karen became Jeff and Margaret's daughter. Since George and Margaret had never become a couple, Karen's patrilineal descent group membership was unclear, and Margaret's marriage to Jeff solved that problem. During my first visits to the Mbuke Islands Karen was attending high school in the provincial capital, but during holidays and at weekends she stayed in the village with Jeff and Margaret. Karen is a bright young woman who did quite well in high school and was an obvious candidate for further education. As is sometimes the case in situations like that her parents, Jeff and Margaret, looked towards wealthy migrant relatives to sponsor the significant tuition fees for university. When this turned out to be difficult in their immediate kinship group, Karen's biological father, George, who was by now a wealthy man living in Port Moresby, came forward offering that Karen could live with him in Port Moresby, and that he would pay for her education. As we shall see, this was not a perfect solution for Jeff and Margaret, but nevertheless they consented to the arrangement.

I met Karen during her first Christmas back in the village after she had moved to Port Moresby. She and George had arrived together a few days

earlier, and I noticed that while she used to refer to Jeff as 'father' (Titan: *papu*), she now referred to George as her father too. One day during that Christmas, I sat chatting with George by his village house when Margaret, Jeff and Karen turned up. Jeff seemed nervous and upset. He said that, in his opinion, George should have brought Karen directly to him and Margaret, when they had arrived on the island. By doing so, Jeff asserted, George would have made it clear that Karen should live with him and Margaret during her stay, and that they would be the ones to look after her when she was in the village. Instead, she was going around the village on her own, had spent time in George's house and had bought food in trade stores, rather than eating in Margaret and Jeff's household.

Jeff said: 'If she has money she must give it to her parents, she must *see* her parents, she must love her parents!' George responded that he had simply given Karen a bit of money in order for her to be able to 'buy a few things for herself', to which Jeff responded that this was the responsibility of the parents; that is, feeding young people and children is the obligation of parents who, from Jeff's perspective, were himself and Margaret, an obligation George had deprived them of the opportunity of fulfilling. George eventually stated that 'there is nothing of what you are saying that I disagree with', and Karen spent the rest of the Christmas holiday with Jeff and Margaret.

On the face of it this might seem to be simply a case of co-parents disagreeing about the strictness of raising their teenage daughter, but I would suggest that it actually reflects the way in which even small actions constitute visual embodiments of relationships. Had Karen been 'turned over' directly to Jeff and Margaret *by* George, he would have himself recognized and made visible to others that they were the parents; but by equipping her with money and not taking her to her parents, he questioned that assumption, and might even be seen to be claiming back his own fatherhood. To Jeff this would not only be emotionally distressing and question his fatherhood, it also jeopardized the assumption that he and his wife should be the ones to receive whatever money Karen had access to, as an expression of the reciprocal obligation for migrants to help their parents in the village in return for their 'hard work' of bringing them up and putting them through school (cf. Sykes 2001). But Karen had instead used George's money in trade stores, and thus made visible to others that she had money of her own. Karen had failed to *see and make seen* Jeff and Margaret as her parents, not only by not giving them money ('she must see her parents'), but also by buying food elsewhere, rather than eating in their household, which would have given them a chance, by feeding her, to establish further grounds to say that they are her parents, to whom those later remittances must be sent.

The Opacity of the Mind

It has been pointed out that in many Pacific cultures there is a particularly strong belief that one cannot know what is in the mind of another person. Robbins and Rumsey have termed this idea of the inaccessibility of other people's thoughts and feelings 'the opacity doctrine' (2008: 408). In a special issue of *Anthropological Quarterly* on 'the opacity of other minds', a number of authors discuss present day examples of this in Pacific contexts. For example, Rumsey explores the role of confession among the Ku Waru of PNG (Rumsey 2008); and Schieffelin shows how, in language socialization of children of the Bosavi of PNG, adults do not teach children to speak by guessing what the child is trying to say – as parents might do elsewhere – because they work on the assumption that one cannot read the minds of others and should not try (Shieffelin 2008: 431ff.). These authors explore the 'opacity doctrine' in relation to 'language ideology'; that is, in relation to local ideas about what language can and cannot do (Rumsey and Robbins 2008: 411), they focus on how ideas of opacity are reflected in language and in the use of language. But when words are not to be trusted in accessing other minds, what is the alternative? Mbuke people do have such an alternative, namely the action of giving as a way of seeing and making seen. In other words, 'the opacity of other minds' is overcome in the social action of giving and this is also reflected in the many concepts of vision and visuality that are used in relation to exchange practices in the Titan language.

If Karen had gone straight to her parents in the village and given them the money she had, it would, as an action of giving, have made the child–parent relationship appear in an appropriate guise, from the point of view of Jeff. Regardless of the fact that George responded to Jeff's criticism by saying 'there is nothing of what you are saying that I disagree with', this claim was contradicted by his actions – seen not only by the parties involved, but also by the store owners where Karen had bought food with big banknotes. The parent–child relationship between George and Karen had appeared in effects that were visual in the form of banknotes and her whereabouts.

The actual terminology used by Mbuke people, both in the vernacular (Titan) and PNG Pidgin (Tok Pisin), regarding a variety of exchange practices reflects the way in which actions 'make appear' social relations and the constitution of the people involved. I often heard the same words used in the example above, where Jeff said that Karen 'must see her parents', used for a variety of kinds of giving. For example, one day, my adoptive father in the village, Polongou, said, as he was leaving for the site where a mortuary exchange event was taking place, 'I shall go and see them with 50 kina' (Titan: 'Yo po kula *lisi* ala me 50 kina', using the same verb as one would use in 'see you later', 'kama tu *lisi* oi'). This kind of usage – to see with money

– is not unusual: a term referring to sight, seeing or perspective is used for the act of giving.

Polongou's giving of money in this case gave visible form to the fact that he was maternal kin, as well as recognizing the receivers as paternal kin by the money he gave. In many cases the parties in exchange already know both parties' place in the genealogy. But such actions of 'seeing and making seen' ensure that others know this, reconfirm it, and negotiate the proportions of the relationship by giving it material form, thereby working on the assumption that what is in the mind of another can only be known if it becomes visually manifest. As we saw in the initial example of kinship diagrams, even the most indisputable kin relations, such as brotherhood, can turn proportionally so small and appear so insignificant that they become socially invisible if they are never made seen, and this was exactly what the young man claimed about his brother: 'He never sees me ... maybe he's dead'.

In Polongou's case he went to 'see' his kinship relation to the deceased and the bereaved by giving to those conducting the exchange (the paternal kin), and in the final stage of the exchange (which takes place over several days) the paternal kin 'saw' back, by giving money to the maternal kin of the deceased, among them Polongou. The paternal kin, on their part, explained giving money to Polongou later in the process of exchange by what may be translated as 'we see Polongou's good seeing' (Titan: yota lisi lele-awian e Polongou). The verb *lele-awian* literally means 'view-good' or 'see-good', *lele* being the substantive form (view/perspective) of the verb *lisi*, 'to see', and *wian* meaning 'good'. In that sense, this kind of giving and receiving could be described as a reciprocity of perspectives confirming and recognizing relationships (Munn 1986: 16). Giving something or acting in a certain way 'makes appear' certain relations, while it may also recognize a visual appearance in response to the actions of the other party. The parties involved in the adoption example knew that George was Karen's biological father, but it was only when he 'appeared' as such and the proportions of the relationship changed (especially in Karen's actions) that his fatherhood took on social existence and became a potential threat to Jeff and Margaret's claim of parenthood.

The important point here is that for social relations and personal properties to exist they must be 'made appear', thereby transilluminating opacity by actual action, in this case by giving, and they must be recognized by such 'appearance' by both parties. If Polongou had not presented himself and contributed money at the exchange event, he would have been given nothing in return; and he had to go there not only to *see* the paternal kin who organized the exchange event, but to make himself *seen* by contributing. Otherwise it would have seemed that he did not recognize the relationships, and the paternal kin on their part would have had no way of reciprocating

that recognition. Polongou's action concurrently constituted him as a maternal relative, and the receivers as paternal kin.

Although concepts of vision in exchange may seem to be figures of speech, they point to the importance of making visible through action that which is otherwise invisible, and indicate ways of overcoming the opacity of various aspects of social life.

Remittances: People and Relationships Made Visible

For the Mbuke migrants the recurrent requests for remittances from village relatives is a constant problem in their life in the city. But simultaneously, to migrants who are cut off physically from the village, 'appearing' in other forms, such as in the form of money transfers, has become particularly useful for maintaining and constituting relationships. Likewise, Bruland (chapter 5, this volume) demonstrates that Tamils in exile in Northern Europe manage to feel that they are back home, while away, during certain ritual performances that create 'a piece of the Tamil homeland' (ibid.). But rather than creating a piece of the Mbuke islands in Port Moresby, Mbuke migrants appear visually, back in their villages, and in that sense they succeed in actually being there, albeit not with their biological body. Migrants often explained – using the vocabulary of visibility that I have discussed – that they had to 'see' (*lisi*) their relatives in the village by way of sending money, because otherwise they and their relatives would become invisible to one another. In Port Moresby I visited Hank, a man from Mbuke, in his office on the 6th floor of a large office building where he works as the director of human resources in a big government organization. He pointed out that he often felt that he had to give money in response to requests from village relatives, because otherwise 'if I go to the village, I will find a way to avoid them ... because I cannot face up with them, I cannot face them, and they will be feeling the same'.

Explanations like this point towards having to be able to actually – as a sensory operation – look at the other person again, and that one would not know how to look at the other person if they had not 'seen them' (through money) in the past. Similarly, other migrants explained that, if they do not send money to village relatives in response to requests, they will have to avoid meeting them back in the villages because, by not having 'seen' them in the past, they would have raised the question of whether or not they cared about their relatives, or of whether they in fact considered them relatives in the first place. Such a refusal would cause serious offence to the requesting party. Hank continued, '[I]f I don't give, and I go to the village, no one wants

to – they will feel hesitant to – come and visit, because they will want to find the reason why I was refusing them'.

In this sense, giving is a recognition of the very existence of the other, as that particular kind of relative that they make themselves appear through their request for money, which cannot be uttered towards any kind of relative. But it is also a way for the absent migrant to appear in a perceptible form in the village. Repeated negative responses to requests might make it hard for both parties to know how to behave towards each other, or to even conceive of each other in a meaningful way. It might create resentment and shame, but also, in a sense, invisibility.

Living in Port Moresby as a work migrant from Mbuke is comparable with the situation of Papua New Guinean prisoners described by Adam Reed (1999). The prisoners conceive of themselves as hidden in the prison rather than as illuminated and exposed (as argued by Foucault 1977, cited in Reed 1999: 44), because they are visually cut off from relations in which they are embedded, and out of which they see themselves as being constituted (Reed 1999: 47). Among other inmates in the prison, on the other hand, they do much to remain *invisible,* by hanging up blankets around sections of beds, for example. The prisoners try to avoid exchanging gazes with other inmates because such an exchange of gazes might acknowledge a relation, and hence obligations for transactions – for example, tobacco sharing (ibid.: 49) – that cannot be met. Exchanging gazes and exchanging things, then, as in the cases that I have discussed, are highly similar in that they mark and make relationships. Migrants from Mbuke occasionally do the opposite of what the prisoners do, by calling village relatives, attempting to give them a chance to 'see' them by requesting things, as well as by sending things that make them visible. When people use concepts of vision in exchange practices these are not only metaphors, as they do refer to actual vision; as one migrant explained during an interview, some migrants worry what would happen if they do not give: 'You go to the village and you see them. Their eyes will go down, look away – because you don't know about [or acknowledge] others'.

As in the case of the prisoners, 'seeing' is both a way of recognizing a relation, metaphorically, while also being related to the actual visual operation of looking at one another; just as Polongou's going to the mortuary exchange was both a matter of his actual physical presence and recognition, and of his 'seeing' by giving.

Perspectives in this sense are always inter-personal, since one perspective reappears in a reciprocal appearance of the other person's perspective, the person can see him or herself in the actions of others. In such reciprocity of perspective, people must see themselves in new forms, and 'the act of

another agent [is] a measure of oneself as an agent' (Strathern 1992: 188; cf. Strathern 1988). In the present context, when a person's perspective is made visible by the giving of it, the person's constitution itself becomes visible, since people are also constituted by the relationships that their actions suggest or imply.

While writing this chapter, I was on the phone with one of my adoptive brothers from Mbuke who lives and works in Port Moresby. We were arranging the transportation of the body of our deceased cousin back to the village from the city where he had died. Another brother of ours was taking care of the transport arrangements, which was already troubling the brother who I was one the phone with, and he said: 'I feel really bad, you know, that [name of the brother in charge of the transport arrangements] is going to the village and I am not. The looks of it are very bad, but it is just that I am really going through a drought these days'.

Apart from this being a request for money from me, it may again be noted how the visual appearance of things was in question. For me, being as cut off from my Papua New Guinea kin relations as I am, giving money to my brother was my chance to appear in perceptible form back in the village in the form of his airline ticket from Port Moresby to Manus, and in the form of the money distributed on my behalf during the mortuary exchange ceremony. So even as I sit in front of my computer in Oslo writing this sentence, I am also in a village in Papua New Guinea, being distributed in the form of banknotes.

Being met with requests, in other words, is not simply a necessary evil, brought about by the moral obligation to help less fortunate kin who ask for help (as in the demand sharing identified by Peterson [1993]); requests are a chance for migrants to become and remain visible while faraway. For someone like me who is an adopted member of a family on Mbuke, not appearing during the mortuary exchange taking place for my first cross-cousin – a very important relation in the kinship structure in question (and for me personally) – would place serious doubt on whether or not I am really that man's cousin and hence the brother of the brother who called me.

Conclusions

The aim of this chapter was to develop a possible explanation for the continuous flow of remittances to the Mbuke Islands from temporary work migrants. I have argued that concepts of vision in exchange reflect how exchange is a way of making certain things visible that are otherwise invisible. People and their perspectives on certain relationships 'appear' in visible forms, as actions and as things. In understanding these concepts of vision in

exchange practices, then, it is important to note that seeing and giving are, in this respect, the same thing: giving is a way of seeing and making visible that which is otherwise veiled by opacity.

References

Bohannan, P. 1959. 'The Impact of Money on an African Subsistence Economy', *The Journal of Economic History* 19(4): 491–503.

Carrier, J., and A. Carrier. 1989. *Wage, Trade, and Exchange in Melanesia – A Manus Society in the Modern State*. Berkeley: University of California Press.

Dalsgaard, S. 2010. 'All the Government's Men: State and Leadership in Manus Province, Papua New Guinea', Ph.D. thesis. Aarhus: Aarhus University.

Gell, A. 1998. *Art and Agency: An Anthropological Theory*. Oxford: Oxford University Press.

Mead, M. 2001[1956]. *New Lives for Old: Cultural Transformation – Manus, 1928–1953*. New York: Perennial.

Munn. N. 1986. *The Fame of Gawa: A Symbolic Study of Value Transformation in a Massin (Paua New Guinea) Society*. Cambridge: Cambridge University Press.

Otto, T. 1992. 'The Paliau Movement in Manus and the Objectification of Tradition', *History and Anthropology* 5(3–4): 427–54.

Peterson, N. 1993. 'Demand Sharing: Reciprocity and the Pressure for Generosity among Foragers', *American Anthropologist* 95(4): 860–74.

Rasmussen, A.E. 2011. 'Sugarloaf Holism: Personhood, Sharing and Community among the Mbuke', Ph.D. thesis. Aarhus: Aarhus University.

Reed, A. 1999. 'Anticipating Individuals: Modes of Vision and their Social Consequence in a Papua New Guinean Prison', *Journal of the Royal Anthropological Institute* 5(1): 43–56.

Robbins, J., and D. Akin. 1999. 'An Introduction to Melanesian Currencies – Agency, Identity and Social Reproduction', in D. Akin and J. Robbins (eds), *Money and Modernity – State and Local Currencies in Melanesia*. Pittsburgh: University of Pittsburgh Press, pp. 1–40.

Robbins, J., and A. Rumsey. 2008. 'Introduction: Cultural and Linguistic Anthropology and the Opacity of Other Minds', *Anthropological Quarterly* 81(2): 407–20.

Rumsey, A. 2008. 'Confession, Anger and Cross-Cultural Articulation in Papua New Guinea', *Anthropological Quarterly* 81(2): 455–72.

Schwartz, T. 1962. 'The Paliau Movement in the Admirality Islands, 1946–54', *Anthropological Papers of the American Museum of Natural History* 49(2): 211–421.

———. 1975. 'Relations among Generations in Time-Limited Cultures' *Ethos* 3(2): 309–22.

Shieffelin, B. 2008. 'Speaking Only Your Own Mind: Reflections on Talk, Gossip and Intentionality in Bosavi (PNG)', *Anthropological Quarterly* 81(2): 431–41.

Strathern, M. 1988. *The Gender of the Gift*. Berkeley: University of California Press.

———. 1992. 'Qualified Value: The Perspective of Gift Exchange', in C. Humphrey and S. Hugh-Jones (eds), *Barter, Exchange and Value: An Anthropological Approach*. Cambridge: Cambridge University Press, pp. 169–91.

Sykes, K. 2001. 'Paying a School Fee Is a Father's Duty: Critical Citizenship in Central New Ireland', *American Ethnologist* 28(1): 5–31.

5

BEING THERE WHILE BEING HERE
LONG-DISTANCE AESTHETICS AND SENSATIONS IN TAMIL NATIONAL RITUALS

Stine Bruland

This chapter explores how diasporic supporters of the Tamil side in Sri Lanka's civil war – the Liberation Tigers of Tamil Eelam (LTTE) – enact and experience LTTE's national symbols and practices during the grandiose ritual of *maveerar naal,* or 'Great Heroes' Day'. Every year on 27 November, tens of thousands of LTTE supporters attend *maveerar naal* in places like Paris, London, Oslo, Copenhagen, Toronto, New Jersey, Chennai and Sydney. In this ritual, they honour their *maveerar*s, 'heroes' or 'martyrs', who died fighting for Tamil Eelam – a Tamil state separate from Sri Lanka. The LTTE supporters invest a great amount of work, time and money in the construction of the ritual sites in the diaspora, making use of an extensive set of national symbols and materials developed by LTTE's leadership. In the everyday life of LTTE's diasporic supporters there was a constant ambivalence between grief at the loss of the homeland, including rage and sorrow for their suffering 'brothers and sisters', and the acceptance and relief that they were living at a safe distance from the war. I discuss how the ritual of *maveerar naal,* even since the end of the war, is essential to the LTTE supporters as a ritual space where everyday existential questions of homeland and exile can be addressed and reflected upon. Given the relational quality of aesthetics in the interaction between the sensing human body and the ritual objects, I argue that the ritual produces experiences in the LTTE supporters that en-

able them to overcome the distance between the new and the old homeland, healing the sores of their unfulfilled longings. The LTTE's national symbols and rituals must therefore be recognized as crucial to their success in gaining and maintaining supporters, as well as to the legitimizing of their violence during one of Asia's longest-running civil wars, a war where an estimated eighty thousand to one hundred thousand lives were lost.[1]

The use of symbols, rituals and practices by Tamil nationalists and the LTTE has attracted the interest of social scientists for some time (see Schalk 1997a, 1997b, 2003a; Roberts 2005a, 2005b; 2007; Natali 2008; Fuglerud 2011). These scholars have searched for the semiotics of LTTE's symbols and rituals. In particular, it has been debated whether the organization's symbols and ritual practices are secular or religious. While analysing the LTTE's symbols and ritual practices in terms of their political and religious context is important, I believe such analyses should also look at empirical data on how this is experienced by those who involve themselves with the organization. My contribution to this field is to shed light on this discussion by drawing on empirical data from ethnographic fieldwork among LTTE supporters in Oslo. I argue that rather than searching for the LTTE's ritual semiotic, there is a need to explore how these symbols and rituals affect the participants – what these symbols and rituals *do*. My arguments are based on continuous fieldwork among a group of LTTE sympathizers in Oslo since late 2007, with an intensive fieldwork until September 2008, and three months' fieldwork among Tamils in Paris during the autumn of 2010.

The ritual of *maveerar naal* is loaded with objects and symbols, which I argue produce a specific aesthetic. In this chapter I understand aesthetics as a relational quality produced in the interaction between human and material objects. It is when humans *perform* the ritual objects and symbols that their inherent sensorial qualities – such as their smell, touch, view, taste and sound – are revealed (Kapferer and Hobart 2005). These sensorial qualities are essential to understanding how different aesthetics are experienced, as the force and potency inherent in aesthetics lies in its intimacy with the sensing body (ibid.: 4). Such a perspective recognizes that 'doing' and 'becoming' of the world includes multiple elements and actors, and is not merely centred around the human subject (Ingold 2007: Damsholt and Simonsen 2009). Objects or 'things', the material forms of the world, are also active and have agency; they are processual, relational and performative, not fixed or passive. Our interaction with our material surroundings thereby has the ability to affect how we experience our world. Despite the LTTE's military defeat in May 2009, the organization's symbols and ritual are still acted out in the diaspora by tens of thousands of their supporters on the day of *maveerar naal*, gathering around fifty thousand in London, nine thousand in

Paris and four thousand in Oslo.[2] Furthermore, the aesthetics is kept alive virtually throughout the year on the web: YouTube, Facebook groups and blogs distribute the LTTE's martial songs and poems.

Long-distance Aesthetics

The LTTE started as a small militant group in 1975 and developed into a highly professional fighting force before they were defeated in 2009. Within this period, the LTTE were able to recruit tens of thousands of soldiers and gain massive support in all corners of the world where Tamil migrants have settled. An indication of the diaspora's loyalty to the LTTE is their financial contribution, estimated to have been between 200 and 300 million U.S. dollars per year (Jane's Intelligence Review 2007).[3] Importantly, the LTTE also established an extensive set of national symbols, practices and rituals. These have not emerged sporadically, but are a result of careful strategic selection and construction, emanating from the LTTE's own propaganda office in Sri Lanka, the 'Office of Great Heroes Belonging to Tamil Eelam', which was established by the LTTE's founder and worshipped leader, Velupillai Prabhakaran, in 1995 (Schalk 1997b: 37).

As the name of the propaganda office indicates, the *maveerar*s are an essentially national symbol. The LTTE's supporters worship their heroes – or their *maveerar*s – for their dedication to the cause of achieving Tamil Eelam (*tiyakam* and *tiyaki*) as they have sacrificed their life, and thus their own dreams (*arapanippu*), in order to liberate the Tamil people. The ritual day of *maveerar naal* came into being on 27 November 1989 when Prabhakaran gathered his troops to commemorate the 1,307 LTTE soldiers who had died in the previous years (Fuglerud 2011). It is in this ritual that the whole set of the national symbols and practices come into play: the national flag of Tamil Eelam is hoisted, the flame of *tiyakam is lit* and the national flower distributed. They perform one minute of silence for the *maveerar*s and dead civilians, and visit the *maveerar illam,* the graveyards for *maveerar*s, where they honour the *maveerar*s with flowers and candles, and sing the national anthem. In addition, but not less importantly, supporters perform a range of songs and poems created by LTTE cadres and supporters – so-called *pulipatukal,* or 'Tiger songs'. *Maveerar naal* thus provides a prominent case for exploring how LTTE supporters sense and experience the organization's material symbols and ritual practices. Although created in Jaffna, *maveerar naal* is now a globally enacted ritual as it has been widely celebrated and performed in almost every town with a significant Tamil population ever since it was first celebrated in 1989.

Life between War and Peace:
LTTE's Presence among Norwegian Tamils

Today, about twelve thousand people of Sri Lankan Tamil background re-
side in Norway (SSB 2007). Through the establishment and operation of a
range of sub-organizations of the Tamil Coordinating Committee (TCC),
a diaspora-wide organization that is closely linked to the LTTE, the LTTE
gained political and social control over this relatively small Tamil popu-
lation. Until their defeat, support for the LTTE was a requirement within
the Norwegian Tamil community in order to be 'a good Tamil', one of the
indications of which was participation in *maveerar naal*. After the LTTE's
defeat, TCC (which coordinates the LTTE-supportive organizations world-
wide) shrank in size and also softened its control over homeland politics
and social activities. However, all the activities continue and TCC continues
to organize the annual *maveerar naal*, in which approximately 4,000 of the
6,000-strong Tamil community in Oslo continue to participate.

The organizations that support the LTTE cover a range of activities such
as a news service, lobbying, fundraising, social and cultural events and the
teaching of the Tamil language and culture to children – all in the spirit of
the LTTE. Through these practices, these organizations made the LTTE's
fight for Tamil Eelam an almost daily presence in the lives of those Tamils
who involved themselves with these organizations (see Fuglerud 1999, and
Bruland 2011, for further elaboration). Conducting fieldwork among young
Tamil migrants in Norway in the early 1990s, Fuglerud (1999) found that
they strived to reorient themselves in their new environment during the first
years of arrival. In this process the question of how to make sense of their
self-identity by overcoming their separation from the homeland was essen-
tial to the young migrants. Twenty years later, this question is still relevant.
Since I initiated my fieldwork in late 2007, I have repeatedly heard stories,
comments and discussions among LTTE supporters that express guilt and
frustration as well as nostalgic longing for the homeland, intertwined with
their acceptance of Norway as the place where they live (Bruland 2011).
Expressions like 'if we were there, we could have done something ... helped'
or 'we need to do something' were commonly heard during the years of war
among LTTE supporters. Now they are sore longings, expressed as 'think
about all the great culture that we have lost, how great we could have been'.
Such utterances are also expressed by LTTE supporters living in Paris and
London.[4]

To make sense of one's own experiences and life situation, to orient
oneself and to experience one's world as meaningful is a prominent human
universal (cf. Finnström 2008: 7): 'Because we are in the world, we are con-
demned to meaning' *(*Merleau-Ponty 1962: xix). Living at a safe distance

from the war, but constantly reminded of the fight and the struggles of the Tamils in their motherland, made such existential questions prominent. Thus, in this space characterized by the new and old homelands, the question of place is at the core of the process of 'meaning-making'.

I choose here to discuss the paper's subject through the experiences of one female supporter, during the morning hours of *maveerar naal* and in her participation in the public ritual. It is, I suggest, fruitful to provide a 'thick' description of one person's experiences to understand the complexity between ritual aesthetics, sensations and meaning-making. Selvi has taken part in *maveerar naal* since it started in 1989. At that time she had been living for a few years in Norway, and was already involved in the activities of the Tamil organizations in Norway that support the LTTE. Escaping the war and securing herself an education, she came to Norway at the beginning of the 1980s, when she was in her early twenties. She is now in her mid-forties, married with two children, and living and working in Oslo. Selvi is dedicated and active, and is considered to be a resourceful person and a role model within the community of LTTE supporters in Norway. She is therefore a poignant example of how the LTTE's symbols and rituals affect and motivate support in the diaspora.

Getting in the Right Mood

The sounds of *miruthangam* and *veenai*[5] pull me out of sleep. I recall that today is *maveerar naal*. The year is 2008 and the LTTE is fighting actively to achieve Tamil Eelam while controlling an area of eighteen thousand square miles in the north and east of Sri Lanka. Today is the day to remember and worship their dead. I get up and find Selvi already in the kitchen of her family's apartment in eastern Oslo. Handing me a cup of coffee with her special touch of ginger and cinnamon she says, '*I turned on the Tamil radio, the one broadcasting from London*'. '*Is it "Tiger songs?"*', I ask. '*No, it is just ordinary songs, but I need it to get in the right mood*,' she explains, while swaying to the rhythm.

For seven days, Selvi and other LTTE supporters have been thinking about their *maveerar*s as it is *maveerarvaranatukurippu*, 'Great Heroes' Week'. In the living room, Selvi has put up a little coffee table where she has placed a picture of her husband's *thambi*, younger brother, who became a *maveerar* in the early years of the fight for Tamil Eelam. Next to her husband's *thambi*, Selvi has also placed a slightly smaller picture of Antony Balasingham, the LTTE's former political advisor. She has bought a pink flower in a pot that she has placed in front of the pictures, and every morning for the last week she has lit a candle. After breakfast, Selvi asks me to

cut the ends of her long, black hair, explaining that she cuts it twice a year, for *maveerar naal* and the summer holiday.

Buying flowers, lighting a candle, turning on music and cutting her hair are Selvi's ritual actions on the day of *maveerar naal*. Except for the hair-cutting (which could be seen as a form of sacrifice), all the other symbols and practices are the same as those found in the public ritual, when Selvi will 'light the flame of *tiyakam*' and 'salute with a garland as a commemoration of the Great Heroes'. Although the music on the radio is 'just ordinary songs', these songs are similar to the 'Tiger songs' that will be performed and played in the public ritual, as Tiger songs follow the same style of rhythm and melody, and use the same instruments, as both classical and modern Tamil music.

Selvi enacts these symbols and practices, developed by the LTTE in Jaffna, to 'get in the right mood' in her home in Oslo. Kapferer and Hobart (2005) emphasize the *performance* of objects, which realizes their aesthetic qualities and thus affect our sensing body. It is when Selvi takes out the picture of their *maveerar* and places it on the table, brings the flowers and candles to the table and lights the candles, and then turns on the radio that image, flowers, music and candles cohere as a specific set of symbols, and thus a particular aesthetics is produced. This interaction reveals the sound, smells and visual forms of the aesthetic, which involve the senses of seeing, hearing and smelling. It is in this interplay that aesthetics gain force and potency, appealing to feelings and bringing forth experiences in humans (Kapferer and Hobart 2005).

The sensorial qualities of the objects and symbols Selvi performs in her home are important in the process of 'getting in the right mood'. It is through the aesthetic qualities of these symbols and their inherent sensorial dimension that the materiality gains what Gell (1998) termed 'agency'– the ability of materiality to affect and act upon the human. This is achieved, as Ingold (2007) argues, in the interaction with humans. In this interaction the aesthetic is able to do something; Selvi acts out the objects at the same time as the objects act upon her.

The particular mood Selvi searches for today appears to be mostly one of joy and anticipation: Selvi seems happy. She is swaying to the music, while preparing a big breakfast of eggs, bacon and fresh-baked baguettes, a treat otherwise reserved for an occasional Sunday. On the previous day she had also brought out the Sunday-best for her children and her husband, and a yellow and red sari for herself. An air of positive expectation fills the home. However, the picture of the family's *maveerar* in the living room acts as a sad undertone to the festive atmosphere, and is a constant reminder of all those who have died in the struggles. Four days earlier, Selvi had told me with a serious voice and sad look about their week of *maveerar*: '*We have a*

lot to think of this week. We think about them all the time, the soldiers who died for the country'. Today, swaying to the music and preparing a feast of a breakfast, she appears to be more light-hearted than in the days before. The visual beauty of flowers and lit candles against the backdrop of music also seems to outrange the sadness of the *maveerar*s in the aesthetics Selvi has created in her home. This echoes the official symbolic interpretation of the *maveerar*s; the dead heroes will bring Tamil Eelam and thereby peace to the Tamil people. *Maveerar naal* is thus also called *elucci naal,* 'Day of Rising' or 'Day of Edification' (Schalk 2003a; Roberts 2007; Fuglerud 2011). The grief for the people lost in battle is downplayed, while new hope and belief in the (success of the) armed struggle is promoted. This was the case, at least, in the years before May 2009.

Re-creating a Piece of the Tamil Homeland

When the breakfast is finished and everybody is ready in their finery, Selvi and her family drive off to the immense hall outside Oslo for the public ritual of *maveerar naal.* Throughout the diaspora, halls filled with thousands of LTTE supporters are transformed into ritual spaces for the day of *maveerar naal.* In the LTTE-controlled areas in Sri Lanka, *maveerar naal* was, until the end of the war, celebrated in the cemeteries of the *maveerar*s, the *tuyilamil-lam*[6] or *maveerar illam.* The LTTE's change of funerary practices is seen by Fuglerud (2011) as one of the most remarkable innovations in the organization's material culture. Until sometime around 1990, the LTTE cremated their soldiers according to Hindu practice and the ashes were given to the parents. Then the LTTE started to bury the dead soldiers in war cemeteries. Until recently these cemeteries were dotted across the LTTE-controlled area, and given *natukal,* 'planted stones' (Schalk 2003a).[7] The LTTE's official explanation for this change was that they wished to adopt the practices of the United States and U.K. to respect their dead (Natali 2008). Fuglerud (2011) was given another reason at the LTTE's administrative headquarters in Kilinochi: that they realized they would eventually run out of wood for the cremations. Whichever was the motive for the change, it has played a significant role in LTTE's ideology and rituals.

In the diaspora, imitations of the *maveerar* cemeteries in Sri Lanka are reconstructed, constituting the central place of the ritual performance. The previous day, Selvi and her family helped to prepare the hall for the ritual, together with some fifty other volunteers: from morning to late at night, men, women and children were working, painting polystyrene boxes, turning them into coffins and gravestones for the *maveerar illam* and cordoning them off with chains, and putting up an entrance. Also, flower decorations

for the graves were made, and the whole hall decorated: the walls were draped in the national colours of red and yellow, red and yellow balloons with the map of Tamil Eelam were blown up and tied to the ceiling and walls, rows of red and yellow streamers were suspended from the ceiling, full-size portraits of Prabhakaran and large television screens were put up, sound- and light-cables were run-out, and, finally, chairs were put out. The hall is lavishly decorated with artefacts and materials, leaving little space bare. It is transformed from a plain site to a ritual site, following the script of *maveerar illam*s in Sri Lanka. In Oslo, it is within this re-created *maveerar illam* of painted polystyrene that the essential ritual performance of *maveerar naal* takes place[8] (see figure 5.1).

Being There while Being Here

Arriving at the hall, Selvi, her family and I find our seats on the left side of the hall reserved for the *maveerar* families and wait for Prabhakaran's only, annual speech, which initiates the ritual.[9] Prabhakaran's figure appears on a large screen and the voice and picture are broadcast on satellite, followed by

Figure 5.1. Recreated *maveerar illam* on *maveerar naal* in Oslo, 27 November 2008. Photograph courtesy of Stine Bruland.

one minute of silence. Music then fills the hall: a 'Tiger song', accompanied by pictures from celebrations of *maveerar naal* in Sri Lanka which are projected onto a screen on the stage. We stand silent, waiting. Some are crying. When the song finishes, the lights in the hall are turned off, leaving a feeling of dusk, only broken by some minor spotlights illuminating the *maveerar illam*. Then small candles, that we all received when entering the hall, are lit. Starting from a few sources in the back rows, the light spreads from one candle to the next along the rows of seats, until there is a sea of small lights in the hall. The Tiger songs still fill the ambience, but now at a slightly lower volume. The *maveerar* families go to 'salute the Great Heroes' first, while the others queue in front of the entrance of the 'cemetery'.

With lit candles Selvi, her daughter and I proceed in silence through the entrance of the *maveerar illam,* an arch painted in yellow and red with thin black borders, and the emblem of the Tamil Tigers on the top. A woman stands to the left, carrying a large silver tray filled to the brim with flower petals. She indicates that we should take some. Just on the inside of the entrance is a large wooden coffin placed on a two-level elevation. It is draped with a Tamil Eelam flag, which is identical to the Tamil Tiger symbol (figure 5.3). The gravestone is nameless, built for those who do not have a *maveerar* to put the candle and flower petals on. Selvi passes this coffin and the eighteen smaller ones made of grey-painted polystyrene boxes, and continues on to the 'wall' of ninety-nine pictures of the *maveerars* of families residing in Oslo and nearby (see figure 5.2).[10] The photos are divided into three rows. Underneath each row of pictures is a narrow shelf on which to put the candles and flower petals. Smoke drifts

Figure 5.2. Honouring the ninety-nine *maveerars* of families residing in and around Oslo with candles and flowers. Oslo, 27 November 2008. Photograph courtesy of Stine Bruland.

out of two smoke generators placed on each side of the cemetery. Selvi places her candle in front of the picture of her husband's brother and lays down the flowers next to the candle. For a moment she remains still in front of the picture. Then she asks her daughter for more candles. Selvi finds the pictures of Tamilselvan and Balasingham[11] and repeats the act.

Walking slowly towards the exit, Selvi stops and glances at the scene: the coffins, the pictures of the *maveerar*s and the flag, in candle-lit surroundings, draped lightly with the smoke seeping in from the sides. Selvi breaks her own silence, saying quietly: '*It's sad*'. I agree with her, the atmosphere is gloomy, so I carefully say, '*Yes*'; but not able to hold back my own curiosity, I continue, '*but is it not a little bit strange with an imitated cemetery?*' Keeping her eyes fixed in front of her, she answers: '*With this, we feel that we are there. We are not able to go there. This is the best we can do. I feel that I'm there*'. She sounds relieved. We stand in silence for a little while. Then we slowly walk out of the cemetery and find our way back to our seats. From there we watch as the large coffin draped with the Tamil Eelam flag becomes covered with candles and flowers (figures 5.3 and 5.4). It takes about an hour and a half for the last person to leave the *maveerar illam*.

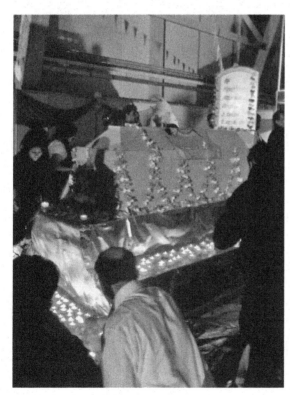

Figure 5.3. Large coffin with nameless gravestone, draped with the flag of Tamil Eelam inside the *maveerar illam*. Oslo, 27 November 2008. Photograph courtesy of Stine Bruland.

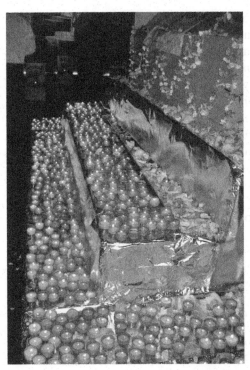

Figure 5.4. The large coffin draped with the Tamil Eelam becomes covered with candles and flowers. Oslo, 27 November 2008. Photograph courtesy of Stine Bruland.

Staged Sensing: Bridging Homeland and Exile

Through the ritual performance, Selvi experiences a feeling of 'being there'. This is achieved by her performances with the candle and flowers, moving through the entrance, observing the coffins, the dim lighting, the smoke and then, finally, the pictures of the *maveerar*s and placing the flowers and lit candles in front of them. As in her home in the morning, the aesthetics of the materiality is revealed and plays with Selvi's sensing body (cf. Kapferer and Hobart 2005): the aesthetics opens up feelings and emotions that are otherwise not accessible, giving her a sense of being in Sri Lanka. This process is made possible by the particular staging of the ritual scene. The many hours of work in carefully decorating the hall with well-defined and predetermined objects, colours, sound and light, and the supporters' efforts in applying these to create the ritual space, illustrate the importance of staging the ritual in a specific way. In particular, the use of the smoke generators makes clear that not only is the ritual to be performed in a certain way, but it is also supposed to be performed within a particular atmosphere.

Thereby, the ritual structure of performance is important for the participants' experience within the ritual: the structure of specific events, their

aesthetic properties, the orientation of the participants and their interaction
with specific elements in particular acts, forms the participants' experience
of the ritual in a particular manner (cf. Kapferer 2005: 41). It is in this
process that the reconstructed *maveerar illam* in a hall on the outskirts of
Oslo on a cold, early winter day transcends the spatial distance and brings
Selvi to the warmth and dust of Sri Lanka. The reconstructed *maveerar il-
lam* 'flips',[12] and becomes a *maveerar illam* in Sri Lanka. I suggest that this
'flipping point' where, in Marcus's words, 'the relationships or connections
between sites are indeed not clear' (Marcus 1999: 7), is realized through the
power of senses and imagination.

Senses and Imagination in the Production of Meaning

Aristotle's notion of *aisthesis* emphasizes that our understanding of the
world comes through our five senses, as an inseparable whole (Meyer 2010:
743). Kapferer and Hobart also argue that:

> The forms and schemes of reason ... are aesthetic in their composition and have
> their potency realised in their appeal to feeling as much as to a rationating body
> ... It is the feeling, intuitive body that is vital in the very production of the
> schemes of reason and in the creation of abstract, objective knowledge. (Kapferer
> and Hobart 2005: 4)

As rational thinking, aesthetics, and its production of senses or feelings
is central to our experiences and understandings of the world, and thus to
our production of meaning. The particular ritual staging of *maveerar naal*
enables the production of sensations that in turn engage and affect the pro-
duction of meaning or reality. Selvi's sensing during her ritual performance
must therefore be recognized as essential to the production of 'being there'
where this experience is part of her reality. This production of reality is, I
suggest, further enabled by Selvi's imagination. Here I understand imagi-
nation as 'the power to represent or picture something in the mind that is
actually not present' (Meyer, forthcoming). Imagination is, in this view, not
just 'mere' fantasy because it is 'just' imagined, leaving behind such views
that see 'imagined' and 'real' as mutually exclusive (ibid.). Instead, imagi-
nation is 'a creative, exteriorizing force that is central to the formation of
being' (ibid.). Thereby, imagination forms reality as we sense and know it
by organizing and guiding perception: perception becomes shaped through
the imagination. It is the performance of the ritual acts in the strictly staged
ritual space that reveals sensations which Selvi perceives through her imag-
ination; this, in turn 'flips' the *maveerar illam* in Oslo into a *maveerar illam*
in Sri Lanka.

When we were taking down the decorations in the hall, tearing down the red and yellow materials, with the children bursting the balloons, and the men carrying away the gravestones made from polystyrene boxes, Selvi commented: 'Now there is one year until next time... Unless we achieve Tamil Eelam before then – then we'll hopefully have another celebration'. The ritual staging provides the frame whereby Selvi is able to imagine herself there. The ritual staging and her imagination are thus mutually dependent in Selvi's process of achieving the experience of 'being there'.

The experience of being in Sri Lanka is desired and appreciated by Selvi. On various occasions during and after the week of *maveerar naal*, Selvi stresses how much she desires 'to be there', and that on *maveerar naal,* in the reconstructed *mavverar illam,* she achieves this. Just after the *maveerar naal* in 2011, the third *maveerar naal* without Prabhakaran, Selvi said, 'Me and my friend, we always talked about how much we wanted to be there on *maveerar naal.* Now it is impossible... But on *maveerar naal* I feel that I'm there'. Selvi's experience of 'being there' heals these sore desires and longings. The perceptually produced reality is meaningful and orders and 'solves' essential questions in her everyday life. In this moment, the frustrations, pain and guilt associated with her absence from the homeland are gone. Starting with the preparatory practices in the morning, Selvi reaches what she has waited for the whole year. The sad undertone from that morning in the home and the days before is gone. Selvi is at ease. She is together with the Tamil people in the nation of Tamil Eelam where she enacts her Tamil citizenship. This experienced 'belonging to the nation' can enhance the meaningfulness of being there; it includes her in something bigger than herself. This can be achieved for a brief time once a year, when the particular stage of *maveerar naal* is put up and performed before it is removed again.

The Politics of Senses

The ritual staging of *maveerar naal* produces experiences. It creates a space where existential feelings and emotions can be addressed and reflected upon. Imagination and sensations of aesthetics depend on former experience and learning (cf. Morphy 2007; Meyer forthcoming). Thereby the types of experiences that are achieved vary between differently situated individuals. However, the persistently high numbers of participants returning each year to participate in *maveerar naal* (even now, after the LTTE has been officially dissolved) is an indication that most participants achieve experiences they value and appreciate. Furthermore, the LTTE's strict framing and organization of the ritual stage, objects and effects also 'frames' the production of experiences within a specific worldview and creates a space for similar ex-

periences among the participants. In particular, I suggest that the recreation of the *maveerar illam*s – Eelam places in the diaspora – and honouring those who have fought for their land and rights, contributes to reflections on the Tamil diaspora's situation of living a life between homeland and exile.

With reference to Rancière (2009), Meyer points out that 'the distribution of the sensible is part of a political project of world-making that is grounded in shaping imagination and perception around particular material cultural forms' (Meyer forthcoming: 13). The LTTE's development and use of material objects and other sensory effects is thus not neutral, but shapes experiences, imagination and perception. The ritual staging of *maveerar naal* and the order of the ritual performances follow the same pattern in the different diasporic locations all over the world, which makes the ritual aesthetics almost identical regardless of its place of performance. This kind of ritual staging must thus be understood as part of the LTTE leadership's search for control and formation, not only of the ritual experience, but also of the participants' worldview more generally. The ritual thereby orders and frames sensations and experiences within the LTTE's specific worldview. In this worldview, the LTTE's interpretation of the *maveerar* successfully conveys that the positive overcomes the negative: 'the heroes' death brings Tamil Eelam'. The fight and the loss of human lives are justified by the liberation of the Tamil people. Here, the diaspora's financial contribution is recognized as important to the LTTE's fight. The potential ambiguity of the migrants' lives in exile is framed and 'organized' in a way that emphasizes their presence and contribution more than their absence. Just as the aesthetic beauty of flowers and candles outstrips the sadness represented and elicited by the pictures of the *maveerar*s, the migrants' participation in the globally enacted ritual as members of the Tamil nation cancels out their sorrow at being absent from the homeland. In the ritual, beauty wins over death and violence, joy over pain, rage over sorrow, and presence over absence. The distance to the homeland is gone and they are part of the Tamil nation.

I suggest that the space that *maveerar naal* gives exiled Tamils to reflect upon central questions in their own life within a frame where their exile life is experienced as meaningful, is crucial to how the LTTE have recruited and maintained support from the diaspora. Offering a meaningful world of interpretation to the exile population as well as those in Sri Lanka was necessary for the LTTE to continue their armed struggle. They depended on a constant supply of soldiers, money and ideological support, without which they could never have kept their position for thirty years – neither within the Tamil population nor against the Sri Lankan Army. It is important to keep in mind that the LTTE has monopolized this staged frame of meaning. Between 1986 and 1987 they 'silenced' alternative and conflicting Tamil voices and organizations through disappearances, murders or individual emigration.

In other words, no one and nothing else suggests an alternative framing of sensations and experiences. By offering the migrants a sense of personal meaning through ritual participation, the LTTE is also able to renew the diaspora's motivation for supporting the organization financially and ideologically. Existential needs therefore benefit the political cause as much as the political cause benefits personal needs.

Conclusion

In this chapter I have focused on the sensations and experiences LTTE supporters in the diaspora achieve in interaction with national symbols, objects and practices in the ritual of *maveerar naal,* a ritual that is strictly designed and organized, down to the last detail, by the LTTE. The Tamil diaspora used to live at a safe distance from the war, now they live at a safe distance from the insecure postwar situation. But with the continuous presence of news, rumours and political propaganda from the homeland, the question of place is both essential and ambivalent for those exiled Tamils who involve themselves with the activities of organizations that support the LTTE. As a result of the relational quality of aesthetics, the participants in *maveerar naal* are able to achieve sensations and experiences in their interaction with the LTTE's particular staged ritual. In this way, the LTTE's framing of the aesthetics also 'frames' the participants' sensations and experiences within the LTTE's worldview. This frame offers the Tamils in exile a place in the nation through their financial and ideological support, thereby transcending the distance between homeland and exile. I have argued that this experience addresses essential issues in a migrant's everyday life by easing the potential ambiguous feelings of grief, pain, guilt and relief of living in the diaspora.

By including empirical data of the LTTE supporters' efforts in staging the ritual scene and how this is experienced, I have sought to surface new insights into how LTTE's material culture became so powerful and thus able to attract large groups of supporters in the Tamil diaspora. Searching for the semiotic of the LTTE's symbols and practices (cf. Robert's debate with Schalk) does not fully explain the force of the LTTE's national rituals and symbols. Additionally, we have to look at what such ritual symbols and practices *do* to the humans who interact with such a specific aesthetic world. I have argued that a perspective that acknowledges the relational quality of aesthetics, and the inherent sensorial dimension of materiality, gives us a lens to see how aesthetics is not simply passive, but essential to our experience and understanding of the world. The existential sensations and experiences framed inside the LTTE's secure worldview make all the hours

of preparation and work, and the making and arranging of all the material objects and sensorial effects ready for use, well worth the effort, while also fuelling the motivation for performing the ritual year after year, despite the Tigers' defeat. There is, thus, reason to believe that the LTTE's aesthetics will live on despite the death of their founders and constructors, and that the experiences and meaning that the LTTE's aesthetics produce will continue to influence the Tamil diaspora's homeland politics for years to come.

Notes

1. http://www.abc.net.au/news/2009-05-20/up-to-100000-killed-in-sri-lankas-ci vil-war-un/1689524. Retrieved 11 December 2011.
2. The numbers of participants have remained roughly the same after the end of the war as they were during it.
3. http://www.c-cft.org/publication/pdf/FeedingtheTiger.pdf. Retrieved 10 September 2011.
4. Private conversations with representatives of the Transnational Government of Tamil Eelam during international video conference in Paris, 29–30 October 2010.
5. Drum and string instruments, respectively.
6. 'Resting place' or 'sleeping place'.
7. These cemeteries were the first things to be destroyed by the Sri Lankan government as they regained the territory. Today all of them are gone.
8. In Oslo the participants walk within the cemetery, whereas in Paris it is walked around. I assume this is a question of logistics; twice as many attend the ritual in Paris as in Oslo and it would take too much time to have all the people circulate through the cemetery.
9. Since May 2009, Prabhakaran's speech has been substituted by a speech of an unidentifiable voice, speaking in the ideological spirit of Prabhakaran.
10. In larger cities the numbers of *maveerar*s are higher, such as in Paris, where the number is about a thousand.
11. Tamilselvan was leader of the political wing of the LTTE. He participated in the peace negotiations in Norway and was one of the closest associates of Prabhakaran. Both Talmilshelvan and Balasingham were highly popular among the LTTE supporters.
12. I am grateful to Birgit Meyer for this thought.

References

Bruland, S. 2011. 'Nationalism as Meaningful Life Projects: Identity Construction among Politically Active Tamil Families in Norway', *Ethnic and Racial Studies* 35(12): 2134–152.

Damsholt, T., and D.G. Simonsen. 2009. 'Materialiseringer: Processer, relationer och performativitet', in D.G. Simonsen, T. Damsholt and C. Mordhorst (eds), *Materialiseringer: Nye perspektiverpåmaterialitetogkulturanalyse*. Aarhus: Aarhus University Press.

Finnström, S. 2008. *Living with Bad Surroundings: War, History, and Everyday Moments in Northern Uganda*. London: Duke University Press.

Fuglerud, Ø. 1999. *Life on the Outside: The Tamil Diaspora and Long Distance Nationalism*. London: Pluto Press.

———. 2011. 'Aesthetics of Martyrdom: The Celebration of Violent Death among the Liberation Tigers of Tamil Eelam', in N. Weiss and M. Six-Hohenbalken (eds), *Violence Expressed*. Farnham: Ashgate Publishing, pp. 71–88.

Gell, A. 1998. *Art and Agency: An Anthropological Theory*. Oxford: Oxford University Press.

Ingold, T. 2007. 'Materials and Materiality', *Archaeological Dialogues* 14: 1–16.

Kapferer, B. 2005. 'Sorcery and the Beautiful: A Discourse on the Aesthetics of Ritual', in A. Hobart and B. Kapferer (eds), *Aesthetics in Performance: Formation of Symbolic Construction and Experience*. New York and Oxford: Berghahn Books, pp. 129–60.

Kapferer, B., and A. Hobart. 2005. 'Introduction: The Aesthetics of Symbolic Construction and Experience', in A. Hobart and B. Kapferer (eds), *Aesthetics in Performance: Formation of Symbolic Construction and Experience*. New York and Oxford: Berghahn Books, pp. 1–22.

Marcus, G.E. 1999. 'What is at Stake – and What is Not – in the Idea and Practice of Multi-sited Ethnography', *Canberra Anthropology* 22(2): 6–14.

Merleau-Ponty, M. 1962. *Phenomenology of Perception*. London and New York: Routledge.

Meyer, B. 2010. 'Aesthetics of persuasion: Global Christianity and Pentecostalism's sensational forms'. *South Atlantic Quarterly*, 109(4): 741–63.

———. (forthcoming). *Sensational Movies: Video, Vision and Christianity in Ghana*. Berkeley: California University Press.

Morphy, H. 2007. 'Making the Familiar Unfamiliar: The Aesthetics of Eastern Arnhem Land Art', in H. Perkins and M. West (eds), *One Sun One Moon: Aboriginal Art in Australia*. Sydney: Art Gallery New South Wales, pp. 73-77.

Natali, C. 2008. 'Building Cemeteries, Constructing Identities: Funerary Practices and Nationalist Discourse among the Tamil Tigers of Sri Lanka', *Contemporary South Asia* 16(3): 287–301.

Rancière, J. 2009. *Aesthetics and Its Discontents*. Cambridge: Polity Press.

Roberts, M. 2005a. 'Tamil Tiger "Martyrs": Regenerating Divine Potency?', *Studies of Conflict and Terrorism* 28(6): 493–514.

———. 2005b. 'Saivite Symbols, Sacrifice and Tamil Tiger Rites', *Social Analysis* 49(1): 67–93.

———. 2007. 'Suicide Missions as Witnessing: Expansion, Contrast', *Studies of Conflict and Terrorism* 30: 857–87.

Schalk, P. 1997a. 'Resistance and Martyrdom in the Process of State Formation of Tamililam', in J. Pettigrew (ed.), *Martyrdom and Political Resistance*. Amsterdam: VU Press, pp. 61–82.

————. 1997b. 'Historisation of the Martial Ideology of the Liberation Tigers of Tamil Eelam (LTTE)', *Journal of South Asian Studies* 20(2): 1–38.

————. 2003a. 'Beyond Hindu Festivals: The Celebration of Great Heroes' Day by the Liberation Tigers of Tamil Eelam (LTTE) in Europe', in M. Baumann et al. (eds), *Tempel und Tamilen in zweiter Heimat: Hundus aus Sri Lanka im deutschprachigen und skandinavischen Raum.* Würzburg: Ergon-Verlag, pp. 391–421.

————. 2003b. 'Tamil Caivas in Stockholm, Sweden', in M. Baumann et al. (eds), *Tempel und Tamilen in zweiter Heimat: Hundus aus Sri Lanka im deutschprachigen und skandinavischen Raum.* Würzburg: Ergon-Verlag, pp. 379–90.

SSB.2007. *Fakta om 18 innvandrergrupper i Norge,* Report 27/2009, Statistics Norway.

6

FOOD PRESENTATIONS MOVING OVERSEAS
RITUAL AESTHETICS AND EVERYDAY SOCIALITY IN TONGA AND AMONG TONGAN MIGRANTS

Arne Aleksej Perminow

Slightly more than one hundred thousand Tongans live in the Polynesian Kingdom of Tonga. Some sources estimate that perhaps as many as a quarter of a million Tongans now live outside Tonga. Many of the homeland-based Tongans rely heavily on remittances from overseas kin. In 2007, such remittances, according to Besnier, made up more than half of Tonga's annual revenue (Besnier 2009: 222). Overseas-based Tongans, on the other hand, acquire substances and objects cultivated or manufactured in Tonga from homeland kin in order to stage characteristic Tongan events. The focus of this chapter is the use in Tonga and among overseas-based Tongans of specific categories of culturally valued things to mark and stage events of social significance. Here, I shall largely concentrate on the staging of food presentations, known among Tongans as *kaipola,* signifying 'board of food' (lit. 'eating the board'). In particular, I am interested in the articulation between the characteristics of such presentations, and the knowledge and practices of everyday living which surround them.

Most of my data is the outcome of fieldwork in Tonga over the last twenty-five years, primarily on the island of Kotu in the western part of Ha'apai. Through two short fieldworks in 2010 and 2011, however, I have also collected data among Tongans who grew up on Kotu twenty-five years ago and

who have since made their homes in New Zealand. My aim here is to look for contrasts in the staging of ritual spaces of sociality among homeland and overseas-based Tongans. By focusing on such contrasts, I hope to be able to illuminate trends of sociocultural continuity and transformation among Tongan overseas migrants and to produce insights into the more general relationship between ritual aesthetics and its environment.

In an analysis of transformations of staged events in the form of Muslim burial rituals in diaspora communities in the Netherlands, Nathal Dessing has characterized such transformations in terms of what she calls 'ritual attrition':

> Due to the transplantation of rituals from one social and cultural context to another that does not support them to the same degree, the ritual repertoire becomes smaller and displays less variety. The erosion of rituals arises from … a loss of competence of the ritual actors and a reduction of ritual redundancy. (Dessing 2001: 183)

In a recent analysis of burial rituals in Norwegian Pakistani communities, the Norwegian researcher, Alexa Døving, argues against the general fruitfulness of the concept of ritual attrition: 'Changes do not necessarily mean that the ritual repertoire diminishes in any way' (Døving 2009: 213). She cites burial practices among Norwegian-Pakistanis as a case in point, claiming that the repertoire 'has grown richer and more flexible' (ibid.: 213). She also questions Dessing's methodology of comparing findings based on today's practices in diaspora communities with findings based on informants' recollection of their homeland past. Thus she calls for 'a broader focus on practice and sociality instead' (ibid.: 222). I share Døving's scepticism towards comparisons between data that are of ontologically different orders, and have, therefore, made an effort to produce comparable data by participating in and discussing the same kinds of practices among both homeland- and overseas-based Tongans.

Like Døving, I have misgivings about Dessing's concept of 'ritual attrition' because it too strongly equates transformation in ritual practice in the diaspora with impoverishment of expression and loss of meaning. Nevertheless, I do find the underlying questions of how moving rituals away from a homeland environment may affect both the competence of ritual actors and the degree of ritual redundancy to be quite relevant for a comparative exploration of the relationship between staged events and their surroundings.

The Art of Composing a Food Presentation

Let me first of all establish a point of departure for this comparative endeavour by focusing on the art of building a presentation of food in Tonga.

Such presentations occur at a variety of occasions, and vary in the degree of formality. They are staged as parts of transitional lifecycle events. They are important ingredients in other sociobiographical events, such as appointments to chiefly titles or to new positions within the ranks of the church. They mark significant events of the church year and are staged in honour of visiting notabilities. The preparation of food presentations is referred to as *ngaahi pola*,[1] which signifies the making, constructing, composing or building of a 'board of food'.

The process of creating such presentations on Kotu was characterized by an uneven distribution of competence among those participating in the construction work. A senior man of the family would manage the work; this position was referred to as 'leader of the earth-oven' (*pule 'oe 'umu*) and sometimes as 'the one who places on the board' (*tu'utu'uni 'oe pola*). He would decide when the earth-oven should be opened. In particular, he would tell his junior assistants how things should be placed on the 'board'. Boys and young men were not generally expected to know much about the different qualities of the ingredients that made up a food presentation, nor the correct terms for many of its ingredients. Claiming such knowledge or competence would indeed quite typically result in rebukes from elders for being 'presumptuous' (*fiepoto*).[2] For instance, when I asked a man in his twenties, on Kotu, who had just uncovered an earth-oven, to identify the *ponahui*, the 'chief's portion' (*me'a 'eiki*) of a turtle in it, he admitted ignorance. His father, overseeing the work, pointed at the fatty meat along the turtle's windpipe hanging from its severed head and said: 'He wouldn't know. He is still a child [*kei leka*]'.

The work of such 'placing masters' was to orchestrate the placing of the food on the board, pointing and giving short orders like: 'Bring the largest pig to the front [*ki mu'a*]!'; 'Bring that yam over there!'; and 'No not like that! Put it with the "head to the front" [*'Ulu ki mu'a*]!'. As experienced gardeners, fishermen and pig raisers it was their duty and privilege to know the relative rank of different kinds of ingredients as well as to know the relative rank of their different parts, and to make sure that the board reflected these differences.

This brings us to a quite fundamental characteristic of Tongan food presentations – their compositional form, structured by the qualitative difference between *mu'a* and *mui*. The opposition signifies 'in front of' and 'behind' as spatial opposites, and 'before' and 'after' as temporal opposites. Thus, their compositional form was structured by what may be called a principle or logic of precedence (see also Perminow 1996, 2001, 2011).

A discussion in 1991 with Heamasi Koloa, a man in his seventies who was both a keen gardener as well as a church minister and the town officer of Kotu, and thus well versed in the *anga faka'apa'apa*, the 'way of respect',

may illuminate some of the roots of this logic. As we were observing the construction of a food presentation, he pointed out how in every category of ingredients certain kinds stood out as particularly valuable: the pig on land; the skip-jack tuna and the turtle from the sea; and the *kahokaho* yam from the garden-land. He went on to elaborate how these outstanding things were themselves constituted by ranked parts. He considered the meat of the upper back of the pig (*tu'a 'i puaka*), the throat of the turtle (*ponahui*), and the part of the chiefly *kahokaho* yam referred to as its 'head' (*'ulu*) as 'chiefly things' (*me'a 'eiki*) and 'frontal' things or *mu'a*. He emphasized how the placement and orientation of these things defined which end of the food presentation as a whole was 'frontal' or *mu'a*, the place of the chief, of the church president or of any other social focal point of the occasion being marked in the presentation. To explain the aesthetic form of food presenta- tions as a visualization of a principle of precedence, he went on to describe how to cultivate the chiefly *kahokaho* yam:

> Do you see the small piece that is attached to the yam-tuber? That is the piece of the 'mature seed yam' [*'ufi motu'a*] from which the 'offspring/son' [*foha*] origi- nated, and by that you know what is the 'head' [*'ulu*] of the yam. You should not plant the chiefly *kahokaho* yam 'haphazardly' [*noa'ia pe*], but put the pieces in separate rows according to which part of the mature seed yam they come from; the 'first part' [*kongamu'a/'ulu*], the 'middle part' [*kongaloto*] or the 'last part' [*kongamui*]. The offspring of the old yam 'growing' [*tupu*][3] from the pieces from the first part grow faster than those of the middle part, which in their turn grow faster than those of the last part of the yam. Your garden becomes well propor- tioned and very beautiful because you can see in it the 'nature/manner of growth' [*anga 'oe tupu*].

Another term for this particular kind of yam is *tokamu'a,* signifying 'planted before', in contrast to all other root crops referred to as *tokamui,* signifying 'planted after'. Elsewhere I have argued for a strong identifica- tion between this chiefly *kahokaho* yam as first-crop and the position of the sacred and most highly ranked chiefly line of pre-Christian Tonga, the Tu'i Tonga line (Perminow 2001). Indications are that in the traditional agricultural cycle, the chiefly yam, preceding the rest of the harvest, and the Tu'i Tonga, preceding all other chiefly lines coming down from a sacred origin, combined to constitute a focal point in a ritual calendar of cultiva- tion. I have shown how the somewhat mysterious proceedings of the *'inasi* ritual observed by Captain Cook in 1777 may make sense as first-fruit presentation of the chiefly *kahokaho* yam to the sacred Tu'i Tonga as the root crop 'planted ahead/in front' (*tokamu'a*)' in order for other root crops, collectively referred to as 'planted after' (*tokamui*) and the 'large crop' (*ta'u lahi*), to 'follow after' (*mui mai*). Thus I argued that rather than viewing the first-fruit presentation of the *'inasi* ritual witnessed by Cook as a part of a

harvesting ritual, his descriptions as well as its timing at the opening of the season of the planting of the 'large crop' indicate that it was performed as a planting ritual to achieve agricultural fertility. Such an interpretation also finds support in the missionary John Thomas's understanding of what this ritual was all about. Thomas spent most of the first half of the nineteenth century in Tonga and became intimately familiar with horticultural routines and practices. Commenting on Cook's description of the ritual, Thomas felt that the explorer had failed to realize what the main aim of the *'inasi* ritual he witnessed was, namely, 'to bless the seed now about to be put into the ground, and to send them suitable weather of rain and sun that the yam set may bring forth a crop and that their labouring may not be in vain' (Thomas 1825–67: 262).

The religious and political significance of the position of Tu'i Tonga as well as this ritual calendar of cultivation are clearly things of the distant past and play no political or religious role in Tonga today. Paul van der Grijp has argued for a strong continuity between the *'inasi* ritual of the past with the contemporary annual Royal Agricultural Show, where people 'exhibit the biggest, best and finest agricultural crops ..., which are ceremonially judged by the king and his followers' (van der Grijp 1993: 212). However, if the *'inasi* ritual was a part of a ritual cycle oriented less around the display of the results of agricultural growth and more around how to achieve agricultural success by engaging sacred sources of fertility and growth, continuity between the *'inasi* and contemporary agricultural shows in terms of their overall aims may be quite limited. On the other hand, two hundred years after Cook's observations, Kotu farmers clearly still cultivated the chiefly yam in separate parts of their gardens (*ma'ala*), planted it before other root crops, considered it the outstanding root crop, and used this knowledge at many events of importance (*mahu'inga*) to create orderliness (*maau*) and beauty (*faka'ofo'ofa*). While the cultural continuity between the institution of the pre-Christian *'inasi* rituals and the institution of the Royal Agricultural Show may thus well be limited, there still appeared to exist considerable continuity in terms of basic and enduring understandings of qualitative differences, of beauty and of orderliness, which seemed to underlie the aesthetics of food presentations in general, as well as in numerous other fields of creative practice in Tonga.

Other students of Tongan culture and society have also been struck by the extent to which the conceptual pair of *mu'a* and *mui* appear to operate to produce characteristic expressive forms (linguistically, materially and socially). Thus the linguist, Giovanni Bennardo, has recently used precisely the conceptual opposition between *mu'a* and *mui* in Tongan language to identify what he hypothesizes to be a foundational model of 'radiality' in Tongan cognition characterizing Tongan perceptions of spatial, temporal and

social relationships. In abstract terms, he defines radiality as 'a structural organization in which a number of vectors share a common origin' or 'the relationship between two points where one of them functions as the origin or the goal of the vector that signals the relationship' (Bennardo 2009: 173) – or, in simpler words, radiality is like the spokes radiating from the hub of a wheel. He goes on to argue that radiality constitutes a cognitive 'molecule' which in Tonga plays a role as a foundational model in the 'generation and organization of a variety of knowledge domains' (ibid.). My own findings, like Bennardo's, indicate that the opposition between *mu'a* and *mui* operates across a wide variety of fields of skills and practices in Tonga to compose or create beautiful, valuable and useful things by differentiating essential qualities of components of the environment (see Perminow 2011). Like his linguistic material, my own material on what Tim Ingold, influenced by James Gibson's ecological approach to perception, refers to as people's creative involvement with components of the environment (Ingold 2000: 2–3), indicates that the relationship between *mu'a* and *mui* is a relationship between origin and result, cause and what is caused. In Dumont's terms it is clearly a part-to-whole relationship in which relative value is a question of hierarchical encompassment (Dumont 1982). In contrast to Bennardo, however, I have no ambition to locate 'cognitive molecules' or foundational cognitive schema existing within individual minds.

Outstanding Events

To the old farmer, Heamasi Koloa, the beauty of food presentations ap-peared to be their orderliness and capacity to make a difference visible by orienting food and people along a single axis towards a focal point. The way in which staged events may serve to make a social relationship stand out by establishing a single focal point for the occasion is well illustrated in formal occasions of kava drinking. Thus, when a kava ritual in honour of Queen Mata'aho (the wife of the late king of Tonga, Topou Taufa'ahau IV) was staged on Kotu in 1992, escorting policemen of the Royal Guard enforced very strict taboos against any communication between those sitting in the kava circle and the villagers who were not in the circle, against smoking or indeed against doing anything indicating less than total commitment to the proceedings or a lack of concentration on the queen at the head of the circle. Being in the circle of kava drinkers myself, this was made very clear to me as I raised my camera in order to capture the moment. I was, in no uncertain terms, ordered by one of the policemen to desist immediately and to pay full attention to the queen. The queen never uttered a word during the ten minutes or so it took for the kava to be prepared and for her 'talking-

chief' (*mataapule*) to distribute it. As soon as the last one entitled to drink had emptied his cup, the queen retreated to the seclusion of the quarters prepared for her. Immediately, people relaxed: some took out their tobacco and lit their cigarettes, some left the circle and others joined it, some spoke to share a story with other kava drinkers, and some muted comments and exchanges between drinkers sitting next to one another could be heard. The atmosphere was by no means noisy or wild but the contrast to the ritual reality of one-dimensional orderliness enforced by strict taboos was quite dramatic.

This brings us to another fundamental characteristic of Tongan ritual presentations as staged events, the transformation from an ordinary state of affairs in which all kinds of circumstances, motivations and relationships are present, to an extraordinary state of affairs in which singular circumstances, singular motivations and singular relationships are fixed by strict rules of procedure and stand out for a moment. Thus on Kotu the process of staging food presentations was always characterized by a dynamics in which the qualities of the phase of 'presentation' stood out in stark contrast to the phases of 'preparation' that preceded it and 'distribution' that followed it. The phase of preparation in the form of cooking often lasted more than twelve hours. The phase of presentation seldom lasted more than thirty minutes, while the phase of distribution of leftovers lasted for a few hours. The phase of preparation was always characterized by unrestrained communication, shouting, loud music, joking and laughter, much sweat and dirt from working over cooking pots, fires and earth-ovens, and much eating 'on the go', as it were, of food considered particularly rich to compensate for energy lost through hard work. The phase of presentation was, in contrast, generally marked by a lack of communication between those sitting along the board of food and those who had been involved in the preparation; according to older informants, communication between people seated at the presentation and others standing or sitting in the vicinity was indeed 'taboo' (*tapu*). In fact, conversations among the participants were, for the time being, replaced by presentations of words from both the host (mostly excusing the poor quality of the presentation) and the representatives of the receivers (praising its quality and abundance). When the phase of presentation ended with the words of recognition by the highest-ranking participant seated at the front of the board of food, there was always much food left. As participants of the first seating withdrew, a second seating consisting of people who had helped in the preparations took over the scene. At the same time the board was dismantled and food was sent with important guests of the first seating to high-ranking kinsmen of the village and to the homes of people who had helped in the staging of the event. Again communication began to flow freely, with much joking and laughter, both at the board of

food and between those seated and those coming to carry off leftovers to their homes.

Such a contrast between an extraordinary and constrained, and an ordinary and an unrestrained state of affairs has received a great deal of attention in the Polynesian literature in the form of analyses of the opposition between the concepts of *tapu* and *noa* as a relationship between the sacred and the mundane aspects of existence. In the context of staged events of food and kava presentations in Tonga, however, it is clearly mostly the concept of 'orderly' or 'well proportioned' (*maau*) which is used in opposition to *noa/ noa'ia*, signifying 'haphazard', 'coincidental' or 'without plan or purpose'; these, as might be recalled, were the terms used by the old yam cultivator to describe an indifferent planting strategy which would fail to produce a well-proportioned and beautiful garden. The concept of *tapu,* on the other hand, signifying 'restriction', 'prohibition' or that which is 'forbidden',[4] is used by Tongans in opposition to the concepts of *fa'iteliha* and *'ataa,* signifying 'unrestrained' and 'open'; for instance, a man whose sister prepared the kava in any kind of kava-drinking event on Kotu would say that it was *tapu* for him because of existing constraints on intimacy in cross-sex sibling relationships.[5] When unrelated to the girl preparing the kava, on the other hand, people would describe themselves as (*fa'iteliha*) 'unrestrained' and the drinking event as (*'ataa*) 'open' to them. In my ethnography, then, *tapu,* rather than referring to a state of affairs, is something which operates to constrain conduct; it is a means to suppress the relevance of other potential modes of acting and thus to achieve orderliness and beauty.

Christianity has been extremely well established in Tonga since the first Methodist missionaries arrived at the beginning of the nineteenth century, and most cosmogonical and cosmological myths and tales of what people refer to as the 'dark times' (*taimi fakapo'uli*) before the coming of the 'light' (*maama*) (see also Toren 1995: 70) have been replaced by biblical stories. Still, frequent transformations from states of *noa* to states of *maau* through the staging of events of singular purpose clearly characterized local sociality on Kotu at the end of the twentieth century.

To my mind, the way such transformations between 'haphazard' and 'orderly' states of affairs were bound up with general, aesthetic appreciation and the way they articulated with fundamental concepts of growth and the everyday practices of cultivation, indicate that they may constitute cultural routines related to quite enduring worldview themes. It is beyond the scope of the current analysis to explore pre-Christian Polynesian beliefs in depth; however, a brief account of Alfred Gell's analyses of the relationship between pre-Christian Polynesian cosmogonical beliefs and characteristic material aesthetic expressions may be useful to anchor the aesthetics of Tongan food presentations in a wider cultural and historical context. In his

analysis of tattooing in *Wrapping in Images* (Gell 1993), his exploration of the relation between style and culture in *Art and Agency* (Gell 1998: 155–215), but most clearly in his exploration of the themes of closure and multiplication in *Cosmos and Society* (Gell 1995: 21–56), Gell argues for a strong relationship between material, aesthetic forms and what he calls a religious premise of immanence, saying that 'Polynesian cosmology is correlated with the religious attitude of immanence. The world is a space within the deity (the plenum of deity) that is kept apart through the preservation of difference' (Gell 1995: 50); and 'the effect of the philosophical attitude of immanence, just as is the case in India, is to place the whole weight of the religious system on the preservation of distinctions and boundaries. Where there is god in everything, the need to keep things apart is overwhelming ... Where boundaries are transgressed, annihilation follows' (ibid.: 36).

I think that Gell's perspective on the relationship between a philosophical attitude of immanence and a chronic struggle or ongoing practices to differentiate and separate through ritual action makes sense and constitutes a useful approach to understanding the aesthetics of Polynesian material expressions. As 'important/outstanding things' (*me'a mahu'inga*)[6], food presentations observed on Kotu were clearly things/events produced by constraining behaviour and bounding spaces, separating people and differentiating substances in order to bring into brief existence tableaux of extraordinary orderliness and beauty. Being ritual events as well as aesthetic artefacts, food presentations may fit with less resistance than most objects with Gell's understanding of art objects as things 'mediating social agency' (Gell, 1998: 7) within 'a system of action intended to change the world' (ibid.: 6). Being routinely staged at points of transition, tableaux of food are, more clearly than most artefacts or works of art, 'directed to alter the circumstances in which the experience of participants has hitherto been constituted' (Kapferer 2004: 51).[7] It is my argument that the aesthetic value of Tongan food presentations as artefacts on Kotu was based on the resonance between their composition and how valuable things were produced in numerous surrounding fields of experience – what Karl Mannheim has called 'experiential spaces' (Mannheim 1982: 191). It is also my contention that the aesthetic appreciation of food presentations as a transformation from an ordinary or everyday state of *noa'ia* (haphazardness) to a state of extraordinary *maau* (orderliness) was based on a shared conviction of living in a world where beauty and orderliness did not come about spontaneously but as a temporary result of considerable concerted effort.

Gell also argues, however, that 'the rapidity and enthusiasm with which the Polynesians accomplished their conversion to Christianity stemmed from their untold relief upon discovering that God was, after all, transcendent, not part of this world' (Gell 1998: 25). The enthusiasm with which

Kotu people, two hundred years after converting to Christianity, were pre-occupied precisely with differentiating, separating and creating well-proportioned and well-aimed tableaux of beauty indicates that this concerted effort to achieve protection against potentially destructive cosmic forces did not stop with conversion. Indeed, one of the most widely shared attitudes I have come across in Tonga is that inappropriate acts, be they in the form of 'sins' (*faihala*) or the breaking of taboos of 'respectful conduct' (*faka'apa'apa*), cause maladies by causing God to stop protecting the culprit from forces that are naturally bent on the destruction of humanity. Thus shark attacks are, without fail, accounted for in term of breaches causing God to let up the defences he has erected around people, and when something bad suddenly happens – like an untimely death or the birth of a disfigured child or an injury through accident – it is often accounted for as an *u'u* or 'shark's bite' caused by 'Nemesis' (Poltorak 2007).

A church minister from Kotu, with whom I spoke in 2011, explained the relationship between wrongdoings and God's protection by retelling the popular story of how Tonga became a Christian nation: 'When King Topou I had converted to Christianity in the mid-nineteenth century he picked up a Bible and placed some soil on it. Lifting the Bible with the soil towards the Heavens he said: "I give Tonga over to you with its 'soil' [*kelekele*] and its 'people' [*kakai*]!" From that day there has been a pact between Tongans and God that he shall "protect" [*le'ohi*] the Tongan people against harm as long as they abide by the rules of God and the rules of respect. Those who do not, God shall stop protecting, allowing "misfortune" [*mala'ia*] to strike.' Asked why God should care about breaches of taboos relating to respect towards, for instance, a sister or one's 'father's sister' (*mehekitanga*), he answered: 'When Topou I turned the land and the people of Tonga over to God, he turned it over with all that was in it, also the way of the land such as the obligation to respect the father's sister'. Thus, for him (as for most Tongans), acting in accordance with 'the way of respect' (*anga faka'apa'apa*) and in accordance with 'the Christian way' (*anga fakalotu*) amounted to one and the same thing.

It is my argument that a philosophy and attitude of immanence was never replaced by Christianity but thrives with Christianity in Tonga to constitute an important context around the frequent transformations from states of *noa'ia* to states of *maau,* from the haphazard to the well proportioned, through constraining/the constraints and constructions of tableaux of precedence. These staged events should not, I think, be seen as the mere reflections of a hierarchical social order, but as a part of an ongoing negotiation of the relationship between the world as it is and the world as it should be in order to constitute a society fit to live in. In the words of Eric Hirsch, from his analysis of the relationship between natural realities and a landscape paint-

ing, the one dimensional ranked beauty of a food presentation may perhaps be regarded as the momentary 'foregrounding' (Hirsch 1995) of what is mostly a 'background potentiality' of everyday sociality.

To others, less experienced as yam cultivators and also less enthusiastic about the 'way of respect' (*anga faka'apa'apa*) than my older Kotu informants, the foremost value of food presentations was perhaps the opportunity they offered to enjoy huge amounts of tasty food. Their staging offered entertaining interaction and particularly rich, sweet and colourful food. This constitutes a fourth and final characteristic of Tongan food presentations as staged events. For if a transformation from the haphazard to the well-ordered and constrained conduct and a logic of precedence constitute characteristics of Tongan food presentations, so obviously do abundance and entertainment that create a strong feeling of fulfilment, vitality and 'togetherness' through collaboration and commensality. There are, then, two basic aspects of Tongan food presentations: their visual beauty or orderliness and their sheer abundance, offering those who participate the opportunity to feast the eye as well as the taste buds on extraordinary amounts of extraordinary foods with a great variety of colours and tastes.

Moving Food Presentations Overseas

This edible artefact then, constitutes a characteristic part of the material repertoire that overseas-based Tongans work with to engage one another and to adapt to other circumstances and the perspectives of the diaspora. Scholars agree that such presentations remain important among overseas-based Tongans. Indeed, it is usual to hear that exchanges and presentations of 'Tongan wealth' (*koloa fakatonga*) and food are even more impressive among overseas-based Tongans than they are 'back home'. In their analysis of the commodification of Tongan wealth in diaspora, Ping-Ann Addo and Nico Besnier conclude that 'the demand for "wealth" is growing, for reasons ranging from the rising unpredictability of weddings to the increasing anxiety of diasporic Tongans about displaying their allegiance to "the Tongan way"' (Addo and Besnier 2008: 45). Thus in 2010 and 2011, when I went to spend five weeks among Tongan migrants in New Zealand who had originated on Kotu, I discussed with them how important and useful they found food and wealth presentations in their lives in New Zealand and how presentations were 'constructed' (*ngaohi*). I also participated in two occasions at which the presentation of food constituted an important element: a wedding (*fai mali*) and a first birthday (*fai'aho*).[8] In order to make comparison possible, I chose to organize the exploration around the four characteristics of food presentations I had observed in a village setting in Tonga: (1) the distribu-

tion of knowledge/competence and the role of leadership in the construction of boards of food; (2) the compositional form of the presentation as a tableau of precedence; (3) the dynamics of transformation from a haphazard (*noa*) *to* a well-proportioned (*maau*) state; and (4) the relative significance of the two aspects of orderliness and abundance.

With regard to the question of knowledge/competence and leadership there was no indication that something resembling a 'placing master' plays a part in the 'building of boards of food' in New Zealand. A discussion with Sione, a man in his late forties who moved overseas in the late 1980s, illuminates this. Sione recalled the role of 'the one who places on the board' from Tonga but said that such leadership was not practised in New Zealand. He felt that access to expertise about how to go about the differentiation is very limited in New Zealand, as is the frequency of peoples' first-hand experience with building food presentations. He was clearly familiar with an aesthetics based on a principle of precedence, and remembered the practice of orienting the yam on the board with its 'head to the front' (*'ulu ki mu'a*) in accordance with the unequal distribution of the seed yam's capacity for growth. He felt, however, that these are notions that few can now relate to and that are totally foreign to his own four grown children and other New Zealand-born Tongans. He did feel, however, that a proper food presentation should always contain pig and, if possible, also yam, and that the pig's head should always point to the frontal end of the board. In his experience, people making a food presentation put an emphasis on impressing everyone with an abundance of all kinds of ingredients and they tended to throw in anything according to their own whims and fancies. With regard to compositional form he felt that rather than ranked differentiation people would emphasize an even distribution of choice ingredients so that everybody would be happy.

Tevita, a man in his seventies who settled in Auckland in the late sixties, said: 'The presentation of boards of food is quite common also among Tongans in New Zealand, but they are not really important to people born and raised over here'. He also described the construction of food presentations 'over here' as more 'haphazard' (*noa'ia pe*) and said that it seldom involved the leadership of a 'placing master'. For him, the decreased significance of expertise in 'the way of respect' in the construction of food presentations was an inescapable fact of life in the diaspora. He was disinclined to try to remedy this by passing on knowledge about it to his grown-up New Zealand-born children. On the contrary, he would, according to his children, very quickly feel provoked if they 'pestered' him with questions about such things. Tevita on his part felt that it goes against the grain of precisely the 'Tongan way of respect' to be questioned by one's children on this or any other matter.

My own observations among Tongans in New Zealand certainly confirmed a lack of clear coordination on how food was placed on the board through anything resembling the expertise of a 'placing master'. They also indicated a relatively weaker emphasis on building an aesthetics of precedence into the board of food. In particular, root crops did not appear to play a significant role in such differentiation at all. Additionally, and most strikingly, the food presentations observed were characterized by a much weaker accentuation of a contrast between, on the one hand, haphazard and unrestrained, and on the other, orderly and restrained phases. However, observations clearly confirmed a very strong emphasis on abundance.

In a food presentation at a wedding between two Tongans in Auckland in 2010, food of all kinds appeared to be evenly distributed along a table seating about seventy people. The stacks of paper plates and plastic cups containing a very wide variety of dishes, and the heaps of fresh fruits, were equally high along the length of the table as guests took their seats. Seating was free, and about half of those participating in the celebration sat in the first seating along the board of food. The food presentation was already several layers deep when the meats and root crops, cooked in an earth-oven in another part of town, were brought in to be placed on the board along which the guests were already seated. A handful of those helping out in the kitchen moved back and forth along the board looking for ways to place plates with meats and pieces of root crops without toppling the towers of dishes balancing precariously on the board. The family who were celebrating the wedding were Baptists. Therefore the food presentation did not include any pig's meat, and none of the ingredients on the board were used to visualize any particular order of precedence. Eating commenced when the minister had said grace, which invariably starts any Tongan meal.

Conversations both among those seated at the board and between people seated and standing or sitting in the vicinity were flowing, uninterrupted by the few speeches made during the meal. After a while the people who served supplemented the mounds of food at the board with mountains of sweet and colourful cakes and ice cream. When people of the first sitting were full, some left their places for others, who sat down to eat from the towers of dishes still remaining on the table.

At a food presentation in Hamilton in 2011 for the first birthday of a first-born daughter, there were about 300 guests, 175 of them seated at the ten tables on which the food was presented. In contrast to the food presentation at the wedding, an order of precedence was indicated by the orientation of whole roasted piglets on each of the tables. No root crops, however, were used to structure the boards of food. The prominence of the high table, seating high-ranking relatives of the child as well as the church minister, was marked both by heaps of Tongan wealth in the form of bark-cloth, pan-

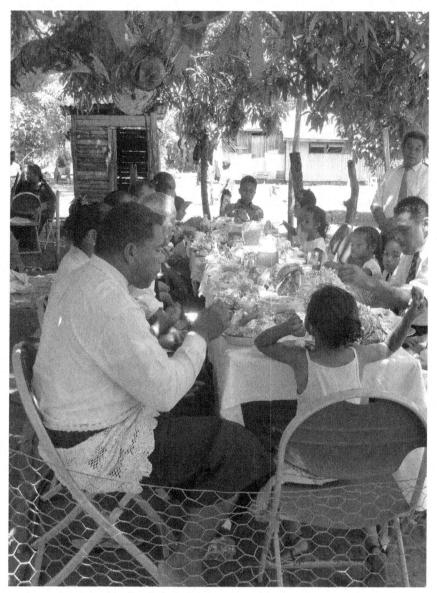

Figure 6.1. Phase of formal eating in food presentation on Kotu Island in Tonga 2011. Photograph courtesy Arne Aleksej Perminow.

danus mats and other fabrics, and by an imposing three-tier birthday cake located beyond its frontal end. Most of all, however, it was marked by the fact that the high table was generally more abundant than the other tables, particularly with regard to pig's meat. Thus the pig-to-person ratio was 1:4

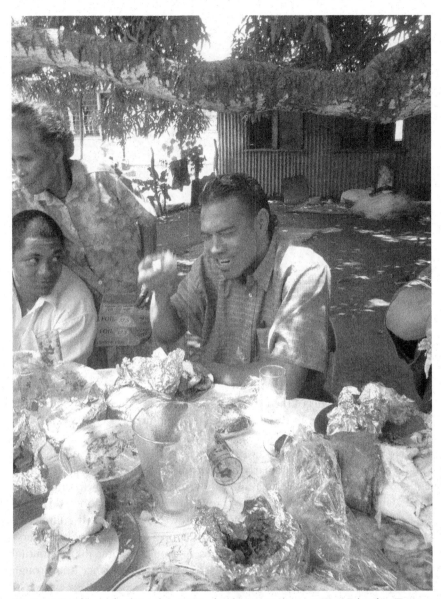

Figure 6.2. Phase of informal eating in food presentation on Kotu Island in Tonga 2011. Photograph courtesy Arne Aleksej Perminow.

at the high table, 1:8 on the table leading up to it and only 1:16 on the eight surrounding tables.

Like the food presentation at the wedding, there was much conversation at each table, between tables and between those seated at tables and those

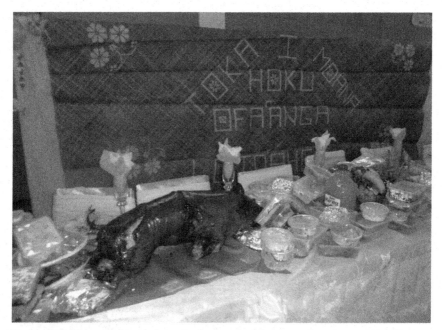

Figure 6.3. Pigs pointing the way in the heaps of food moving overseas at a Tongan food presentation in Hamilton, New Zealand, to mark a first birthday in 2011. Photograph courtesy Arne Aleksej Perminow.

seated along the walls of the room or moving about. There was much music and laughter throughout the staging of the event, no clear contrast between the first and second sittings, and a general fuzziness between the phases of preparation, presentation and distribution of food. Thus, no phase or moment stood out as particularly momentous, solemn or orderly. Rather, a collaborative effort, of cooking and preparing the food and decorating the tables, climaxed in the sharing of extraordinary amounts of food and a loud and joyful distribution of huge amounts of 'wealth' (*koloa*). It culminated with the distribution of food leftovers in the form of an invitation to everyone to help themselves from the food presentation. Laughter, joking, mutual goodwill, extravagant generosity and extraordinary abundance ran through all the phases of the occasion.

Starting out I claimed that food presentations occur at a wide variety of occasions that also vary in their degree of formality. Thus food presentations may be dressed up or down to fit the occasion. Clearly, food and wealth presentations are a part of ritual proceedings that may differ considerably in overall tone and communicative style. Still, I believe that contrasts indicated by the findings of this preliminary comparison indicate some important trends of transformation that are well worth further investigation.

First of all, the findings clearly indicate a much lower reliance on the expertise of the elders and a weaker emphasis on 'the traditional way of respect' or the *anga faka'apa'apa*. This may be due to a combination of factors: a scarcity of knowledgeable elders in the diaspora; a general decrease in the relevance of their knowledge and competence in a different cultural environment; and, finally, an unwillingness of those who have the knowledge and competence of how to build a food presentation to part with that knowledge outside of the context of its building. Thus it may be difficult for junior kin who want to actively seek and acquire knowledge and competence from their seniors to do so without being considered forward or disrespectful.

Secondly, the findings clearly indicate a weaker emphasis on building precedence into the physical object of the board of food. In particular, the 'chiefly *kahokaho* yam' appears to play no role at all in the diaspora in visualizing a principle of precedence. To the extent that precedence is visualized through the orientation of ingredients on the board it is the pig that does it. More than anything, however, the visualization of differences in rank or social importance appears to be a matter of relative abundance – that is, it is carried not by differences in quality but first of all by differences in the quantity of both pork and other ingredients. The diminishing structuring role of the chiefly yam is no doubt partly caused by its scarcity in New Zealand, but it is also the result of a weaker emphasis on 'the way of respect' and the scarcity of knowledge and competence linked to the role of knowledgeable elders in the construction of the boards of food. Finally, it is probably also related to the lack of practical engagement with farming in general and yam cultivation in particular among those who collaborate to build food presentations overseas. For New Zealand-born Tongans, neither the presence of the chiefly yam nor its orientation on the board of food can be intuitively beautiful or obviously appropriate through articulation or resonance with their experiences with it beyond the context of the occasion at hand. This may be a transformation of the kind that Nathal Dessing has in mind when she argues that a reduction of ritual redundancy may be a common characteristic of transformations of rituals on the move.

Thirdly, the findings indicate that food presentations among Tongan migrants, far less strikingly than those observed in Tonga, involve a transformation where strict restraints on conduct make one phase stand out as a momentary space of one dimensional orderly sociality. This finding may be a product of the fact that the number of food presentations that I observed in New Zealand was limited; to some extent, however, it may reflect the fact that the spaces of sociality created in food presentations among overseas Tongans are surrounded by everyday spaces of sociality that do not involve frequent, habituated transformations of the same kind.

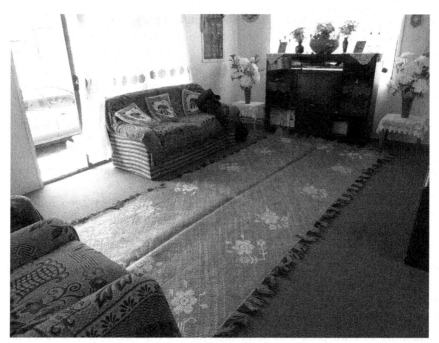

Figure 6.4. A Tongan living room in Auckland, 2010, furnished for formal exchange. Photograph courtesy Arne Aleksej Perminow.

A final case from an everyday life setting may illuminate this. As I entered Paula and Lani's house in Manurewa on the outskirts of Auckland in 2011, I immediately noticed that something had changed: they had rearranged the living room. During my visit in 2010, the furniture stood along the walls of the living room, leaving a wide, open space between chairs and sofas facing one another, and there was a television cabinet on the fourth wall. Since then they had bought a low table and arranged the two sofas and the chairs close together in a group around it, in front of the television. That evening, as I was sitting on the sofa with Paula and his cousin, I felt quite a bit more at ease and comfortable than on previous visits, and the conversation flowed much more freely. The arrangement appeared to foster a more intimate atmosphere, another mode of communication. It struck me how the arrangement of furniture they had before is the conventional one in Tonga; in Tonga, a chair is routinely placed with its back to the wall, next to or close to the entrance, and visitors are invited to sit in it. The host sits on a chair separated from the visitor's chair by an open and often quite wide space. The wideness of this space between the interlocutors appears to go with a clear spacing of utterances in the form of pauses between statements and responses between guest and host. Thus the arrangement appears quite well suited for

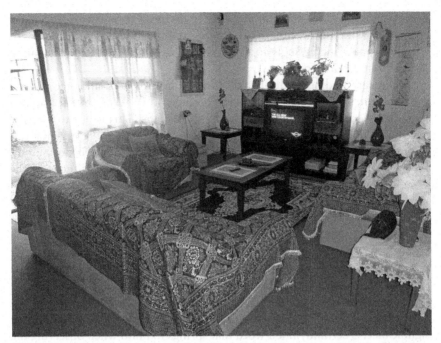

Figure 6.5. The same living room in 2011, furnished for informality. Photograph courtesy Arne Aleksej Perminow.

exchanges in the form of presentations and formal greetings or news, but less well suited for free-flowing conversation. The Tongan expression, *tauhi vaha'a,* which has recently been used by several scholars of Tongan culture to approach Tongan sociality, may illuminate this characteristic style of communication. The expression means, literally, 'nurture/care for the space between' and has been used by scholars to approach the significance of reciprocity and networking in the reproduction of Tongan kin relations (see Ka'ili 2005; Young-Leslie 2007; Poltorak 2007; and Thaman 2008). It also, however, clearly refers to a particular mode of appearing/behaving in public which does not intrude on the space that separates people – that is, acting with decorum and respect. Thus, for some of my Tongan informants, *tauhi vaha'a* was not primarily what you did to feed a kin relationship but what you refrained from doing out of respect or compassion. In this sense, some would translate it as 'to keep the peace' in public interaction. Contrasting the communicative style of kava drinking in kava clubs in Auckland with informal sessions of kava drinking in a Tongan village setting, the Tongan linguist, Mele Taumoefolau, claimed that in the latter situation *tauhi vaha'a* or 'caring for the space which separates the drinkers' is so strong it is almost tangible. It is possible that a general reduction of emphasis on this kind of

decorum in everyday experiential spaces of diaspora sociality tends to make the way in which separation may be made tangible in staged ritual spaces of sociality appear increasingly foreign to overseas-based and, in particular, to New Zealand-born Tongans.

Finally, my findings indicate that the significance of abundance in food presentation, both in terms of sheer volume and in terms of variation of ingredients, has increased among overseas Tongans. This is not to say that abundance does not constitute a very important aspect of food presentations in Tonga, for clearly it does and probably always has done. It does imply, however, that the sheer amount of what is presented carries more of the weight, so to speak, of the ritual occasion in the Tongan diaspora. Clearly, moving boards of food overseas has affected the relevance of experts' knowledge and the competence of ritual actors; also, changed conditions of resonance between what goes on in rituals and what goes on in surrounding spaces of sociality may have affected what Dessing has labelled 'ritual re-dundancy'. Moving ritual to new settings may very well change its form as well as its resonance with everyday surroundings. That such changes involve what Dessing has called 'ritual attrition', however, is far from clear. Attri-tion, with its connotations to something decreasing in size and declining in significance, is certainly not a word that springs to mind when observing the collaborative energy and the impressive quantities of wealth and food that are brought together from near and far, and distributed and consumed with immense joy, by overseas-based Tongans. Probably, the possibilities that such an impressive mustering of people, wealth and food offers to demon-strate or achieve social success and a sense of common 'Tonganness' abroad are far more attractive to overseas Tongans than their capacity to visualize precedence and naturalize hierarchy.

Notes

1. According to some informants, *ngaohi* is the more 'correct term', while for Churchward (1959: 382) *ngaahi* and *ngaohi* are lexical variants that both sig-nify 'to make'.
2. Literally, the term signifies 'wanting to appear *poto*' or competent, but is always used to question or criticize claims to competence. For analyses of the signifi-cance of *poto* as a central cultural value in Tongan socialization and notions of seniority, and a related sensitivity to issues of claims to competence, see Morton 1996: 156–74.
3. *Tupu* signifies both growth/to grow, and origin/to originate, and is used for plants, animals and people.
4. *Tapu* clearly also signifies 'sacred' or 'holy', and the Tongan term 'Bible' or 'The Holy Book' is *Tohi Tapu*. It also serves as a standard introduction in any formal

public speech, known as *fakataputapu,* intended to excuse oneself or apologize for disturbing or intruding on persons of rank and respectability by standing up to speak in their presence.

5. Such constraints are referred to as the brother–sister taboo in the literature of Western Polynesia, and on Kotu in the 1990s they clearly still operated quite strongly to reduce intimacy in cross-sex sibling interaction, particularly with regard to behavioural or linguistic expressions of sexuality, hunger and anger (see Perminow 1993).

6. *Mahu'inga* is conventionally translated as 'important, valuable, precious' (Churchward 1959: 318). It is formed by the verbal core *mahu'i* signifying 'to become detached by force, torn loose, to become forcefully separated' (ibid.: 318) and the noun-forming suffix *-nga,* signifying 'basis, cause for', making 'outstanding' an alternative and perhaps more idiomatic translation.

7. Kapferer formulated this to identify an emphasis on transformative capacity or agency in certain ritual events, distinguished as 'rites that are not so much concerned with presenting the nature of apparent reality (varieties of public and formal ceremonial, rites of commemoration, parades, festivals) as with entering directly within the forces of their production, construction, and reinventions' (Kapferer 2004: 51).

8. *Fai'aho* may refer to the celebration of birthdays in general, which over the last decades have, among some Tongans, become annual events. For most people, however, *fai'aho* is still understood to refer to the more traditional celebration of a person's first and 21st birthdays.

References

Addo, P.A., and N. Besnier. 2008. 'When Gifts become Commodities: Pawnshops, Valuables, and Shame in Tonga and the Tongan Diaspora', *Journal of the Royal Anthropological Institute (N.S.)* 14: 39–59.

Bennardo, G. 2009 *Language, Space, and Social Relationships: A Foundational cultural Model in Polynesia.* Cambridge: Cambridge University Press.

Besnier, N. 2009. 'Modernity, Cosmopolitanism, and the Emergence of Middle Classes in Tonga', *The Contemporary Pacific* 21(2): 215–62.

Churchward, C.M. 1959. *Tongan Dictionary.* Nuku'alofa: The Government of Tonga Printing Press.

Dessing, N.M. 2001. *Rituals of Birth, Circumcision, Marriage, and Death among Muslims in the Netherlands.* Leuven: Peeters.

Døving, C.A. 2009. 'Migration – Ritual Attrition or Increased Flexibility? A Case Study of Pakistani Funerals in Norway', in A. Kahn (ed.), *Pakistani Diasporas: Culture, Conflict, and Change.* Oxford: Oxford University Press.

Dumont, L. 1982. 'On Value' (Radcliffe-Brown Lecture 1980). *Proceedings of the British Academy,* LXVI: 207–41.

Gell, A. 1993. *Wrapping in Images: Tatooing in Polynesia.* Clarendon Press, Oxford.

———. 1995. 'Closure and Multiplication: An Essay on Polynesian Cosmology and

Ritual', in Daniel DeCoppet and Andre Ineanu (eds), *Cosmos and Society in Oceania*. Oxford: Berg, pp. 21–56.

———. 1998. *Art and Agency: An Anthropological Theory*. Oxford: Clarendon Press.

Grijp, P. van der. 1993. *Islanders of the South: Production, Kinship and Ideology in the Polynesian Kingdom of Tonga*. Leiden: KITLV Press.

Hirsch, E. 1995. 'Introduction: Landscape between Space and Place', in E. Hirsch and M. O'Hanlon (eds), *The Anthropology of Landscape: Perspectives on Place and Space*. Oxford: Clarendon Press, pp. 1–30.

Ingold, T. 2000. *The Perception of the Environment: Essays in Livelihood, Dwelling, and Skill*. London: Routledge.

Ka'ili, T. 2005. 'Tauhi Vaa: Nurturing Tongan Socio-spatial Ties in Maui and Beyond', *The Contemporary Pacific* 17(1): 86–105.

Kapferer, B. 2004. 'Ritual Dynamics and Virtual Practice: Beyond Representation and Meaning', in Don Handleman (ed.), *Social Analysis* 48(2): 35–51.

Mannheim, K. 1982. *Structures of Thinking*. London: Routledge & Kegan Paul.

Morton, H. 1996. *Becoming Tongan: An Ethnography of Childhood*. Honolulu: University of Hawai'i Press.

Perminow, A.A. 1993 *The Long Way Home. Dilemmas of Everyday Life in a Tongan Village*. Oslo: Scandinavian University Press.

———. 1996. 'Moving Things of Love: An Ethnography of Constitutive Motions on Kotu Island in Tonga', Ph.D. dissertation. Oslo: University of Oslo.

———. 2001. 'Captain Cook and the Roots of Precedence in Tonga: "Leading" and "Following" as Naturalised Concepts', *History and Anthropology* 12(3): 289–314.

———. 2011. '"It is a Tree that Fights": Engaging Notions of Qualitative Difference in Tonga', in I. Hoëm and R. Solsvik (eds), *Identity Matters: Movement and Place*. Occasional Papers, Volume 12. Oslo: Kon Tiki Museum, pp. 111–23.

Poltorak, M. 2007. 'Nemesis, Speaking, and Tauhi Vaha'a: Interdisciplinarity and the Truth of "Mental Illness" in Vava'u Tonga', *Contemporary Pacific* 19(1): 1–36.

Thaman, K.H. 2008. 'Nurturing Relationships and Honouring Responsibilities: A Pacific Perspective', *International Review of Education* 54: 459–73.

Thomas, J. 1825–67. *Journals (1825–59)*. Mitchell Library Microfilms FM 4/1439 (MMS 48). Sydney: Library of New South Wales.

Toren, C. 1995. 'Cosmogonic Aspects of Desire and Compassion in Fiji', in D. DeCoppet and A. Ineanu (eds), *Cosmos and Society in Oceania*. Oxford: Berg.

Young-Leslie, H.E. 2007. '…Like A Mat Being Woven', *Pacific Arts* 3–5: 115–27.

7

IMAGINATIONS AT WAR
THE EPHEMERAL AND THE FULLNESS OF LIFE IN SOUTHWEST CHINA

Katherine Swancutt

The imagination is often believed to be the engine of invention, triggering unpredictable, fortuitous or even 'chaotic' life experiences. Not only does the imagination frequently draw people, things and other beings into the same shared 'space of indeterminacy in social and cultural life' (Sneath, Holbraad and Pedersen 2009: 24). But when faced with the 'essentially un-predictable and often quite unintended' force of someone else's imagination, the person typically has little other recourse than to respond imaginatively to it (ibid.: 22). It is, of course, no easy feat to envisage someone else's im-aginative thoughts or behaviours. Yet, in this chapter, I offer ethnographic materials which show that the task does become easier where people down-play, capture or even altogether block the imaginative potential of others.

Taking up the editors' focus on 'vision and truth', I argue that there is an often-overlooked ontological slippage between these phenomena. My argument is grounded on my anthropological fieldwork among the Nuosu of Southwest China – a Tibeto-Burman highlands group also known by the Chinese ethnonym of 'Yi' – who regularly pit their imaginations against those of devious ghosts in exorcisms carried out as ritualistic warfare. Nuosu rites offer a novel window onto the recent turn to 'materiality' in anthropol-ogy, which stresses that people build actual, substantive relations with other people, beings, 'objects' or even 'things', rather than mere 'representations'

of those relations in their minds (Miller 2005: 5–6, see also 31; Henare, Hol-braad and Wastell 2007: 8–10). Significantly, the anthropological literature on materiality emphasizes that objects/things can draw people unwittingly into relations with them. The idea is that objects/things (like people) have their own agency and subjectivity. Occasionally, objects are even attributed the stature of 'thingness', which entails them being '*concepts* as much as they appear to us as "material" or "physical" entities' (Henare, Holbraad and Wastell 2007: 13). It follows that objects should not be viewed, by default, as mere signs or tokens of whoever produced, owned or otherwise came to be associated with them. This literature has made great strides in anthro-pology and, broadly speaking, it usefully articulates the agency of a wide order of things. Yet the Nuosu ethnography – which has also captured my imagination – forces me to ask what happens when Nuosu actively want to think through representations, to ensure they do not unwittingly (or imagi-natively!) forge unwanted relations to other beings, such as devious ghosts?

I have described exactly this kind of scenario among Buryat Mongol shamans, who regularly hold private divination sessions to confirm whether an inquirer has been harmed by rival shamans, dangerous spirits or other hostile forces (Swancutt 2012a: 2–8). One important premise of Buryat div-inations is that shamans must carefully control their divinatory implements, such as a simple deck of playing cards, to ensure they merely represent their rivals. Sometimes, though, shamans fail to control the implements. Buryats say that when this happens, rival shamans may seize the opportunity to 'hijack' the implements, imbuing them with their presence and power so as to gain invisible entrance to the divinatory purview (ibid.: 81–91; see also 158–72 and 183–86). Using the implements as a platform for secret attacks, rival shamans may thus sabotage the divination by eavesdropping on questions, distorting the divinatory pronouncements, cursing the divin-ing shaman and his or her inquirers, or even stealing their souls. The Buryat rival who hijacks a divinatory implement, then, effectively transforms it into a material conduit for his or her own presence and power, in line with Gell's (1998: 19–21) theory on objects that carry the agency of people within them. From the Buryat point of view, this is a risky situation that is best avoided by ensuring that the divinatory implements can be nothing more than representations of the people, beings, objects or things they are meant to reveal. Similar concerns about hijacking ritual objects pervade Nuosu exorcisms, where both ordinary shamans (*suni*) and the priests I have called 'text-reading shamans' (*bimo*) make effigies of the devious ghosts they wish to expel from the home (Swancutt 2012b and 2012c). Nuosu make most of their effigies from freshly gathered plants, twisting or plaiting them into the shapes of 'grass ghosts' (see figure 7.1). They also make 'ghost board' effigies from flat wooden stakes that they decorate with ghostly features, using the blood of sacrificial animals or charcoal (see figure 7.2).

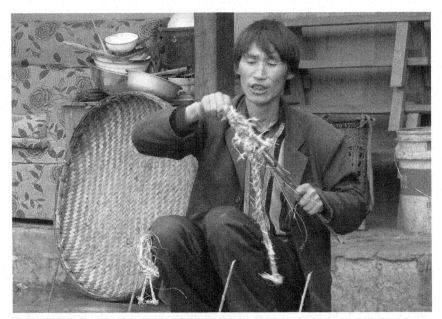

Figure 7.1. Nuosu priest (*bimo*) twisting plants into the shape of a grass ghost effigy. October 2011. Courtesy of Katherine Swancutt.

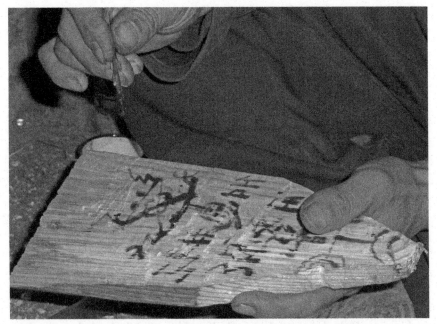

Figure 7.2. Nuosu priest (*bimo*) painting ghostly patterns onto a ghost board effigy, using a twig and the blood of a sacrificial chicken. October 2011. Courtesy of Katherine Swancutt.

Both grass ghost and ghost board effigies are meant to bear an attractive 'resemblance' to actual ghosts, enticing them to enter the ritual space of an exorcism, from which the shaman or priest can expel them from the home. Certain rites even require that Nuosu use plants to make effigies of the homes or jails that ghosts are meant to be trapped within (Swancutt 2012b: 68). Usually the officiating shaman or priest is assisted by laypersons (most often men) in collecting fresh plants and crafting the effigies, so that some knowledge of their production is acquired by non-specialists.

Revealingly, Nuosu liken their effigies to 'representations' or 'symbols' (Chinese: *daibiao*), which are explicitly meant to 'lure' (*yingyou*) ghosts into the ritual purview so that they can be exorcised from the home. Nuosu make effigies irresistible to ghosts by daubing them with raw flesh and the blood of sacrificial animals – which as they point out, is definitely not a mere representation, but a real sacrificial meal (more on the significance of this below). They also attach choice raw organs to effigies, such as the sacrificed animal's kidneys. The combined lure of the effigies and sacrificial flesh may be enhanced by adding live chickens to the mix, which Nuosu priests tie by the legs with rope and suspend in an upside-down position, just above the effigies. Bound chickens appear like potential ghostly meals, but even they are mere decoys used to signal the arrival of ghosts. Ghosts may be further enticed to the effigies with offerings of alcohol, which is typically rice wine (*baijiu*) but may also be beer. Additionally, ghosts may be given some cooked sacrificial meat or fat, boiled eggs, buckwheat bread, porridge, biscuits, sweets, carbonated fruit drinks or anything else that might appeal to their appetites. However, despite these elaborate techniques for luring ghosts to their own exorcism, Nuosu risk succumbing to the reprisals of ghosts who manage to remain within the home, having imbued the effigies with their presence and power. For like the rival Buryat shamans described above, Nuosu ghosts are capable of putting into practice Gell's (1998: 19–21) theory on agency, by transforming the effigies from mere representations into platforms for ghostly counter-attacks.

To safeguard against these ghostly reprisals, Nuosu priests and shamans punctuate their exorcisms with the continuous chanting of 'speech bullets' (*ddop ma*). They also deploy other dramatic tactics of ritualized warfare, like attacking ghosts with shotguns, dynamite, fireworks, hot coals and live flames, or scalding them with water spat against iron ploughshares heated in the household fire until they glow red. Nuosu say that bombarding ghosts with weaponry expels them from the home and prevents them from transforming the effigies into anything more than representations. I note also that Nuosu use forms of artillery that combust into nothing, leaving minimal residue to which ghosts might attach themselves. Similarly, their grass ghost effigies wilt rapidly during an exorcism, shrinking into a nearly residue-free

form. Furthermore, at the close of an exorcism, Nuosu priests and shamans always take the final precaution of binding together any effigies not yet destroyed in the rite with a long thin rope, whilst chanting speech bullets over them. These bound-up effigies are taken outdoors (often into the surrounding forest), where they continue to act as lures for ghosts at a safe distance from the home, until they fully decay with the passing of time. Through their relentless attacking of ghosts, Nuosu leave little scope for any ontological slippage to occur between viewing representations of ghosts and building unwanted relations to them.

Many Nuosu friends took the initiative to reassure me in a clear manner – using logic that is surely at odds with the materialist stance fashionable in anthropology today – that their effigies are just representations. They used the Chinese term *daibiao* to get the message across, but agreed (when I asked) that the Nuosu language equivalent of *sat* also captured their meaning. At first, I wondered if my friends were bandying around this dated sense of the anthropological term, which I assumed had been popularized through Chinese discourse on 'ethnic minority culture' (*minzu wenhua*), to deflect any suspicions that their exorcisms might entail some degree of illegal 'superstition' (*mixin*). It did not take long, though, before I realized that I had been overthinking things and that they were speaking entirely literally. Nuosu explicitly wanted their grass ghost or ghost board effigies to be simply representations. Their views resonate with those of the Nuosu anthropologist Bamo Ayi, whose fieldwork in Sichuan allowed her to occasionally act as an 'apprentice' to a famous Nuosu priest, and who observes that 'ghosts are formless, so using tied bundles of straw to give them form not only gives the ritual to expel them a visible result but, more importantly, has a psychologically reassuring effect' (Bamo Ayi 2007: 83). I attended numerous exorcisms in 2007 and 2011, while living in two different Nuosu villages in Ninglang throughout autumn and winter, which are the high seasons for Nuosu rites. Every exorcism I observed required that priests or shamans lure ghosts to the effigies, whilst bombarding them with the non-stop chanting of speech bullets and other ritual weaponry. As the exorcisms unfolded, these ritual specialists and the laypersons attending them instructed me that the point of the rites is to expel ghosts from the home – a task that vitally depends on luring them into the ritual purview and attacking them, so that they cannot attach any unwanted ghostly agency to the effigies, the household or other material items.

At this point, I wish to propose several reasons for why concerns about the hijackings of ritual objects are central to the study of materiality, objects and the imagination. First, these hijackings flag up situations where people, such as those Nuosu involved in exorcisms, actively wish to reduce their rivals to representations, as a form of protective magic. Second, the hijackings

throw into relief a key tactic of imaginative warfare, namely what Ingold (1997: 119) – drawing on Gould and Vrba (1982) – calls 'the "exaptative" relationship between technology and culture', where someone (such as a Nuosu ghost) co-opts a technology (i.e. an effigy) originally intended for a different purpose (like luring the ghost into close range for an exorcism; Sneath, Holbraad and Pedersen 2009: 22). Third, the hijackings reveal penetrating insights into the fluctuating ontological qualities of objects and the imaginative responses people have to them. Nuosu, for instance, benefit from using the natural life cycles of plants that gradually wither – or of artillery that combusts into nothing – for the purpose of preventing ghosts from transforming effigies into vessels of ghostly agency. Since shrinking plants, dying flames, chanted words and clouds of gunpowder leave behind little residue for even ghosts to get their hands on, they are the ideally 'a-material' weaponry for evading counter-attacks. What ephemeral effigies and forms of artillery offer, then, is a sure means of preventing ghosts from maintaining their presence in the household and depleting it of the fullness of life. As I will show, these inventive precautions underpin Nuosu ritualized warfare, where ghosts may at any time open up the haunted 'space of indeterminacy in social and cultural life' that Sneath, Holbraad and Pedersen dub 'the place of the imagination' (2009: 24).

Let me be clear by saying that Nuosu do more than merely fantasize about warfare with ghosts. My argument is more extreme, namely that Nuosu undertake ritualistic warfare against ghosts which they consider to be devious, highly imaginative and fully capable of derailing an exorcism. To win these battles, Nuosu produce ephemeral effigies from freshly harvested plants that attract ghosts even as the plants wither on the vine. Other weapons in their artillery – such as the aforementioned gunshots, fireworks, dynamite, hot coals, live flames, and water that vaporizes into steam when spat against red-hot iron ploughshares – produce smokescreens that, to the chagrin of ghosts, obscure the ritual procedure just moments before combusting or evaporating. Even the speech bullets chanted by Nuosu priests and shamans are ephemeral weapons, dispersing at the very moments they are released from the practitioner's lips.

Given this, Nuosu battles with ghosts unfold within the purview of what Sneath, Holbraad and Pedersen call 'the emergent quality of the imagination', where the very real tactics of using lures, decoys and explosive weaponry that obscures the ritual procedure are needed because no victory is guaranteed and 'the unconditioned emerge as such' (2009: 26). And yet, as I will show, there is scope for Nuosu to craft these same battles. It is common to find Nuosu fearlessly (and even smugly) twisting plant effigies into evocative ghostly shapes, unleashing volleys of heavy artillery right across their household thresholds, and occasionally even risking financial ruin by

sacrificing their last head of livestock – all in the effort to mould the other-
wise 'unconditioned' battle against ghosts into their preferred format (ibid.).
By carrying out surprise attacks that prevent ghosts from retaliating, Nuosu
retain control over their exorcisms and ensure that the welfare of their
households remains 'of immediate concern to the punters themselves' (ibid.).

Furthermore, and in dialogue with the editors of this volume, I propose
that Nuosu battlefield reflexes guide the emergent quality of their imagi-
nations. In one sense, then, my Nuosu ethnography echoes Fuglerud and
Wainwright's observation in the Introduction to the present volume that
'there is a pact of sorts, or at least an apparent complementarity between
vision and truth, which lends visual representation the semblance of "given-
ness" or "facticity"'. The editors have used this turn of phrase to tackle the
history of representation in Western thought, stereotypes, museum displays
and collections. Yet my ethnography of Nuosu ritualized warfare also of-
fers another angle onto this link between vision and truth, since effigies,
sacrificial flesh and blood, or chicken decoys may undergo some degree
of ontological slippage from being visual representations of ghosts to be-
coming true vessels of unwanted ghostly agency. Ontological slippages
like these raise the question: 'How far could the link between vision and
truth influence the emergent quality of the Nuosu (or perhaps any other)
imagination?'

One key to answering this question is recalling that ghosts are a perpetual
problem in Nuosu terrain because they cannot be killed, but merely expelled
from the home. Unlike the ephemeral effigies that are only kept temporarily
in the home during rituals, ghosts are endemic in Nuosu villages and house-
holds. The best a Nuosu person can do is to shoo ghosts out of the home
for a finite length of time. Exorcisms, though, are complicated by the ghosts'
ability to 'slip' out of visual focus (and hence out of firing range) during an
exorcism, and stealthily imbue the effigies with their agency. Paradoxically,
this power of Nuosu ghosts stems from the fact that they have more 'materi-
ality' than the effigies which merely bear their likeness. Not only are ghosts
endemic in the landscape, but they manage to eat sacrificial flesh, blood,
and other food offerings. By contrast, the effigies steadily wilt, combust, or
evaporate over time. Yet ghosts may also evidence an 'erratically immaterial'
behaviour, by flitting in and out of the perceptual field of human vision, even
for the shamans who can see them. As one Nuosu shaman (*suni*) I knew
attested, ghosts look like shadows (Chinese: *yingzi*), shades or mere silhou-
ettes of human outline. Ultimately, then, ghosts must be brought into one
visual focus – and corralled into one specific locale – to be battled effectively
and expelled from the home. This is why 'virtuoso' priests or shamans en-
sure that effigies possess the ontological status of lures or bait, and for only
a limited length of time, before discarding them in the surrounding forest

(Swancutt 2007). Masterful practitioners summon ghosts into the ritual purview with attractive offerings, but prevent them from claiming the effigies as material vessels of ghostly agency. They keep alert for the moments when ghosts might sabotage the ritual by hijacking the effigies, knocking them down, or simply refusing to enter the ritual purview. Tellingly, Nuosu trace every difficulty in completing an exorcism to the imaginative methods that ghosts use for evading expulsion. Priests and shamans thus work to unleash doubly imaginative assemblages of battlefield techniques that disorient ghosts enough to expel them from the home. What Nuosu ritualistic warfare essentially unleashes, then, is a competition between humans and ghosts at controlling – on a moment-by-moment basis – the ontological status of their would-be 'symbolic' effigies that are daubed with 'sacrificial' offerings.

This competition between people and ghosts sheds significant light on how Nuosu conceive of the relationship between vision, truth and the imagination. Further insights can be gained into the Nuosu views on vision, truth and the imagination when juxtaposing them against Taussig's famous study on the 'magic of mimesis' among the Cuna of Panama and Colombia, whose handmade ritual figures of Euro-Americans have captured the imaginations of scholars since the late 1920s (Taussig 1993: 2–7). Drawing on secondary sources about the highly decorative Cuna figures of Euro-Americans and their important role in rituals, Taussig argues that 'the making and existence of the artifact that portrays something [i.e. a Euro-American] gives one power over that which is portrayed' (ibid.: 13). Like the Cuna who carve their ritual figures from wood, Nuosu ostensibly can be said to gain some power over the ghosts they portray with their handmade effigies. But I suggest that Nuosu actually obtain a different kind of power to that imbued in Cuna ritual figures, which, according to Taussig, act as animated receptacles – or even spirit-doubles – that embody the power and personae of Euro-Americans (ibid.: 8–18). As already mentioned, Nuosu actively deny animated power to their own effigies, which should ideally lure ghosts to their own likenesses, in line with what the editors of this volume call the apparent complementarity between vision and truth. Recall too that Nuosu effigies are meant to work like decoys. Revealingly, Taussig also discusses decoys in his work on mimesis (ibid.: 11–13). These are the rough-shod decoys of turtles that Cuna use for luring actual turtles to them in the hunt – decoys that stand in stark contrast to the elaborately carved ritual figurines of turtles that Cuna use (much like their ritual figures of Euro-Americans) as animated receptacles that embody the magical presence of turtles during ritual preparations for the hunt. Key to this distinction is Taussig's own (hesitant) openness to the ontological slippage that may arise between decoys and ritual figurines, as evidenced by his question of whether 'the decoy is closer to what the [Cuna] Indians think a real turtle thinks a real turtle looks

like? – in which case, why make the magical turtle-figures look so "real"?' (ibid.: 11–12).

In fact, the power of Nuosu effigies is only partly accounted for by their ability to portray ghosts, especially when taking into consideration the common Nuosu view that effigies are only and exclusively 'representations'. Beyond this, the power of Nuosu effigies is tempered, on a moment-by-moment basis, by the emergent qualities of human and ghostly *imaginations,* which mobilize the ritual battles where effigies may slip from being ideally human-made lures to becoming hijacked receptacles of ghostly power. Nuosu effigies are thus vested with a mutable power that is never guaranteed to remain in the hands of those who produce the effigies. Being less stable or predictable than Taussig suggests Cuna ritual figures tend to be, Nuosu effigies may, at any point, shift dangerously out of the priest's or shaman's control.

Perhaps, then, it would be more apt to compare the Nuosu effigies to Severi's (2002) study of the Cuna, which underscores the pivotal roles of reflexivity, scepticism and doubt among Cuna religious specialists. Like the Cuna shamans in Severi's study, Nuosu actively harness imaginative methods of interacting with 'supernatural beings' such as ghosts, using methods that are meant to 'challenge them, or be performed in order to test the effectiveness of their powers' (ibid.: 26). Nuosu in fact regularly 'challenge' ghosts by luring them to effigies that, to the human eye, appear to be merely representations. Yet Nuosu also believe that these same ghosts might realize the effigies are mere decoys and try to hijack them *unless* they are tempted to distraction by tasty sacrificial blood, flesh, organs and live chicken decoys. So Nuosu gain further power over the ghosts not by representing them more beautifully, but by covering their symbolic effigies with real sacrifices that deter ghosts from preparing a counter-attack. This strategy of adding just a dash of 'real' sacrifice to what is otherwise deemed a 'pure representation' highlights the prominent place in the Nuosu imagination for what Michael Scott calls a 'poly-ontology' (Scott 2005: 108–10; see also 2007: xxxi). For ultimately, Nuosu decoy-like effigies can and do slip between the ontological registers of vision and truth – as do their cultural tropes of luring (Chinese: *yingyou*), capture (*fulu*), slave-raiding, hunting and even recent warfare with the Chinese. What Nuosu really want to retain, then, is exclusive control over this ontological slippage, by tempting ghosts with their beautiful likeness in the form of grass ghosts (*mimicry*), live chicken decoys (*mimicry* again) and, finally, the real sacrificial blood and raw flesh (*non-mimicry*) that is daubed onto the grass ghosts, so that the ghosts will be too distracted to hijack the effigies or exorcisms.

This assemblage of mimicry and non-mimicry bids me to briefly invoke yet one last ethnographic comparison to the hunting strategy that Willerslev

identifies among Yukaghirs in Siberia, who mimic the mannerisms, comportment, and other notable characteristics of their prey animals during the hunt (Willerslev 2004: 638–49; see also Willerslev 2007: 94–118). Willerslev shows that the Yukaghir hunter carefully dons key features of the prey animal's 'personhood', while simultaneously retaining his own human 'perspective' in order not to 'forget' what his human perspective actually entails when face-to-face with the prey (Willerslev 2004: 647, see also 635–36). Yukaghir mimicry, then, is meant to produce an '*incomplete* copy' of the prey animal, which imparts the hunter with the (as I view it, imaginative) 'ability to be like, yet also different from, his victim' (Willerslev 2007: 108). The Nuosu strategy for luring ghosts goes one step further than this, since Nuosu mimic ghosts with grass ghost or ghost board effigies, while they simultaneously offer them actual, non-mimicked sacrificial blood, flesh, and other tempting foodstuffs. Besides offering ghosts an 'incomplete' copy of ghostly personhood (in the form of effigies meant to be mere visual representations), Nuosu affirm they also give ghosts a true feast of sacrificial flesh, blood and foodstuffs, while occasionally tempting them with live chicken decoys to boot. Through this 'ultra-complete' offering – and the militant weaponry unleashed by priests or shamans – Nuosu hope to ensure that ghosts cannot gain any imaginative leverage for sabotaging an exorcism. To fully show how Nuosu manage ritualized warfare with ghosts, I now turn to an in-depth examination of their exorcisms and the imaginative battles they unleash.

Motifs of Luring and Capture

Dispersed among the 'Cool Mountain' (*Liangshan*) highlands straddling the border between Sichuan and Yunnan provinces, the Nuosu are famous in China for their recent history of slaveholding and ranked lineages, both of which are upheld by an essentialist theory of blood superiority. I lived among Nuosu, whose ancestors migrated from Sichuan to Ninglang County in Yunnan about 150 years ago. When these Nuosu first entered Ninglang, they either drove out the resident populations they encountered or incorporated them as slave labour. Traditionally any Nuosu person of noble, commoner or slave extraction could own slaves, so that elites often displayed their prestige and wealth through their slave retinues. Nuosu slavery, though, was dismantled in 1956 –1957, when the People's Liberation Army entered the Nuosu highlands to implement the Democratic Reforms, which unfolded as guerrilla skirmish warfare across mountaintops between Nuosu and Chinese forces. At that time, the Nuosu became officially classed as living exemplars of a 'slave society' who desperately needed political edu-

cation. Nowadays, Nuosu commonly attest that their shotguns were seized by the Han (the ethnic majority in China) to cripple Nuosu efforts at armed combat and the Nuosu capturing of (predominantly Han) slaves, who grew the opium once sold to the Han for fresh instalments of guns and silver. Indeed, the Nuosu cycle of accumulating guns, slaves and silver – which peaked between 1906, when China outlawed opium growing in Han-held areas, and the mid-1950s, when the Reforms were introduced – is well documented and has not faded from living memory (Hill 2001: 1037–38). Warfare tactics thus remain palpable themes in Nuosu religious life, which centres around the exorcisms of ghosts often identified as outsiders of slave extraction or enemy soldier origin. These ghosts invade the Nuosu home, bringing a host of troubles with them. Yet since ghosts are prolific, needy and cannot be killed, their endemic presence in Nuosu terrain gives rise to what I call 'the perpetual cycle of exorcisms'.

When Nuosu experience a haunting, they invite an ordinary shaman or a priestly text-reading shaman to the home to exorcise the ghost(s) with ritualistic warfare. Both kinds of Nuosu religious specialists frequently battle a specific class of ghosts called *shubi*, which is comprised of former slaves captured from other ethnic groups, and especially the Han (Swancutt 2012b: 61–62, see also 67–68). *Shubi* appear at night as phosphorescence (*bbit dut*) on mountaintops, flashing like live flames, as they race to disband and reaggregate. Some Nuosu say *shubi* take the form of phosphorescent will-o'-the-wisps because they are the ghosts of people who never received a proper Nuosu funeral, which culminates with cremation. Enemy soldiers who died on Nuosu terrain, for instance, often joined the ranks of *shubi*, who evoke the processes of phantasmagoric combustion to which they succumb. At the same time, the flame-like movement of *shubi* calls to mind their constant travel and formation into bands that include the ghosts of higher-ranked Nuosu dead (*nyici*; Chinese: *mogui*) who either failed to produce male descendants for the lineage or otherwise shamed the lineage and so were expelled from it. These higher-ranked ghosts never gained entrance to the ancestral afterlife, which Nuosu consider to be located in either Zyzypuvy (near present-day Zhaotong) or in the 'parallel world' in the heavens called Shyp Mu Nge Hxat. Additionally, there are some Nuosu ghosts (*nyici*) awaiting their post-mortuary rites – which are usually held one to three years after the funeral – to stabilize their transformation into guardian spirits for their descendants. During the interim between their funerals and post-mortuary rites, the ghosts of upstanding Nuosu can thus also haunt people's homes. Significantly, though, most Nuosu problems are sourced to either shameful Nuosu ghosts or *shubi*.

Caught in the limbo of being 'non-ancestors', each of these ghosts is doomed to wander mountaintops, seeking food and, in the case of *shubi*,

searching for roads that would reunite them with the families they lost when captured as slaves. Some *shubi* benignly haunt their former masters' homes, carrying out slave labours that render certain agricultural tasks unnecessary for the living. If treated well, they may remain as good help, although Nuosu are wary that *shubi* might one day insidiously inflict illnesses on them. Most of the haunting, though, is ascribed to the hunger, lack of clothing and insufficient shelter that *shubi*, the ghosts of enemy soldiers and Nuosu ghosts who shamed the lineage suffer when barred entrance to the afterlife, where they could have feasted on the 'spirits' of livestock and crops. Wandering ghosts thus enter the homes of living Nuosu, out of starvation and spite, making themselves noticed by inflicting illnesses and misfortunes, depleting resources, capturing human souls and possibly unsettling people's attachments to the lineage. In so doing, ghosts echo the behaviour of former slaves who slyly tried to climb the Nuosu social ladder by feigning attachments to a higher-ranked Nuosu lineage (Hill 2001: 1042–48). Alternatively, ghosts evoke the behaviour of Chinese soldiers who dismantled Nuosu slavery whilst trying to efface their lineage rankings (Pan 1997: 111–12). Finally, ghosts call to mind the behaviour of those Nuosu people who were expelled from the lineage (Qubi and Ma 2001: 102) or failed to produce male descendants for it, so that their mere presence in Nuosu society threatens to undermine lineage security and solidarity.

But as I have shown elsewhere, the Nuosu penchant for luring and capture can be traced to their notion that the human soul takes the form of a tiny 'soul-spider' (*yyr*) residing on the outer surface of the human body, which is often only visible during soul-calling ceremonies (Swancutt 2012b: 63; see also 2012c: S113; and 2012d: 184–85). Nuosu ritually lure soul-spiders home in rites that require placing a white thread – which is meant to resemble a real spider's thread – across the household threshold. Tied to one end of the thread, which is placed just outside the home, is a special variety of long, sturdy grass (*yyr yy*; botanical names: *ophiopogon* 'lily turf') that in the Nuosu language contains the word for 'soul-spider' and grows near riverbanks (Aku Wuwu, Bender and Jjiepa Ayi 2005: 129). According to legend, Nuosu were saved from a sudden flood by clinging to this grass when on migration and pulling themselves out of a river channel by using its long fibres. Inside the home, the white thread is tied to a swatch of cloth intended for keeping the soul-spider warm, which is placed with tempting cooked meat or fat inside a basket or traditional lacquer box. Seated next to the threshold, the person who has lost his or her soul calls to the soul-spider, praising the warmth and food-stores at home whilst deprecating the cold and hunger outdoors. When the soul-spider is seen to have started climbing the white thread, making its approach towards the basket, the person handling the thread quickly wraps it up in the soul-spider's wake, shutting the

basket lid over it in an act of capture. Several days are allowed to pass until a good astrological day arises, whereupon the basket is opened, releasing the soul-spider so that it can willingly climb back on its owner. Sometimes Nuosu look to see whether a needle that they placed inside the basket with the cloth and meat has moved, since this indicates the successful capture of the soul-spider. Note, though, that people retain the upper hand in soul-calling rites, since they convince soul-spiders to return home, preventing them from being captured by someone else. The soul-spider thus underpins a larger complex of Nuosu notions about luring and capture, which presuppose an asymmetric power relation that is more transparent to the captor than the would-be captive.

This rift between the imaginative agency of captors and would-be captives is the founding principle for how to exorcise ghosts effectively. Every Nuosu knows that exorcisms are difficult because ghosts craftily obstruct the ritual or hide in remote parts of the home to evade expulsion. So ghosts are lured into the ritual purview with effigies of themselves, their homes and jails, covered with offerings of blood, flesh, organs of sacrificial animals and sometimes live chicken decoys. Whilst effigies bear an attractive resemblance to ghostly life, their purpose is hidden from ghosts and apparent to Nuosu people only. Nuosu thus explain their use of visible effigies by pointing to the hidden purpose of capturing ghosts, whereas ghosts use invisibility for the rather obvious purpose of hiding.

There is a clear process to the ritualized warfare of exorcisms, which unfolds as a two-way game of catch and release. First, Nuosu ambush troublesome ghosts, forcing them to release the human souls they have stolen. Then they rudely eject these ghosts from the home, before recapturing their stolen soul-spiders. Nuosu are aware that ghosts exorcised from one household often wander into another soon after, so that whole villages face the collective burden of exorcising them. Yet since Nuosu cannot kill ghosts, they have no other option than to keep expelling them to new locations, knowing the exorcised ghosts will enter other households that will need to hold fresh rites. Still, no hard feelings are directed at other Nuosu for the need to hold new exorcisms, because it is understood that ghosts cannot be prevented from visiting other homes after being ritually expelled.

Note that Nuosu exorcisms and tactics of luring, capture and expulsion resonate with the people's past history of warfare with the Chinese, their cultural tropes of capturing the soul-spider or slaves, their efforts at maintaining attachments to ranked lineages, and the lure-to-capture strategies deployed by both people and ghosts. Their ritualistic warfare – and the imaginative tactics they use in it to vanquish ghosts – is thus inspired by the more general strategies of luring and capture that pervade their lives. Nuosu ambush ghosts much like they ambush other rivals – namely, by an-

ticipating their efforts at escape and undercutting them with a fast response. Some Nuosu therefore say that priests and ordinary shamans use ghostly effigies as conduits for their invisible human agency, so as to lure ghosts into the ritual purview for expulsion from the home. Priests and shamans, then, slyly use their ritualistic prowess to control the ontological status of effigies – imagining several steps in advance how ghosts might respond to the exorcism, so as to pre-empt any ghostly attacks. Ghosts often respond by cunningly disorienting people, with tactics such as suddenly running up to the effigies and disturbing them before racing away to hide again. Revealingly, these ghostly antics neatly echo the fleeting appearances that ghosts make as phosphorescence on mountaintops. Like Nuosu people, then, ghosts produce 'smokescreens' which disguise their presence and improve their chances of mastering the household. Yet ghosts do not create smokescreens with artillery that combusts into nothing. Instead, they use their imaginative capacity to launch surprise attacks that divert people's attention from the critical phases of the exorcisms.

The Lure of Exorcisms

Some imaginative warfare tactics unfolded in several exorcisms I attended – together with the local Nuosu man I call Datlamuo – from summer to early winter 2011 in a rural village of Ninglang County. According to his own reckoning, Datlamuo (then aged 25) became increasingly familiar with the Nuosu religious repertoire, and especially its ritualistic warfare, when bringing me to rites held by his neighbours. In return for the favour of letting us attend the rites, Datlamuo volunteered to act as one of the priest's or shaman's assistants, which any Nuosu man can do. Throughout my stay, Datlamuo frequently shared with me his insights into the rites, often interpreting the views of fellow villagers with something approaching the finesse of a 'native anthropologist'. Beyond this, Datlamuo shared with me popular notions about ghosts and their local haunts, explaining that human-ghostly contests are endemic in Nuosu terrain.

Near the start of my 2011 trip, my curiosity was struck by the Nuosu scholar I call Mitsu, who is based in the county seat of Ninglang but who grew up in a rural Nuosu village. Mitsu told me that rural Nuosu consider the phosphorescent lights they see flashing on mountaintops at night to be ghosts – and he surmised that the phosphorescence comes from the bones and bodies of dead creatures decomposing there. Significantly, Nuosu fear will-o'-the-wisps and combustion of the dead, which are distinctly 'non-Nuosu' features of their landscape. Over time I learned that, like Mitsu, other Nuosu believe they fear the phosphorescent form of *shubi* because

their own dead never have this appearance. Nuosu cremate, but other ethnic groups like the Han bury their dead. In the Nuosu view, burial is a frighteningly 'anti-funereal' practice which easily produces ghosts that can be viewed in phosphorescent form.

Early into my stay, I asked Datlamuo what the ghosts that take the form of phosphorescence actually look like. Our conversation took place in the evening and Datlamuo had been relaxing lazily in bed watching television. But he suddenly turned over, wide eyed and excited, when I asked him about the phosphorescence. He started off by modestly conceding that his mother knew far more than he did about ghosts, before rattling off his answers and relating details gathered from his mother. According to Datlamuo, only *shubi* take the form of phosphorescence, and not the ghosts of deceased Nuosu (*nyici*) who await their post-mortuary rites (*nimu cobi*) which send them to the afterlife. I asked what colour *shubi* are, adding that the phosphorescence I had seen over California oceans at night had looked turquoise-blue. Datlamuo, however, said that I must have seen ocean ghosts because *shubi* take the colour of live flames, with the orangey-yellow hues of fire. Elaborating on this theme, he pointed out that *shubi* can only be glimpsed as flashes of phosphorescence that elude the eye, because they constantly race between different parts of Nuosu terrain to team up with other ghosts, collectively seeking out the needed shelter, food and clothing to sustain themselves. In fact, *shubi* often disband and reaggregate into new vagabond teams of ghosts through their perpetual wanderings. Finally, Datlamuo added that *shubi* are doomed to their wandering existence since, as members of other ethnic groups, they did not receive the post-mortuary rites needed to enter the Nuosu afterlife, where shelter, food and clothing are abundant.[1]

At my request, Datlamuo showed me where *shubi* are sighted most often in the village. One common place where villagers see them is along the tops of a tall mountain ridge known to be good for hunting, but which is not the abode of their local mountain spirit. Another common place to sight *shubi* is along the road to the nearby township, especially since these roadsides are ditches overgrown with tall grasses that often emanate phosphorescent light from their depths. Hearing this, I asked whether this road leading to the township could be filled with *shubi* seeking to locate their former relatives, since in 1958 the Chinese converted this township into a Nuosu 'slave village' that, to this day, still remains largely populated by Nuosu of slave (*gaxy*) origins (Jiarimuji 2010a: 54; see also 2010b: 199). Initially Datlamuo did not make the connection between the road and the possible efforts of slave ghosts trying to find their lost kin. Instead, he pointed out that the long stretch of road, with its low muddy ditches, is simply conducive for giving rise to the phosphorescence. On further reflection, he surmised that some

shubi could be trying to reach their relatives along these roads. But he felt these *shubi* would not be successful at reuniting with their family members, since they did not know where they were. Most often, Datlamuo confirmed, *shubi* simply return to invade the homes of their former slave masters, depleting their supplies of food, clothing and other desirable resources that contribute to the fullness of life. Like all ghosts, Datlamuo said, *shubi* also make their presence and plight known by inflicting illnesses, misfortunes and business difficulties onto living Nuosu, who have no other choice than to undertake ritualistic warfare and exorcise them from the home.

With ghostly lore like this at the forefronts of our minds, Datlamuo and I attended several exorcisms held by his relatives and friends in the village, which offered exemplary views into Nuosu battlefield politics with ghosts. Each of these exorcisms was actually comprised of several different rites held in quick succession, as is common when Nuosu face severe or long-term problems. These exorcisms entailed struggles over the ontological status of the effigies, which the Nuosu priests, ordinary shamans and laypersons worked to maintain as representations, while the ghosts tried making them into vessels of their own agency. Long hours passed in which these Nuosu let their battlefield reflexes guide their imaginations, in order to anticipate the imaginative manoeuvres of ghosts and successfully exorcise them from the home. So while these Nuosu used familiar practices for exorcising ghosts, they unleashed these practices rapidly and in imaginative ways that baffled and ultimately vanquished the ghosts.

The first exorcism was held by relatives of Datlamuo, who invited a priest to their home for two days of rites to eliminate a small child's persistent illness. During the exorcism, one group of ghosts was lured into the ritual purview with effigies of themselves, their jail (which contained a slip of paper with summoning words written on it by the priest), a plate of sacrificial cooked meat placed next to the jail, rice wine that the priest kept sprinkling onto the jail, and a live chicken decoy hanging above the jail (see figure 7.3).

These ghosts were captured in a glass bottle during an outdoor rite, and the priest used the live chicken decoy to lure ghosts into that bottle, which was placed next to the jail effigy. Datlamuo helped to bury that bottle in nearby cornfields, telling me later the ghosts would only escape if the bottle was dug up or smashed open, as sometimes happens when Nuosu forget the location of their ghost traps and plough up fresh fields. During a lengthy indoor rite that soon followed, another group of ghosts was lured into a wooden barrel traditionally used for storing water, and then expelled all the ghosts from the home.

As these exorcisms unfolded, I asked Datlamuo whether the ghosts might somehow enter the effigies, using them as a safe haven for launching a counter-attack. But he replied with a confident smile that ghosts rarely manage

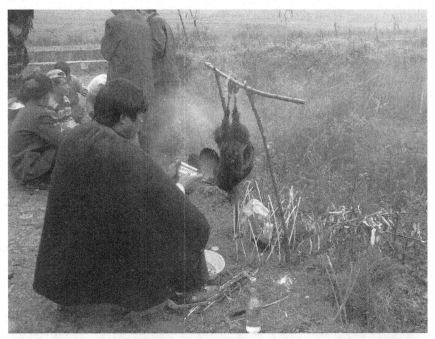

Figure 7.3. Nuosu priest (*bimo*) holding an outdoor rite with grass ghost effigies, an effigy of a ghost's jail, sacrificial meat and a live chicken decoy. October 2011. Courtesy of Katherine Swancutt.

this because Nuosu priests or shamans fire speech bullets at them and use other tactics of ritualized warfare. He then carefully explained what a difficult feat it had been for the priest to capture the ghosts in the outdoor rite, who were running wildly around the jail effigy but refusing to enter the bottle. Since priests ordinarily cannot see ghosts (except as phosphorescence), the live chicken decoy alerts them to the presence of ghosts by responding with sudden fits of shaking and clucking. So the priest watched the chicken closely – and kept his senses alert for the moment when the ghosts came into close range of the glass bottle – whilst continuously firing speech bullets and sprinkling rice wine over the jail effigy. Datlamuo told me that by using these techniques, the priest had been able to give him the cue, along with the other assistants, to shut the lid over the bottle at the exact moment when the ghosts had entered it. Immediately after this bottle was shut, the priest told them to carry the ghosts off and bury them, while he set fire to the jail effigy, ensuring no ghosts in the area could cling to any residue from the rite or use it as a point of re-entry to the home.

Just a week later, Datlamuo and I attended another exorcism that was held to expel the ghosts responsible for an infant's illness. An ordinary

shaman (*suni*) from the village officiated at these rites in the client's home, and he occasionally saw the ghosts with his own eyes. These rites lasted only a few hours, and began with the shaman divining that the household's sow had acquired an inauspicious (*shufi*) quality that had attracted the ghosts. So the pig was sacrificed and the shaman began plaiting plants into a large grass ghost effigy, to attract the troublesome ghosts of Nuosu who had shamed the lineage. Datlamuo confirmed that these ghosts were unable to resist the giant pig feast and the effigy, which operated as bait. Even the cooking steam from the pig, Datlamuo said, had unleashed a delicious smokescreen that lured the ghosts into the shaman's firing range. Some of this cooked sacrificial meat was taken outdoors, to lure the ghosts away from the home. Soon after, the shaman also violently whipped the remaining ghosts away from the household threshold, using the ribbons fastened to the end of his bell, whilst chanting speech bullets (see figure 7.4). At the close of the rite, the effigy was also bundled up and taken away from the home, so the ghosts would follow it to some other location.

Only a fortnight had passed before we attended another exorcism held in the face of a tragedy: devious ghosts had made a five-year-old boy recklessly

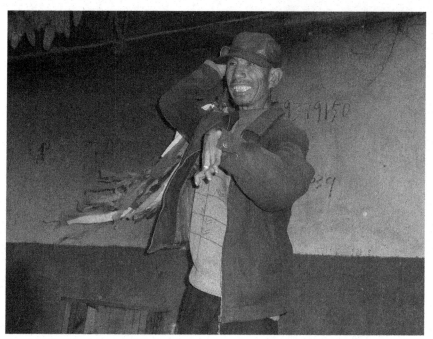

Figure 7.4. Nuosu shaman (*suni*) exorcising ghosts by violently whipping them away from the household threshold. October 2011. Courtesy of Katherine Swancutt.

climb a ladder, which collapsed and killed him. So the parents of this boy, who were in their early thirties and had lost yet another son to illness just two years earlier, summoned a priest. The young couple benefited from the fact that the ordinary shaman who officiated at the rite described immediately above happened to be the paternal grandfather of the boy. This shaman attended the entire exorcism (occasionally joining in with the chanting) and agreed with the priest to host a forty-eight-hour marathon of rites that would expel the ghosts responsible for the deaths of both sons. These rites were especially needed because, in the Nuosu view, the boy's parents could only reach the ancestral afterlife if they produced sons that would help to propagate their lineage across generations. Since the couple had lost two sons to devious ghosts – and only had a third son still living – their own chances of entering the afterlife had become tenuous. So this couple not only mourned the loss of their two boys, but feared for the life of their remaining son and suffered from the thought that their chances of reaching the ancestral afterlife had diminished. Their sadness detracted enormously from the fullness of life in their home, and many villagers visited to comfort them, to wish their young son a long full life and to express their hope that the couple would have many more children.

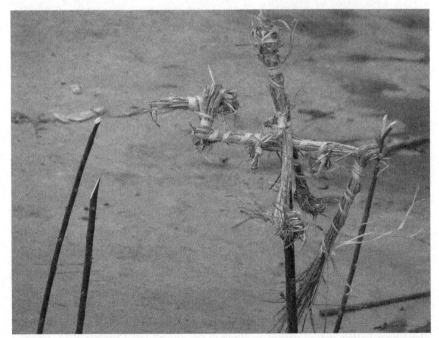

Figure 7.5. Ghost effigy made from twisted plants. October 2011. Courtesy of Katherine Swancutt.

Six different rites were held to expel the ghosts and replenish the couple's capacity for accumulating the fullness of life. The priest began by making grass ghost effigies of three Nuosu men who had failed to produce male descendants for the lineage (and so did not enter the ancestral afterlife) – as well as an effigy of the gremlin-like ghost (*syp lup*; Chinese: *jingling* or *jingguai*) of a horse ridden by one of the human ghosts (see figure 7.5).

According to the priest, these ghosts were jealous of the couple for having borne three sons, and hoped that by eliminating their children, the couple would also be barred entrance to the ancestral afterlife. Yet the priest had no trouble vanquishing the ghosts with a wide range of artillery, including a live chicken decoy suspended near to the ghost effigies, which were covered with sacrificial blood, flesh and organs (see figure 7.6).

These tactics culminated with a dramatic flourish on the first evening of the rites. After hours of chanting speech bullets, holding sacrifices and watching the chicken decoy in an effort to detect when the ghosts had finally entered the ritual purview, the priest managed to trap them in an effigy of their jail. Not surprisingly, the priest had prepared well for this moment, by heating a ploughshare in the hearth fire several hours beforehand. He asked

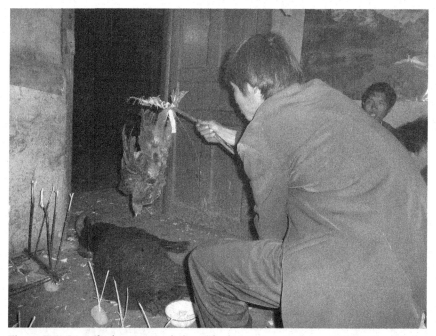

Figure 7.6. Live chicken suspended upside down, near to the sacrificial sheep and ghost board effigy placed within an effigy of the ghost's jail. October 2011. Courtesy of Katherine Swancutt.

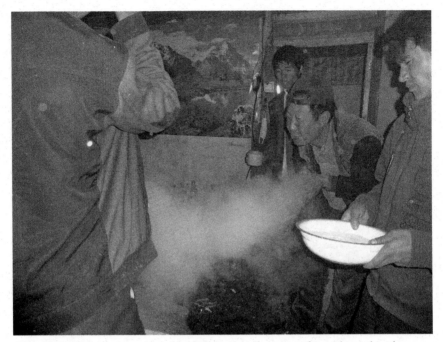

Figure 7.7. Water spat over a ploughshare that the priest (*bimo*) heated in the hearth. October 2011. Courtesy of Katherine Swancutt.

another man in the home to assist him, by spitting water from a bowl over the ploughshare, so that the steam rising from it would scald the ghosts and fill the room with a giant smokescreen that prevented them from evading the exorcism (see figure 7.7).

While this man produced voluminous clouds of steam, the priest chanted his strongest speech bullets to expel the ghosts across the household threshold. Still not done, the priest asked several other men to tie two small sticks of dynamite to a bamboo rod and suspend them across the household threshold, so that they could explode any remaining ghosts away from the entrance to the home. The priest helped these men to synchronize the explosion with yet another man's job of tossing a shovel load of hot coals from the hearth outdoors, to burn any remaining ghosts still clambering to enter the house. So much ash was tossed up from the hearth, the coals and the dynamite that tears streamed from the eyes of everyone in the room (see figures 7.8 and 7.9).[2] Finally, the priest told the men to burn down the effigy of the ghost's jail and instructed the mother of the deceased child to sweep the cinders of that jail outdoors, to fully expel its residue and prevent the ghosts from clinging to it.

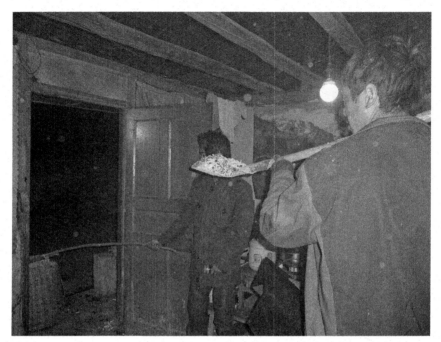

Figure 7.8. The moment before tossing a shovelful of hot coals and exploding two sticks of dynamite, to expel ghosts across the household threshold. October 2011. Courtesy of Katherine Swancutt.

This wide range of artillery, used in rapid succession, ensured the ghosts would have little chance of predicting what weapon would come next and certainly no chance of remaining in the home. Moreover, the combustion of artillery and burning of the effigies meant the ritual weaponry would be ephemeral, posing no risk of accidentally retaining the ghosts and having them sabotage the couple's efforts at renewing their fullness of life.

I asked Datlamuo whether this sweeping away of the ghosts echoed the popular Nuosu taboo against sweeping the home within several days of a family member leaving on a journey, since this often causes the traveller to lose his or her soul. Datlamuo agreed that the sweeping was meant to be aggressive and dangerous to the ghosts. But he was less interested in this overlap with household protective magic and more impressed with how the priest deflected ghosts by using the bombastic tactics of ritualized warfare. Datlamuo confirmed that although the ghosts had tried hiding in the home throughout the exorcism – and only occasionally raced up to eat the sacrificial blood and flesh or disturb the ghost effigies and chicken decoy – they ultimately had been blinded by the smokescreens and overwhelmed by the

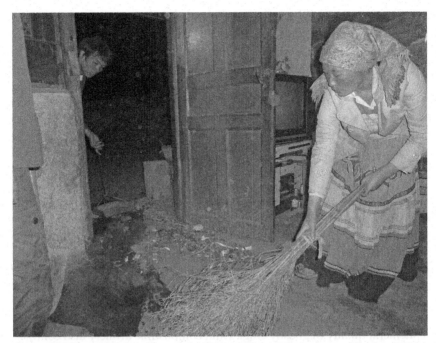

Figure 7.9. Sweeping the effigy of the ghost's jail outside the home. October 2011. Courtesy of Katherine Swancutt.

priest's speech bullets. According to Datlamuo, the ghosts had distorted the priest's field of vision with devious antics. However, the priest, in turn, had distorted the ghosts' perceptive faculties with speech bullets that flushed them out of hiding and then lured them to the effigies, chicken decoy and sacrificial blood and flesh, where he unleashed smokescreens, hot coals and explosive artillery to fully eject them from the home. In Datlamuo's view, the ghosts simply did not have any chance to evade the priest's assemblage of ritual warfare tactics.

Indeed, everyone attending the exorcism (and not just the priest or Datlamuo) was entirely aware they were battling the ghosts for mastery of the household. And they vouched that, since invisibility is a key asset of the ghosts, the priest chose to trump their efforts at hiding by using the following tactics to lure them into firing range: (1) effigies that operated merely as representations; (2) sacrificial blood and flesh used as bait; (3) the chicken decoy that heralded the ghosts' entrance into the ritual purview; (4) a smokescreen obfuscating the ghosts' vision and freedom of movement; and finally (5) everyday items in the home (e.g. ploughshares and hot coals) imaginatively deployed as weapons against ghosts.

Ritualized Warfare is Symbolic for a Reason

I proposed at the start of this chapter that Nuosu explicitly consider the effigies they make of ghosts, ghostly homes and ghostly jails to be mere 'representations' or 'symbols'. There is good reason why Nuosu insist their effigies have a 'purely symbolic' quality, namely, success in ritualized warfare depends on subterfuge and distorting the perceptual faculties of ghosts. By making ghostly effigies into 'mere symbols' rather than items capable of carrying agency within them, Nuosu readily lure ghosts into the ritual purview, capture them, and exorcise them from the home. Yet Nuosu exorcisms are only temporary measures against the problem of endemic haunting, since their highlands are filled with wandering ghosts who can be neither killed nor sent off to the ancestral afterlife. Nuosu are thus caught within a two-way game of catch-and-release, in which ghosts and people compete for control over the Nuosu household, its fullness of life, and the wider landscape. Both exorcisms and the will-o'-the-wisp appearances of *shubi* highlight this uncomfortable bind between Nuosu people, ghosts and the fifty-year-old memories of warfare against the People's Liberation Army who wrested the Ninglang highlands from Nuosu control. Notably, the ephemeral quality of ghostly effigies and combustible artillery also contrasts with the constant quests Nuosu make for obtaining the fullness of life, for which they wage never-ending battles against devious ghosts.

Ultimately, then, Nuosu discomfort in coexisting with ghosts arises not only because they cause illnesses, misfortunes and business difficulties. The discomfort can be traced back to the Nuosu person's uneasy feeling that, at any moment, ghosts doomed to wander mountaintops might somehow usurp their livelihoods. Every haunting is difficult to bear because it throws the Nuosu household into disarray, following the dynamics of what Roy Wagner calls a 'figure-ground reversal', so that the fullness of life is hijacked by the ghosts of Nuosu who once shamed the lineage or the ghosts of peoples from other ethnic groups (Wagner 1987: 56). This is not to say that Nuosu are entirely uncomfortable with their pasts, their history of slavery or warfare. On the contrary, they are fiercely proud of those conquests which, in the Nuosu view, give testimony to the strength of their prestigious bones and blood (Pan 1997: 108, see also 110, 115–16 and 119–21). But Nuosu are highly aware of that martial principle, so common in human history, that at some point 'the conquered may conquer the conquerors'. And the most sure-fire way for Nuosu to pre-empt that possibility is by reducing their effigies to mere representations – and making them as ephemeral as their artillery – so as to prevent ghosts from appropriating the materiality of effigies for a counter-attack.

I would like to close by underscoring that Nuosu evidence imaginative brilliance when insisting that their decoy effigies are representations that merely lure ghosts into firing range. As I have shown, Nuosu carefully craft their ritualistic warfare to expel devious ghosts and protect their fullness of life in the home. Yet since none of their battles is ever guaranteed, each exorcism must deploy imaginative precautions against the possibility that ghosts could hijack the effigies, 'animate' them and overturn their ontologically safer status as mere representations. Some of the more imaginative Nuosu tactics are traceable to the fresh combinations of exorcistic tactics that the priest or shaman assembles. Even more imaginative, though, is the Nuosu use of the effigy, which begins as a ghostly representation made of plants, but is soon covered with a ghostly feast of sacrificial blood, flesh and organs – possibly accompanied by a live chicken decoy. This recipe is designed to distract ghosts thoroughly, ensuring that Nuosu retain complete control of the exorcism and of the ontological status of their effigies. Tellingly, the hybrid recipe of symbol and sacrifice makes Nuosu effigies more palpably 'real' to the senses than if they were not adorned with food. And it is this dash of added 'reality' that gives Nuosu imaginative leverage over ghosts, who may perceive the ruse of a sacrificial feast for just a brief moment, before relinquishing the fullness of life to their human captors.

Notes

1. The Nuosu anthropologist Jjiezy Muji told me in 2011 that it is possible for text-reading shamans to hold post-mortuary rites (*nimu cobi*) that 'attach' the ghost of former slaves, including *shubi*, to their masters' family lines. This allows the ghosts of slaves to enter the Nuosu afterlife in Zyzypuvy (or Shyp Mu Nge Hxat). However, Nuosu ensure these ghosts enter the afterlife as slaves and always reside there with the social distance of outsiders. In the final stage of the post-mortuary rite, after the priest has placed an effigy of the deceased into a special 'spirit vessel' made of hawthorn wood (*madu*), the Nuosu hosting the rite ensure this vessel is not actually interred in a secret cliff crevice devoted to the lineage (Ma 2000: 55). Instead, Jjiezy Muji confirmed, the spirit vessel is secretly interred in a nearby cliff crevice – with the connotation that Nuosu may keep extremely close emotional connections to outsiders in life, but in death they will always retain the ideally pure distance from non-Nuosu, and more specifically, from outsiders to their own lineage.

2. Even I had a tough time capturing the photographs used in figures 7.7, 7.8 and 7.9, having been blinded by ash floating in the air, with my eyes watering and stinging.

References

Aku Wuwu, M. Bender and Jjiepa Ayi. 2005. 'Four Poems', *Manoa* 17(1): 119–30.

Bamo Ayi. 2007. 'Chasing after *Bimo*, 1992–1993', in Bamo Ayi, S. Harrell and Ma Lunzy (eds). *Fieldwork Connections: The Fabric of Ethnographic Collaboration in China and America*. Seattle and London: University of Washington Press, pp. 72–88.

Gell, A. 1998. *Art and Agency: An Anthropological Theory*. Oxford: Clarendon Press.

Gould, S., and E.S. Vrba. 1982. 'Exaptation – A Missing Term in the Science of Form', *Paleobiology* 8: 4–15.

Henare, A., M. Holbraad and S. Wastell. 2007. 'Introduction: Thinking through Things', in A. Henare, M. Holbraad and S. Wastell (eds), *Thinking through Things: Theorising Artefacts Ethnographically*. London: Routledge, pp. 1–31.

Hill, A.M. 2001. 'Captives, Kin, and Slaves in Xiao Liangshan', *Journal of Asian Studies* 60(4): 1033–49.

Ingold, T. 1997. 'Eight Themes in the Anthropology of Technology', *Social Analysis* 41(1): 106–38.

Jiarimuji (Jjiezymuji). 2010a. 'Yunnan Xiao Liangshan "Nongchang Yiren" de Xingshi Xuanze' [The Selection of Surnames among the 'Yi Slave Villagers' of the Xiao Liangshan Mountain Region in Yunnan]. *Minzu Yanjiu (Ethno-National Studies)* 5: 50–59.

———. 2010b. 'Lun Liangshan Yizu Zushu Renti de Danxing Gouzao: Cong Xiao Liangshan de "Nongchang" Xianxiang Shuoqi' [On the Egg-Shaped Structure of the Ethnic Identification of the Liangshan Yi People: A Field Study of Xiao Liangshan Villages]. *Shehuixue Yanjiu (Sociological Studies)* 5: 192–207.

Ma Erzi. 2000. 'The Bimo, their Books, and their Ritual Implements', trans. S. Harrell, in S. Harrell, Bamo Qubumo and Ma Erzi (eds), *Mountain Patterns: The Survival of Nuosu Culture in China*. Seattle and London: University of Washington Press, pp. 51–57.

Miller, D. (ed.). 2005. 'Materiality: An Introduction', in *Materiality*. Durham, NC and London: Duke University Press, pp. 1–50.

Pan Jiao. 1997. 'The Maintenance of the LoLo Caste Idea in Socialist China', *Inner Asia* 2(1): 108–27.

Qubi Shimei and Ma Erzi. 2001. 'Homicide and Homicide Cases in Old Liangshan', in S. Harrell (ed.), *Perspectives on the Yi of Southwest China*. Berkeley, Los Angeles and London: University of California Press, pp. 94–103.

Scott, M.W. 2005. '"I was like Abraham": Notes on the Anthropology of Christianity from the Solomon Islands', *Ethnos* 70(1): 101–25.

———. 2007. *The Severed Snake: Matrilineages, Making Place, and a Melanesian Christianity in Southwest Solomon Islands*. Durham, NC: Carolina Academic Press.

Severi, C. 2002. 'Memory, Reflexivity and Belief: Reflections on the Ritual Use of Language', *Social Anthropology* 10(1): 23–40.

Sneath, D., M. Holbraad and M. Pedersen. 2009. 'Technologies of the Imagination: An Introduction', *Ethnos* 74(1): 5–30.

Swancutt, K. 2007. 'The Ontological Spiral: Virtuosity and Transparency in Mongolian Games', *Inner Asia* 9(2): 237–59.

———. 2012a. *Fortune and the Cursed: The Sliding Scale of Time in Mongolian Divination*. Oxford: Berghahn Books.

———. 2012b. 'Fame, Fate-Fortune and Tokens of Value among the Nuosu of Southwest China', *Social Analysis* 56(2): 56–72.

———. 2012c. 'The Captive Guest: Spider Webs of Hospitality among the Nuosu of Southwest China', *Journal of the Royal Anthropological Institute* 18(S1): S103–S116.

———. 2012d. 'Masked Predation, Hierarchy and the Scaling of Extractive Relations in Inner Asia and Beyond', in M. Brightman, V. Grotti and O. Ulturgasheva (eds), *Animism in Rainforest and Tundra: Personhood, Animals, Plants and Things in Contemporary Amazonia and Siberia*. Oxford: Berghahn Books, pp. 293–326.

Taussig, M. 1993. *Mimesis and Alterity: A Particular History of the Senses*. New York and London: Routledge.

Wagner, R. 1987. 'Figure-ground Reversal among the Barok', in L. Lincoln (ed.), *Assemblage of Spirits: Idea and Image in New Ireland*. Minneapolis: Minneapolis Institute of Art, pp. 56–62.

Willerslev, R. 2004. 'Not-animal, not *Not*-animal: Hunting, Imitation, and Empathetic Knowledge among the Siberian Yukaghirs', *Journal of the Royal Anthropological Institute* 10(3): 629–52.

———. 2007. *Soul Hunters: Hunting, Animism, and Personhood among the Siberian Yukaghirs*. Berkeley, Los Angeles and London: University of California Press.

8

HOW PICTURES MATTER
RELIGIOUS OBJECTS AND THE IMAGINATION IN GHANA

———◄•◊•►———

Birgit Meyer

The central theme of this volume is the role of objects in the construction of everyday life. It acknowledges their – literally – constructive role, but takes a critical stance with regard to radical versions of new materialism that foreground the 'thingliness' of objects at the expense of the meaning they have for people. At stake here is a broader understanding of human–object relations as shaped by historically transmitted, more or less institutionalized frames or imaginaries. Proposing that 'a sharpening of focus on the imagination will contribute crucially to studies in material anthropology' (Fuglerud and Wainwright, this volume), the guiding idea of this volume is to take objects as entry points to synthesize the still quite separate fields of inquiry into materiality, on the one hand, and imaginaries, on the other. This book shows how inadvisable it is to emphasize the former and neglect the latter, and vice versa.

In this chapter I seek to contribute to developing a material approach to the imagination. Thinking about the imagination from a material angle, I emphasize the importance of objects in general, and pictures in particular, in establishing and anchoring shared (religious) imaginaries. My ideas are grounded in my research, conducted over the past fifteen years, on the inter-face of religion and media in Southern Ghana's transforming public sphere. Here, as in many other countries in Africa, the concomitant adoption of a democratic constitution, the deregulation of hitherto state-controlled media,

and the liberalization of the economy implied the emergence of new players and new themes in the arena of the public sphere (Meyer 2004). A new public culture has arisen which is heavily indebted to Christianity and makes profuse use of Christian imagery, involving a strong dualism of the divine and the demonic.

New possibilities of mass reproduction bring a dazzling flood of Christian visual culture that can be found in various forms in private homes, in work places and in the public sphere (Meyer 2010). Of particular interest to me for the purpose of this chapter are pictures of Jesus, especially of the Sacred Heart of Jesus. I understand this motif as a global icon that moves across time and space in the Catholic Christian World, and beyond. Pictures of the Sacred Heart of Jesus are devotional objects that involve a desired encounter with the divine. Conversely, there is also a strong concern with dangerous objects that involve a feared and fearful encounter with the realm of the demonic and occult. Such objects include masks, sculptures and other paraphernalia associated with traditional worship, which from a Christian perspective are understood as 'pagan' and as involving demons and the devil. In normal life, Christians try to eschew exposure to these feared power objects. This is somewhat different on the sets of locally produced movies that emerged thanks to the easy availability of video technology, and that became a popular phenomenon since the early 1990s (Meyer n.d.). Seeking to speak to popular imaginaries by making profuse use of Christian imagery, staging the 'occult' for the sake of a movie is a necessity. Doing so, however, may still generate anxieties on the part of the actors.

I take the Sacred Heart of Jesus and the props employed to simulate the occult as prime cases to explore 'how pictures matter' to those who use and make them, and by extension, to scholarly understandings of their role in the imagination. While the former involves a desire to get in touch with the divine, the latter involves a deep anxiety about being hurt or affected by the demonic. Before delving into a deeper exploration of these objects and pictures in the latter part of this chapter, I will first present my ideas about the imaginaries and the imagination, and then about the role of objects and pictures in practices of religious mediation. My central argument is that a close analysis of the use, valuation and purported effects of religious objects and pictures can help us to grasp their constitutive role in the politics and aesthetics of religious world-making.

Imaginaries and the Imagination

In anthropology, the 'imagination' is a topic that draws considerable interest in current debates (see Fuglerud and Wainwright, this volume, for a brief overview), but stands remarkably separate from debates revolving around

materiality. Echoing Durkheim's notion of collective representations, the imagination is usually understood as a social phenomenon, bringing people together and effecting some degree of cohesion. Path-breaking scholars such as Benedict Anderson (1991), Arjun Appadurai (1996) and Charles Taylor (2002) have explored the role of the imagination in times of transition from one social order to another. I agree with the constructivist approach to the imagination proposed by these authors and share their basic idea that social imaginaries underpin the organization of social life and make it real. As Castoriadis, whose ideas are foundational for the idea of a social imaginary, put it succinctly, 'each society is a construction, a constitution, a creation of a world, of its own world' (Castoriadis 1997: 9). In short, imaginaries not only represent the world, they take part in making it. They do so via particular media, and infrastructures of circulation, that constitute their publics in particular ways.

However, my approach in a number of ways also differs from and expands upon the mode of analysis proposed by these authors. Firstly, I find it important to distinguish more clearly between the imagination and imaginaries. In my understanding, the imagination is the individual creative and formative faculty to picture something before the mind's eye which is not necessarily there. Making use of 'materials' situated in a life world, the imagination is partial and selective; it does not simply represent the world 'as it is'. The imagination may wander in different directions, escaping from the world into realms of fantasy, visions and ecstasy (a reason why, from a rational perspective, the imagination is met with suspicion; see Kamper 1981: 86–106). But it may also be harnessed to dominant social imaginaries that underpin certain social formations. The fact that people imagine along similar lines is an effect of a successful process of captivating and concentrating the individual imagination into a social imaginary, which I understand as a set of collective representations around particular issues, such as the nation, city, the family, religion, and so on. Rather than referring to one coherent social imaginary which is dominant in a given society, I opt for a pluralized understanding of interconnected imaginaries revolving around significant semantic domains. Distinguishing between the individual faculty of the imagination and the social imaginaries into which it is honed opens up a dynamic field. This allows us to study the interface between the social and the individual, showing how and to what extent the latter is harnessed into shared imaginaries.

Second, as noted already, I would recommend taking the materiality of the imagination and imaginaries more seriously. Here I would like to stress that the imagination is not limited to processes within the mind, but is fed by and materializes through concrete cultural forms to which people relate with their senses, and which they employ to make sense (see also Ingold

2012).[1] A great deal of current work tends to be trapped in a mentalistic perspective on the imagination and imaginaries, which generally views the social as an abstraction expressed through collective representations. Throughout the twentieth century, the predominant interest in scholarly inquiry in the social sciences was geared towards the normative or symbolic order underpinning modern societies. The constitutive dimension of artefacts, space and affect/emotions in 'assembling the social' (Latour 2005) tended to be easily overlooked and was barely taken seriously as a focus for research (Reckwitz 2012).[2] Since the 1990s, bodies (and the senses and emotions), material culture, visual culture and spaces have become central foci in scholarly inquiry. I see this shift of focus from rather abstract concepts to the (seemingly) concrete – often referred to by so many 'turns': linguistic,[3] sensory, aesthetic, pictorial, iconic, material, spatial – as indicative of a significant shift in scholarship in the social and cultural sciences. Exhausted by modernist abstract thinking *and* its post-modernist critique, scholars appeared to long for a solid ground, for something tangible. Bodies, objects and spaces were no longer taken as mere signs of the social, but as active agents and forces that shape the social. This is, in my understanding, the driving force of the appeal of the notion of materiality: it assists in putting the social on its feet.

What, then, could the notion of materiality do for approaches to imaginaries and the imagination? Obviously, this complex issue cannot be addressed in full in this chapter. In my understanding, the point is not to simply replace a mentalistic with a material perspective. I reject both a mentalistic and a radical post-human perspective, as proposed by proponents of 'new materialism'.[4] At stake for me is a synthesizing approach that is not reduced to the level of abstract ideas, values, norms and meanings but also takes into account the material forms and practices through which imaginaries are anchored and present in the world.

Third, in order to grasp the processes through which the individual imagination is captivated and imaginaries become persuasive, I developed the notion of 'aesthetic formation'. Its purpose is above all to suggest a methodological procedure that helps to capture 'the formative impact of a shared aesthetics though which subjects are shaped by tuning their senses, inducing experiences, molding their bodies, and making sense, and which materializes in things' (Meyer 2009: 7). As Bruce Kapferer and Angela Hobart put it, 'aesthetic processes highlight not merely that realities are symbolic constructions.... Immanent in the compositional symbolic dynamic of aesthetic construction is *how human beings imagine and form* their existential circumstances to themselves and others. It constitutes both the reality and the emergent possibility of the worlds they come to live' (Kapferer and Hobart 2005: 7; emphasis mine). A focus on aesthetics, understood in the

broad sense of a sensory or *aisthetic* engagement with the world, is fruitful
for gaining deeper knowledge about the actual modes through which hu-
mans 'imagine and form' their everyday lives. In so doing, the imagination
is approached as grounded in aesthetic practice. Of course, I do not adopt
a conventional post-Kantian understanding of aesthetics as situated in a
rather apolitical domain of the arts (e.g. Verrips 2006), but place aesthetics
within a regime that regulates 'the distribution of the sensible', as Jacques
Rancière (2006) put it aptly. What is 'sensible' is not given naturally, but
always subject to authorized selection and distribution in a hierarchy of
power. Placed at the interface of imagination and formation, aesthetic prac-
tices partake in shaping a world. By the same token, aesthetics also offers a
potential for a critique of dominant regimes, by rendering sensible hitherto
unmarked alternative matters.

Lastly, I would like to call explicit attention to the notion of the image.
If shared imaginaries constitute, or effect, social relations, the question is
which role images play in this sharing. An imaginary is shared – and thus
becomes social – by gathering people who imagine in synchronization. This
implies a process of tuning through which individuals incorporate exterior,
material cultural forms as an assemblage of mental images. Here I would
like to introduce the distinction made in the study of visual culture between
the mental image and the physical picture. As Hans Belting points out suc-
cinctly, 'the picture is the image with a medium' (Belting 2011: 10; see also
Mitchell 2005: 85; 2008: 16–18). The point here is that a mental image re-
quires a medium in order to be externalized in a physical form as a picture.
Belting argues that media provide a material body for mental images; this is
the condition for mental images to be expressed and shared, and eventually
to be recognized and incorporated. At the same time, media shape a mental
image in accordance with their technological properties and affordances.

I regard the distinction between image and picture as an excellent starting
point for exploring the interactive relation between the internalization and
incorporation of physical pictures as mental images and the externalization
of mental images as physical pictures (and other cultural forms, including
texts). Being indispensable for the material expression and figuration of
mental images, media are at the centre of the transfer between the contin-
uous incorporation of external pictures and the externalization of internal
images. As Belting succinctly puts it: 'Our internal images are not necessarily
personal in nature, but even when they are collective in origin, we inter-
nalize them in such a way that we come to consider them as our own. We
perceive the world as individuals, all the time making use of the collective
conventions of the day' (Belting 2011: 11). While individuals appropriate
pictures differently, they still use the same pictures. The point is that the
social becomes embodied as personal through media. At the same time, in-

dividuals engage in externalizing their mental images. This is a creative process that, again, depends on the use of media in order to reach out to others.

As material manifestations of mental images, pictures partake in constructing a particular public environment and, in turn, shape the individual imagination, induce sensations and support notions of belonging. The pictures that are part of a particular social imaginary that underpins an environment or habitat are internalized and incorporated as mental images, leaving their imprint on the habitus and its embodied habits of looking at and dealing with pictures. Taking seriously the material dimension of the imagination – the way in which it is expressed in pictures and other cultural forms, shaping a *habitat,* and embodied in people as a *habitus* – allows us to study its world-making capacity in a concrete sense.

What are the implications of this approach for the study of religion, a field in which imaginaries involve an 'otherworld' inaccessible via ordinary sensory perception, and in which material forms, including objects and pictures, have a key role in making that realm tangible?

Religious Objects and Pictures

I have pointed out in recent work (Meyer 2012, 2013) that an approach to religion as a practice of mediation, to which media are intrinsic, has great potential for opening up new methods and theories for a (self-)critical study of religion that acknowledges the importance of materiality. I employ a broad understanding of media that exceeds a common sense definition confined to modern mass media and also includes, for instance, substances, objects, pictures, words, sounds, texts and the human body. Note that this implies not a substantive definition, but rather a fluid approach of media according to which anything can in principle be employed as a medium, understood as a mediator or intermediary that connects what is held to be separate. Imagining a 'beyond' that demands a special mode of access and special acts, religion itself may well be characterized, as Peter Weibel (2011: 33) put it, as a 'medium of absence' that involves a particular infrastructure of transmission which effects some kind of presence of the transcendent (or divine) in the ordinary world. However, the use of media in a religious setting is often overlooked because they are enveloped in a theology of immediacy that stresses a direct encounter between believers and the transcendent 'beyond'. This is characteristic of modern Protestantism in particular, which emphasizes the living word of God, and is highly critical of the use of material objects, such as icons, figurines and sculptures, in other religious traditions.

As pointed out by various scholars, the study of religion itself has long been haunted by a so-called Protestant bias that has espoused a mentalistic

understanding of religion in terms of an inner belief (Asad 1993), privileging spirit above matter and reducing objects to symbols that operate as vehicles of meaning (e.g. Geertz 1973; see Engelke and Tomlinson 2007 for a critique of meaning-centred approaches in the study of religion). The critique of the legacy of this bias yielded new approaches to religious material culture that take into account the constitutive role, for instance, of objects and pictures in shaping religious experiences (e.g. Pinney 2004; Morgan 2010, 2012; Vásquez 2011; Houtman and Meyer 2012).[5] This also entailed a critical engagement with the categories of 'bad objecthood' (Mitchell 2005: 188) – including the notions of the fetish, the idol and the totem – that have long been employed as markers of distinction to express the superiority of modern (Protestant) Christianity above other religious traditions; those that were charged with maintaining a 'primitive' stance to objects as instances with their own will, agency and desires.

These notions are ideological constructs that constitute objects in a particular, dismissive manner. The very same object may be framed differently, and thus have a different role in a religious imaginary. For instance, in the frontier areas of Western outreach, clashes occurred between Western missionaries and local populations, especially around the 'fetish'. Compared to the notions of the idol and idolatry, which have long been intrinsic to Judaism, Christianity and Islam, the term fetish is a recent notion that emerged in the late fifteenth century in the context of the Portuguese presence in West Africa (Pietz 1985, 1987, 1988; Böhme 2006). Deriving from the pidgin term *fetisso,* it is grounded in African-European encounters and exchange. The notion of the 'fetish' was deeply inflected with struggles between Protestants and Catholics about the status of objects in worship (the discourse on idolatry) (Böhme 2006: 183); with the rise of the critique of religion in the name of rationality in the Enlightenment it became the epitome of an irrational attribution of life to an object (which, in turn, inspired Marxian ideas about commodity fetishism, and Freud's thinking on sexual fetishism). Frontier areas of Western outreach are instructive sites to delve into contestations over categories of moral – good and bad – objecthood and the question of the ontology of 'things' at large, and thus, by implication, into conflicts about the role of objects in religious practice (Spyer 1998; Keane 2007; see also Meyer 2012).

In my study of the encounters between nineteenth-century Pietist missionaries of the *Norddeutsche Missionsgesellschaft* and the Ewe in current South East Ghana – place of origin of the 'fetish' – I found that the latter were inscribed into a pre-existing script according to which they were 'idol worshippers' (Meyer 1999). The notions of the idol and the fetish were used interchangeably. Invoking the Second Commandment, the missionaries spoke with disgust about the Ewe's human-made gods. This implied a cri-

tique of fetishism as being a false and dangerous form of worship through which the Ewe linked up with the devil (albeit unknowingly, since they had not yet heard about the Gospel). The missionaries rejected a form of worship in which humans actively engaged in the 'making' of their gods. By contrast, according to Ewe cosmology, in principle all gods required a material vessel in order to enact their power. Humans could access, and partake in generating, this power through certain religious acts (e.g. Blier 1995; see also Barber 1981), including the actual carving or moulding of a figure, its subsequent animation, its regular maintenance through sacrifices and feeding, its worship through repeated incantations, body movements, prayer and so on. Here, human action and objects were indispensable for the gods to be present and act on people.

Exploring these encounters and the local appropriations of Christianity that came out of them through archival and oral history research, I realized that the notion of the fetish was placed in a minefield of contestations about the role of objects in mediating contact with the divine or spiritual. My findings resonate with the point made by Bruno Latour that the 'fetish' was so problematic to Westerners because it violated typically modern distinctions between human-made things and God, between objects and subjects, between construction and reality (Latour 2010). Making or fabricating something – a 'factish' – is not simply an instrumental act in which the maker is in control. It is a generating process in which subjects and objects are mutually constituted, becoming enmeshed with and indistinguishable from one another, and which creates a surplus: 'in all our activities, what we fabricate goes beyond us' (ibid.: 22–23). Humans are shaped by and shape the material world in such dynamics of excess. Thus, Latour suggests, 'we help to fabricate the beings in which we believe' (ibid.: 39).

A focus on religious fabrication rather than on fetishism involves a completely different standpoint for studying human–object relations. It stresses an inalienable mutual interdependency, not only of humans from the figurines, iron bells, moulds and other (human-made and 'natural') forms that render present the gods, but also, according to humans, from the perspective of the gods who need to be maintained and catered for. Framing this interdependency in terms of fabrication leads beyond the dismissive and normative notion of the fetish, towards a more fundamental understanding of how pictures and objects act and have 'wants' (Mitchell 2005) in a religious frame, and beyond. In other words, focusing on fabrication allows for studying the genesis of a sense of extraordinary, super-sensory presence which arises through a complex assemblage of acting and sensing humans, sets of practices and various material media, including objects and pictures.

To conclude, from the standpoint of a material approach to religious imaginaries, objects and pictures are not understood as mere symbols, but

instead as material media that effect and bring into being the reality of the otherworld which these imaginaries envision and claim to help access. The various objects and pictures employed in a religious setting do not have intrinsic power, but they are present and able to engender an extraordinary presence for their beholders. How does this happen, or, in other words, how may an understanding be gained of the genesis of the surplus that ensues from a dynamic of religious fabrication? In order to answer this question, I propose to take the following dimensions into account: (a) the way in which objects and pictures are embedded in a particular religious imaginary; (b) the categories of moral objecthood in which religious objects and pictures are framed and approached; (c) the aesthetic regimes, authorized in a particular religious tradition, through which objects and pictures can show and conceal, and which demand a particular sensory engagement; and (d) the ways in which the aesthetic engagement with objects and pictures – in other words, sensation – ties into making sense.

Desires and Anxieties: The Sacred Heart and Props of the Occult

Nineteenth- and early twentieth-century missionary assaults on traditional worship proved to be successful, and many people turned their backs on local religious traditions and were attracted to Christianity (as part of a broader 'conversion to modernity' [Van der Veer 1996]), but nonetheless retained an understanding of the old gods and spirits as existing entities, albeit 'demonic' ones (Meyer 1999). Next to the classical mission churches, African Independent churches arose that sought to develop a form of Christianity closer to African people's concerns and ways of worship. Since the 1980s, the popularity of these churches has been superseded by the rise of Pentecostal-Charismatic churches. They started to play a central role in shaping the public sphere in the aftermath of Ghana's adoption of a democratic constitution, which entailed the liberalization of media and markets, thereby opening new possibilities for the public manifestation of religion (Meyer 2004; n.d.). This generated a host of Christian-Pentecostal programmes on radio and television, as well as a strongly Christian-oriented public culture and video-film industry.

Born out of a skilful appropriation of cheap video technology that entered the country via Ghanaian migrants to Western countries, this video-film industry emerged at the moment of breakdown of the hitherto state-controlled national film industry. It started to thrive in the context of concomitant democratization and media deregulation, the privatization of the state and the opening up towards neo-liberal capitalism, as well as the phenomenal rise of Pentecostal-Charismatic churches as a major public player

(Meyer 2004). Following the deployment of this industry over a span of fifteen years, I became particularly interested in the interface of cinematic and religious modes of making visible what remains hidden to the naked eye (about which more below). Since these movies remain close to popular life-worlds, they offer a valuable resource for anthropological research. I view them as externalizations of the popular imagination at work, that show how people imagine.

The evolving religious field is diverse and complex. However, certain patterns prevail. Importantly, the missionary discourse about fetishism and idol worship is still employed. The Pentecostals, in particular, owe their popularity at least in part to the fact that they tie into grass-roots Christian understandings – or an 'Africanization from below' – which regards traditional religion as demonic (Meyer 1999). Paradoxically, traditional religiosity is rejected as a matter of the past, but by the same token kept present and alive.[6] Today, the notions of the fetish and the idol are still employed by many Christians, especially those who call themselves Pentecostal and 'born again', to dismiss so-called traditional practices of worship, but in so doing their power is acknowledged. Moreover, notwithstanding the constant emphasis on the part of Christians to affirm their dissociation from traditional worship and powerful religious objects via these terms, the logic of fabrication sketched here is very much at work in grass-roots Christianity, albeit in hidden and indirect ways – and intriguingly exposed in Ghanaian movies.

In presenting this perspective, I do not want to suggest that traditional religiosity is straightforwardly resilient in the present. What I find most striking about the massive conversion to Christianity that occurred in Ghana over the twentieth century is people's preparedness to leave behind the 'old ways', and open up to the colonial promise of 'civilization', the independent nation-state's promise of 'development', and the possibilities of globalization in the neo-liberal era (all entailing their particular ambiguities and disappointments). One of the appeals of Christian conversion was that it offered possibilities for extending beyond the confines of the local, by adopting new techniques of the self that generated new notions of personhood and ways of being in the world. This remarkable preparedness to accommodate and incorporate the foreign is indicative of what Jean-François Bayart described as 'extraversion': 'mobilizing resources derived from their (possibly unequal) relationship with the external environment' (Bayart 2000: 218). For my purposes here – understanding transformations *and* continuities with regard to people's attitudes towards religious objects and pictures – the notion of 'extraversion' is a fruitful starting point. Thinking about these attitudes from this angle defies a simple framework of continuity versus change: if what is continuous is extraversion, change is part of this very continuity.

As indicated earlier, in this third and last part I will turn to two sets of objects: devotional pictures of the Sacred Heart of Jesus, understood to allow beholders to access the divine, on the one hand, and on the other, film props of the occult that are feared to open up a straight alley to the realm of the 'powers of darkness'. Here I do not intend to offer extensive ethnographic accounts, instead I take these sets of objects and how people relate to them as exemplary cases for exploring how religious imaginaries materialize in aesthetic practice.

Pictorial Devotion: the Sacred Heart of Jesus

The well-known motif of the Sacred Heart of Jesus is based on the experience of Jesus appearing to the late seventeenth-century French nun Marguerite Marie Alacoque (b.1647 d.1690; see Morgan 2012: 112–18).[7] Her trance-like experience of pain and pleasure in encountering apparitions of Jesus who presented his bleeding heart to her in her cell (between 1673 and 1675) was mediated via numerous written accounts and paintings. Pompeo Batoni's painting (c.1740), placed in the Jesuit baroque *Chiesa del Gesù* in Rome, is the best known. As a picture authorized to mediate the apparition of Jesus to Alacoque, it became the typical Sacred Heart of Jesus template that spread throughout the world with the Jesuit mission, which strongly promoted the devotion to the Sacred Heart, as well as with other Catholic mission orders. In 1899 Pope Leo XIII consecrated the whole world to the Sacred Heart; in 2006 this was reaffirmed by Pope Benedict XIV. It has circulated not only in the Catholic realm, but also beyond. The possibilities of cheap printing, mostly in China, facilitate its current global circulation.

The picture is a 'global icon' (Haustein 2008) par excellence. It is a picture in a hyper-state of 'transit': an object that moves across time and space, often along with its owners (Svašek 2012: 2–3), by being reproduced infinitely, speaking to millions of people in partly similar but partly different ways. How does it touch ground in Ghana? The Sacred Heart is part of Catholic piety with its authorized devotion to the Sacred Heart, but it is also popular outside of Catholic circles. It appears in several shapes, as stickers, posters, statues and paintings (Meyer 2010; see also Woets forthcoming) and can be seen on cars, buses and canoes, as well as on the walls of shops, beauty salons, market stalls and restaurants. Street vendors sell it in markets and traffic jams (see figure 8.1). On the level of everyday religious practice, Protestants – in Ghana and elsewhere – prove to be less iconophobic than strict Calvinist reformation theology might suggest. Conducting research on the Sacred Heart and other Jesus pictures in the framework of the HERA research programme 'Creativity and Innovation in a World of Movement', on the results of which this volume is partly based,

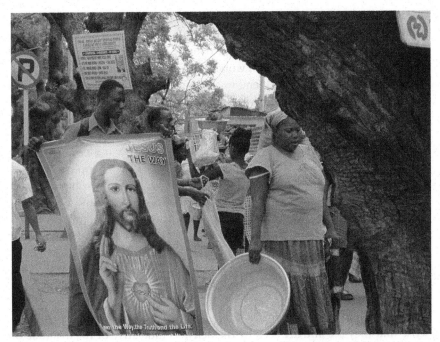

Figure 8.1. Selling Jesus posters in Accra. Courtesy of Birgit Meyer, 2010.

Rhoda Woets and I found that for many Ghanaian Protestants the picture of Jesus is an important material item, placed at the centre of a domestic prayer site, or in a workplace.

The whiteness of Jesus is barely a topic of debate, at least for common people. In the aftermath of the Second Vatican Council (1962–1965), which favoured the use of local aesthetic forms so as to 'acculturate' Catholicism to specific cultural circumstances, Ghanaian Catholic intellectuals and European priests proposed pictorializing Jesus as black. However, the well-known template of the Sacred Heart, and other popular paintings of Jesus (e.g. Da Vinci's *Last Supper*) remained popular through copying and reproduction. Africanizing Christianity does not necessarily entail a black Jesus: in line with indigenous attitudes to gods, a god deriving from elsewhere is regarded as particularly powerful. This also played an important role in the attraction of Christianity as a foreign religion, through which people could link up with a new power source. In line with the logic of 'extraversion', the key issue on the level of popular grass-roots Christianity was not Africanization in the sense of a superficial acculturation that would insist on a black Jesus on the level of visual representation, but in a deeper sense of linking up with a power from outside (see also Meyer 2010: 114–15; Woets forthcoming).[8]

Asked about their attitudes towards the picture of the Sacred Heart, people insist that they do not 'worship' the object itself. The fact that this argument needs to be made over and over again shows how powerful the old missionary discourse on 'idol worship' still is. Many have an affectionate relation with the picture, and tend to attribute it with power and agency: to remind them of what is good when they have something bad in mind, but also giving power to prevent others from doing evil, thus protecting those who put the Jesus picture in their house against robbery and other attacks. Even when a picture is old, people do not like to throw it away, because it is felt to be 'loaded' with so many personal prayers. Often people stress that the power imbued in the picture is due to the look of Jesus: his eyes and those of the beholders meet in a chiastic relation of seeing and being seen. Beholders engage in what David Morgan, in his work on the devotional use of Jesus pictures in popular American Protestantism, called 'looking acts' (Morgan 1998: 8). This is similar to the 'corpothetic' relation which Hindu beholders maintain with regard to mass produced lithographs that present 'photos of the gods' and involve a mutual visual engagement called 'darshan' (Pinney 2004).

I understand this mutual visual engagement, through which beholders sense that they see and are seen by the deity, as indicative of the dynamic of religious fabrication that achieves a surplus and commands belief. Dealing with the picture of the Sacred Heart, even though it is human made and mass produced, resonates with older modes of addressing and catering for the gods in local religious traditions, as suggested in the second part of this chapter. There is an intriguing convergence between traditional notions about the need for the presence of the gods to materialize in some kind of abode, on the one hand, and the capacity assigned to the picture of the Sacred Heart in a Catholic universe to represent the divine apparition of Jesus, on the other. The picture here is taken to be *more* than a sign or symbol, but *less* than the actual bodily presence of Christ. It stands in for his absent body: 'Where the body is absent, the picture takes its place' (Belting 2005: 67; author's translation). As a typical product of the baroque, the Sacred Heart of Jesus engages the gaze of the beholder and leads it astray, towards a 'beyond' – an 'absent truth', as Walter Benjamin put it – that cannot be depicted as such, but only alluded to (van de Port 2012). It seems to me that this, as it were, intrinsic intersubjectivity and potential for transcendence, is what makes the picture so compelling. Reminiscent of Loyola's practices of 'spiritual exercise' that sought to activate the imagination through the senses (Smith 2002),[9] the picture of the Sacred Heart invites a religious engagement via the gaze through which beholders move beyond the limits of what they can normally see (see also Morgan 2012: 120).

In my research on Ghanaian video movies, I found that they mobilize the gaze of the audiences in a similar way, by engaging them in a religious mode of looking that reveals what occurs in the realm of the 'spiritual' which is hidden to the naked eye, and yet held to shape what occurs in the ordinary 'physical' realm (Meyer n.d.). I came across numerous movie scenes that involve the Sacred Heart of Jesus. Take, for example, *The Witches of Africa* (Ebcans Enterprise, 1992), one of the early movies made in the industry about a female witch who seeks to destroy others through witchcraft. The Sacred Heart of Jesus features prominently in it. The film thrives on a typical dualistic structure, in which the witch and the traditional priests to whom she recurs are associated with the devil, and the pastor with the Christian God. The pastor is shown in his church, preaching with zeal, against the background of a picture of the Sacred Heart (see figure 8.2). Many scenes show the witch in action; in order to do evil, she conjures in her head pictures of those she wants to affect (as shown with special effects of photographs being summoned). This is indicative of an idea, widespread in Southern Ghana and beyond (see Behrend 2003, 2013), that taking a photograph may potentially snatch a person's soul or spirit. Accordingly, pho-

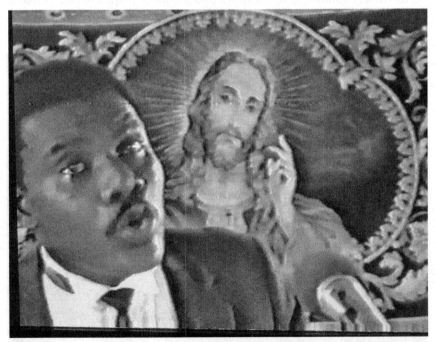

Figure 8.2. Pastor preaching. Still from *The Witches of Africa* (Ebcans Enterprise, 1992).

tographs may also be used as substitutes for a person's presence, and hence – following the logic of sympathetic magic – as targets for doing harm. The movie reveals to the viewers that the actions taken by the witch do not go unnoticed by Jesus: in the midst of a voodoo-like ritual through which the witch tries to affect a man under her spell, the picture of the Sacred Heart is shown to emerge, suggesting that Jesus sees what is going on (see figure 8.3). The movie culminates in a spectacular scene, in which the pastor drives out the spirit of witchcraft from the woman. The success of this prayerful act is shown by a final special effect that moves the picture of the Sacred Heart of Jesus right into her head, suggesting that she is now under His control (see figure 8.4).

The use of the picture of the Sacred Heart in this movie is intriguing. I would like to propose that it lays bare, via the pictorial language of the cinema, how the picture, which is held to epitomize the power of Jesus, is imagined to act and how it acts – literally – in the imagination. It backs the pastor during his powerful sermons and prayers, and is able to look deep into the witch's secret, spiritual machinations; it moves finally into her head. Here an external picture is actually shown to be in motion and in action all the time, culminating in the move into the interior space of the personal spirit, which is imagined as an open space that may be occupied by different forces, evil or good.[10] I take this scene as offering a glimpse of the dynamics

Figure 8.3. Jesus sees. Still from *The Witches of Africa* (Ebcans Enterprise, 1992).

Figure 8.4. Born again. Still from *The Witches of Africa* (Ebcans Enterprise, 1992).

of in- and externalization of images described in the first part of this chapter. The picture of the Sacred Heart is not just a picture out there in the world, but also a mental image that – as the special effect suggests plastically – fills and takes hold of a person's interior. This exemplifies the process of the internalization of external pictures as mental images sketched in the first part of this chapter.

However, the Sacred Heart of Jesus is not always understood in such positive terms. For staunch Pentecostals, the picture is a problematic object, similar to an 'idol' or a 'fetish' that, by virtue of its materiality invites evil forces to inhabit it. They warn against the devotional use of the picture which may, after all, just use Jesus as a mask for a demonic spirit that seeks to take control of a person (Meyer 2010: 121–26).

On Set: Simulating the Occult and the 'Real Thing'

The fear of objects to wield an evil influence on people also comes across on the set of Ghanaian movies, where actors have to handle props that are used to simulate the occult. In the Ghanaian video-film industry, the pro-

ducers (who closely follow the whole process of shooting, and often help
to develop the script, handle the camera and oversee editing), film crew and
actors share the everyday world of their viewers. Resonating with popular
imaginaries and audio-visualizing them on screen, one of the main attrac-
tions of many movies is the attention paid to what is regarded as the realm
of the 'powers of darkness', which are held to operate in secret and generate
a sense of 'spiritual insecurity' (Ashforth 2005). These movies, which adopt
the format of 'revelation', revel in depicting the occult and the horrific,
showing that ultimately the Christian God is superior, and that staunch be-
lievers will be saved. Filmmaking requires building sets, designing costumes
and using props, thereby constructing a material world that involves people
of flesh and blood, tangible things, powerful words and rhythms. This world
is constructed for the purpose of recording motion pictures that are put
together through editing and circulate as films. Even so, during my research
I noted that it was not perceived as an entirely artificial setting from which
film crew and actors could fully dissociate themselves. The film set was ex-
perienced as an ambiguous space, betwixt and between illusion and reality
(see also Pype 2012).

Acting – certainly in those roles involving the occult – required actors to
bracket their personal moral convictions and to enact attitudes they would
normally despise; but many actors could not simply suspend their belief in
the existence of spirits and in the efficacy of certain (speech) acts of conjuring
them. I do not want to suggest that they perceived the film set as a site of per-
manent enchantment. My point is that since they found that imitation could
possibly call into being the 'real thing', they took practical measures – above
all prayer – to keep spiritual forces out of bounds. The aim was to limit the
access of spiritual powers to one's own spirit by generating a kind of spiritual
wall that would prevent evil powers from intruding. Although there was an
agreement that it was absolutely necessary to feature evil characters and spir-
its in movies that set out to reveal the 'spiritual' operation of the 'powers of
darkness', many actors were not eager to take up such roles. Quite a number
of stories circulated about actors who attributed illness to having played such
a role, which was seen to potentially disturb one's spiritual balance.

Likewise, setting up an artificial shrine also invoked the possibility that
what was represented for the sake of the movie assumed a real presence. In-
terestingly, such film shrines bore little visual resemblance to actual shrines
because the latter were not necessarily visually colourful and, in addition,
were often subject to restrictions with regard to audiovisual representation
via photo- and film-cameras (de Witte 2004). By contrast, film shrines were
characterized by a bricolage of elements from Hollywood movies, Indian
films, voodoo imagery, photo-books of African culture, and tourist art (see
figure 8.5). And yet, shrines in films and actual shrines held a crucial feature

Figure 8.5. On the set of *Turning Point*. Courtesy of Birgit Meyer, 2003.

in common: they were understood from within the same basic idea that I sketched earlier in the chapter, which stressed the importance of human acts in setting up an abode for spirits. As noted, in the context of indigenous religious cults, the importance of good craftwork in making sculptures and furnishing a special room for them was regarded as a necessary prerequisite for the gods to come and dwell in these artefacts.

According to the logic that underpinned indigenous worship, human action and material objects were indispensable for getting in touch with spirits. As pointed out, instead of being understood as supernatural forces (that acted, as it were, ex nihilo), spirits were held to depend on the appropriate human acts and use of objects in order to operate. In local religious traditions the human role in making or fabricating the gods and mediating the spiritual was acknowledged, and this stance was extended to the film set. And even though such practices were dismissed in Christian discourse with its anti-idolatry rhetoric, they were still regarded as powerful and able to conjure demons. Recognizing mediation as central to indigenous religious practice implied that setting up a film shrine – even if just for the purpose of a movie – was considered as potentially tricky.

Film shrines were on the verge of flipping from being artificial sites to animated ones. As there were held to be numerous spirits roaming about in search of new dwelling places, one had to take care that they were not attracted to intrude on set and inhabit the props, thereby tuning them into veritable animated 'idols'. At stake is the interference of two opposing logics: while films framed as revelation claimed to offer a superior perspective into the hidden operations of the 'powers of darkness', pinning them down via audio-visual *representation*, the imitation of occult figures and shrines on set was held to potentially generate the *presence* of these powers. Although filmmakers and actors did their best to keep apart the 'real thing' from cinematic representation by praying or making use of certain substitutes, the boundary between the two remained permeable and unstable. The spheres of religion and filming were blurred. Religion being here understood as involving effective human acts, the mimicking of these acts through *acting* was thought to be prone to invoke spirits. While it was the purpose of movies to come over as a realistic depiction of how the normally hidden dimension of the occult was imagined to be, the performance of likeness required on the film set was understood as problematic because it was held to be likely to actually generate the original.

Conclusion

Rejecting an understanding of imaginaries and the imagination as mere mental phenomena, I argued that pictures and objects – as material media without which mental images could not be expressed or shared – are suitable entry points for a more balanced approach. Zooming in on pictures of the Sacred Heart of Jesus and props used to picture the occult, I sought to point out that these items are not only materially present, but also effect a sense of some kind of spiritual presence – be it desired or feared – to their beholders. As material media, they 'take place' in the here and now and, in so doing, point to an otherworld that is not visible to the naked eye, but becomes accessible via a super-sensory engagement. This engagement is grounded in a particular, transmitted and shared religious aesthetic that shapes the habitus of the people involved and paves the way for them to experience an encounter with the divine or occult. Outside of this religious aesthetic, which revolves around its pictures and objects but cannot be reduced to them, one might just see one of so many cheap, mass-produced posters or a simple prop. The possibility to see and sense more – to one's delight or horror – depends on taking these items as anchor points of a shared religious imaginary, according to which they are meaningful and held to

operate in a specific way. Such a shared imaginary shapes the way in which objects are valued and treated, and at the same time it depends on those objects so as to become shared and real.

In my understanding there is a no fundamental difference between the role of objects and pictures in a religious imaginary and in a non-religious one. From the perspective of mediation, all pictures and objects act as media that are materially present *and* point beyond themselves; they are both immanent *and* transcendent, tangible *and* elusive. While shared imaginaries are necessarily grounded in pictures and objects, these material items are not just there, in their sheer materiality, but reach out to something else. It is intriguing to explore how, in our entangled and globalized world, ever more and different pictures and objects are employed as material media for articulating and, indeed, fabricating new and old imaginaries. A fruitful analysis of such processes, I would like to propose, requires taking into account the complicated interlocking of both the materiality of the imagination and the imaginary dimension of matter.

Notes

This chapter is based on research conducted in the context of the HERA research programme 'Creativity and Innovation in a World of Movement'. With many thanks to Øivind Fuglerud and Leon Wainwright for encouraging me to contribute to this volume, and to Rhoda Woets for valuable comments on an earlier version.

1. Tim Ingold, in his recent introduction to *Imagining Landscapes*, proposes a view of the imagination as 'not just the capacity to construct images, or as the power of mental representation, but more fundamentally as a way of living creatively in a world that is itself crescent, always in formation', the point being that to imagine means 'to participate from within, through perception and action, in the very becoming of things' (Ingold 2012: 3). His formative take on the imagination, which is tied to a phenomenological understanding of the relation between people and the world, resonates with my view that the imagination is not a mere mental affair, but part of a process of actual world-making (or 'fabrication', see below). However, as will be pointed out below, I would insist that this process is not direct and immediate (as suggested in the phrase 'from within') but depends on mediation and media.

2. I regard this concern with an abstract order as a secular version of a modernist mentalistic understanding of religion, as it was formulated in Durkheim's notion of the sacred (understood as the norms and values set apart at the centre of social life) or in Weber's 'Protestant ethic' which transformed into the secularized spirit of capitalism. See the next section for a critique of this de-materialized, abstract understanding. See also Meyer and Houtman (2012).

3. Often the linguistic turn is (mis)understood as a turn to 'mere' discourse. Protagonists of subsequent 'turns' tend to mobilize a focus on the body, the senses, pictures and things as a critique of the linguistic turn, which is criticized for being indebted to a Saussurian understanding of language as a symbolic code that is geared to representation, and hence understood as distanced from the 'real' grounds of existence. However, there are good reasons to argue that language itself is not merely a system of representation, but a generator of presence. I think that the quite dazzling emergence of all these 'turns' betrays a larger issue that has haunted modern thinking since the Reformation: the relation between representation and being.

4. My reservations stem from the fact that, as an anthropologist, my main interest is to understand the dynamics of world-making. This involves complex relations between people and things that cannot be reduced to either human intentionality and imposition of meaning or to acting objects and living matter. Still, I seek to grasp how *humans* make and live their worlds.

5. The foundation of the journal *Material Religion* in 2004, of which I am one of the editors, is also indicative of this trend.

6. Intriguing differences exist between popular grass-roots versions of Christianity and the understandings of intellectuals and artists. While the former tend to strongly reject indigenous religious traditions exactly because they take seriously the existence of gods and spirits, the latter profess a more positive attitude, but do not necessarily believe in the existence of these beings.

7. This section is based on research conducted together with Rhoda Woets on pictures of Jesus in Ghana. For a more extensive presentation of this material see Meyer (2011) and Woets (forthcoming).

8. In an interview with missionary Koos Franssen (conducted by Rhoda Woets and myself at the SMA mission house, Kadier en Keer, 27 January 2012), he told us how he sought, in vain, to introduce African sculptures and other forms based on local aesthetics. He noted to his dismay that after his retirement (in the mid-1980s) what he called 'Italian kitsch' – including the Sacred Heart – quickly took over.

9. The aim of Loyola's spiritual exercise (developed prior to 1540, and published in 1548) was to invoke the senses so as to invoke a vivid mental image of, for instance, the suffering of Christ. In this way, spiritual matters achieved a plastic form in the imagination. There is a clear thread that connects Loyola's notion of spiritual exercise, Alacoque's vision, and Batoni's painting, bringing together the senses, the imagination and the picture.

10. In the confines of this chapter, it is impossible to lay out the notion of personhood that underpins this imaginary. Suffice it to note here that, generally, there is the idea of the person as permeable to outside influences. A person's spirit is conceived as an open space, like a room, that may be occupied either by a good or demonic spirit. The practice of deliverance, prominent in Pentecostal circles and beyond, is intended to free a person's spirit, with the help of the Holy Spirit, from an evil occupant and turn him or her into a born-again Christian (see also Meyer 1999).

References

Anderson, B.R. 1991. *Imagined Communities: Reflections on the Origin and Spread of Nationalism*. London: Verso.

Appadurai, A. 1996. *Modernity at Large: Cultural Dimensions of Globalization*. Minneapolis: University of Minnesota Press.

Asad, T. 1993. *Genealogies of Religion: Discipline and Reasons of Power in Christianity and Islam*. Baltimore, MD: Johns Hopkins University Press.

Ashforth, A. 2005. *Witchcraft, Violence, and Democracy in South Africa*. Chicago: University of Chicago Press.

Barber, K. 1981. 'How Man Makes God in West Africa: Yoruba Attitudes towards the òrìsà', *Africa: Journal of the International African Institute* 51(3): 724–45.

Bayart, J.-F. 2000. 'Africa in the World: A History of Extraversion', *African Affairs: The Journal of the Royal African Society* 99(395): 217–67.

Behrend, H. 2003. 'Photo Magic: Photographs in Practices of Healing and Harming in East Africa', *Journal of Religion in Africa* 33(2): 129–45.

———. 2013. *Contesting Visibility: Photographic Practices on the East African Coast*. Bielefeld: Transcript.

Belting, H. 2005. *Das echte Bild: Bildfragen als Glaubensfragen*. Munich: C.H. Beck.

———. 2011. *An Anthropology of Images: Picture, Medium, Body*. Princeton: Princeton University Press.

Blier, S.P. 1995. *African Vodun: Art, Psychology, and Power*. Chicago: University of Chicago Press.

Böhme, H. 2006. *Fetischmus und Kultur: Eine andere Theorie der Moderne*. Reinbek and Hamburg: Rowohlt Taschenbuch Verlag.

Castoriadis, C. 1997. *The Castoriadis Reader*. Oxford: Blackwell Publishers.

Engelke, M.E., and M. Tomlinson (eds). 2007. *The Limits of Meaning: Case Studies in the Anthropology of Christianity*. Oxford: Berghahn Books.

Geertz, C. 1973. *The Interpretation of Cultures: Selected Essays*. New York: Basic Books.

Haustein, L. 2008. *Global Icons: Globale Bildinszenierung und kulturelle Identität*. Göttingen: Wallstein Verlag.

Houtman, D., and B. Meyer (eds). 2012. *Things: Religion and the Question of Materiality*. New York: Fordham University Press.

Ingold, T. 2012. 'Introduction', in M. Janowski and T. Ingold (eds), *Imagining Landscapes: Past, Present and Future*. Farnham: Ashgate, pp. 1–18.

Kamper, D. 1981. *Zur Geschichte der Einbildungskraft*. Munich: Carl Hanser Verlag.

Kapferer, B., and A. Hobart. 2005. 'Introduction: The Aesthetics of Symbolic Construction and Experience', in A. Hobart and B. Kapferer (eds), *Aesthetics in Performance: Formations of Symbolic Construction and Experience*. New York and Oxford: Berghahn Books, pp 1–22.

Keane, W. 2007. *Christian Moderns: Freedom and Fetish in the Mission Encounter*. Berkeley: University of California Press.

Latour, B. 2005. *Reassembling the Social: An Introduction to Actor-Network-Theory*. Oxford: Oxford University Press.

————. 2010. *On the Modern Cult of the Factish Gods.* Durham, NC: Duke University Press.

Meyer, B. 1999. *Translating the Devil: Religion and Modernity among the Ewe in Ghana.* Edinburgh: Edinburgh University Press.

————. 2004. '"Praise the Lord": Popular Cinema and Pentecostalite Style in Ghana's New Public Sphere', *American Ethnologist* 31(1): 92–110.

————. 2009. 'Introduction: From Imagined Communities to Aesthetic Formations: Religious Mediations, Sensational Forms and Styles of Binding', in B. Meyer (ed.), *Aesthetic Formations: Media, Religion, and the Senses.* Basingstoke: Palgrave Macmillan, pp. 1–28.

————. 2010. '"There is a Spirit in that Image": Mass-produced Jesus Pictures and Protestant-Pentecostal Animation in Ghana', *Comparative Studies in Society and History* 52(1): 100–130.

————. 2012. *Mediation and the Genesis of Presence: Towards a Material Approach to Religion.* Utrecht: Utrecht University.

————. 2013. 'Material Mediations and Religious Practices of World-making', in K. Lundby (ed.), *Religion across Media: From Early Antiquity to Late Modernity.* New York: Peter Lang, pp. 1–19.

————. (forthcoming). *Sensational Movies: Video, Vision and Christianity in Ghana.* Berkeley: California University Press.

Meyer, B., and D. Houtman. 2012. 'Material Religion – How Things Matter', in D. Houtman and B. Meyer (eds), *Things: Religion and the Question of Materiality.* New York: Fordham University Press, pp. 1–23.

Mitchell, W.J.T. 2005. *What Do Pictures Want? The Lives and Loves of Images.* Chicago: University of Chicago Press.

————. 2008. 'Four Fundamental Concepts of Image Science', in J. Elkins (ed.), *Visual Literacy.* New York: Routledge, pp. 14–30.

Morgan, D. 1998. *Visual Piety: A History and Theory of Popular Religious Images.* Berkeley: University of California Press.

———— (ed.). 2010. *Religion and Material Culture: The Matter of Belief.* New York: Routledge.

————. 2012. *The Embodied Eye: Religious Visual Culture and the Social Life of Feeling.* Berkeley: University of California Press.

Pietz, W. 1985. 'The Problem of the Fetish Part I', *Res: Anthropology and Aesthetics* 1985(9): 5–17.

————. 1987. 'The Problem of the Fetish Part II: The Origin of the Fetish', *Res: Anthropology and Aesthetics* 1987(13): 23–45.

————. 1988. 'The Problem of the Fetish, Part III: Bosman's Guinea and the Enlightenment Theory of Fetishism', *Res: Anthropology and Aesthetics* 1988(16): 105–24.

Pinney, C. 2004. *Photos of the Gods: The Printed Image and Political Struggle in India.* London: Reaktion.

Port, M. van de. 2012. 'Genuinely Made up: Camp, Baroque, and Other Denaturalizing Aesthetics in the Cultural Production of the Real', *Journal of the Royal Anthropological Institute* 18: 864–83.

Pype, K. 2012. *The Making of the Pentecostal Melodrama: Religion, Media and Gender in Kinshasa*. New York: Berghahn Books.

Rancière, J. 2006. *The Politics of Aesthetics: The Distribution of the Sensible*. London: Continuum.

Reckwitz, A. 2012. 'Affective Spaces: A Praxeological Outlook', *Rethinking History* 16(2): 241–58.

Smith, J.C. 2002. *Sensuous Worship: Jesuits and the Art of the Early Catholic Reformation in Germany*. Princeton: Princeton University Press.

Spyer, P. (ed.). 1998. *Border Fetishisms: Material Objects in Unstable Spaces*. London: Routledge.

Svašek, M. 2012. 'Introduction: Affective Moves: Transit, Transition and Transformation', in M. Svašek (ed.), *Moving Subjects, Moving Objects: Transnationalism, Cultural Production and Emotions*. New York: Berghahn Books, pp. 1–40.

Taylor, C. 2002. *Modern Social Imaginaries*. Durham, NC: Duke University Press.

Vásquez, M.A. 2011. *More than Belief: A Materialist Theory of Religion*. Oxford and New York: Oxford University Press.

Veer, P. van der (ed.). 1996. *Conversion to Modernities: The Globalization of Christianity*. New York: Routledge.

Verrips, J. 2006. 'Aisthesis and An-aesthesia', *Ethnologia Europea* 35(1/2): 27–33.

Weibel, P. 2011. 'Religion as a Medium: The Media of Religion', in B. Groys and P. Weibel (eds), *Medium Religion: Faith, Geopolitics, Art*. Cologne: Distributed Art Publishers, pp. 30–43.

Witte, M. de. 2004. 'Afrikania's Dilemma: Reframing African Authenticity in a Christian Public Sphere', *Etnofoor* 17(1/2): 133–55.

Woets, R. (forthcoming). 'The Moving Lives of Jesus Pictures in Ghana: Art, Authenticity and Animation', in M. Svašek and B. Meyer (eds), *Creativity in Transition*. Oxford: Berghahn Books.

PART III

ART

9

ART AS EMPATHY
IMAGING TRANSFERS OF MEANING AND EMOTION IN URBAN ABORIGINAL AUSTRALIA

——◄•◆•►——

Fiona Magowan

This chapter will argue that moving is key to creative empathy among suburban-based Aboriginal artists[1] as they make, imagine and shape fragmented identities and (re)connect with others. It compares the paintings and narratives of artists, who were exhibiting at the Tandanya Art Fair,[2] as they reflect upon the ongoing effects of Acts of Parliament that led to children being taken from families from the mid-1800s to the mid-1970s.[3] Known today as the 'Stolen Generations', some of the artists have experienced the impact of forced removal from their families and some are grandchildren of forcibly removed grandparents. The long-awaited historic Apology, in February 2008 by Prime Minister Kevin Rudd, acknowledged these atrocities and created an arena for renewed efforts around reconciliation agendas and events. This gesture led to calls for shared responsibility as an engagement of shared power (see Chaney 2009) and has since provided public opportunities for artists and musicians to express their own aesthetics and poetics of Aboriginality.

The argument brings into focus one public context which has facilitated the expression of emotions as well as providing the potential for empathetic exchange. Many of the suburban-based artists exhibiting at the Tandanya Art Fair in Adelaide engage with viewers and audiences to depict the effects of migratory experiences of relatives and make sense of their own life journeys. Firstly, I analyse how these artists' moving stories of dispossession and

hope invite others to engage with their poetics of Aboriginality as their nar-
ratives speak to 'particular cultural meanings, beliefs and practices' (Throop
2010: 772); secondly, I consider how place-memories are captured in colour
and texture to evoke feelings of nostalgia and longing, as well as desires and
hopes for relatives and country; thirdly, I examine how artists invite open-
ended dialogue in art, with a view to facilitating respect and empathy from
buyers (see Mattingly 2008).

Contextualizing Empathy

In their recent volume on empathy in the Pacific, Hollan and Throop (2012)
outline the contested concept of empathy, noting that it is a particularly elu-
sive state and little consensus has been reached about its definition. Philos-
ophers argue as to whether empathy is an unmediated feeling or whether it
is prompted by historical and cultural knowledge (ibid.: 2). Halpern (2001:
91–92) posits that it is a bodily response of emotional and cognitive res-
onance providing the conditions for imagining another's experience and
that, more specifically, it requires the situatedness of dialogue with another,
enabling a first-hand experience of their thoughts and feelings (Hollan and
Throop 2012: 4). Throop (2010: 780) has cautioned that empathy is not a
unilinear process of adopting the thoughts and feelings of others, and that
'homologous experiences' do not necessarily result in mutual respect or
appreciation. Questions remain then, about the extent to which one might
be able to imagine another's context and accurately assess the experience of
others.

In addressing this problem, Hollan and Throop (2012: 4) employ Stue-
ber's (2006) analysis of empathy as a complex process that embodies a
distinction between its 'basic' and 'reenactive' elements. 'Basic' mechanisms
are those that enable one person to recognize and identify with the emo-
tional states of others while 'reenactive' capacities are those that provide
an explanatory model or rational interpretation about why another person
responds and acts in a particular way in relation to their environment. This
distinction is useful in analysing suburban artists' responses to their works
as it informs differences between narratives *of* art and narratives *about*
art. It also seeks to avoid reducing empathy to a particular condition of
sympathy or pity but rather opens up the complexity and fluidity between
different kinds of emotional responses and rationalizations. When telling
stories of their art, artists describe how they feel about particular pieces of
art which viewers then seek to relate to in a 'basic' mode by identifying with
their emotional responses to the piece as described by the artist. However,
it is only as artists provide broader narrative contexts for the art that the

'reenactive' potential of empathy comes into play. As artists explain the catalysts behind the work, rather than the meaning of the work per se, viewers also draw upon the 'reenactive' dimensions of empathy to appreciate the motivating factors and modelling responses that shape artistic expressions. It is, in part, the non-transparency of the image that invites viewers to look behind the work and explore artistic intention in order to make sense of their emotional responses. Just as viewers seek to understand how they respond to artists' works, so the artists discussed in this paper also draw upon 'reenactive' capacities as they rationalize and provide models for their own emotional responses to their environments and those who have shaped their experiences within it. Empathy thus entails the power relations of history, culture and identity politics as artists negotiate the extent to which they reveal certain aspects of their lives to others. In some situations, concealing emotions may also inadvertently draw attention to their absence and may in fact constitute a means of revealing particular kinds of intent (cf. Rumsey 2008). Thus, Hollan and Throop (2012: 8) posit that, 'Empathy is an ongoing, dialogical, intersubjective accomplishment that depends very much on what others are willing or able to let us understand about them'. In the case of suburban-based Aboriginal artists, empathy is shown to be a mix of doing and performing the self in an effort to connect with viewers and bring awareness to them and the nation about the history of Indigenous artists, as well as to re-establish the legitimate place of Aboriginal people within it.

The suburban-based Aboriginal artists discussed here express conflicted emotions through place-related imagery as they have experienced the effects of forced removal from their families, while others are grandchildren of removed grandparents. They bring diverse histories of themselves and the members of their families to bear upon their aesthetic forms. In a musical context, Barney and Mackinlay (2010) have described how members of the Stolen Generations sing about personal trauma and losses of culture and identity but there has been little analysis of how those who self-identify as Stolen Generation artists use aesthetics to convey their emotional reactions to past events. We shall see how exhibiting artists witness to the pain of dislocation, while seeking to transform attitudes in processes of sharing and artistic exchange. I analyse how artists make sense of colour to evoke senses of empathy about being-in-place, belonging-to-place and returning home in emotional life-journeys. I show how they redefine and reclaim their rights in the present, as well as in the migratory pasts of their relatives, challenging hegemonic cultural readings of suburban Aboriginal art. By examining how moving affects empathy in artistic narratives, this perspective seeks to redress a lacuna in the analysis of Australian art in which scholars seldom discuss 'the beauty of the art *and* the often appalling conditions in which it was made' or imagined (McLean 2011: 13, my emphasis). It also aims to

highlight the context of (post)colonial traumas and struggles that have de-
fined the impetus and conditions for artistic production and set the context
in which empathetic exchanges can take place.

Problematizing 'Migratory Aesthetics'

In October 2010, the impassioned sound of an Aboriginal rock ballad drew
me towards Adelaide's Tandanya Cultural Centre to a grass verge beyond,
where a gateway of two red 'kangaroos', standing seven metres tall, made
of strips of orange and white cloth wrapped around cane and wire frames,
welcomed passing visitors. *Tandanya* is the Kaurna name for kangaroo
which, for me, located the ontological form of these mammmals as the spir-
itual guardians of the festival site, in contrast with their more ambivalent
position on the coat of arms over the entrance to Parliament House.[4] Five
awnings were grouped together in a semi-circle, their backs to the road,
playing host to the visiting Aboriginal artists and providing an enclosure for
a free-seating area where performers sang and spoke about their homelands,
backgrounds and identities to the predominantly Aboriginal audience. This
site of the second Tandanya Art Fair brought South Australian Aboriginal
artists together with Aboriginal artists from across Australia, as well as
art advisers, curators and enthusiasts. The setting of the fair struck me
as unusual, being positioned beside a major road intersection with traffic
streaming along different routes into and away from the city. The Adelaide
populace bustled past, most seemingly oblivious to the creative energies of
aesthetic exchange inside.

For the artists and performers, Tandanya's liminally located exhibition
ground offered a welcoming niche in which they could explore a transient
and temporary space of Indigenous belonging. Given the representation
of Indigenous artists from every state across the continent, the exhibition
itself constituted a microcosm of 'migratory aesthetics' (see Bal 2008).[5] This
concept has been analysed as the 'various processes of becoming that are
triggered by the movement of people and places' (Durrant and Lord 2007:
11). Many artists had travelled long distances to attend the Art Fair, and the
exhibition area further created an illusion of pan-Indigeneity through the
juxtaposition of artistic genres in spite of the cultural specifics of Aboriginal
practices. This melting pot of Aboriginal identities celebrated diversity and
offered the opportunity for exhibitors and viewers to gain a better apprecia-
tion of the relationship of Aboriginal people to places across different parts
of the continent as expressed through their art.

Ideas of travel and movement have long been expressed in Aboriginal
designs and it could be argued that a 'migratory aesthetic' is to a large ex-

tent an inherent dynamic of Aboriginal works since relationships with the land are foundational to personal and spiritual identity. Knowledge of this relationship has been analysed mainly in so-called 'traditional' contexts in which aesthetic cartographies of belonging and iconographies of mental mapping indicate rights of access to land, resource use, affiliation and ritual knowledge (see, for example, Sutton 1998). The aesthetics of movement have also been discussed in terms of performing ritual maps (Munn 1986; Morphy 1991); in chronological art movements that chart the aesthetic developments in an individual's style and ideology over time (Johnson 2010); and in surveys of change, fusion and innovation in genres (Willsteed 2004).

The understanding that Aboriginal groups in remote communities paint ancestral laws and rights to land has led scholars to align spirituality with ideas of 'tradition' or 'the Law'. An integration of spirituality in art means that artists and performers are understood to be vehicles *for* creativity (cf. Rudder 1993; Keen 2003; Dussart 2007; Morphy 2008) as much as being creators of their works.[6] Ritual contexts of authorization also legitimize remote artists' rights to paint (cf. Morphy 1991; Glaskin 2010). But the question remains, how do suburban-based artists who no longer have regular contact or direct involvement with their ancestral lands or their spiritual foundations create intimacy in artistic sentiment and legitimize their connections to remote places? How do they evoke emotional continuities or discontinuities of genealogical, biographical and ecological relatedness and distance? What role does storytelling play in this process?

Capturing Bittersweet Enchantment

For exhibiting artists, narratives *about* artwork and narratives *of* artwork are often highly skilful performances, just like the production of the artworks themselves. They have the potential to regulate the political and moral orders of 'emotion-talk' between interconnected and intercultural selves (Lutz and Abu-Lughod 1990: 13). As I will show later on, in an Aboriginal context educational narratives *about* paintings can facilitate a poetics of inner reflection upon trauma and restitution. These feelings can be contrasted with descriptive narratives *of* artworks and associated emotions that explain the artistic composition of images. A number of Aboriginal artists at the Tandanya Art Fair viewed talking about paintings as a specific kind of ethical behaviour towards belonging and empathy. By engaging with narratives of what their art means, suburban-based artists explained how they could educate the public about Aboriginal issues and also elaborate further on their personalized narratives about art that conveyed senses of identity and belonging that they felt might lead viewers to recognize and respect

cultural difference. To generate awareness of this ethical engagement, artistic narratives entailed 'making special' (Dissenayake 2000) those moments of encounter. Some artists considered that through such encounters they could inspire the potential in viewers for transformation and enchantment that might change how they and other Aboriginal people are imagined in the nation.

For these artists, a sense of enchantment was dependent upon prior recognition and acknowledgement of government policies in relation to the Stolen Generations that had impacted upon their families and effected their own separation from their ancestral country. Some historians have tended to superimpose a uniform view that missionaries in Australia were responsible for cultural loss in Aboriginal communities due to an autocratic dormitory system, a view which has proven partially erroneous as other scholars have detailed the nuances and considerable flexibility that existed in various missions' rules and practices. The mission dormitory system that existed from the mid-1800s to 1970s meant that boys and girls were segregated, although degrees of freedom and volition of residency differed between states, depending upon the mission superintendent in charge. Nonetheless, the dormitories could not but result in the dislocation of children from everyday cultural routines, language use, ritual involvement and performance practices. The unforeseen emotional impacts of these encounters were to have ramifications for every aspect of Aboriginal lives, not least in the domain of art. As those members of the dormitory systems became part of their white urban surroundings, so they were faced with the dilemma of how to engage with hegemonic and unfamiliar cultural practices. In seeking emotional release some suburban-based artists have turned the traumatic effects of this period into a motivation to paint and to find healing and empathy with Aboriginal and non-Aboriginal viewers alike. This dimension can be seen especially in the growing participation of Aboriginal women in art, which gives them the opportunity to express their knowledge of families, homelands and lost histories whilst benefiting from the bittersweet emotional release that art offers (see also, Hutchinson 1998).

Emancipation in Aboriginal Art

One of the exhibiting Tandanya artists, Daphne Rickett, has explored powerful Ngarrindjeri[7] analogies of healing the hurts of the past in 'weaving' together strands of experience, using bodily metaphors of moving physically and emotionally through the landscape in pathways, trees and branches of life. This process of weaving art and identity through a landscape of emotional journeys is a hallmark of many female painters in their desire to com-

municate their sense of belonging in the world. Renowned Sydney artist, Bronwyn Bancroft commented: 'The things that I create are all personal stories, some understood, some not ... I just allow my creative drive to take me on continuous journeys that enable me to tell stories from what is instinctively in my heart. The journey to be human, to feel, to be Koori' (Bancroft 1990).

Themes of healing also run through the work of male painters who seek to turn the pain of 'migratory aesthetics' into educational benefit for others through story-images. Another Tandanya exhibitor, forty-year-old Adelaide-based artist, Burthurmarr[8] Christopher Crebbin, views painting 'as a language' which he uses to reflect upon the effects of being a member of the Stolen Generations. He combines image-making with stories of his travels. Born in Sydney and attending school in Brisbane and Townsville, Crebbin has also lived in Devon in the U.K. and now has a son in South Australia and a daughter in Torquay. The child of a white Australian father, his activism is borne out of the feelings of injustice meted out to his Aboriginal grandmother who was taken from Mornington Island to Palm Island when she was pregnant. It is ironic, however, that the pain of colonial hegemony has shaped an emotionally painful practice whose images are now desired by non-Aboriginal purchasers. Many artists' traumas, fears and recollections of the controls and constrictions placed on many of their family members by austere colonial state policies echo behind their images, paradoxically circumscribed, at one level, by the symbolic violence of artistic exchange.

Crebbin, who has been painting since 1991, explained how the artistic process allowed him to work with deeply emotional experiences and social philosophies. He created *Suburban 2.1* in 2007, he told me, as a commentary on the paradox of individuals' attempts to gain freedom from an environment which is being destroyed by state control. He considers that Western individualism creates chasms in relationships, which he depicts in boxes in his painting (see figure 9.1). Adopted by the organizers of the Tandanya Art Fair as the design for their promotional leaflet and internet materials, his painting begins from the moonlit Australian spinifex on the right which becomes engulfed by plots made up of squares and rectangles conveying a sense of reductionism as people move from wide expanses and thousand-acre properties to smaller blocks and eventually to suburban sites. Crebbin commented:

> This one is *Suburban 2.1*. It's full of all different types of metaphors with the city burning and the birds are a signpost there to say they are being controlled ... There are trees down there in a little square but they are being felled to clear ground. The trees are shaped like fish – not normal fish but square controlled fish – living together but controlled within the boundaries of each of those shapes. (Crebbin in interview, 23 October 2010)

Figure 9.1. *Suburban 2.1.* Acrylic on canvas. Collection of the artist. Image courtesy of Christopher Crebbin. Photograph by Fiona Magowan.

While Crebbin's painting depicts negative feelings of constriction and containment, it is also inspired by desires for freedom, fuelled by the vision of possible emancipation from the postcolonial Australian context which he relates to the Aboriginal struggle for liberation. His art reflects his aspirations to influence and educate Aboriginal and non-Aboriginal alike to work against the grain, generating a utopic vision that, nevertheless, is itself a praxis of coercive power (Ashcroft 2009: 16). His 'hidden transcript' evokes his 'imaginal world' of trauma and healing (Csordas 1994: 162) and offers personal testimony along with a critique of power (cf. Scott 1990). Thus, I would suggest that suburban-based Aboriginal creativity is intimately shaped not only by identity politics but by a sense of self-presence and co-presence with others (Csordas 1994: 14). This kind of 'making-special' relies upon how artists imagine the emotional impacts of their work in transforming others, in addition to the aesthetic transformation of ordinary elements such as the body, nature and common artefacts into another form and purpose (Dissenayake 2000: 30–31). Painting can, thus, be a vehicle for expressing psychological reflections and shaping moods about autobiographical backgrounds. As Crebbin continued:

> Emotionally yeah, at the time when I did this painting, I was quite angry with the reds and blacks – you can see that. I was down on my luck. I had separated from my ex-wife and so forth and I was missing my two children – I've got one back now. The red of the flames of the city shows how I felt about the city and what I thought people were doing to the city at the time. (Burthurrmarr interview, 24 October 2010)

Crebbin told me how his works 'are very tactile, to do with texture that you can't get from a print'. Thus, his depictions of migration are enhanced by an intersensorial aesthetic: the viewer is literally invited to feel the movement in his works in the changing textures of the canvas. He considers that the combination of touch and sight creates a complex emotional engagement with his paintings. He distinguishes between uncontrolled 'environmental emotions', metaphorically perceived in natural forces in the world, and 'manipulated emotions', which are reactive human responses to external states that need to be kept in check. In the case of *Suburban 2.1*, for example, red is multivalent, representing both the environmental emotion of anger in fire and his anger and discontent with state regulations of space and governmental constraints imposed upon human freedoms. This attribution of emotional agency to a sentient environment resonates with extensive writings in other parts of Australia on the politics of sentiment in spiritually animated country (cf. Dussart 2000; Myers 1986, 2002; Holcombe 2003). Aboriginal artistic perceptions of environmental sentience expand the interactive energy of human emotion within the world, subsuming the effects of 'unnatural emotions' within a sentient landscape;[9] for example, in *Bush Fire* (figure 9.2), Crebbin explains how flames of anger pulse up the sides of the

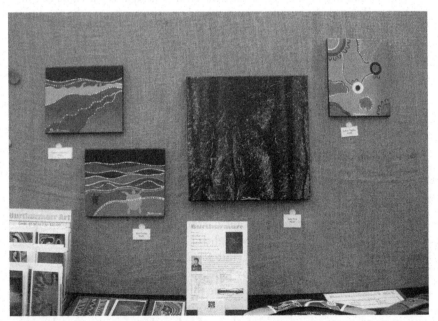

Figure 9.2. Display by Burthurmarr. The largest painting on the wall, *Bush Fire* (centre), is flanked on the left by two turtle pictures. Acrylic on canvas. Collection of the artist. Image courtesy of Christopher Crebbin. Photograph by Fiona Magowan, October 2010.

stringybark trees completing his emotional relationship to place rather than being emotion out of place.

Empathy as Personal Journey

For Crebbin, heated emotional dynamics are heard and felt in the land as it turns hot, crackles and roars. These colours of his emotional palette are juxtaposed with the blue lapping of the ocean in tones and rhythms of peace and calm that he says soothe the pain of dislocation and the nostalgia for return as expressed in his turtle paintings. Hope is a journey embodied in the homologous image of himself as a turtle, whose animation as a navigator, seafarer and traveller continues to fuel his desire to return to north Queensland to affirm his sense of home and belonging. Strong feelings of hope and despair are also strikingly imaged in colour contrasts of blue and black:

> Looking up through the water at the moon ... it's very bright and it's that ratio of light to dark that makes it glow. The more light you have the greater the dark appears, and the more dark you have the greater the light is – it's a bit like life... You need that dark, just like you need hard times to appreciate the good times. (Crebbin in interview, Adelaide, 23 October 2010; see figure 9.3)

Crebbin's reflections are intended to be outward looking and mutually constitutive of others through the intersubjective impact of his work. He notes: 'That's what I really enjoy, affecting people on an emotional level and having people that, actually, when they have a painting in their home, it becomes more of an emotional tie than just a decoration'. In negotiating identity politics with buyers, artists like Crebbin deliberately reflect and comment upon the emotional impact of their aesthetic forms. Crebbin explained how viewers could find ways of identifying with his works in the sharp colour contrasts and that he wanted them to appreciate the motivations and aspirations that lie behind his images. In storytelling he believes that empathy is made possible as his narratives about art challenge colonial discourses, instead reasserting the rightful authority of the signs of Indigenous knowledge (see Townsend-Gault 1992). Thus, the acquisition of suburban-based Aboriginal paintings by non-Aboriginal purchasers could be said to invite a shared exposure of belonging through environmental images, that Bennett (2011: 12) has called 'being-in-common'. This process seeks to draw 'stranger-encounters' into an interface of cultural appreciation and inquiry (ibid.: 121).

This ethos was espoused by fifty-year-old Adelaide-based artist/musician, Conrad Blackman,[10] who noted the satisfaction gained from creative transmission: 'If someone's gone to the trouble of buying a painting and frames

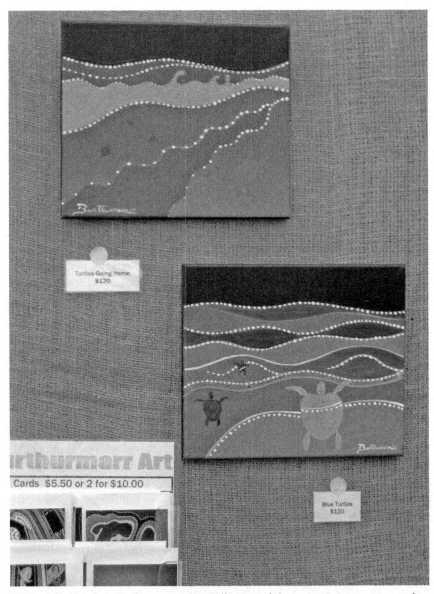

Figure 9.3. *Turtles*. Acrylic on canvas. Collection of the artist. Image courtesy of Christopher Crebbin. Photograph by Fiona Magowan.

it and hangs it in a special part of their house, that makes it different from doing it on a piece of canvas that I have just finished and rolled up' (Blackman in interview, 25 October 2010).

Conrad Blackman has been painting over a fifteen-year period and considers himself a relatively new artist. He has produced around 220 pieces

which he has sold to buyers within Australia as well as in other countries, including the United States, England, Germany, Austria, Switzerland, Bolivia, Chile, Canada, India, Hawai'i, Mexico and New Zealand. A broad spiritual ethos frames how he views his art as a process of inquiry into moral and ethical dilemmas as he explains his spiritual and emotional ties to his grandfather's Batjala people on Frazer Island:

> When I went about seven to eight years ago to Frazer Island, it was just magical. I thought the land is speaking to me, my ancestors are there speaking to me. I might not understand the language but they are speaking in some sort of vibrational sense, and it was just a strong connection. I felt at peace. (Blackman in interview, 25 October 2010)

The visceral sentience of his grandfather's land is foundational to his sense of empathy. Longings caused by dislocation are soothed by memories of return visits to this country. However, he prefers not to dwell on the pain of the past in his images. Instead, his art allows him to rewrite personal hurts in uplifting and regenerative aesthetic forms that affirm and transform the sense of belonging to land and ancestry in positive terms. For Blackman, empathy is about hope, which he sees in the beauty and infinity of myriad forms of colour and style.

In exploring their suburban identities, some artists look to their ancestral lands and seek to legitimize their identity through families still living there. This can be a difficult arena to negotiate as absence and fragmented histories may create uncertainties among more distantly related family members, in some cases compounding a sense of shame and further erasure of personhood for artists if their affiliations are not recognized. Despite Blackman's childhood absence from the land, this does not dampen his co-constitutional sense of relationship with its features or his relatives. He expresses his enchantment with Queensland in paintings of the cassowary which he associates with his mother, while his compulsion to paint provides therapeutic emotional release. Drawing upon other universal imagery such as snakes, water courses and trees, he does not reference the styles of specific Aboriginal groups or places. Rather, he embraces tensions between revealing aspects of his and his family's histories through positive and negative pseudo-transparencies in the shifting foreground and background effects of a rainbow serpent simultaneously emerging from and disappearing into the painting (see figures 9.4 and 9.5). These two paintings comprise part of a series, entitled 'Joining Differences', in which the contrast between straight lines and curved patterns reflects the generative potential for human strength, beauty and positivity in the coming together of individual differences, rather than division or separation (Blackman pers. comm., 2014).

Figure 9.4. *Rainbow Serpent.* Acrylic on canvas. Collection of the artist. Image and photograph courtesy of Conrad Blackman.

Figure 9.5. *Rainbow Serpent*. Acrylic on canvas. Collection of the artist. Image and photograph courtesy of Conrad Blackman.

In other works, he also employs a complementary fractal, holistic aesthetic evident in colourful dot mosaics, such as the *Rainbow Serpent* (see figure 9.6). He commented: 'I try to make a small section but there's seven different colours … [It's the same] with electronic microscopes at the sub-atomic [level], they're still finding things. So, the deeper we look the more there is to see and it all makes up the beauty of everything, but it gets lost in our everyday lives' (Blackman in interview, 25 October 2010).

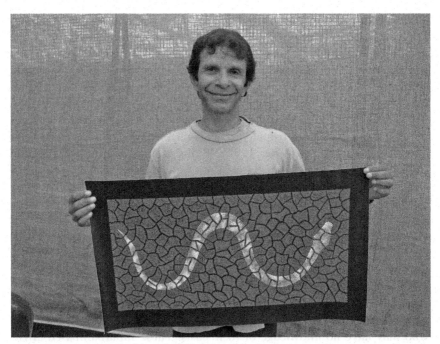

Figure 9.6. Conrad Blackman holding *Rainbow Serpent*. Acrylic on canvas. Image and photograph courtesy of Conrad Blackman.

Blackman's art of 'making special' attends to shifting attitudes and emotional states between himself and others. His strict parental upbringing combined with Catholic Maris Brothers schooling in Queensland coloured his early sense of discipline, care and other-centredness, and underpins his self-identification as a Christian. This influence of history, memory and religious ethos seeps through Blackman's feelings about his work as a process of inquiry, for the moral dilemmas of which there is no easy resolution. Painting is a means of articulating the potential for changing emotional hurts of the past. Instead of being written out of the country, some suburban-based artists like Blackman engage upon pilgrimages of temporary return in a regenerative process of 'making special' by reconnecting with the land, which allows them to paint their sense of belonging to ancestry even though they are in ongoing states of dislocation.

Conclusion: Empathy and the Aesthetic Imagination

I have argued that the processes of moving within and between communities creates an emotional aesthetic for each artist around the 'kind of thing art is ... and how it contributes to the context in which it occurs' (Morphy and

Perkins 2006: 15). For these suburban-based artists, liminal periods of journeying across and between countries, rather than the movements of art objects per se, inform their processes of painting and prompt reflections upon emotional self-transformation. Some places thus accumulate greater sensory worth in the aesthetic imagination through increasing attachments and re-attachments of continual return, while other places recede. For some artists, working between several places of emotional identification can provide a sense of moving on from troubled pasts while creating a space in which the 'sacred self' can rest (Csordas 1994). In this process, I would suggest that suburban-based artists are imagining not only their own place within the nation but also responding to how others perceive their identities as both removed from ancestral lands and yet connected to them. As artists rationalize dislocated bonds with homelands in relation to their urban circumstances, they affirm a network of memories and images about places that had been lost to them but which they can reclaim as part of their ongoing heritage through acts of painting and telling stories about their art. This is a triadic process in which artists look to their extended families for recognition and acceptance of their identity and artistic abilities, by engaging artistically with them, at the same time as they seek to create empathy with audiences who may have no knowledge of their pasts. These suburban-based artists perceive their paintings as part of a process of educational activism in which they view their role as 'bridging the gap' through cultural explanation. Others lean more towards political activism, expressing a social and political conscience about Aboriginal land rights or equal opportunities in order to challenge, critique and confront the injustices between urban and traditional, Aboriginal and white Australia.

In this aesthetics of mobility and empathy, suburban-based Aboriginal artists evoke political injustices of the past, revealing multidimensional and contested ideas of identity and belonging. In the cases presented here, artists do not consider that empathy is about having pity or sympathy for their circumstances; rather it is about recognizing the complexity of political and historical trajectories that have shaped a range of emotional dynamics and expressions upon which their works are based. Consequently, for these suburban-based artists, painting is both an act of transition and a process of transformation (see Svašek 2012), as it affords a means of moving betwixt and between place-memories of journeys in body, mind and emotion. Living between worlds, we can see how artists' feelings of pain, suffering and hope are mediated on the one hand, by journeys around loss and, on the other hand, by a search for their own self-discovery and self-renewal in a co-constitution of 'knowing' between the 'lived body' and a perceptual field that is full of irreducible meaning (Merleau-Ponty 1965: 21–22). I suggest that suburban-based Aboriginal art is a means of creating co-constitutional flows

between actual and imaginary journeys, generating a mnemonic for recalling and empathizing with the past. As we have seen, for these artists, journeying acts as a metaphorical voice, questioning, defining and transforming their emotional engagements with others. As they represent rhythms of movement within and across the country through tactile and visual media they literally bring the 'feel' of their journeys to life. They share the emotional efficacy of their works, inviting others into their lives as they tell moving stories through the colours of their environments. Thus, as artists narrate their personalized 'migratory aesthetic', they offer viewers the chance to empathize with the artists' real and imagined emotional (re)attachments to previously displaced and fractured family relationships, dislocated senses of belonging and diverse cultural landscapes.

Notes

1. I am very grateful to HERA (Humanities in the European Research Area) for funding from 2010 to 2012, as part of the 'Creativity in a World of Movement' project, led by Dr Maruska Svašek, Queen's University, Belfast. I would like to thank all of the artists, who so generously gave of their time in 2010. They include Daphne and Terri Rickett, Heather Shearer, Christopher Crebbin and Conrad Blackman. I am grateful to the latter two for also giving permission for images of their artworks to be used.
2. I use the term 'suburban-based Aboriginal artists' to indicate their highly mobile and often mixed backgrounds. While these artists may spend the majority of their time within a suburban or city environment, this does not imply that they have always done so.
3. Acts of Parliament in respective states condoned the forcible removal of children from their families by federal and state government organizations which took place from around 1869 to the mid-1970s.
4. Kaurna is an Aboriginal group belonging to the Adelaide region.
5. Mieke Bal (Bal 2008) coined the term 'migratory aesthetics' to address the link between migration and aesthetics explored in the exhibition '2MOVE' which examined the relationship between moving images in video and the social movement of people.
6. In different parts of Aboriginal Australia, the terms improvisation and creativity resonate with notions of 'aesthetic effect', 'aesthetic force', 'variation' and 'innovation' (see, for example, Morphy 2009).
7. The Ngarrindjeri comprise eighteen dialect groups whose lands are located in the Murray River, Coorong, and Western Fleurieu Peninsula.
8. Burthurmarr is an Aboriginal name in Lardil language for the Brolga bird, or Australian Crane, from far north Queensland.
9. 'Unnatural emotions' have been defined as a lack of emotion or emotional disengagement (see Lutz 1988: 68).

10. Conrad Blackman is the brother of well-known Aboriginal artist, Mark Black-
 man.

References

Ashcroft, B. 2009. 'Beyond the Nation: Post-Colonial Hope', *Journal of the Euro-
 pean Association of Studies on Australia* 1: 12–22.

Bal, M. 2008. 'Migratory Aesthetics: Double Movement', *EXIT, Imagen & Cul-
 tura* 32. Retrieved 3 March 2012 from http://www.exitmedia.net/prueba/eng/
 artculo.php?id=266.

Bancroft, B. 1990. 'Designer Aboriginals', *Artlink* 10(1–2): 101–2.

Barney, K., and E. Mackinlay. 2010. '"Singing Trauma Trails": Songs of the Stolen
 Generations in Indigenous Australia', *Music and Politics* 4(2): 1–25.

Bennett, J. 2011. 'Migratory Aesthetics: Art and Politics beyond Identity', in M. Bal
 and M.Á. Hernández-Navarro (eds), *Art and Visibility in Migratory Culture:
 Conflict, Resistance and Agency*, vol. 23. New York and Amsterdam: Rodopi
 B.V., pp. 109–26.

Chaney, F. 2009. The Lowitja O'Donoghue Oration, Adelaide, 28 May. Retrieved 30
 December 2009 from http://www.reconciliation.org.au/home/media/speeches.

Csordas, T. 1994. *The Sacred Self: A Cultural Phenomenology of Charismatic Heal-
 ing*. Berkeley: University of California Press.

Dissenayake, E. 2000. 'The Core of Art: Making Special', in R.E. Miller and K.
 Spellmeyer (eds), *The New Humanities Reader*. Boston: Houghton Mifflin, pp.
 201–22.

Durrant, S., and C.M. Lord. 2007. 'Introduction', in S. Durrant and C.M. Lord
 (eds), *Essays in Migratory Aesthetics: Cultural Practices between Migration and
 Art-Making*. Amsterdam: Rodopi Publishers, pp. 11–20.

Dussart, F. 2000. *The Politics of Ritual in an Aboriginal Settlement: Kinship, Gender
 and the Currency of Knowledge*. Washington, DC and London: Smithsonian
 Institution Press.

———. 2007. 'Canvassing Identities: Reflecting on the Acrylic Art Movement in an
 Australian Aboriginal Settlement', *Aboriginal History* 30: 156–68.

Glaskin, K. 2010. 'On Dreams, Innovation and the Emerging Genre of the Individual
 Artist', *Anthropological Forum* 20(3): 251–67.

Halpern, J. 2001. *From Detached Concern to Empathy: Humanizing Medical Prac-
 tice*. New York: Oxford University Press.

Holcombe, S. 2003. 'The Sentimental Community: A Site of Belonging – A Case
 Study from Central Australia', *The Australian Journal of Anthropology* 15(2):
 163–84.

Hollan, D.W., and C.J. Throop. 2012. 'The Anthropology of Empathy: Introduc-
 tion', in D.W. Hollan and C.J. Throop (eds), *The Anthropology of Empathy:
 Experiencing the Lives of Others in Pacific Societies*. ASAO Studies in Pacific
 Anthropology. Oxford: Berghahn Books.

Hutchinson, G. 1998. *Gong-wapitja: Women and Art from Yirrkala, Northeast Arn-
 hem Land*. Canberra: Aboriginal Studies Press.

Johnson, V. 2010. *Once Upon a Time in Papunya*. New South Wales: University of New South Wales Press.

Keen, I. 2003. 'Dreams, Agency, and Traditional Authority in Northeast Arnhem Land', in R. I. Lohmann (ed.), *Dream Travelers: Sleep Experiences and Culture in the Western Pacific*. New York: Palgrave Macmillan, pp. 127–47.

Lutz, C. 1988. *Unnatural Emotions: Everyday Sentiments on a Micronesia Atoll and their Challenge to Western Theory*. Chicago: University of Chicago Press.

Lutz, C., and L. Abu-Lughod (eds). 1990. *Language and the Politics of Emotion: Studies in Emotion and Social Interaction*. New York: Cambridge University Press.

McLean, I. (ed.). 2011. *How Aborigines Invented the Idea of Contemporary Art*. Institute of Modern Art: Power Publications.

Mattingly, C. 2008. 'Reading Minds and Telling Tales in a Cultural Borderland', *Ethos* 36(1): 136–54.

Merleau-Ponty, M. 1965. *The Phenomenology of Perception*, trans. C. Smith. New Jersey: Humanities Press.

Morphy, H. 1991. *Ancestral Connections: Art and an Aboriginal System of Knowledge*. Chicago: University of Chicago Press.

———. 2008. *Becoming Art: Exploring Cross-cultural Categories*. Sydney: University of New South Wales Press.

———. 2009. 'Art Theory and Art Discourse across Cultures: The Yolngu and Kunwinjku Compared', in C. Volkenandt and C. Kaufmann (eds), *John Mawurndjul: Between Indigenous Australia and Europe*. Berlin: Dietrich Reimer Verlag.

Morphy, H., and M. Perkins. 2006. 'The Anthropology of Art: A Reflection on its History and Contemporary Practice', in H. Morphy and M. Perkins (eds), *The Anthropology of Art: A Reader*. Malden, MA: Blackwell Publishing, pp. 1–32.

Munn, N. 1986. *Walbiri Iconography: Graphic Representation and Cultural Symbolism in a Central Australian Society*. Ithaca, NY: Cornell University Press.

Myers, F. 1986. *Pintupi Country, Pintupi Self: Sentiment, Place and Politics among Western Desert Aborigines*. Washington, DC: Smithsonian Institution Press; and Canberra: Australian Institute of Aboriginal Studies.

———. 2002. *Painting Culture: The Making of an Aboriginal High Art*. Durham, NC: Duke University Press.

Rudder, J. 1993. 'Yolngu Cosmology: An Unchanging Cosmos Incorporating a Rapidly Changing World', Ph.D. thesis. Canberra: Australian National University.

Rumsey, A. 2008. 'Confession, Anger and Cross-cultural Articulation in Papua New Guinea', *Anthropological Quarterly* 81(2): 455–72.

Scott, J.C. 1990. *Domination and the Arts of Resistance: Hidden Transcripts*. New Haven, CT: Yale University Press.

Stueber, K.R. 2006. *Rediscovering Empathy: Agency, Folk Pscyhology and the Human Sciences*. Cambridge: MIT Press.

Sutton, P. 1998. *Dreamings: The Art from Aboriginal Australia*. Ringwood, VIC: Viking.

Svašek, M. 2012. *Moving Subjects, Moving Objects: Transnationalism, Cultural Production and Emotions*. Oxford: Berghahn Books.

Throop, J.C. 2010. 'Lattitudes of Loss: On the Vicissitudes of Empathy', *American Ethnologist* 37(4): 771–82.

Towsend-Gault, C. 1992. 'Kinds of Knowing', in *Land, Spirit, Power,* catalogue for the National Gallery of Canada, Ottowa. Retrieved 8 January 2011 from http://ccca.finearts.yorku.ca/c/writing/t/townsend-gault/tgault012t.html.

Willsteed, T. (ed.). 2004. *Crossing Country: The Alchemy of Western Arnhem Land Art.* Sydney: The Art Gallery of New South Wales.

10

TRANSVISIONARY IMAGINATIONS
ARTISTIC SUBJECTIVITY AND CREATIVITY
IN TAMIL NADU

---◆◦◆◦◆---

Amit Desai and Maruška Svašek

We rose from our chairs at the end of our interview and the artist Vidya-shankar Sthapathy showed us a bronze sculpture that sat on a long table pushed up against the wall of his house. It was of a man and a woman lying together and comprised of six parts: two heads, two pairs of legs, and one pair of hands. The man's head was resting on that of the woman. One hand lay on his knee; the other was placed to the side at the end of an invisible arm that was cradling his companion (see figure 10.1). Vidyashankar was eager to demonstrate the versatility of this piece of work. As we watched, he rearranged the sculpture. He moved the heads so that they stood upright and placed the hands into a different position. Instead of an image of reclining lovers, he now presented us with one of a tender seated cuddle. Then, he took a head from another statue, placed it on a box and flanked it with two separate hands (figure 10.2). He seemed to delight in the playful aspect of his sculptures, the varied possibilities they afforded him, and the imagination he deployed in the fashioning of alternatives (figure 10.3).

Looking back on this, what strikes us is the question of movement. There were all sorts of movement going on. Firstly, when Vidyashankar wanted to change the position of the sculpture, he looked at the existing configuration and, moving his hands to accomplish the task, rearranged the various pieces of the sculpture so that it became something different. The movement and

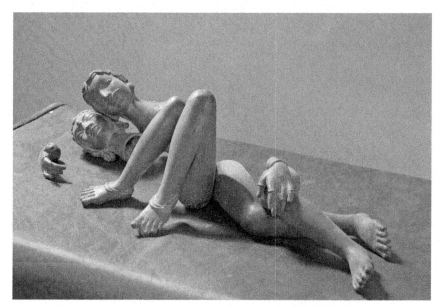

Figure 10.1. First position of the bronze sculpture by Vidyashankar Sthapathy. Photograph courtesy of Amit Desai, 2011.

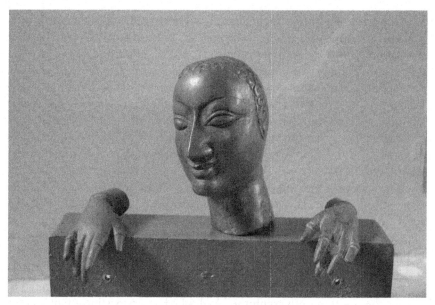

Figure 10.2. Rearranged elements of another sculpture. Photograph courtesy of Amit Desai, 2011.

Figure 10.3. Vidyashankar Sthapathy. Photograph courtesy of Amit Desai, 2011.

coordination of hands and eyes, essential to the initial formation of the sep-
arate pieces, was also key to this new engagement. Situated physical ability
and levels of dexterity, in other words, were central to the process of (re)
making the statue.

Secondly, as the artist played around with the parts, the configuration
of pieces changed in relation to past positions. This movement of things in
space was not open-ended. It was limited by the fact that there were never
more than six parts, and it was also subject to the materiality of the work:
being bronze, without a source of heat and the right tools the pieces could
only be manipulated in certain ways. While Vidyashankar could alter the
positions of the parts, he could not modify their sizes or shapes. His cre-
ative imagination worked in concert with these possibilities. He actively
responded to constraints given by the context in which he worked, and ex-
perimented within its limitations. Through active embodied engagement and
improvisation, he reacted to and changed the concrete material environment
(see also Svašek 2009: 65; Svašek 2012: 249; Hallam and Ingold 2007).

Our interest in artistic imagination, improvisation and materialization
takes us to a third kind of dynamic: the unfolding of the artist's trajec-
tory within and across local, national and global fields of artistic produc-
tion. In this chapter, we are particularly interested in several dimensions
of Vidyashankar's professional trajectory. The first is the artist's concrete

embeddedness in, and movement through, specific times and spaces, gaining situationally and historically specific knowledge as his career develops. With regard to this first dimension, Cristina Grasseni (2007: 3) has noted that when learning and developing their professions, apprentices (including students of arts and crafts) are engaged in processes of 'visual "enskilment"', learning '*particular* skilled visions that are *specific* to *situated* practices'. Skilled visions, she pointed out, can be analysed in terms of practical routines, social and ideological *belonging* as well as of aesthetic *longing*' (ibid.: 7, emphasis in original). As we shall see, questions of longing and belonging are central to the second dimension of Vidyashankar's trajectory: his identification with historically and geographically close and distant people through focused material production.

We shall examine the interrelation of the two dimensions through the notion of transvision, which we define as situated, material-focused acts in which visuality is a main factor, and through which mobile artists experience, practise and claim particular notions of creative personhood and relatedness to relevant others. In this process, they interact within co-present social and material environments, and aim to overcome historical and geographical distances.

Our choice of the metaphor 'vision' needs further elaboration. Not intending to ignore the multi-sensorial nature of people's dealings with material objects (that is, smelling, hearing, tasting, seeing and touching things), the concept of transvision captures the centrality of visuality in art practices by sculptors such as Vidyashankar. Admitting that sculptural practices cannot be understood through the prism of 'vision' alone, as will become clear in the course of the analysis, we agree with Grasseni's (2007: 4) statement that '*skilled visions* are embedded in multi-sensory practices, where look is coordinated with skilled movement, with rapidly changing points of view, or with other senses, such as touch'.

Mirzoeff's (2000: 7) theory of 'intervisuality' is also relevant to our approach, as it highlights the necessity to explore 'interacting and interdependent modes of visuality' when analysing image production. By implication, 'the spectator needs to bring extratextual information to bear on what is seen within [a specific] frame to make full sense of it' (ibid.). Our musings at the beginning of this chapter on Vidyashankar's playful interactions with the parts of the sculpture, are incomplete without a proper analysis of the different, possibly contradictory, modes of visuality that he has employed throughout his career. In our approach to vision we prefer the prefix 'trans' over 'inter' as, we argue, the urge to connect to and appropriate distant modes of visuality must be understood as a process of perspectual movement, where movement itself transforms the overall outlook at any point in time. There is a link here to the conceptualization of 'the transnational', a

dynamic state of being defined not by an adding up of distinct experiences in multiple places, but rather by the ways in which the experience of movement between places frames the experiences within these locations.

Unlike Mirzoeff, who introduced his theory of visuality to explore *diasporic* processes of cultural production, we employ the concept of transvision in this chapter to examine the production and self-presentation of an Indian artist who has remained within his country of birth. This does not, of course, mean that he has been isolated within the limits of a static geographical unit. As we will see, his imagination has partially been mediated through access to visual reproductions of distant non-Indian works of art, and through texts and stories about artists and art societies beyond the Indian subcontinent.

Embeddedness in Changing Times and Places: The Madras Movement

When we met him in 2011, 74-year-old Vidyashankar Sthapathy lived in Kumbakonam, a small city in central Tamil Nadu with a population of just over 140,000 inhabitants. He was born in 1938 in Srirangam, a temple town on a small island in the Kaveri River, situated about forty miles west of Kumbakonam. At the time of his birth, India was still part of the British Empire, and the main base of power in South India was the coastal city of Madras (today Chennai), about three hundred miles north-east of Kumbakonam. The country gained independence in 1947 when he was nine years old.

As an adolescent, Vidyashankar moved to Madras where he was trained in sculpture at the Government College of Arts and Crafts. In the late 1950s and early 1960s, he was taught by and alongside many of the leading artists of the Madras Movement in contemporary art. The movement was part of a broader attempt by artists in different parts of India to counter a dominant trend of working in styles that were developed in Europe and the United States.

Painter Gulam Mohammed Sheikh (1989: 109–10) reflected on the fascination many Indian artists had at the time with the latest avant-garde styles promoted in Europe and the United States. Commenting on his time at the Maharaja Sayajirao University of Baroda, India, during the second half of the 1950s, he noted:

> Michelangelos and Picassos in the art history classes (and glimpses of Sienese murals and Indian miniatures) opened hundreds of windows, although *our souls and hearts were tied to the abstracts of Soulages, Kline, and others, which jumped out of international art journals*. Indeed, swept up in the high tide of 'modern art',

the motto was to be here in the moment of the day; the entire stockpile of earlier traditions was left ashore or in the oblivion of art history. [Emphasis added]

The orientation of Indian artists towards European trends, mediated through reproductions in journals, had a historical precedent in the colonial period. At the time, so-called 'Company painters' (who were commissioned by the East India Company to visually document the Indian environment) and artists like Raja Ravi Varma appropriated naturalist styles to create commissioned portraits and paint strongly romanticized Indian mythological scenes. Their materializations of 'fine art' were strongly informed by specific skilled visions, gained through training received from European art teachers and through their own explorations of reproductions in European magazines and art books (Guha-Thakurta 1992: 15; Mitter 1994: 14–20). At the beginning of the twentieth century, one of most fervent critics of the appropriated European styles, that promoted naturalist depictions of the human body and endorsed perspective as modes of superior artistic and scientific vision, was the Calcutta-based painter Abanindranath Tagore (1871–1951). He found inspiration in Indian, Japanese and pre-Raphaelite art traditions to create a form of art that expressed the nationalist sentiments of the Swadeshi movement. He established the Bengal School of Art, promoting art that reflected Asian values, and articulated ways of seeing that were in line with Indian – that is, Hindu – spirituality. His 1905 painting *Bhārat Mātā* (Mother India), for example, portrayed the Indian nation as a four-armed Hindu goddess, and was used as an icon of nationalist feeling during the struggle for independence (Guha-Thakurta 1992: 258; Mitter 1994: 235). In 1929, one of his students, the painter and sculptor Devi Prasad Roy Choudhury, moved to Tamil Nadu as Superintendent of the Madras College of Art, a position he kept until 1958. Influenced by the Bengal movement, in his own work he 'tried to synthesize Eastern ideas with Western techniques, thus providing the required impetus towards modernism in the south'.[1]

Vidyashankar entered the Government School of Arts and Crafts in Madras in 1963. He joined at a time when the artist K.C.S. Paniker (1911–1977), one of the driving forces of the Madras Movement, was Principal of the School, having taken over from Choudhury in 1958. Paniker, who had received training at the same institution (from 1936 to 1940), had wanted to create an art that was 'Indian in spirit and world-wide contemporary', renouncing a dominant artistic trend that was 'at best an almost sterile version of a European way of art expression' (James 2004: 12). Headed by Paniker, the art school provided an alternative environment, stimulating students to study both European artistic trends and examples of Indian heritage. These dynamics shaped the emerging professional identities of students such as Vidyashankar (see also Grasseni 2007: 12).[2]

Vidyashankar pursued a three-year diploma course in Fine Arts Sculpture. He explained to us that he had been strongly inspired by his 'guru', the teacher and sculptor S. Dhanapal (1919–2000). Like Paniker, Dhanapal was a former student of the school, having taken a painting degree in 1935–1940. He joined as a staff member in 1941, making sculptures in bronze, cement, terracotta and wood, and took charge of the sculpture department in 1957. The art historian Josef James noted that Dhanapal had been 'the first artist to turn traditional elements into progressive ideas in contemporary Indian sculpture' (James 1993: 46). Having a good knowledge of work by Indian artists who belonged to the Bengal School, such as Tagore and Choudhury (the latter being the principal of the Government School of Arts and Crafts in Madras when Dhanapal joined), and being inspired by 'the spirit of free expression found in the work of the Impressionists abroad', Dhanapal began drawing on 'the rich folk tradition of the region and discreetly from classical bronzes' (James 1993: 46). The perspective of 'transvision' can be used to analyse this process of creative oscillation, where producers of visual material culture move between (1) ocular engagements with co-present material realities, and (2) inner perceptions of absent phenomena through visually oriented memory and imagination. The oscillation led to materializations that began to make up the new learning environment at the school, leading to the birth of the Madras Movement.

The approach by the academy teachers to styles and artistic traditions both near and far in time and space influenced many of their students' views on artistic practices. In Vidyashankar's case, it also shaped his perception of his own past and future. As we shall see later in the chapter, it fed his understanding of himself as a unique artist. At Madras, Vidyashankar was immersed in a learning environment that valued a meaningful artistic relation with the past with the aim to create a truly 'Indian' version of artistic modernity. As a student, he learnt how to appropriate elements of past visual practices. Then as now, art students in South India were taken on field trips to Chola- and Pallava-era temples in order to copy the sculpture that adorns the walls and precincts.

Making a name for himself as one of the representatives of the Madras Movement,[3] he then moved back to central Tamil Nadu, taking up the position of sculpture teacher at the Art College in Kumbakonam. Also serving for a time as its principal, he helped to shape the educational programme there, stimulating his students to draw on 'European' and 'Indian' art traditions. As we observed during our fieldwork in Kumbakonam, the art students not only copy casts of Classical European sculptural pieces, and 'masterpieces' made by famous painters such as Rembrandt, but also go to the temples in the city to improve their skills of observation, narration and drawing, and to imagine the makers as artistic predecessors. Through the

repeated process of sketching and copying the temple panels, they reflect on the intentions and skills of these ancient artists, framing them as early producers of 'Indian heritage', and are encouraged by their teachers to access the 'deep concepts' that the panels contain in a process of transvision. While it is true that training of this kind is not an end in itself, and students are expected to go beyond the temple panels and produce work that is regarded as original, it was expected that creation must come through an embodied and meditative engagement with the past, and an identification with the makers of the ancient temple sculpture.

Vidyashankar's Claim to Authentic Transvision

As noted earlier, Vidyashankar is one of a group of contemporaries, all artists who, developing their careers in the 1950s and 1960s, looked for a specifically 'Indian' road to modernity and contemporary creative practice. A visual exploration of concrete examples of 'Indian art and heritage' (through direct observation, copying and incorporation) and 'Western art' (mostly seen as reproductions), allowed them to appropriate a diversity of forms and techniques, leading to the development of new artistic styles. Visual elements of previously produced paintings, sculptures and other material objects, produced in earlier times in nearby and faraway places, were observed, isolated, reproduced, remembered and re-imagined, eventually materializing in a diverse but recognizable Madras style.

Vidyashankar, however, was in a slightly different position to his contemporaries as his professional trajectory was marked by his birth into an art-producing family. As attested by his name, Vidyashankar is a *sthapathy*. Most sthapathys in Tamil Nadu belong to the Vishwakarma caste, many members of which include highly skilled and classically trained professionals, such as temple architects, bronze sculptors and stone sculptors. References to Vishwakarma can be found in the Vedas and the Puranas, and the sthapathy class of architects and designers emerged during the 'construction boom' in the Pallava and Chola periods (Levy et al. 2008: 22). Mythical stories about the origin of the caste tell of a five-faced, three-eyed, ten-armed god called Vishwakarma, who was born out of the third eye of Shiva and appointed as deity of all artisans. His five sons, stemming from his multiple face, became clan deities who are each responsible for one of five specific crafts: iron specialists (*Manu*), vessel makers (*Dwasta*), goldsmiths (*Visvagnya*) and icon makers, who work in either stone or metal (*Shilpi*) (ibid.: 25–26). Sthapathys are generally competent in more than one of these fields. Those specialized in bronze making work in workshops in and around Swamimalai, a temple town not far from Kumbakonam.

When interviewed by us, Vidyashankar positioned himself as a creative artist whose uniqueness stemmed not from his connection to the Madras Movement, but rather from his multiple identity as contemporary artist *and* sthapathy.[4] In an interview in 1982 with the art historian Josef James, he proudly acknowledged his sthapathy ancestry:

> I am a sthapathy. I belong to a line of those learned in architecture, iconography and ritual and the related crafts. The line includes distinguished figures like my father Gowrishankar Sthapathy, grandfather Muthuswami Sthapathy … the line goes back to the legendary Raja Raja Perumthachan, the designers of the famous Brihadeeshwara temple at Tanjavur. My ancestry means much to me and I am proud of it. (James 1998: 82)

This genealogy was partially represented in his house. During the course of our interview with him, he pointed up to the photographs of his father and grandfather who looked down from a wall of his studio.[5] Speaking with three practising sthapathys during our visit to Tamil Nadu, we noticed that each one of them stressed the importance of kinship in emphasizing professional continuity, not only in their stories about the profession,[6] but also in visual representations. One of them, Srikanda Sthapathy, displayed a genealogical map in the office adjacent to his bronze-making workshop, and had published a genealogical chart on the workshop's website.

Vidyashankar explained that he was a sthapathy by virtue of the process of enskilment that had taken place during his childhood and adolescence, when he had learned to perceive and relate to his social and material environment in a particular way. Attention to the techniques of apprenticeship as they attune the senses and shape cognition and emotional engagement, is useful here as it documents 'how different ways of knowing are embedded in social practice and in an ecology of aesthetic and practical standards' (Grasseni 2004: 41). Vidyashankar explained that when growing up in the towns of Srirangam and Swamimalai, he had observed his father, who was specialized in stone and wood carving, and had learnt about the rules of *tala,* a system of measurement according to which the size of different icons is calculated by multiplying a chosen unit. In addition, he had gained knowledge of bronze-casting techniques, and had worked under his grandfather as an apprentice. He gained detailed knowledge of Hindu iconography – how to represent the different deities, their gestures (*mudras*), vehicles and ornaments, which he said he had also read about in various texts. During the interview, he referred, for example, to the cosmological symbolism of Nataraja (figure 10.4), the dancing form of Lord Shiva, and outlined its measurements for us on a piece of paper (figure 10.5). He also demonstrated several classical postures using his own arms, explaining that he had received several years of training in classical dance.

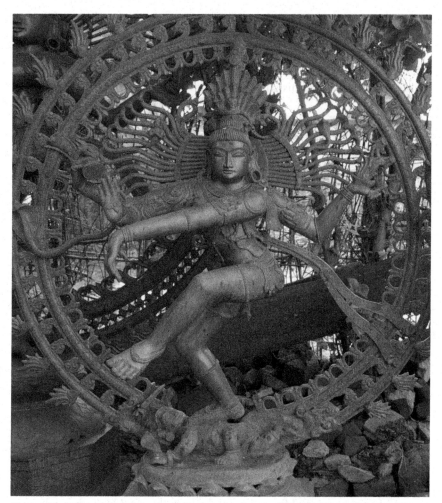

Figure 10.4. Bronze sculpture of Nataraja in the workshop of Suriyanarayanan Sthapathy, Swamimalai, India. Photograph courtesy of Amit Desai, 2011.

The art historian/critic Ramnarayan (1993: 81–82) wrote in romantic language about the sensorial and cognitive impact the local environment had had on young Vidyashankar:

> The ambience [in Srirangam] was conducive to a direct absorption of the living arts as exemplified in the daily and festive celebrations of the great Vaishnava shrine. As the splendidly adorned *Utsava* idols were taken out in procession at appointed times, they swayed to the variegated movement of their bearers, simulating the *Sarpa nadai* (of the serpent), the imposing *Gaja nadai* (of the royal

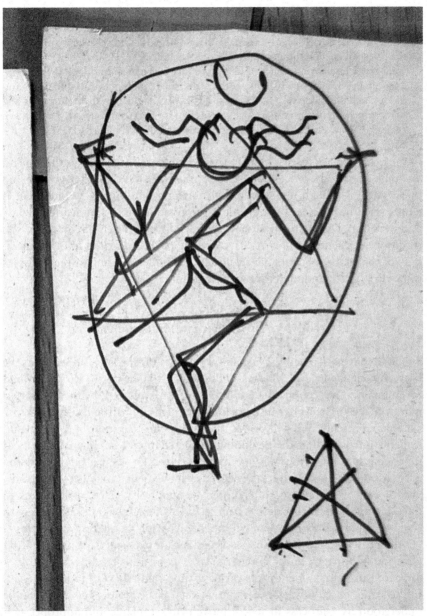

Figure 10.5. Vidyshankar Sthapathy's sketch of Nataraja, drawn to demonstrate the principles of measurement for bronze sculpture. Photograph courtesy of Amit Desai, 2011.

tusker), of the *Simha nadai* (of the lion) while the nadaswaram piped age-old melodies, fast or slow, heightened by exuberant percussion. Torches flared, camphor glowed, flowers were strewn, sandalwood paste and rosewater splashed as the priests recited mantras and the devotees chanted the name of the Lord. There were other fascinating scenes of intense beauty and concentration, as Vidyashankar watched father Gowrishankar Sthapathy, the redoubtable traditionalist, hammering and chiselling pieces of granite and wood, animating them into gods and heroes, intricately patterning their ceremonial mounts and chariots. The father's craft skills and *sastraic* erudition were naturally imbibed by the son.

In the text, Vidyashankar's imaginative potential clearly emerges through an assemblage of gods, procession objects, priests, flowers, a father, granite and knowledge. Although undoubtedly idealizing a 'traditional' world, what is emphasized is an affective embeddedness in embodied relations of skill, art and devotion. During the interview with us, he noted that his rootedness in tradition was central to his creative personhood. Compared to other members of the Madras School, he suggested, his understanding of the past was more deeply felt, and therefore more authentic.

Creativity, Movement and Artistic Being

So far we have discussed Vidyashankar's modes of learning and seeing at the Government College in Madras and among sthapathys in Srirangam and Swamimalai. The section which follows further explores how these different modes of enskilment offer insights into the forms of artistic being that Vidyashankar presents. We will do so through a consideration of 'movement', a theme introduced at the beginning of the chapter. Looking at movement more closely is important not only because it is a key element of transvision across time and space, but also because movement (and therefore transvision) can be stopped or interrupted in temporary essentialist claims to fixed identity. Our earlier description of Vidyashankar's improvisations with sculptural parts illustrates our argument. Each of the pieces he used were (1) the result of an active process of making (movement), (2) fixed materialization (stoppage), and (3) material objects in transit and transition that appeared in new configurations in new times and spaces (appropriation). In the same sense, Vidyashankar's situational projections as an artist can be understood as a process in which movement, stoppage and appropriation intersperse. The oscillation of perspectives reveals contrasting understandings of the relation between creativity and time, both of which are central to our exploration of transvision.

The 'fixing' of subjectivity is dependent to a great extent on the operation of power; power affects why and how the perspectives oscillate. Contests

over authentic and inauthentic transvisions whereby different artists claim particular ways of seeing into the past, and privilege connections with other creators, indicate a play of power. For instance, and as we explore in more detail below, Vidyashankar's claim to be more 'creative' than his contemporary sthapathy kin means that he elevates the process of enskilment and apprenticeship associated with formal art education over that associated with present-day traditional bronze-maker workshops. This is produced by and reinforces the hegemonic status of the 'art school' over the 'workshop' as the centre of artistic production in South India. And yet, conversely, Vidyashankar is clearly responding to another configuration of power when he positions himself as more 'authentic' than his art school colleagues who, he claims, lack proper access to the imaginations of ancient Indian sculptors because they do not have sthapathy ancestry.

Contemporary Sthapathys as Object of Movement and Stoppage

As is already clear from the discussion so far, Vidyashankar is at times identified and identifies himself with sthapathy traditions. In the setting of workshops, the sthapathys engage with each other in shared time/spaces, where they form 'communities of practice'.[7] For the sthapathys, close interaction is thus essential to the reproduction and intergenerational transmission of the style. In the larger workshops, men of different ages with different levels of skill cooperate to produce the artefacts. The lengthy production process requires numerous technical procedures, including wax moulding, casting, hammering and filing. Daily interaction creates an acute sense of multi-sensorial sociality (particularly relating to sound and vision), reinforced through shared or complementary knowledge of icon making.

Vidyashankar claims relatedness to the other sthapathys because his own bronze making relates to a system of apprenticeship that shapes 'specific skills of relation, cognition and perception' (Grasseni 2007: 10), a practice handed down through generations of kin. Photographs of sthapathy relatives that hang in his work space are a visual reminder of these connections. Vidyashankar can thus look back over a long history of working with bronze and stone, and imagine close identification with his ancestor temple builders whose structures are now UNESCO World Heritage sites. He also works in the same material – bronze – as that of his forefathers. Thus, the processes of enskilment that have gone on in his own life are conjoined with his imagination of the transmission of sthapathy skill from previous generations of sculptors and architects.

New apprentices are socialized into the sthapathy profession through a process of enskilment that promotes a particular understanding of copying

as essential to the creation of material agency. Imitation and appropriation of existing designs is crucial, and is not only an important method of learning the craft, but also a required practice. With regard to the production of Hindu imagery, the aim is to create artefacts that can transform or be transformed into active mediators of the divine. Consequently, sthapathys do not actively search for an innovative visual language, and this is where Vidyashankar's identification with contemporary sthapathys stops short. As we shall see, positioning himself as a unique artist, he constructs an image of two opposing identities: that of ancient, creative, authentic sthapathys, and that of their contemporary, less-creative descendants.

In his twenties, Vidyashankar turned away from the sthapathy community of practice, developing an ambiguous attitude towards contemporary production. Early on in the interview with us, immediately after pointing out that all sthapathys in Swamimalai were related to him, he added that he had felt the need for change, as in his view all 'were doing the same', reproducing 'icons like Durga, Kali, Shiva, Vishnu, Nataraja and so many things'. In the interview with James he explained that he could not accept the limitations of the trade: 'I am acquainted with most of these things, although I cannot say I have learnt them. I respect them as great learning but I cannot say that I ever wanted to surrender to them as a full-fledged sthapathy is required to do' (James 1998: 88).

> Traditionalists will never accept anything other than the art made according to the traditional canons. There is truth, sincerity and justice in their commitment. Why, without that strong foundation in the past, there can be no present – the new will have no meaning, no existence, no beauty. But I cannot live in a confined past. I see changes everywhere and I want my work to reflect those elements of change. I want it to be part of that change. I don't want to live in yesterday's dreams. I want to stimulate the reality of the present in myself, in my thought, and of course in my work.[8]

Distancing himself from an ethic that, in his view, resulted in an overly repetitive practice, he rejected what he saw as lack of creativity in the present-day production of bronze icons. Endless copying, he stated, was partly driven by commercial pressures to produce similar looking depictions of the Divine for local, national and global markets.[9] Another factor was a lack of knowledge amongst many of the bronze makers about the philosophical foundations of religious sculpture, the Sanskrit language and the other Indian arts, such as dance.

Several times in the interview with us he stressed that he was a 'creator', not just a 'maker', and that he aimed to find new forms for old concepts, a contemporary visual language to express ideas central to Hindu philosophy. He stated that this was exactly what the original designers of the currently

much repeated sculptural forms had done: taking the freedom to create new forms. He concluded that he was therefore much closer to the sthapathys, who lived many centuries ago, than to his contemporaries, who were satisfied with the limited space for individuality offered by *manodharmam* (parts of traditional works left to a sculptor's discretion).

In these assertions, Vidyashankar's approach seems close to a modernist understanding of temporality, in which time and history come to be seen as separate concepts. As Ingold and Hallam suggest, 'the replications of tradition, endlessly repeated, belong to time; the novelties of invention, each a one-off, belong to history ... Time in this view is not creative; it brings nothing forth. Rather, what has once been brought forth through a unique historical event of creation, ultimately sinks back into time through its subsequent replication' (Ingold and Hallam 2007: 10).

Vidyashankar's view that his contemporary sthapathy kin are not creative allows him to emerge as a uniquely inventive individual. But this distancing from a relation also involves the construction of another more proximate one which subverts a conventional linear view of the progress of history. Through the practice of skilled knowledge, Vidyashankar Sthapathy seeks to excavate, bring forth and emulate the genius of his long-distant sthapathy forebears. Thus, he does not reject the past in its entirety as being totally separate from him. He rejects only those parts of the past that consist of 'empty time'; by way of contrast, he fully embraces history. Indeed, it could be said that he makes sthapathy activity properly part of history again through his uniquely creative practices. Through this making of a connection to past creativity, he engages a temporality that is at odds with a linear, constantly innovative and perpetually distancing history. In his pursuit of 'new forms for old ideas', he reveals himself to be an innovator in the short term and an improviser when understood over the longer term. He seems, however, to deny the attribution of this latter form of creativity to present-day sthapathys, who might also be regarded as improvisers in the shorter term.

What interests us here are the moves that Vidyashankar makes between different subject positions. In order to put himself in motion and become transvisionary, Vidyashankar has to 'stop' the movements of his sthapathy contemporaries: he fixes them as inhabiting a particular static position with respect to creativity and time.

Movement and Stoppage

Our understanding of perspectual movement as an aspect of transvision is informed by Massumi's discussion of Henri Bergson's famous analysis of Zeno's paradoxes of movement. The object of discussion is an arrow shot

by the archer Zeno, and the various ways in which its motion can be under-
stood. Should the arrow's flight be imagined as a series of points in the air as
it heads towards its target? The problem with that view, Massumi suggests,
is that 'between one point on a line and the next, there is an infinity of inter-
vening points. If the arrow occupies a first point along its path, it will never
reach the next – unless it occupies each of the infinity of points between'
(Massumi 2002). If one can plot the movement of an arrow by connect-
ing a series of pre-existing points, then, paradoxically, the arrow becomes
incapable of movement. Bergson suggests another way of thinking about
movement, 'that the arrow moved because it was never in any point' (ibid.:
6). The domain of actual movement is of a different reality to that of a ret-
rospective tracing of the arrow's trajectory. In other words, it is impossible
to break down the ongoing movement of an arrow into identifiable separate
points that constitute it. Doing so would mean to effectively stop the arrow
in its path through the act of tracing. Bergson (1911: 308) used the meta-
phor of the moving arrow to evaluate different philosophical understand-
ings of change. What is key is his understanding of the spatial. He argued
that when we plot, measure and divide space into points, we eliminate the
continuity of motion and relegate movement to a second-order event.

In our view, the two ways of understanding the path of the arrow, either
as an infinite potentiality or as an arch of connecting points, is relevant to
our analysis of both Vidyashankar's artistic output and his personhood.

Creativity and Subjectivity at
the Government School of Arts and Crafts

Vidyashankar's drive for 'creativity as freedom to find new forms for old
ideas' not only relates to his claim to artistic freedom (unlike his staphathy
contemporaries), but also reflects some of the tensions he experienced while
training at the Government School of Arts and Crafts. When the young art
student had finished his first degree, he had wanted to join the Sculpture
Department for a second degree. Paniker, however, sent him to the metal
section instead, a craft department where students were taught metal tech-
niques, and produced applied art products. During the interview with us,
when Vidyashakar spoke about this, his body language and the tone of his
voice betrayed his strong feelings of disappointment with Paniker's decision.
From the latter's perspective, it had made sense for his pupil to enter the
metalworking department because of his sthapathy antecedents. By doing
this, however, Paniker separated out a 'sthapathy aspect' of Vidyashankar,
and Vidyashankar felt himself being forced into a specific artistic position.
He strongly objected at first, concerned as he was that working in the met-
alworking department would hamper his creative freedom.

The preoccupation with freedom during his interview with us was produced through stoppage: he embraced a modernist image of artistic endeavour to throw into relief the sthapathy position in which he was placed by his teacher. He proudly recalled how he had begun experimenting with metal techniques, making freestanding work from pieces of beaten copper sheet metal. He also experimented with 'frontal statues', sculptural pieces that are meant to be viewed from one side. Both art historians and sculptors who have taken on the technique acknowledge that this was Vidyashankar's innovation. Paniker's son, the sculptor S. Nandagopal, said, for example: 'Where would I be without the inspiration from Vidyashankar Sthapathy's work?' (Ramnarayan 1993: 84). The genre of frontal statues had a direct link with temple sculpture, arising 'out of a religio-ritualistic necessity in ancient and medieval India'. Ramnarayan also stated that 'Vidyashankar Sthapathy, raised and trained in those traditions, became a natural pioneer in the attempts to transpose it to a contemporary context. The idea of attention from a single angle of worship intrigued him enough to adopt a secular approach to explore its artistic potentials' (ibid.: 90).

While claiming true innovation in the modernist spirit and also distancing himself from actually practising sthapathys, Vidyashankar then went on to distinguish himself from his colleagues at the Madras College who were busy appropriating visual elements from ancient monuments. But he did this by drawing on the very sthapathy ancestry that he had in other contexts sought to keep at arm's length. In the competitive world of the Madras School, where most artists jostled to be recognized as creators who successfully interrogated the relationship between tradition and the modern (indeed, in many cases trying to overcome the dichotomy), he claimed a more authentic enskilled vision for himself. In an interview for the Safion Art Network, he stated:

> Other modern sculptors have to go to a temple to see the deity or a frieze or a vahana to discover the number of hands or the kinds of symbols accompanying each concept. But all those details are imprinted in my mind by hereditary transmission so that I can mentally visualise what I want, and go on to achieve it in my medium. I know the tantrik concepts and the dhyana sloka of each image as well as I know the methodology of their execution in stone or metal or wood. This gives my compositions a proportional accuracy and balance which are missing in the works of many other modern sculptors. I believe even distortions must follow a norm to impart repose, equipoise and vibrancy. They transform your art object into living sculpture. (http://safionart.com/vidyashankar-stapathy.html, last accessed 19 July 2012)

Other art historians see the development of frontal sculpture as the collective field of 'play' among students and teachers at the Madras College, and as part of the search to be modern through tradition, thus in a sense obliterating the discreteness of both. James, for instance, saw the develop-

ment of frontal sculpture as a progression of steps in which several sculptors (Dhanapal, Kanayi Kunhiraman, Janakiram, Anila Jacob and Vidyashankar Sthapathy) had had an impact, a process that had not taken place according to a predetermined plan.

> The fairly long-drawn-out journey towards abstract sculpture advanced through a series of significant and catalytic contributions by key personalities in a historic attempt to get on a level with the methods and aims of traditional sculpture. The whole point of traditional workmanship, it can be argued, had been to abstract the surface from the material that one starts with in order to make sculpture. It should not be difficult to visualize it handled as if it were a free agent, modulating, inflecting, and accenting itself with flourishes of ornamentation and enlivening detail as in traditional sculpture. (James 1993: 27)

While this was the field, 'traditional' and 'modern' did emerge through the ways in which different artists became associated with particular responses, and thus how they came to be defined as artistic subjects. As the art historian Ashrafi Bhagat (personal communication) notes, whereas Vidyashankar developed frontal sculpture in an explicitly modern conversation with the iconography of Hindu images, Janakiram invented a technique combining the kavachas or the sheet metal coverings in silver and other metals for the main icon in the sanctum and for the doors of the temples, and extended its use to create what are known popularly as 'frontal sculptures'.

Vidyashankar's early works, such as *Mourner-I* (1963) and *The Women* (1964) had non-religious themes, but the artist soon turned back to Hindu mythology. To explain his move he adopted a language of modernist innovation, claiming to have initiated a stylistic movement. 'I was the first to introduce iconographical and epigraphical elements in sculpture. My shapes and forms are modern, but my subjects are drawn from the rich resonances of the past. I try to evoke those resonances in everything I do' (Ramnarayan 1993: 93). Here again, we witness the operation of transvision: Vidyashankar looks across time to ensure that his work contains 'resonances'. Although he emerges as a subject in this exposition, stopped in movement by the plotting of his art in time, one can understand the art object itself containing movement since these 'resonances' remain undefined or indivisible, and can be made to happen in as-yet-unrealized future works.

Conclusion

Transvision may seem to have some affinities to 'memory'. We could have argued, for instance, that the communities of practice that exist in both the sthapathy workshop and among students and teachers at the art school

draw selectively on the past through processes of remembering in order to make themselves in the present. The 'resonances' that Vidyashankar mentions above, for instance, might be understood as forms of memorialization or commemoration.

The boom in memory studies in anthropology, however, has recently been criticized for deploying and developing the scope of memory so widely that it covers every kind of cultural and social activity (see Berliner 2005). The stretched term of 'memory' no longer requires people to actively remember: ritual, kinship, and so on have been discussed by anthropologists as forms of memory. Indeed, as Berliner argues, the notion of 'memory' has come to occupy the same ground as the concept of 'culture'. We suggest that for the purpose of our analysis, transvision is a more precise conceptual tool than memory for two reasons; firstly, it allows us to follow the artists we worked with in privileging the sense of seeing in reaching across time and space, and secondly, transvision does not operate solely within the imagination, but needs to be actively performed through materialization in order to come into being. This does not imply permanence; specific transvisions may only exist for a moment as very restrictive kinds of imaginative operation. Thus, while transvisionary imagination builds connections, these connections are always highly contingent.

Transvision yokes together a focus on enskilment with that of movement; by combining these, we believe that we come to an enhanced understanding of power, creativity and artistic subjectivity. Grasseni notes that 'the local construction of skilled knowledge … actually contributes to the establishment and maintenance of hegemonic, often global standards of practice through which we perceive, order and manage the world' (2007: 7). She additionally looks for spaces of resistance (which she identifies with creativity) and which emerge in the management of compromises that those who undergo training have to make; as Grasseni states, 'often these very strategies reinstate the marginality and subalternity of their protagonists' (ibid.: 8).

The attention to power is welcome and instructive. Grasseni poses a question about the possibilities of resistance and creativity of those working in such a hegemonic situation. We, in turn, draw attention to three aspects that are implied by this configuration: firstly, resistance is linked with creativity, implying that while they remain two separate concepts, there is nevertheless much that they share; secondly, resistance and creativity create a composite image of agency, one that is associated with (artistic) freedom from the institutional or other hegemonies of skilled knowledge; and thirdly, resistance and creativity are seen as requiring 'space', distinct from or separate from the 'spaces' of skilled knowledge construction.

The configuration of power produced by processes of enskilment and the identification of marginality and resistance is complicated here by the types

of movements involved in transvisionary practices. Vidyashankar appears as an artist who enacts varying forms of subjectivity by moving between positions. The combination of the movement between positions forms the whole of his subjectivity. Thus, at certain times and in certain spaces, Vidyashankar appears as a contemporary artist and at others as a traditional sculptor, or even a combination of these two separate elements. The position he enacts and is placed in by others becomes bound up with the play of power that Grasseni describes, as the standards by which he is judged (and judges himself) shift. He appears alternately powerful and marginal, depending on where and when we fix his subjectivity. His subjectivity thus appears to us like a 'thing', as an object.

This is also a meditation, therefore, on the tradition–innovation dialectic. It is during moments of stoppage (such as when Vidyashankar's teacher, K.C.S. Paniker, asked him to go to the metalworking department) that 'tradition' and 'innovation' emerge as separate categories and Vidyashankar identifies (and is identified) with one or both of these distinct ideas. In his conceptualization of his artistic endeavour, he fixes tradition at a point in time and space, and innovates in relation to that fixed point. At other moments, however, such as during his formative education at the Madras College, the separate and distinct concepts of 'tradition' and 'innovation' melt from view as artists collectively work through experimental techniques to overcome the positing of the separateness of the terms.

We considered how references to material production and specific objects were central to his accounts of subjectivity, which operates on a plane of reality that permits Vidyashankar to assume certain positions in space and time. In this, the subject positions of the artist appear much like the parts of the sculpture that we discussed at the beginning of the chapter.

From one perspective, the movement of the parts of the sculpture into different positions that result in the sculpture taking a particular form can be likened to the movement of Zeno's arrow through the air. As Vidyashankar moves a part with the objective of altering the sculpture, he is confronted with an open-ended field of possibilities. As his fingers grapple with the bronze object, the potential for a new trajectory appears and an infinite number of positions in space present themselves. In his playful improvisation, remembering earlier works (made by himself or others), he may come up with a variation, or alternatively, surprise himself with a new solution. The paradox is that the parts themselves are predetermined and cannot be changed. Once the artist has decided on a new configuration of the parts, the sculpture comes into view retrospectively as a thing – an assemblage of parts that have not altered, limited as they are by their shape and material. In Massumi's words, 'a thing is only a thing when it isn't doing' (2002: 6).

In turn, the different sculptures that emerge through this repositioning of parts can be plotted temporally as points in relation to one another, implying movement and change when seen in retrospect. This parallels the way in which Vidyashankar's telling of his life during the course of our interview with him follows the path of Zeno's arrow: he retrospectively plots a path which makes sense of where he finds himself now, but deprives the points of the movement they had as his artistic life unfolded.

Notes

1. http://www.contemporaryart-india.com. Accessed 15 July 2012.
2. Paniker was strongly driven to pass his ideas on to a younger generation of artists. In the late 1950s and the 1960s, he firmly established the Madras Movement, gathering a group of students and ex-students around him, first at the art college in Madras, and later at the newly established art village of Cholamandal. He promoted the idea that a balance should be found between an engagement with Western-dominated international art movements and the appropriation of local visual genres. At the same time, he tried to create a market for this art. Following this philosophy, representatives of the movement, such as N. Viswanadhan, A.P Santharaj, Redeppa Naidu and Ramanujam, all aimed to depart from ideals promoted by Western Renaissance art traditions, such as naturalism and perspective.
3. His work has been exhibited in galleries all over India and also in Europe, and is housed in public and private collections.
4. He referred to different stages in his career and pointed at a variety of artistic influences and choices, in much the same way as he played around with the sculptural pieces. Moving back and forth in his life story, he highlighted, combined, connected and contrasted different fragments of his past, presenting multiple storylines. He shaped his story partly in reaction to our questions and the artefacts available in the studio, including photographs, books, sketches and some of his works.
5. In this he was not unlike other Indians who keep portraits of their ancestors in one place where they can be greeted with light and incense, but Vidyashankar made a specific note of his *professional* link to his forefathers.
6. It was one of the first things Srikanda Sthapathy mentioned in January 2011 when we visited him in his workshop in Swamimalai. Similarly, when historian William Dalrymple (2009: 176) first heard about Srikanda, he was told that the 'idol maker' was 'the twenty-third in a long hereditary line stretching back to the great bronze casters of the Chola empire, that ruled most of southern India until the end of the thirteenth century'.
7. As Grasseni has pointed out, the 'community of practice' perspective 'offers a pragmatic scope for observing cognition and skill at work and in their making' (Grasseni 2007: 10).
8. http://safionart.com/vidyashankar-stapathy.html. Accessed 19 July 2012.

9. The demand for Hindu icons not only comes from temples in India, but also from recently built Hindu temples around the world. In addition, tourists and art lovers (of Indian and other origins) are interested in 'showpieces', unconsecrated works.

References

Bergson, H. 1911. *Creative Evolution,* trans. A. Mitchell. New York: Holt, Reinhart and Winston.

Berliner, D. 2005. 'The Abuses of Memory: Reflections on the Memory Boom in Anthropology', *Anthropological Quarterly* 78(1): 197–211.

Dalrymple, W. 2009. *Nine Lives: In Search of the Sacred in Modern India.* London: Bloomsbury.

Grasseni, C. 2004. 'Skilled Vision: An Apprenticeship in Breeding Aesthetics', *Social Anthropology,* 12(1): 41–55.

———. 2007. 'Introduction', in C. Grasseni (ed.), *Skilled Visions: Between Apprenticeship and Standards.* Oxford: Berghahn Books, pp. 1–22.

Guha-Thakurta, T. 1992. *The Making of a New 'Indian' Art: Artists, Aesthetics and Nationalism in Bengal, c.1950–1920.* Cambridge: Cambridge University Press.

Ingold, T., and E. Hallam. 2007. 'Creativity and Cultural Improvisation: An Introduction', in E. Hallam and T. Ingold (eds), *Creativity and Cultural Improvisation.* Oxford: Berg, pp. 1–24.

James, J. (ed.). 1993. *Contemporary Indian Sculpture: The Madras Metaphor.* Madras: Oxford University Press.

——— (ed.). 1998. *Contemporary Indian Sculpture: An Algebra of Figuration.* Madras: Oxford University Press.

———. 2004. *Cholamandal: An Artists' Village.* New Delhi: Oxford University Press.

Levy, T.E., et al. 2008. *Masters of Fire: Hereditary Bronze Casters of South India.* Bochum: Deutsches Bergbau Museum.

Massumi, B. 2002. *Parables for the Virtual: Movement, Affect, Sensation.* Durhan, NC: Duke University Press.

Mirzoeff, N. 2000. 'Introduction: The Multiple Viewpoint – Diasporic Visual Cultures', in N. Mirzoeff (ed.), *Diaspora and Visual Culture: Representing Africans and Jews.* London: Routledge.

Mitter, P. 1994. *Art and Nationalism in Colonial India 1850–1922: Occidental Orientations.* Cambridge: Cambridge University Press.

Ramnarayan, G. 1993. 'Vidyashankar Sthapathy', in J. James (ed.), *Contemporary Indian Sculpture: The Madras Metaphor.* Madras: Oxford University Press, pp. 78–95.

Sheikh, G.M. 1989. 'Among Several Cultures and Times', in C.M. Borden (ed.), *Contemporary Indian Tradition.* Washington, DC: Smithsonian Institution Press, pp. 107–20.

Svašek, M. 2009. 'Improvising in a World of Movement: Transit, Transition and Transformation', in H.K. Anheier and Y.R. Isar (eds.), *Cultural Expression, Creativity and Innovation*. London: Sage, pp. 62–77.

———. 2012. 'What You Perceive Is What You Conceive: Evaluating Subjects and Objects through Emotion' in M. Svašek (ed.), *Moving Subjects, Moving Objects. Transnationalism, Cultural Production and Emotions*. Oxford: Berghahn, pp. 245–68.

11

AN INDIAN COCKTAIL OF VALUE/S AND DESIRE
ON THE ARTIFICATION OF WHISKY AND FASHION

Tereza Kuldova

Remember, that by 2020, we will be talking in terms of lifestyle brands and not merely fashion brands. These are brands that will touch many parts of consumer life – from home furnishings to perfumes to clothes to automobiles and hotels … By 2020 I also envisage a huge demand that will have to be catered to within this country as a young population seeks style 'nirvana'.

– JJ Valaya, Indian fashion designer

It is May 2011, and once again I am on my way back to New Delhi. Waiting at the airport in Helsinki for a connecting flight, my phone beeps. 'Get me Chivas Regal 18, for my bar, pay you when you reach, better take two bottles', says the message. Not the first message of this kind, and not the last, I suspect. The appeal of airport duty free is still immense. After I get through the immigration queue at the Indira Gandhi International Airport I pass the Duty Free shop. I am struck by large posters suggesting I purchase Chivas Regal 12, 18 or 25 and be the lucky winner of a luxury stay at the Cannes film festival. Is this just a coincidence?

Arjun, who demanded the whisky bottles for his bar, is a *Jat,* a businessman and the son of a politician (not an uncommon combination, certain Jats have always occupied premier positions in society, as statesmen, businessmen, landowners, warriors or army officers). The bar is in his secret flat,

which serves only one purpose – private meetings with his fellow fashion-able 'gentlemen' – sons of politicians, industrialists, businessmen, restaurant, bar and club owners; and, more practically, some lawyers. Nobody lives in that flat, except for the bar stuffed with the world's finest whisky, liqueur and wine, a fridge with Western beer, ice cubes and juices, some furniture and three ACs. The bar's value is purely symbolic, reaffirming Arjun's status and position (Bourdieu 1984). Arjun and his 'gentlemen' drink every time they meet, and so the finest in drinks must be available. Most prefer whisky or beer, but cocktails are becoming increasingly popular, too. They discuss the 'art of making cocktails' regularly – the knowledge of the world of liquor and cocktails is a cultural capital in its own right, as is the knowledge of brands, big names in fashion, business and politics.

Fast forward a few days, and we are sitting in an SUV; Mayawati's[1] party flag is wildly spinning around on the front bonnet of the car as we drive fast through the night streets of Delhi. I am heading with Arjun and Rajesh, an upcoming fashion designer, educated at NIFT (National Institute of Fashion Technology, New Delhi) and from a rather wealthy Jodhpur family, to a 'by invitation only' fashion party at one of Delhi's five-star hotels. Arjun, who is driving, is having a beer, and Rajesh a whisky. Almost every night-time drive, with young and relatively wealthy men in the car, is accompanied by alcohol. I am enjoying a coffee. As I was told, drinking is something that is 'meant for men' and 'girls who drink are cheap, maybe one cocktail – sometime – is fine, but they cannot drink like a man, look at these girls at the parties, they get drunk and how they behave, it might be fun with them, but who wants to marry them?' I realized that my dress perfectly matched this statement. Before they picked me up, Arjun instructed me to dress for a party but, at the same time, 'decently'; Rajesh suggested Indo-Western style. I have been told several times that since I am white, I should be dressed at a party even more modestly than Indian girls so that I am not perceived as one of those 'easy to get, cheap model girls', as Arjun called them, and added, 'I mean, do you have any idea that they are paid to attend these events and drink with the rich guys? I don't want you to look like I paid you'. After attending several events and parties, I have realized that these girls are always there; they are beautiful, most of them 'white', tall, and dressed in the latest fashions; they sit around with older, wealthy men, drinking one drink after another; some smile, some dance, some just sit there. This has become a regular part of their 'modelling' jobs in Delhi, a way to make extra money, get free drinks and pose for the camera. The idea behind this is that they 'beautify' the event and increase its aesthetic appeal. It was essential that I do not fall visually into this stereotype. A long-sleeved Indo-Western dress with traditional embroidery did the trick for me. Both of the boys wear Jodhpuri bandhgala jackets; Arjun's is by Raghavendra Rathore, a high-

class fashion designer and notably also a prince of the erstwhile royal family of Jodhpur, whose collections solely revolve around royalty and class. This style of jacket is hugely popular, no less because it was worn by the young princes and rulers during the birth of 'new' India; it is synonymous with Indian luxury, style and class. Rajesh wears his own creation, decorated with heavy embroidery. Both of them match these jackets with casual jeans, and Arjun also with his favourite Dior shoes.

We reach the hotel, have the car parked, after it is thoroughly checked by the security guards, and are greeted with a namaste from a man dressed in a traditional Rajasthani outfit, with a large red turban and an enormous moustache. We pass through another airport-like security check at the entrance. Finally we are off to the top floor of the hotel, where we are checked by security again. Our names are on the list, but since we arrive late, we miss the official part of the event – a small fashion show which apparently took the form of performance art. Yet the 'artsy' atmosphere is still in the air, the models, dressed in the collection pieces featuring a mixture of fabric prints inspired by Indian miniature art and pop art, are mingling among the guests, alternative music and light projections are still in full swing, the bartenders are juggling with bottles of Smirnoff. In between, a few invited 'celebrities and events'-journalists are trying to get the right pictures of the right people. Rajesh manages to sneak in on a picture with the main designer. Arjun is not interested in any of that – he refuses to have his picture taken, as he is there only to 'show up', meet some of the 'uncles' and pass on greetings from his father, strengthening the mutual bonds. Then he sneaks out of the main crowd and sits at a corner table with his friends/cronies, drinking whisky, smoking, discussing local politics, world politics, business, global brands, local brands, possible joint ventures and, not least, the alcohol industry. It is one of those industries that is booming, yet at the same time is a high-risk one; there is corruption at every level, taxation is high and it is dominated by global magnates, all of which makes it an exciting challenge. I sit there, watch them, and laugh when I am expected to. My purpose there is more to enhance status than to speak my mind; I am more talked about than talking. I am the beautiful and intelligent Western adornment.

I keep moving between Rajesh and Arjun; we are at the same event, yet it seems like two parallel worlds – one visible and mediated, the other invisible. Rajesh is standing with his cocktail glass and mingling with people, his small talk consisting of fun stories and gossip. He is there to shine and smile, to show off, to be seen and acknowledged and to promote himself as a unique, creative, slightly strange and flamboyant individual, with a radical take on fashion (though this is not supported by the stereotypical royal jacket with embroidery, as the essence of Indianness). While he uses me as a status-enhancing device, he lets me speak for myself as well, as he

knows it is good for him if he appears to be surrounded by Western literati (the highest status enhancement can be achieved at events where literati and glitterati mingle). The models are still cruising through the standing crowd, throwing poses at the cameras, drinking cocktails at the bar, moving to the sound of the music and petting/patting 'their sponsors' on their backs. The wives of these men are either at home or sitting in a corner, some dressed up in heavily embroidered saris and others in various Indo-Western designer creations. They keep moving from the corner to their husbands and back; they often throw around some big smiles, greet, briefly comment and leave. The big topics among them are fashion and the collection they have just seen, as much as gossip, all of which they discuss while sipping their cock-tails, some smoking slim light cigarettes, while having bites of olives, cheese, gourmet appetizers and Indian 'luxury' snacks. Before leaving I notice that the fashion party was sponsored by Blender's Pride, which apparently has an arrangement with the designer.

Alcohol and Fashion in the Global Aesthetic Financescape

This little piece of ethnography shows a world of interdependence, where markets are intertwined, where fashion depends for its value creation on art as much as on alcohol; a world where media plays a crucial role in making certain people more valuable than others. Fashion has recently spurred the imagination of an increasing number of anthropologists and sociologists, yet many of them tend to treat the world of fashion as a world unto itself. While this might be the case, to a certain degree, I wish to take a different perspec-tive and look at a particular intersection – namely, the junction between fashion industry, alcohol industry and art, or rather the 'aura of art'. The meeting point of these three elements is all about pleasure, and since plea-sures are often predicated upon privilege, as well as upon exploitation and oppression, they should be interrogated (Smith 1996). I have shown how these realms are deeply connected to each other and how they draw prestige and value from each other, and argue that the value of the products of each industry, including the works of art, is created at this intersection. Fashion, art and alcohol feed each other through the power of association and con-notation that mutually reinforces them; the notion of luxury emerges at the crossroads of the imaginaries that they produce. A cocktail is turned into a work of art, a whisky into a fashion statement, an inauguration of an art exhibition is not interesting unless it has a celebrity factor and cocktails are served, and a fashion show loses its appeal if it does not pose as an 'artsy' expression of a creative genius. It is through this mutual reinforcement of the associated imaginaries of art, fashion and 'the pleasurable experience'

of alcohol drinking, often connected to status and royalty, that the brands, designers and artists are able to sell more than products, they are able to sell values, lifestyles and their attached emotions. Imagination is the prime source of value of these objects. What we investigate here is thus imaginative value, closely linked to positional value (Beckert 2011). By weaving together an aesthetically pleasing narrative about 'essences', designers, as much as alcohol companies, manage to enhance the symbolic value and increase the symbolic capital of the products, which acquire their value only by meaningful entanglement within a larger system of goods (Entwistle 2009).

Fashion, art and alcohol all participate in what I would call an 'aesthetic' financescape – a financescape where aesthetics is rendered calculable, a financescape that revolves around appearances and attention, a financescape where economic and cultural calculations merge (Appadurai 1996; Entwistle 2009). We will explore one particular constellation of this global aesthetic financescape as it has emerged in the context of postcolonial neo-liberal India by looking at 'the way in which and the conditions under which objects – aesthetic or otherwise – attain and change meanings in an interconnected world' (Fuglerud and Wainwright, 'Introduction' this volume). I argue that the way in which objects are 'framed' is crucial for our understanding of how value is created. As objects move across space, time and various social positions, their meanings and value change; their value is equally influenced by other objects that share that particular social location at a given moment in time. This suggests that the material is inherently unstable; it is a result of specific practices. This also means that we need to look at economy in practice, rather than conceiving it in terms of an abstract economic system (Bourdieu 1984). In our case, we need to focus on the concrete manifestations of the aesthetic financescape in a particular location.

To this end, we will examine an Indian promotion strategy of Chivas Regal, considered one of the world's premium whiskies. The alcohol industry in India is getting increasingly interested in finding new ways of making itself visible and desirable in order to penetrate the imagination of consumers. Sponsoring fashion shows and art events is one of them. The campaign 'Live with Chivalry' and the institutionalization of the global concept of Chivas Studio, a platform that brings together performance art, visual art, fashion design, music, film and mixology (the art of making cocktails) in a yearly three-day event staged in Delhi and Bombay, will be our case in point. This is an illuminating case for understanding the ways in which value/s is/are created and shaped over time and is particularly interesting in the postcolonial context of neo-liberal India. This case provides the necessary context for a deeper understanding of our little introductory ethnographic note while speaking directly to the central premises of this volume, which is that the

'treatment of artifacts as fine art is currently one of the most effective ways to communicate cross-culturally a sense of quality, meaning, and importance' (Clifford 1997: 121). The question however is, how does this happen in practice and what does it mean?

Throughout the text, I use the concept of 'artification' to capture what Clifford refers to here. Artification is a process of turning non-art into art and using reference to art in order to increase the status and symbolic value of products (Shapiro 2004). Artification has been popular with Indian fashion designers since the mid-1980s. They realized early on that fashion is 'attentive to the residual aura attached to what is revealingly termed "high" art' (Radford 1998: 153). Notably, those designers who exploited this logic to the full today enjoy the privileged top rank. I also argue that artification legitimates what otherwise might be considered conspicuous consumption – a lavish and wasteful spending intended to attract attention to one's wealth and to enhance social prestige, where fashion is often a favourite target (Veblen 1970). Artification redefines conspicuous consumption by transforming it into an investment in art, a strategic move through which both meaning and value change. To answer our question of how this happens and what it means, which we are about to tackle through the example of Chivas Regal, I believe we need to get at least a little contextual knowledge in order to be able to weave certain threads/strands of the argument together.

Luxurious Intoxications of the Indian Elites through History

Indian mythology is imbued with narratives of drinking liquors with mind-transforming properties, which suggests that during the Vedic period (2000–800 BC) the Aryans of north-west India were familiar with fermentation and distillation (Isaac 1998). The Vedas often refer to *soma*, 'an elixir of life', apparently a drink of the social elite, credited with positive qualities (Saxena 1999), and *sura*, a fermented beverage drunk by the warrior caste and on special occasions. Later on, the Mughal monarchy transformed wine drinking into a refined courtly art. Court poetry and miniature painting were both centred on the depiction of wine as a realization of the divine world. Filling the cup with wine equalled living a life of joy, power, wealth and success. While enjoying the intoxicating drinks, the nobility was dressed in the most exquisite muslins and luxurious silks, indulging in attires most lavishly embroidered with gold and silver, and embellished with jewels. As much as they indulged in fashion, they took pleasure in the harem and performances of skilled and talented courtesans – wine and women went hand in hand. While wine was one way to come close to God, fashion was another – es-

pecially shiny garments heavily embroidered in gold. Cloth transactions underpinned the commercial structure of the Mughal Empire (Bayly 2008), as much as alcohol production and bars did. Mughal royals were trendsetters and thus, even though drinking was commonly referred to as evil in many religious scriptures and among commoners, the power of its glamorization by the ruling classes and its association with a life of lavishness, exuberance, luxury and wealth (Singh and Lal 1979) proved to be stronger.

The era of colonial rule saw a further rise in alcohol consumption. Alcohol drinking slowly acquired positive connotations and became desirable; it began to be normalized: 'Drinking changed from ritualistic and occasional to become a part of routine everyday social intercourse and entertainment' (Saxena 1999: 39). The British not only gave licenses to big distilleries but also allowed for a local production of liquor, which further encouraged its consumption (Saxena 1999). At this point alcohol became tied up with two predominant imaginaries that have endured to this day, as manifested in the popular conceptions of alcohol, as much as in the very branding of these products: firstly, the royal connection, be it the Vedic elite, Mughal courtly nobility, or British royalty; and secondly, the Western connection, whereby drinking became indefinitely associated with a Western lifestyle. We should remind ourselves that alcohol was one of the issues upon which the independence struggle was fought; Mahatma Gandhi himself campaigned against liquor production and sales, and alcohol prohibition is in fact built into the Indian constitution, even though this does not always reflect in reality (Isaac 1998; Saxena 1999).

The 1990s were synonymous with liberalization of industrial licensing, increased promotion of imports and exports and collaboration with transnational corporations, and privatization of public industries. This attracted international brands to India. Since then the alcohol industry in India has thrived; alcohol consumption shows huge increases every year,[2] as compared to the 'old' European and U.S. markets where it has stagnated. The alcohol industry in India sponsors more and more fashion events (Blender's Pride Fashion Tour, Lakmé Fashion Week, Smirnoff International Fashion Award), sport events (Chivas Regal Polo Championship, Royal Challenge Indian Open, Chivas Regal Invitational Golf Challenge, and cricket events sponsored by Royal Stag), music events, movies (for instance the Bollywood movie *Fashion* from 2008 featured direct shots of Smirnoff vodka), tourism and more (Das 2007). Blender's Pride, Royal Challenge, Chivas Regal and Royal Stag are all whisky brands, most of them manufactured and distributed by Pernod Ricard, the world's largest spirits and wine company. The fact that it is whisky brands that sponsor these events is far from surprising; whisky is the most commonly consumed alcohol in India, and India the largest whisky market in the world (Argenti 2007).

The (Brand) 'Essence' of Chivas

Chivas Regal whisky offers a metaphor of both colonialism and postcolonialism in India. Even the contemporary branding of the whisky suggests profound links to concepts and lifestyles that go back centuries. The phantasm (Favero 2005) that Chivas Regal creates through its branding is therefore a powerful one. The story goes as follows. In 1801 the Chivas brothers opened a grocery store in Aberdeen, where they sold luxury foods, such as exotic spices, coffee and Caribbean rums, and also began producing a smooth blended whisky. In 1843 they were granted a Royal Warrant to supply goods to Queen Victoria, and finally in 1909 they launched Chivas Regal. In 2003 Chivas launched 'Royal Salute 50 Year Old', a special edition to celebrate Queen Elizabeth II's Golden Jubilee. The story of Chivas is intertwined with the story of royalty. This connection to monarchy, royalty and luxury provides Chivas with its luxury status. The tacit belief of the consumer that the whisky has a particular essence, which has the power to transform the drinker into a member of this exclusive club, is one of the things that drive whisky sales and consumption.

There is an expression in pop-economics, 'the Chivas Regal Effect'; it refers to a product that sells in larger quantities because its price has been increased (Martin 2011). Chivas Regal was initially a rather obscure Scottish whisky, which turned into one of the most luxurious whiskies in the world because of its exaggerated price tag. The logic behind the Chivas Regal Effect is simple: people tend to equate quality with price – the more expensive the better and the more valuable. This very same logic is exploited in most markets, most visibly probably in the case of fashion. It is interesting to note that even a number of studies in neurophysiology confirm this effect, showing that the actual experienced pleasantness of wine was higher when the wine tasted was believed to be expensive. These studies conclude that 'EP (experience pleasantness) depends on non-intrinsic properties of products, such as the price at which they are sold' (Plassman et al. 2008: 1052). This suggests that our belief that a more expensive wine, or whisky, is *essentially* tastier, in fact alters our sensory expectations which in turn alter our perceptual interpretations, and so it happens that we experience what we *expect* to experience. This is why essence as much as values play a crucial role in branding (Bloom 2010).

This logic resonates with what Max Warner, the global ambassador of Chivas Regal, who travelled all over India to promote the 'art of mixology', says about Chivas in the *Urban Male Magazine*: 'We've got a *legacy*. John and James Chivas originally pioneered blending; these guys were *visionaries*. They were *artists* and they provided goods and services to the royal family in Scotland, hence the name Chivas Regal or Chivas Royal. I am contin-

uing their legacy in providing the *aristocracy of the world* with the finest information about Scotch whisky and associating the right brands' (Warner 2010: 102, emphasis mine). This is where the essence of this whisky is located. Now let us look at the core value promoted by Chivas Regal, chivalry, and see how that feeds into the desired phantasm, and after that, how the Chivas Studio creates what I term the 'total environment of value display'.

'Live with Chivalry': Creating a Brotherhood of Luxury Whisky Drinkers in India

'Chivas Studio' is a concept and a three-day event that is intended to promote the core brand value – life with chivalry. The event, structured around this concept, invites fashion designers, filmmakers, musicians and artists to enact this core value of chivalry as much as does the core statement – 'art is life is art'. Chivas Studio is a global concept, and after New York, Sydney, Paris, Madrid and Hong Kong, it was launched in India in 2010. It claims that it stands for 'exuberance perfected to an art and a way of life'. The term 'Chivas life' thus not only refers to living a life with chivalry, brotherhood, honour, gallantry and loyalty, but also living the life of the aristocracy – a life that is a masterpiece, perfected to the last detail through the most luxurious and sensuous experiences, attires, tastes, smells, messages and movements. In the Indian context this brings forth the imagery of the Mughal courts and the maharajas of the princely states, as much as it does the British aristocracy. The idea of the Chivas Studio was to create a total experience that reenacts this imagery and captures all senses, transforming everything that this experience includes into high art – be it fashion, cocktails or haute cuisine. This event could, perhaps, be likened to or juxtaposed with the food presentations of the Tongans described by Arne Perminow in this volume. Events such as Chivas Studio, modern ritual spaces of sociality, give us as much insight into society and the relationship between modern 'ritual' aesthetics and its environment, as the moving Tongan food presentations do; both create a total experience, in the Indian context an experience that refers to an extrapolated phantasmagoria of life in the social elite, where images from the past and present intermingle.

Chivas commercials are saturated with elitist bias. One of them for instance cheers: 'Here is to a code of behaviour that sets certain men apart from all others. Here is to us. Live with chivalry'. In the Indian context, this campaign feeds directly into pseudo-Orientalist visions of India that are, in fact, central to the production of many fashion designers. The unique selling point of the Indian fashion industry is heritage – India's crafts, weaves, silks and unique hand embroideries. The most famous Indian fashion designers

actively incorporate royal imagery, blending it with modern cuts but keeping a distinctively Indian feel, at the same time as labelling their creations as works of art. Luxury in India is ultimately 'royal' luxury. It is thus no wonder that many whisky brands, which are often predicated upon an association with royalty, are forging alliances with Indian fashion designers, who already embody the 'essence' of royal luxury in their products – the core value of many whisky brands. But what about chivalry, this peculiar medieval concept that was revived in the Victorian era and which, combined with imperialism, provided moral justification for England's rule in its colonies (Girouard 1981)?

It is not clear if the ideology of knighthood and the institution of chivalry were mere literary inventions or had an actual material basis, but it is certain that 'the ideology of knighthood was profoundly influential in constructing and sustaining actual structures of power based on class, gender and religion. … Chivalry, even when it formed and authorized the class, gender and racial/religious superiority of the knight, *also provided a young male of the lower aspiring aristocracy with the means of upward social mobility*' (Rajan 2004: 41, emphasis mine). This point is still crucial today, and especially in modern day India where upward mobility is becoming something that can be bought. It seems that the object associated with a certain value becomes the value itself, and thus by possessing that object or drinking that whisky, in the right environment, one can actually become a part of the social circle with which the value is associated, in this case the upper-class men of power. Chivalry in colonial India was a value ascribed to the British, as much as the Indian – by the British and by Indians themselves. It was Queen Victoria who institutionalized several orders of chivalry in order to unify the British governors and the ruling princes. From the Order of the Star of India (1861), to the Imperial Order of the Crown of India (1878) and The Most Eminent Order of the Indian Empire (1878), the aim of these orders was to 'rank, reward and reconcile the British proconsular elite and the Indian princely elite' (Cannadine 2002: 88). The British understood well that what mattered in India was rank, status, honour and respect, and it was by exploiting the obsession of the princely rulers with status and their desire for imperial honours that the British managed to unite the elites. Yet, the acceptance of an honour did not merely elevate someone in the social and imperial hierarchy; it also put them formally in a direct and subordinate relation to the monarch.

The Chivas Regal campaign 'Live with Chivalry' claims that life is not just about having more, 'the new luxury is about being more'. This directly touches on values, and what we perceive in life as valuable. Values, such as chivalry, presented as desirable, are those that we are supposed to value, as the price tag on the whisky suggests. Yet this chivalry is reserved only for

the male part of the world. Power, wealth, royal and luxurious lifestyle, all this belongs to the brotherhood of the modern-day knights or the maharajas of contemporary India. As Arjun said, drinking is for men. Women, even though they do drink whisky, are excluded from this exclusive men's club. If women appear at all in the whisky commercials, it is only to be seduced by a man holding a whisky glass or to pose as objects or decorations.

Consider the Indian *Chivas Studio* promotion; it boasts about being a platform for artists, musicians, fashion designers and yet all of them are men (see figure 11.1). The idea behind the photo shoot for the promotion poster was, according to the photographer, to capture the essence of the Indian creative elite, the unique male genius. Each man was supposed to have a unique facial expression in the picture. On the other hand, when shooting another promotional poster for Chivas, with female models, these women had to look like lifeless, expressionless statues, surrounding a musician with an expression of animated spirit on his face. The poster ended up looking all too similar to the Mughal harem. I can even see myself in it when I was sitting at the table with Arjun and his fellow gentlemen, as much as I can see all those models at the fashion party. Masculinity always went hand in hand with bar culture (Mann and Spradley 1975). After all, one of the beliefs of chivalrous gentlemen at the end of nineteenth century Britain was that 'women who compared themselves with men were betraying the essential role of womanhood' (Girouard 1981: 260).

Figure 11.1. Backstage at the Chivas Studio 2011 promotion photoshoot. Image courtesy of Vijit Gupta, 2011.

'Art is Life is Art':
Authenticity and Artification of Fashion and Whisky

The story of fashion and whisky has, across the centuries, been closely related to the story of royalty and elites, and the Chivas Studio is only a contemporary manifestation of this unfolding story. A multinational corporation that stands behind Chivas Regal and numerous other whisky brands, wines and liquors, penetrates India and through the power of its capital and its brands aims to transform the definition of art itself, or rather, to elevate objects not previously considered as art into the realm of art. The association with art is necessary to increase the value of the product through a powerful intertwined range of associations. It claims that fashion design as much as cocktail mixing should be understood as an art form and, especially, enjoyed as such. Events such as Chivas Studio appeal to the aura of high art associated with its high value, high class and a certain kind of authenticity. While the Chivas Studio is a global concept, it takes different shapes and forms in the various diverse locations.

Chivas revives the notions of royalty, using the combined power of the 'English gentlemen' and Indian maharaja; it talks of the moral code of chivalry, of the brotherhood of honourable men, while exploiting the appeal of high art and the persona of the artist. It draws credibility from both reputable personas of the Indian art world and filmmakers turned celebrities. The connoisseurs of whisky cocktails become connoisseurs of art. This event and a range of other related events, such as Chivas Studio Spotlight, which moves around big Indian cities and features fashion shows, art exhibitions and music events alongside film, gourmet food and cocktails, all capitalize on a combined power of association and imagination and heavy aesthetization, as much as on our desires. Media report excessively on these events, presenting them as desirable, while celebrities pose with the Chivas logo in the background. These media messages feed as much as create the dreams of the viewers, who exercise their imaginations as much as any artist does.

All of this is encompassed in the notion of essence, which goes hand in hand with the idea of 'authenticity'. When it comes to the branding of Chivas Regal, this authenticity seems to come from many sources. In fact, the idea is to draw on as many narratives, objects, concepts and individuals from which authenticity can be derived, as possible. Living with chivalry appeals to notions of living an authentic life; a life true to one's values. Living a life that is art can also be perceived as living a life of authenticity, a life that is genuine – the way the life of an artist is often imagined. Authenticity might also be derived from the historical narratives that Chivas appeals to; they give it authenticity, which is, after all, 'that quality that somehow connects the commodity to a place or time with special significance, often

rooted in notions of tradition; and taste (or distinction, in Bourdieu's sense)' (Smith 1996: 506). These notions of authenticity are all brought into action in order to legitimize and justify the market price at the same time as that very market price increases the value of whisky, while the limited series further enhances the value of all the remaining bottles ('Chivas Royal Salute Tribute to Honor' from 2011, a limited series of twenty-one bottles, retailed at two hundred thousand U.S. dollars each). Fashion is predicated upon the exact same logic. The role of fashion designers in enhancing the essence of the Chivas brand in India is crucial. Manish Malhotra, one of Bollywood's most celebrated designers, in his 2011 collection for Chivas combined fashion with Broadway art, and yet the designs were distinctively Indian. It was a collection deeply rooted in the Indian aesthetics. On display were heavily embroidered saris and lavish *lehengas*; the menswear was equally Indian and predicated upon royal aesthetics. According to Manish himself, the collection was intended to be very Indian, very flamboyant and very glamorous, with perfect pieces of Indian cocktail-party wear. Rohit Bal is often talked about as a true artist in the Indian fashion world for whom designing is a form of art. In the promotional video of the Chivas Studio he even says, 'My life is art and I live for art'. Bal is perceived as an artist who 'blends history, folklore and fantasy to create magic' where 'each of his garments is a masterpiece in its own sense'.[3] In his designs he draws heavily on the fantasies of the Indian royal courts of the past, and intentionally creates for the modern maharajas of contemporary India, both old and nouveau riche. His Chivas Studio collection was called *Yasas,* a Sanskrit word meaning glory. He commented on it as follows: 'Taking inspiration from the fact that India was once called a golden peacock, I wanted to recreate that in a modern sense of opulence and exuberance'.[4] Both of these designers have, throughout their careers, appealed to art to increase their status and increase the authentic value and the perceived authenticity of their creations.

The authenticity of the luxury whisky, and of the other objects on display in these events, is derived from a range of essential characteristics attributed to it as much as characteristics attributed to objects that it seeks association with. Clifford defines four semiotic zones into which objects are classed and assigned value; these are: authentic masterpieces – authentic artefacts – inauthentic masterpieces – inauthentic artefacts (Clifford 1988). Artification enables traffic between these zones, turning what might have been perceived as authentic artefacts into authentic masterpieces, the most valuable form. In the case of the famous Indian fashion designers, the authenticity of their 'masterpieces' comes both from their positioning as unique creative individuals with a strong desire for self-expression, along the lines of Western artists, as much as it comes from their ethnicity, which they enact through their fashion products, which explicitly appeal to the unique Indian heritage

and through their statements. Their statements often suggest that first one has to be Indian, and then one can adopt anything Western (a very popular statement that regularly crops up in film and media, as well as in daily conversations). The designers thus mix a cocktail of values and authenticity that draws on both Western concepts of creativity and on tradition, royal heritage, Indianness, Indian pop art and heavy embroidery. Being Indian is the asset as much as the unique selling point of Indian fashion.

Artification goes hand in hand with power and hierarchy. Not only does it create a hierarchy of objects which are deemed to be valuable, but through these objects it also creates a hierarchy of people who possess these objects. It tells us that some people are more authentic than others. A chivalrous gentlemen with the right family background always stood above an equally chivalrous gentlemen without that background (Girouard 1981) – just as an authentic masterpiece stands above an authentic artefact. There are originals and there are fakes, there are the elite and there are aspirants. Max Warner, the already mentioned brand ambassador of Chivas, has himself said, while promoting Chivas cocktails in Kolkata, that he wants to make whisky drinking 'aspirational', a style statement for 'cool, adventurous and successful people'.[5] Aspiration is the buzz word in India nowadays; it sometimes feels as if the whole contemporary Indian world boils down to this distinction, the distinction between the elite and the rest – the aspirant class and the masses – regardless of their diverse backgrounds. Disseminated through the media, the words 'art', 'Chivas', 'status', 'fashion', 'taste', 'cocktails' and 'glamour' blend with powerful images, movements and gestures, and create a phantasmatic world of aspiration. Chivas Studio, along with many similar events, is what I call a 'total environment of value display' – it is a theatre of power, in which politics of display and politics of authenticity join forces. Maybe Baudrillard would have said that this is a clear manifestation of an era of simulation, where there is 'no longer a question of imitation, nor duplication, nor even parody. It is a question of substituting the signs of the real for the real' (Baudrillard 1994: 2).

Coda: Value and Values

In 2010 the Bombay High Court, based on the appeal of Tarun Tahiliani, one of the Indian star designers, proclaimed a fashion designer to be an artist, which means that 75 per cent of the total income of the designer from foreign sources is exempt from tax.[6] Distinctions between fashion and art are thus blurred, even officially. This shift towards broadening the idea of art, and including what two decades ago would have been labelled as non-art, is happening at the crossroad between the interests of the profit-

oriented corporations, of the media and of the artists themselves who, if not sponsored and appearing in media, can no longer earn a living. The consequence of this is that although art is becoming more and more popular in India, the link is now being made between art, indulgence, high society and celebrity culture. As Kalayni Saha, who runs the art gallery 'Montage Arts', pointed out in an interview, 'With the art boom, it has become fashionable to have soirees, and if you don't mention wine, cheese and cocktails, people actually don't show up'.[7] As much as fashion derives its status from art, art in today's India has to be fashionable. If an exhibition is not inaugurated by someone popular with the media, and if there are no drinks or gourmet food, the event is rarely covered, especially in places like Delhi and Mumbai.

Campbell has shown that when individuals are defining themselves, 'that is specifying what they see as their essential identity', they do so 'almost exclusively in terms of their tastes' (Campbell 2004: 31); and tastes are increasingly becoming framed through the rhetoric of brands, so the very self is becoming more and more shaped through branded messages, tastes and values. At a bar in June 2011, I commented on Arjun's taste for expensive whisky and suggested that it may not be really necessary to waste so much money on it. He looked a little shocked at first, the expression on his face saying, 'You will never get the point, will you?' After that he asked, 'So, what do you suggest, that I buy some *cheap whisky,* like some middle-class *mamuli aadmi* [undistinguished or insignificant person] having a little fun once in a month, or maybe I should not drink at all, right? For your information, I am a Jat guy and we Jats drink; we are aggressive men and we drink only the best and we also give our guests the best, that is how we are. You should know by now that I am no *cheap middle-class clerk.*' Is it not striking how the property of the whisky – its cheapness, its valuelessness – was transposed on the middle-class person? The equation is obvious: cheap valueless whisky equals cheap valueless person.

It appears that objects become part of ourselves, they maintain our social identity and become embodiments of our values and worldview (McCarthy 1984: 116). Sartre once pointed out that having and being merges, and that the only way to know who we are, is by observing what we have (Sartre and Elkaim-Sartre 2003). Very often, '*I like that* merges into *I'm like that*' (Postrel 2004: 101). Commodity is a 'thoroughly socialized thing' (Appadurai 2008: 6) and maybe that is why it is no wonder that consumption clearly affirms, confirms and even creates identity. With this example in mind, it is no longer surprising that India is a home to many who seek and desire aspiration and choose to achieve it through the purchase of status-laden goods, be it clothes, whisky, cocktails or cars. Baudrillard's (1994) point that capital now defines our identities seems valid here. Value is what mobilizes desire,

and 'just as royal splendor calls on its audience to do as others have done, so does the perception of value in objects of exchange. "Others have sought to acquire these things," is the implicit message, "and therefore you should too"' (Graeber 2001: 105). The imagined future, what life would be if one possessed all those things and through them became someone else, is what drives the desire to action; this is what impels those who aspire and believe that a perceived essence of an object will change their own essence. Imagination, the strength of the human species, can at times turn out to be its weakness. This is an ambivalent issue, but there is always hope. After all, it might be the case that 'it is in and through the imagination that modern citizens are disciplined and controlled – by states, markets, and other powerful interests. But is it is also the faculty through which collective patterns of dissent and new designs for collective life emerge' (Appadurai 2000: 6).

Notes

1. Mayawati was at that time the BSP (Bahujan Samaj Party) chief minister of Uttar Pradesh, North India, who represented the *Bahujans* or Dalits, the weakest strata of Indian society.
2. From 2009 to 2010 it increased by 8 per cent according to *The Economic Times* ('Alcohol consumption to grow by 8% this year', 21 June 2010).
3. http://www.mapsofindia.com/who-is-who/health-life-style/rohit-bal.html.
4. Chivas Fashion show in Mumbai, http://www.newstrackindia.com/newsdetails/142868.
5. 'Max Warner promotes Chivas brand of Scotch in Kolkata', at http://calcuttatube.com/max-warner-promotes-chivas-brand-of-scotch-in-kolkata/121779/.
6. http://www.dnaindia.com/lifestyle/report_fashion-designers-are-artists-bombay-high-court_1396503.
7. http://www.indianexpress.com/news/is-art-the-new-fashion/784409/.

References

Appadurai, A. 1996. *Modernity at Large: Cultural Dimensions of Globalization.* Minneapolis: University of Minnesota Press.
———. 2000. 'Grassroots Globalization and the Research Imagination', *Public Culture* 12(1): 1–19.
———. 2008. *The Social Life of Things: Commodities in Cultural Perspective.* Cambridge: Cambridge University Press.
Argenti, P.A. 2007. *Strategic Corporate Communication.* New York: McGraw-Hill.
Baudrillard, J. 1994. *Simulacra and Simulation.* Michigan: University of Michigan Press.

Bayly, C.A. 2008. 'The Origins of Swadeshi (Home Industry): Cloth and Indian Society, 1700–1930', in A. Appadurai (ed.), *The Social Life of Things: Commodities in Cultural Perspective*. New York: Cambridge University Press, pp. 285–321.

Beckert, J. 2011. 'The Transcending Power of Goods: Imaginative Value in Economy', in J. Beckert and P. Aspers (eds), *The Worth of Goods: Valuation and Pricing in the Economy*. New York: Oxford University Press.

Bloom, P. 2010. *How Pleasure Works: The New Science of Why We Like What We Like*. New York: Norton.

Bourdieu, P. 1984. *Distinction: A Social Critique of the Judgement of Taste*. London: Routledge & Kegan Paul.

Campbell, C. 2004. 'I Shop Therefore I Know that I Am: The Metaphysical Basis of Modern Consumerism', in K.M. Ekström and H. Brembeck (eds), *Elusive Consumption*. Oxford: Berg, pp. 27–44.

Cannadine, D. 2002. *Ornamentalism: How the British Saw Their Empire*. New York: Oxford University Press.

Clifford, J. 1988. *The Predicament of Culture: Twentieth-Century Ethnography, Literature, and Art*. Cambridge, MA: Harvard University Press.

———. 1997. 'Four Northwest Coast Museums: Travel Reflections', in J. Clifford (ed.), *Routes, Travel and Translation in the Late Twentieth Century*. Cambridge: Harvard University Press, pp. 107–45.

Das, P. 2007. 'A Conceptual Review of Advertising Regulation and Standards: Case Studies in the Indian Scenario', *International Marketing Conference on Marketing & Society*. Kozhikode: Indian Institute of Management, pp. 743–52.

Entwistle, J. 2009. *The Aesthetic Economy of Fashion: Markets and Values in Clothing and Modelling*. Oxford: Berg.

Favero, P. 2005. 'India Dreams: Cultural Identiry among Young Middle Class Men in New Dehli', VI, 267 s. Stockholm: Stockholm Universitetet.

Girouard, M. 1981. *The Return to Camelot: Chivalry and the English Gentleman*. New Haven, CT and London: Yale University Press.

Graeber, D. 2001. *Toward an Anthropological Theory of Value: The False Coin of our Own Dreams*. New York: Palgrave.

Isaac, M. 1998. 'India', in M. Grant (ed.), *Alcohol and Emerging Markets: Patterns, Problems, and Responses*. London: Taylor & Francis Group, pp. 145–75.

Mann, B.J. and J.P. Spradley. 1975. *The Cocktail Waitress: Woman's Work in a Man's World*. New York: John Wiley & Sons, Inc.

Martin, R.E. 2011. *The College Cost Disease: Higher Cost and Lower Quality*. Northampton, MA: Edward Elgar.

McCarthy, E.D. 1984. 'Toward a Sociology of the Physical World: Herbert Mead on Physical Objects', *Studies in Symbolic Interaction* 5: 105–21.

Plassman, H., J. O'Doherty, B. Shiv and A. Rangel. 2008. 'Marketing Actions Can Modulate Neural Representations of Experienced Pleasantness', *PNAS* 105(3): 1050–54.

Postrel, V. 2004. *The Substance of Style: How the Rise of Aesthetic Value Is Remaking Commerce, Culture, and Consciousness*. New York: Perennial.

Radford, R. 1998. 'Dangerous Liasons: Art, Fashion and Individualism', *Fashion Theory* 2(2): 151–64.

Rajan, R.S. 2004. *Real and Imagined Women: Gender, Culture and Postcolonialism.* New York: Taylor and Francis.

Sartre, J.-P. and A. Elkaim-Sartre. 2003. *Being and Nothingness: An Essay on Phenomenological Ontology.* London: Routledge.

Saxena, S. 1999. 'Country Profile on Alcohol in India', in L. Riley and M. Marshall (eds), *Alcohol and Public Health in 8 Developing Countries.* Geneva: World Heath Organization, pp. 37–60.

Shapiro, R. 2004. 'The Aesthetics of Institutionalization: Breakdancing in France', *Journal of Arts Management, Law and Society* 33(4): 316–35.

Singh, G., and B. Lal. 1979. 'Alcohol in India', *Indian Journal of Psychiatry* 21: 39–45.

Smith, M.D. 1996. 'The Empire Filters Back: Consumption, Production and the Politics of Starbucks Coffee', *Urban Geography* 17(6): 502–24.

Valaya, J.J. 2009. 'Foreword', in H. Sengupta (ed.), *Ramp Up: The Business of Indian Fashion.* New Delhi: Dorling Kindersley, pp. viii–xiii.

Veblen, T. 1970. *The Theory of the Leisure Class: An Economic Study of Institutions.* London: Unwin Books.

Warner, M. 2010. 'Max Warner Global Ambassador for Chivas Regal', *Urban Male Magazine* 102: 109.

CONTRIBUTORS

Peter Bjerregaard is an anthropologist and postdoctoral researcher at the Museum of Cultural History, University of Oslo. His research interests concern museums and materiality. He is currently involved in developing new methods for turning exhibitions and exhibition making into integrated parts of research processes.

Stine Bruland is a Ph.D. fellow at the Norwegian University of Science and Technology (NTNU). Her research focuses on Sri Lankan Tamil family practices in the diaspora and the country of origin, including rituals, generational relations, religion and long-distance nationalism. She has published the articles '*Nationalism as Meaningful Life Projects*' in the *Journal of Ethnic and Racial Studies* (2012, vol. 35, no. 12) and 'Transgressing Religious Boundaries' in *Material Religion* (2013, vol. 9, no. 4).

Amit Desai is visiting research fellow in the Department of Anthropology at Brunel University, London. His research interests include Hindu devotion, nationalism, kinship, art and creativity, and he has conducted fieldwork in both rural central India and urban south India. He has published in journals such as the *Journal of the Royal Anthropological Institute* and is co-editor, with Evan Killick, of *The Ways of Friendship: Anthropological Perspectives* (Berghahn Books, 2010).

Øivind Fuglerud is professor of social anthropology at the Museum of Cultural History, University of Oslo. His research interests include Diaspora formations, politics of cultural representation and aesthetics. He has published a number of works on the conflict in Sri Lanka and its consequences, including *Life on the Outside: The Tamil Diaspora and Long-Distance Nationalism* (Pluto Press, 1999).

Sylvia S. Kasprycki is lecturer at the Goethe University, Frankfurt am Main, and an independent exhibition curator. Her research has focused on the ethnohistory, material culture, and contemporary art worlds of Native America and Sri Lanka. She has published a number of works, including *Die Dinge des Glaubens: Menominees und Missionare im kulturellen Dialog* (Lit Verlag, 2006), *Artful Resistance: Contemporary Art from Sri Lanka* (ZKF Publishers, 2010), and *On the Trails of the Iroquois* (Nicolaische Verlagsbuchhd, 2013).

Tereza Kuldova is a postdoctoral fellow at the Department of Archaeology, Conservation and History at the University of Oslo and a researcher with the international HERA project 'Enterprise of Culture: International Structures and Connections in the Fashion Industry since 1945'. Her research interests include material culture, contemporary India, design, craft and fashion. Recent publications include 'Fashionable Erotic Masquerades: Of Brides, Gods and Vamps in India', *Critical Studies in Fashion and Beauty* 3:1&2 (2012). In 2013, at the Museum of Cultural History in Oslo, she curated the exhibition *Fashion India: Spectacular Capitalism* which was based on her doctoral thesis and resulted in an accompanying edited book.

Fiona Magowan is professor of anthropology at Queen's University, Belfast. Her publications focus on indigenous art, music, performance, Christianity, and sex and gender. She has conducted fieldwork in Arnhem Land, Northern Territory, Queensland and South Australia. Her books include *Performing Gender, Place, and Emotion in Music: Global Perspectives* (Rochester, 2013; co-edited with Louise Wrazen), *Melodies of Mourning: Music and Emotion in Northern Australia* (James Currey, 2007) and *The Anthropology of Sex* (Berg, 2010; co-authored with H. Donnan).

Birgit Meyer is professor of religious studies at Utrecht University. She has conducted research on and published about colonial missions and local appropriations of Christianity, modernity and conversion, the rise of Pentecostalism in the context of neoliberal capitalism, popular culture and video-films in Ghana, the relation between religion, media and identity, as well as on material religion and the role of religion in the twenty-first century.

Saphinaz-Amal Naguib is professor of cultural history in the Department of Culture Studies and Oriental Languages, University of Oslo. Her main fields of research are Ancient Egyptian religion, Coptic and Copto-Arabic hagiographies, Islamic studies, and heritage and museum studies. Among her latest publications is 'Translating the Ancient Egyptian Worldview in Museums' (in *Lotus and Laurel: Studies on Egyptian Language and Religion in Honour of Paul John Frandsen,* Copenhagen: Museum Tusculanum).

Arne Aleksej Perminow is associate professor in social anthropology at the Museum of Cultural History, University of Oslo. The relationship between everyday engagements with the natural environment, ritual aesthetics and sociality is central in his research. Among his publications is 'The Other Kind: Representing Otherness and Living with it on Kotu Island in Tonga' (in *Oceanic Socialities and Cultural Forms*, Berghahn Books, 2003).

Anders Emil Rasmussen teaches anthropology at Aarhus University. He has done extensive urban as well as village level fieldwork in Papua New Guinea. Research interests include the anthropology of value, materiality and personhood. He is the author of *Manus Canoes: Skill, Making and Personhood* (Occasional Papers, 2013), and his second monograph, *In the Absence of the Gift: New Forms of Value and Personhood in a Papua New Guinea Community*, is in press (Berghahn Books, 2015).

Maruška Svašek is reader at the School of History and Anthropology, Queen's University, Belfast. Her main research interests are emotions, migration, art and material mediation. Major publications include *Moving Subjects, Moving Objects: Transnationalism, Cultural Production and Emotions* (Berghahn Books, 2012), *Emotions and Human Mobility: Ethnographies of Movement* (Routledge, 2012), and *Anthropology, Art and Cultural Production* (Pluto, 2007). Svašek is co-editor (with Birgit Meyer) of the Berghahn Books series 'Material Mediations: People and Things in a World of Movement'.

Katherine Swancutt is lecturer in the Anthropology of Religion at King's College London. She has worked on animistic religions for over a decade across Inner Asia, among Buryat Mongols and the Nuosu of South West China. Her recent publications include *Fortune and the Cursed: The Sliding Scale of Time in Mongolian Divination* (Berghahn Books, 2012) and numerous articles on religion. Currently, she is working on the relationship between dreaming and ethnography in South West China.

Leon Wainwright is Kindler Chair in Global Contemporary Art at Colgate, New York, reader in Art History at The Open University, UK and editor-in-chief of the *Open Arts Journal*. His publications include *Timed Out: Art and the Transnational Caribbean* (Manchester University Press, 2011), *Triennial City: Localising Asian Art*, co-edited with B. Kennedy and A. Mitha (Cornerhouse, 2014), and numerous writings on modern and contemporary histories of art and global change. He is a recipient of the Philip Leverhulme Prize for the History of Art.

INDEX

transvisionary imaginations: creative
oscillation, 213–14, 218–19,
220–21, 223–24, 225–26; and
Vidyashankar's work, 210–11, 213–
14, 218–19, 223–24, 225–26
Tsing, Anna Lowenhaupt, 20

urban and suburban Aboriginal artists,
8, 187–203

Valaya, J.J., 230
value. *See* monetary value and art
values and Chivas Regal in India,
238–40, 241
van der Grijp, Paul, 115
Varma, Raja Ravi, 212
video film industry in Ghana, 161,
168–69, 173–78, *173–75, 177*
Vidyashankar and transvisionary
approach, 207–27; art training in
Madras, 211–14, 222–24, 226;
creative oscillation and past,
213–14, 218–19, 220–21, 223–24,
225–26; movement and work,
207, *208–9*, 209, 218–19, 221–22,
225–27; sketch of Nataraja, 215,
217; and sthapathy family and
tradition, 214–18, 219, *219–21*,
222–23
viewers of art: engagement with
Aboriginal artists, 191–92, 196–98,
202; Native American art, 32
'Villa Sovietica' exhibition, 46–49

visible. *See* seeing; invisible in Papua
New Guinea
Vogel, Susan, 41–42n7

Wagner, Roy, 156
Wainwright, Leon, 139, 160
warfare: ghosts and Nuosu ritual in
China, 133–57
Warner, Max, 237–38, 243
Wastell, Sari, 4, 134
wealth: food presentations, 121, 123–
25, 126, 130
weapons and Nuosu warfare ritual,
136, 137, 138, 139–40, 152–55
Wertsch, James, 74–75
whisky. *See* 'artification' of whisky and
fashion in India
Willerslev, R., 141–42
Wirklichkeit and museum experience,
50, 60
Witches of Africa, The (film), 173–75,
173–75
Woets, Rhoda, 171
Womack, Craig S., 40
women: Aboriginal artists, 192–93;
status in India, 231, 232–33, 239–40

Young Man, Alfred, 35, 37
Yukaghir people of Siberia and
hunting, 141–42

Zeno's arrow and movement, 221–22,
226, 227

Lightning Source UK Ltd.
Milton Keynes UK
UKOW06f1623131117

312663UK00007B/198/P